MANGA DRAWING SCHOOL

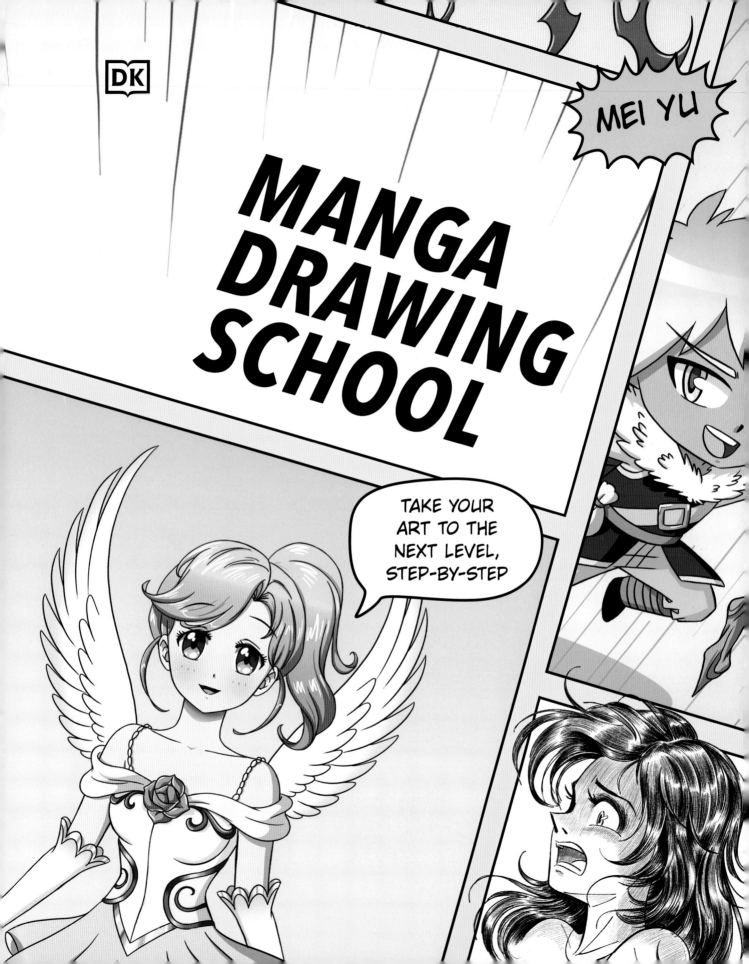

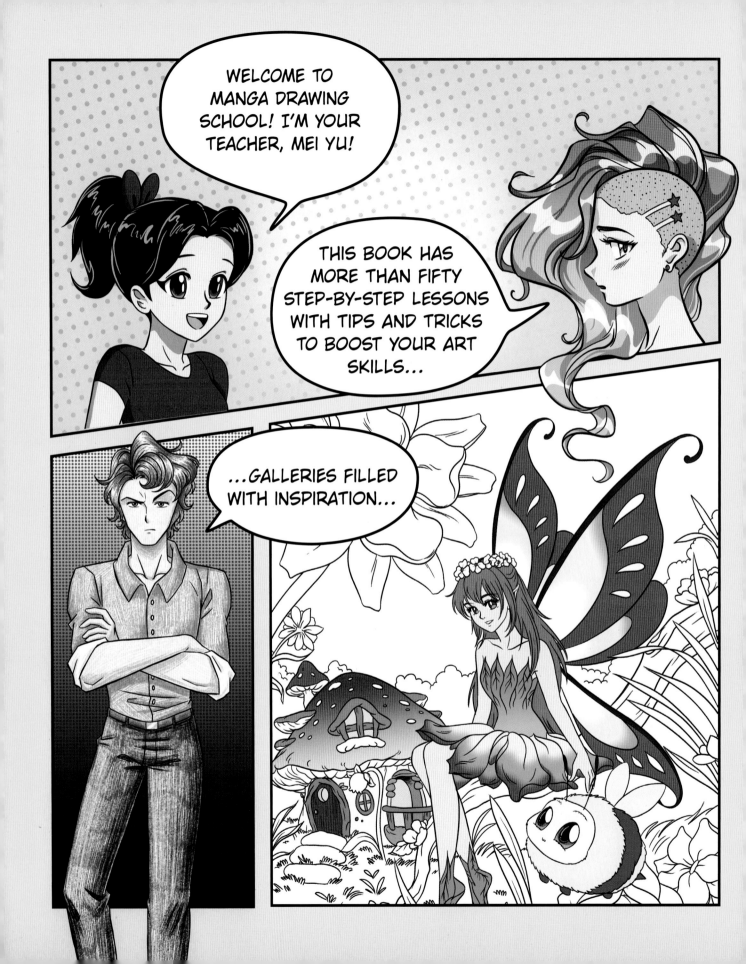

...AND MASTERCLASSES TO TRANSFORM YOUR ART WITH DIFFERENT MANGA ART STYLES, EXPRESSIONS, POSES, AND MORE!

CONTENTS

LET'S TALK ABOUT MANGA!

"Manga" are comics originating in Japan. They can be of any genre—romantic comedies, modern-day slice-of-life, crime, fantasy epics, coming-of-age stories—or anything else you want to create in a visual, creative way!

Manga has a long history. Some say that it dates back to the 12th century, making it older than Shakespeare. I know, I was surprised too!

From those 12th-century scrolls, which show animals behaving as if they were people, manga has evolved to become a global phenomenon with artists in every corner of the world. You, too, can become part of this sensation.

Welcome to *Manga Drawing School*, where I will help you learn how to draw manga and create your own professional-looking characters. It's like having a personal art teacher by your side, showing you how to make awesome manga of your own.

Before we get started, let's take a brief look at some of the most well-known types of manga.

Shonen

Shonen manga is the most popular kind of manga. It typically involves male main characters and battles between good and evil, though many exceptions exist. A wide variety of genres can be found within shonen manga, including action, fantasy, sci-fi, mecha, and comedy. Shonen manga underwent major changes in the late 1940s. Osamu Tezuka, known to many as the father of manga, is often credited with influencing many elements of modern shonen manga (and manga in general), including the idea of manga as a long-running story.

Shojo

Shojo typically includes female leads; characters with large, highly-detailed eyes; and stories that focus on relationships and emotions. Some typical shojo genres include romantic comedy, magical girl, and horror. Originally, shojo manga was created by male authors but, in the 1960s, many female creators joined the scene. By the 1970s, most shojo manga artists were women.

Josei

Josei manga came about in the 1980s, following a growing desire to create manga stories for adult women—stories that were more serious or grounded in reality. Reflecting this, characters in josei manga tend to look more mature or realistic (but, just as with any art form, there are always exceptions). Josei manga often focuses on mature themes, realistic relationships, or social issues, and it often depicts the everyday lives of young women. Genres common in josei manga are drama, romance, and slice-of-life.

Seinen

Catering to adult male readers, seinen manga puts great emphasis on mature themes, shows realistic portrayals of relationships, and usually has more detailed character design. While it may feature action like shonen manga, seinen manga tends to focus more on the story and character development. Genres typically include action, thriller, war, sports, and comedy. Art styles can vary between series, but many artists draw their characters with beautiful, highly detailed lines and shading.

In this book, I want to show you many different techniques, tips, and tricks for how to draw unique characters. I'll show you how to create eyes, hairstyles, and clothing while trying out a range of popular manga art styles.

Whether you want to create your own manga or original characters for fun, become a professional manga artist, or just get better at drawing, this book is a great foundation from which to learn new skills and take your art and creativity to the next level.

Pencil? Check. Paper? Check. Let's begin!

CHIBI

Chibi-style characters are usually drawn with large heads, tiny bodies, and small, stubby arms and legs. Their outfits, hair, limbs, and other details are very simplified. Chibi describes a way in which characters are drawn and most often appears in shojo and shonen manga.

GETTING
STARTED

MANGA VERSUS WESTERN ART STYLES

What is it that makes manga art styles different from Western comic art styles? Let's take a look! I have drawn the same character in four different styles—two Western-inspired and two manga-inspired—so we can compare them.

Generally, manga art is drawn with confident strokes and thin lines. Characters tend to have tiny, pointy chins and large, expressive eyes. Manga eyes often include at least one highlight, which gives them an attractive shine. Noses are usually small—sometimes, they're nothing more than a dot! Mouths are usually simple in shape and detail, often formed in triangular smiles. For characters with long hair, manga artists tend to use flowing lines and finish the artwork with bright highlights. You can see some of these elements in the top two examples on the right.

In comparison, the art in Western comics varies wildly! Characters can range from having simpler, flat, geometric shapes with exaggerated eyes to more realistically proportioned faces. Chin and face shapes can vary from being very soft or stylized to hard or realistic. The line art and shading also vary from one character to the next. Sometimes, Western comic characters have no shading at all, while others might have lots of dramatic, dark shadows inked across their faces or hair. Take a look at some of these elements in the bottom two examples.

Both new and established artists are constantly creating manga and Western comics. They bring their own visual language into their creations but are also inspired by other art they've seen. Some manga art styles reflect the influence of Western comics, and vice versa.

Remember—there will always be exceptions to a specified art style, and some manga art will have different characteristics than what's shown here. This is because art and artists are always evolving! It ultimately depends on how the artist wants to design their characters and tell their story.

THE WONDERFUL THING ABOUT ART IS ITS STAGGERING VARIETY AND RANGE OF POSSIBILITIES. KEEP READING TO DISCOVER LOTS OF DIFFERENT MANGA TECHNIQUES, WHICH WILL HELP INSPIRE YOU TO CREATE YOUR OWN STYLE!

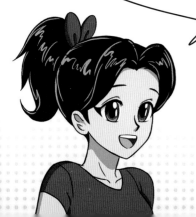

EXAMPLES OF MANGA ART STYLES

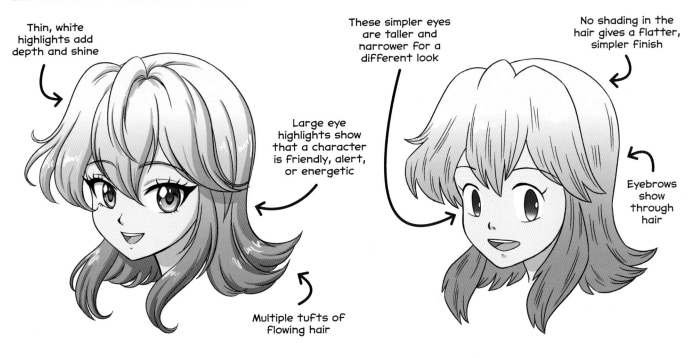

Thin, white highlights add depth and shine

These simpler eyes are taller and narrower for a different look

No shading in the hair gives a flatter, simpler finish

Large eye highlights show that a character is friendly, alert, or energetic

Eyebrows show through hair

Multiple tufts of flowing hair

EXAMPLES OF WESTERN COMIC ART STYLES

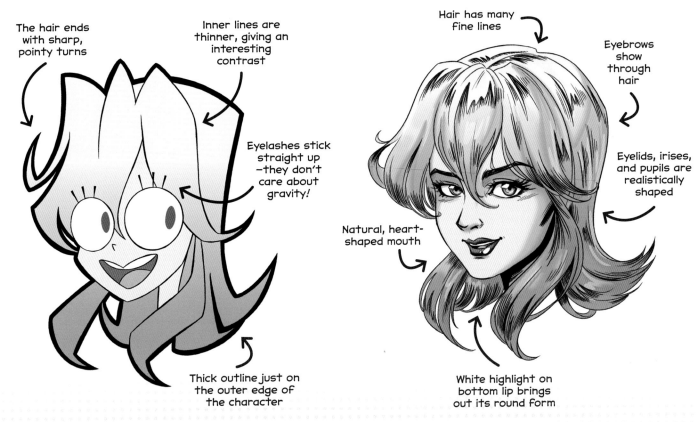

The hair ends with sharp, pointy turns

Inner lines are thinner, giving an interesting contrast

Hair has many fine lines

Eyebrows show through hair

Eyelashes stick straight up —they don't care about gravity!

Eyelids, irises, and pupils are realistically shaped

Natural, heart-shaped mouth

Thick outline just on the outer edge of the character

White highlight on bottom lip brings out its round form

CHOOSING YOUR MEDIUM

No matter which drawing materials you use, you can achieve great results! But it's useful to understand how each material works and when it's best to use them. Here are four examples of different art media: three were drawn and colored on paper, and a fourth was made by using digital software.

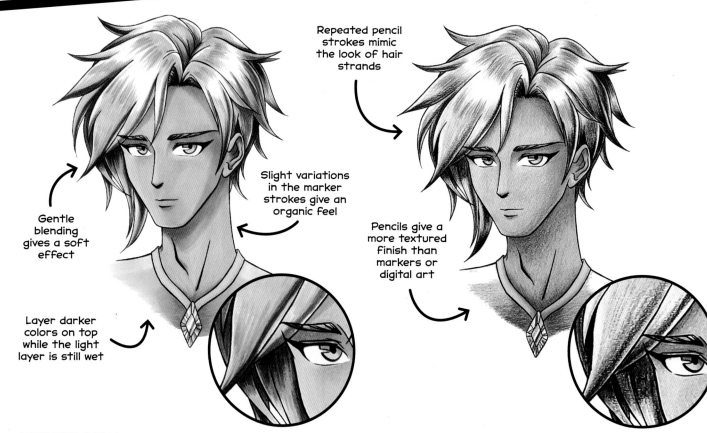

Repeated pencil strokes mimic the look of hair strands

Slight variations in the marker strokes give an organic feel

Gentle blending gives a soft effect

Pencils give a more textured finish than markers or digital art

Layer darker colors on top while the light layer is still wet

MARKER PENS

There are many types of markers you can use, ranging from cheap, everyday felt-tip pens to expensive, artist-grade ones. Experiment with different types to see what you're comfortable with. This image has been created with alcohol-based markers with brush tips because they blend gently into other colors. Brush-tip markers are great for soft blending when coloring hair, skin, and clothing. In this drawing, you can see the soft strokes of color, particularly in the hair and highlights. Other types of markers include thin tips and wider chisel tips. These work well when drawing harder edges or fine details.

COLORED PENCILS

Colored pencils can give your manga art a beautiful, textured look, and the paper you choose—depending on how rough or smooth it is—can add to the effect as well. Colored pencils can be wax-based or oil-based. Wax-based pencils offer a softer blend, while oil-based pencils tend to have brighter colors. When using wax-based colored pencils, layer your colors slowly to avoid wax build-up on your art. For this image, I used oil-based colored pencils, giving it a vibrant look.

TIP!

TRY OUT A VARIETY OF ART SUPPLIES TO SEE WHICH ONES YOU'RE MOST COMFORTABLE WITH!

You are not limited to using a single medium for your drawings. Try mixing different ones together to create your own unique styles. For example, you could lay base colors with markers, then use colored pencils to add the shading for a more textured look.

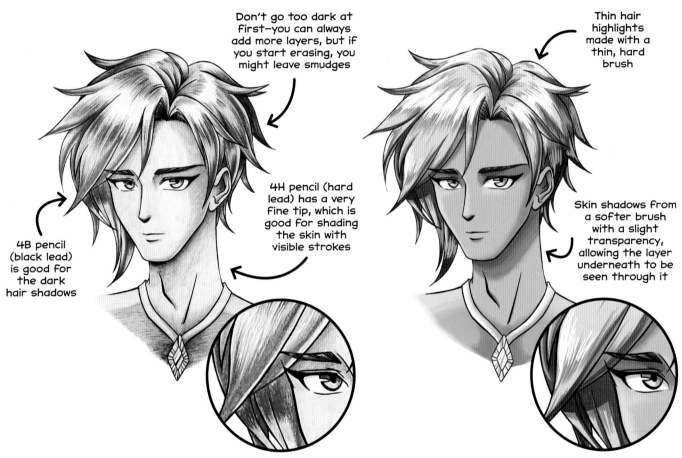

Don't go too dark at first—you can always add more layers, but if you start erasing, you might leave smudges

4H pencil (hard lead) has a very fine tip, which is good for shading the skin with visible strokes

4B pencil (black lead) is good for the dark hair shadows

Thin hair highlights made with a thin, hard brush

Skin shadows from a softer brush with a slight transparency, allowing the layer underneath to be seen through it

PENCILS

Pencils are great for sketching and shading—a monochromatic look can make your artwork really stand out. Pencil leads go from H "hard leads" to B "black leads." Hard leads are lighter and finer. Black (or soft) leads produce softer, darker lines, which are perfect for shading. The most common type of pencil lead is HB, like the ones most people use in school. These can be a great starting point for pencil-based artwork, as HB pencils generally produce both light and dark lines.

DIGITAL

Using software to create manga art offers so many different ways to express yourself! Depending on the program you use, there are a variety of digital tools that can help you achieve a huge range of effects. From paint buckets and different brushes to erasers and gradient tools, take time to explore your program's tools. Some software allows you to create your art in layers—and you can add different effects to various layers and see what happens! The best part is that you can undo changes if you make a mistake!

START WITH SHAPES

Now, let's start drawing! A helpful technique, especially when drawing manga for the first time, is to think about your art as a collection of shapes. This can help break down even the most complex manga design into something more manageable!

FACE SHAPES

With just a circle, a triangle, and a pair of lines, we can quickly create the basic shape of a character's head! The circle is the basis for the skull, while the triangle completes the face, including the jaw and chin. The triangle's shape changes, depending on which way the character is facing. For example, a wide, curved triangle with the point in the middle can work for a front-view girl, whereas a less symmetrical triangle with a flatter side can work for a face in profile. A pair of curved lines makes up the neck.

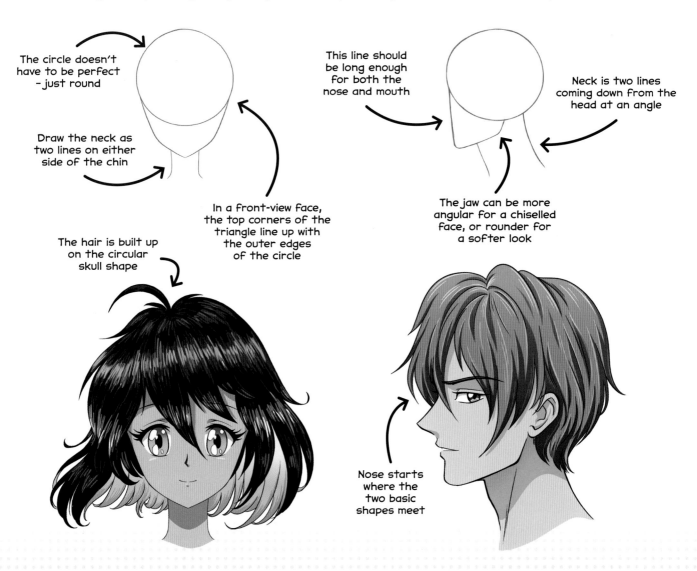

The circle doesn't have to be perfect – just round

Draw the neck as two lines on either side of the chin

In a front-view face, the top corners of the triangle line up with the outer edges of the circle

The hair is built up on the circular skull shape

This line should be long enough for both the nose and mouth

Neck is two lines coming down from the head at an angle

The jaw can be more angular for a chiselled face, or rounder for a softer look

Nose starts where the two basic shapes meet

BUILDING A BODY

Drawing an entire character can seem complex at first, but even a full body can be broken down into simple shapes. Below, you can see how this character's body structure is built from groups of different shapes. When you separate them into their basic shape elements, drawing the body becomes a lot easier!

Head and neck made from a circle, triangle, and pair of curved lines

Torso is two stacked shapes: one wider, one narrower

Arms are rounded cylinders that taper at elbows and wrists

Hips are a triangular wedge shape

Legs are longer rounded cylinders that taper at knees and ankles

Hands are uneven squares to start with

Knees are narrow diamond shapes

Feet are elongated wedges

THROUGHOUT THIS BOOK, YOU'LL SEE MANY EXAMPLES OF HOW DIFFERENT HEADS, HANDS, BODIES, AND ENTIRE SCENES ARE BUILT FROM SIMPLE SHAPES. HOPEFULLY WITH PRACTICE, YOUR ART SKILLS CAN SHAPE UP NICELY!

LOVELY LINES

Line art is very important for creating attractive, professional-looking manga characters. How you handle the lines makes a big difference in the overall art style. Here's a comparison of four different types of line art to help you see their differences!

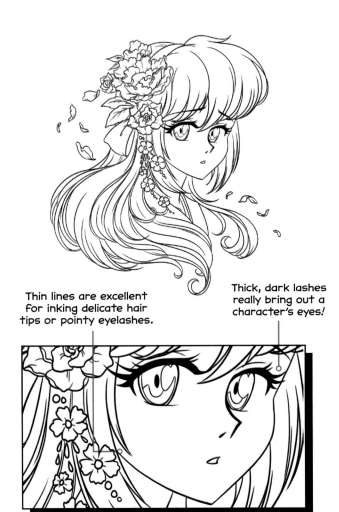

Use a combination of thick and thin lines to help make the petals look more realistic

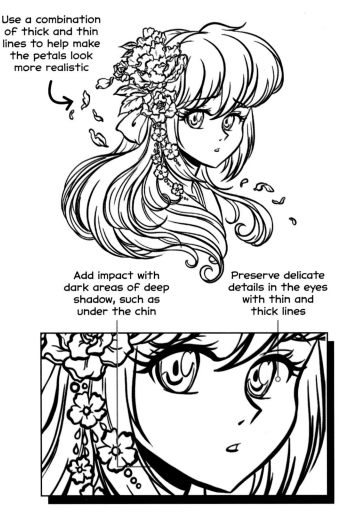

Thin lines are excellent for inking delicate hair tips or pointy eyelashes.

Thick, dark lashes really bring out a character's eyes!

Add impact with dark areas of deep shadow, such as under the chin

Preserve delicate details in the eyes with thin and thick lines

THIN LINES

This art style uses mostly thin, delicate lines. It's pretty uniform, aside from a few areas that are a bit thicker, including the eyebrows, lashes, and nose. This variation helps make certain areas or features stand out. The lines also taper off into very slim points in certain places, such as the flower petals and leaves.

THICK LINES

This is a more dramatic, inky style of line art. The lines are a lot thicker, although some areas include thinner lines, such as for fine hair details, eye highlights, and within the flower petals. The lines are thickest around curves and bends. This variation between thick and thin helps give the art a more organic and natural look.

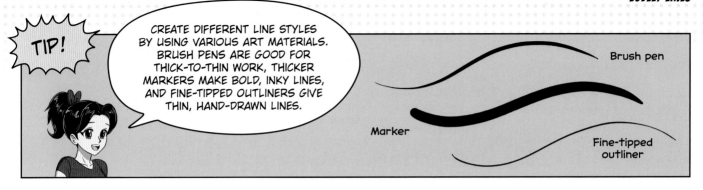

TIP!

CREATE DIFFERENT LINE STYLES BY USING VARIOUS ART MATERIALS. BRUSH PENS ARE GOOD FOR THICK-TO-THIN WORK, THICKER MARKERS MAKE BOLD, INKY LINES, AND FINE-TIPPED OUTLINERS GIVE THIN, HAND-DRAWN LINES.

Brush pen

Marker

Fine-tipped outliner

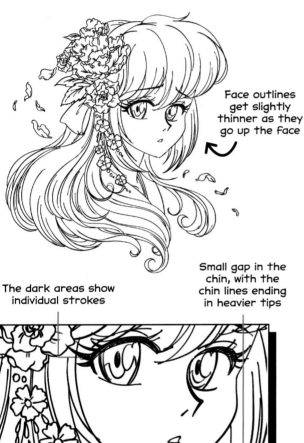

Face outlines get slightly thinner as they go up the face

The dark areas show individual strokes

Small gap in the chin, with the chin lines ending in heavier tips

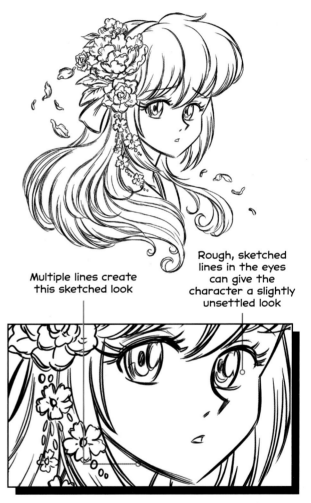

Multiple lines create this sketched look

Rough, sketched lines in the eyes can give the character a slightly unsettled look

PEN LINES

This style of line art looks rougher and less perfect than the two previous styles—as if you are drawing with a pen or outliner, using quick, confident movements. The lines have a thicker weight near the start or end, and they don't all join neatly together. Note how the dark lashes are not fully filled in, giving the character a lively, hand-drawn look.

SKETCH LINES

This style of line art uses a sketchy approach that can give your work a spontaneous, organic feel. You can also apply this technique if you want to give your character a specific look or emotion, such as extremely shaken, shocked, or in the middle of a frantic action sequence. The sketched look comes from multiple thin lines grouped together or overlapping to build up the outlines.

THE POWER OF COLOR

Colors have a tremendous effect on how we perceive art and character design. A great way to learn how to handle colors is with a color wheel. Are you ready to add color to your manga world? Let's go!

Yellow-green · Yellow · Yellow-orange · Green · Orange · Blue-green · Red-orange · Blue · Red · Blue-violet · Red-violet · Violet

SECONDARY · PRIMARY · SECONDARY · PRIMARY · SECONDARY · PRIMARY

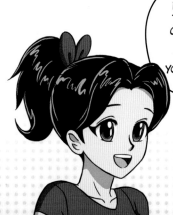

WHEN CHOOSING COLOR SCHEMES FOR YOUR CHARACTERS, THINK ABOUT THEIR PERSONALITIES. ARE THEY BOLD OR HOT-HEADED? TRY MORE REDS. ARE THEY COOL, UNFEELING, OR ICY? TRY BLUES AND VIOLETS. OR, IF THEY ARE YOUNG, CUTE, OR BUBBLY, TRY YELLOWS, PINKS, AND YELLOW-GREENS.

THE COLOR WHEEL

By adding white, black, or gray to the colors of the color wheel, you can change them, creating muted, lighter, or shadowy versions. Grouping colors into pairs or sets can help you come up with a color scheme for your art. There are different ways to combine colors, depending on the look you want to achieve. Some options include grouping primary, secondary, complementary, analogous, warm, or cool colors.

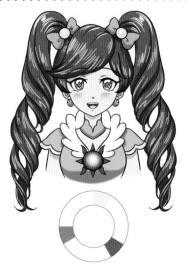

Primary colors:
red, yellow, blue
Primary colors are the three basic colors that cannot be made by mixing others together. Combining primary colors creates every other color. Using only primary colors can give your art a bold, bright look.

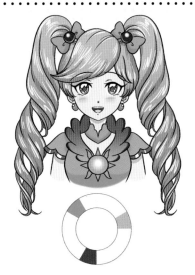

Secondary colors:
orange, violet, green
The three secondary colors come from mixing any two primary colors together: Yellow mixed with red makes orange, red and blue make violet, and blue and yellow make green.

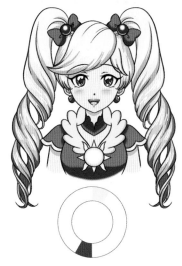

Complementary
colors
Complementary colors are opposite each other on the color wheel, such as yellow and violet (shown here), orange and blue, and red and green. They are a great way to add striking contrast to your art!

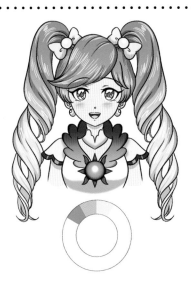

Analogous colors
Analogous colors are three neighbors on the color wheel. They look harmonious together, such as yellow, yellow-green, and green.

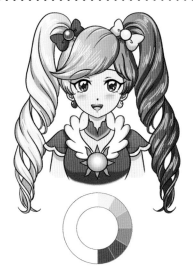

Warm colors
Warm colors make up half of the color wheel. They create a warm effect and can be used to depict many things, including sunlight, heat, rage, or a cozy setting.

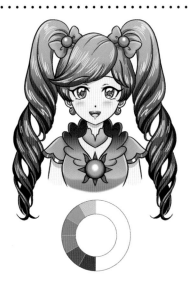

Cool colors
Cool colors make up the other half of the color wheel. These are colors that can give a calm, relaxing vibe and can remind you of water, the sky, or snow.

BUILDING DIMENSION

Now that we've looked at some basic types of lines and color palettes, let's see how we can use these to build dimension in our characters. Here, we have two versions of the same character, but she looks very different because of the distinct techniques I've used to bring out her dimension!

CROSS-HATCHING

Using cross-hatching on your character to create areas of shadow and light helps build dimension. Giving your art a monochromatic finish also makes a dramatic impact. This can be a nice way to give your character a more sophisticated, serious, or intense feel. The fine crosshatched lines help add a lot of texture, and they give a more realistic, formed look.

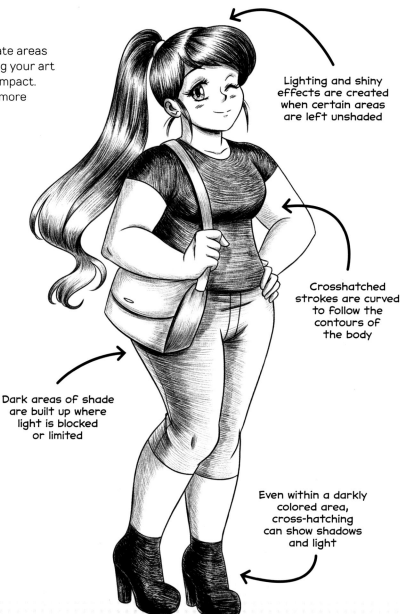

Lighting and shiny effects are created when certain areas are left unshaded

Crosshatched strokes are curved to follow the contours of the body

Even within a darkly colored area, cross-hatching can show shadows and light

Line art only

Dark areas of shade are built up where light is blocked or limited

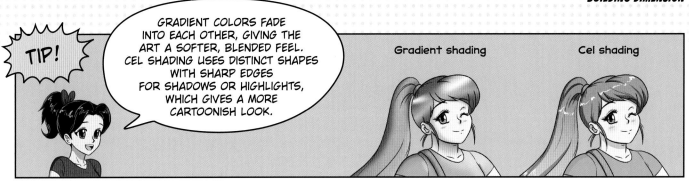

TIP! GRADIENT COLORS FADE INTO EACH OTHER, GIVING THE ART A SOFTER, BLENDED FEEL. CEL SHADING USES DISTINCT SHAPES WITH SHARP EDGES FOR SHADOWS OR HIGHLIGHTS, WHICH GIVES A MORE CARTOONISH LOOK.

Gradient shading

Cel shading

SHADING WITH COLOR

This shading technique starts with a flat base-color layer. Then, darker and lighter colors are added on top to build dimension by using gradients, cel shading, or a combination of the two. This style gives a less detailed finish than cross-hatching because the solid or blended blocks of color leave no visible strokes.

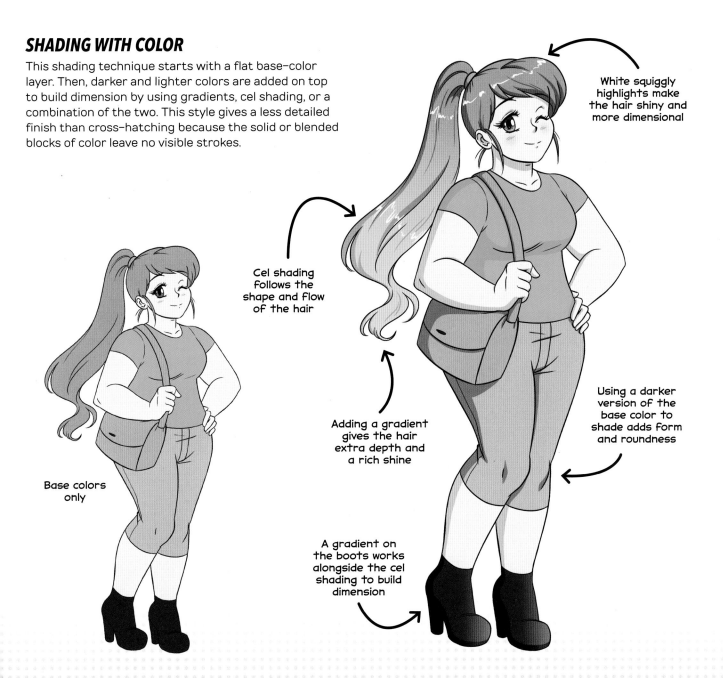

White squiggly highlights make the hair shiny and more dimensional

Cel shading follows the shape and flow of the hair

Adding a gradient gives the hair extra depth and a rich shine

Using a darker version of the base color to shade adds form and roundness

A gradient on the boots works alongside the cel shading to build dimension

Base colors only

PANEL BASICS

Manga storytelling uses a variety of different panels to create a narrative. Here are examples of five basic panel types you can use. These panels show the same character, starting from the long shot all the way to an extreme close-up.

Long shot

Long shots establish the setting and may show important characters' positions relative to the background or other characters. This type of shot is often used to set the scene or transition to a new one. It can show multiple characters, just one, or none. This long shot shows our character in the living room of a high-rise apartment building.

Medium shot

Medium shots are balanced to focus on characters while still showing part of the background. Use them when you want to show your characters' expressions but also their upper body or surroundings at the same time. This type of shot will include some space between your characters and the edges of the panel.

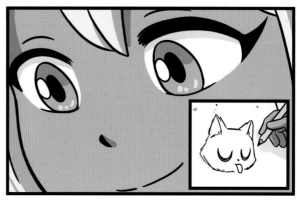

Extreme close-up shot

Zooming in even more, an extreme close-up gets up close and personal to a character's face. This shot creates a more profound or memorable experience, useful for important, impactful, scary, or emotional moments.

Inset panel

As the name suggests, inset panels are set within a larger panel. Use them to show something happening simultaneously with the events of the larger panel or to show smaller details. Here, we see exactly what our cat lover is sketching.

Close-up shot

A close-up zooms in, often to show just a character's head and shoulders. This can show their expression in greater detail, convey a sense of closeness to them, highlight their emotion, or add tension. Close-ups can also be useful to show the reactions of characters to something that happens in the previous panel.

MAKING A MANGA PAGE

The magic of storytelling comes down to how you show a story or scene, including your choice of shot and panel layout. Mix things up and vary each panel to make your story as exciting as possible!

Manga is read from right to left, starting from the top right corner. This means that the speech bubbles in each panel read from right to left, too, the opposite of English reading order.

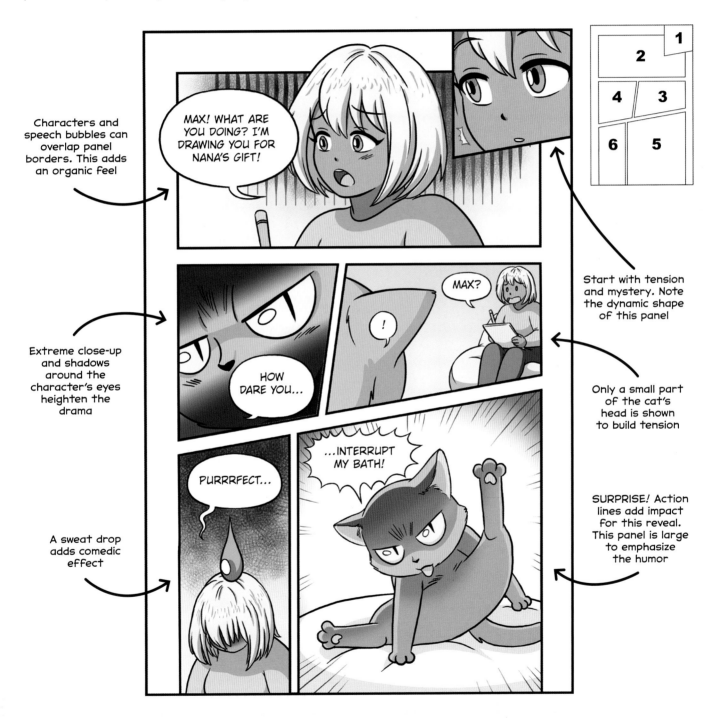

Characters and speech bubbles can overlap panel borders. This adds an organic feel

MAX! WHAT ARE YOU DOING? I'M DRAWING YOU FOR NANA'S GIFT!

Extreme close-up and shadows around the character's eyes heighten the drama

HOW DARE YOU...

MAX?

!

A sweat drop adds comedic effect

PURRRFECT...

...INTERRUPT MY BATH!

Start with tension and mystery. Note the dynamic shape of this panel

Only a small part of the cat's head is shown to build tension

SURPRISE! Action lines add impact for this reveal. This panel is large to emphasize the humor

EMOTIONAL ICONS

To make your manga more dramatic, moving, or memorable, focus on taking your character's emotions to the next level! Adding special little symbols or textures can emphasize your character's moods and add humor too.

Usually red and shaped like a burst of some sort

Place around head or fist

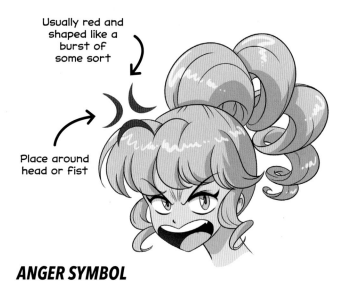

A blue or black background completes the effect

Place behind or in front of the head

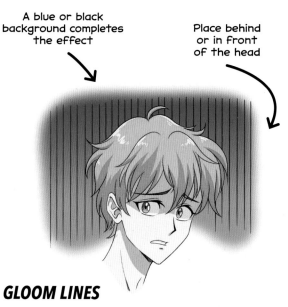

ANGER SYMBOL

Steer clear if you see this symbol, which looks like bulging red veins on someone's head! Maybe she found out her bratty younger brother read her diary.

GLOOM LINES

To show fear, anxiety, or sadness, you can add multiple vertical black or blue lines around the character's head.

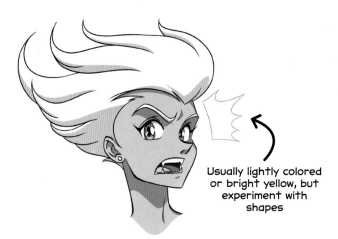

Usually lightly colored or bright yellow, but experiment with shapes

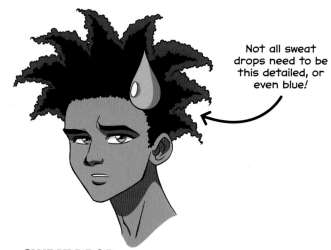

Not all sweat drops need to be this detailed, or even blue!

SHOCK MARK

Ideal for a moment of shock or sudden realization. Maybe they just heard something truly surprising!

SWEAT DROP

This is a manga classic to show discomfort, nervousness, or embarrassment. Here, the raised eyebrow and flat gaze suggest he is unamused.

BUBBLES OF FEELING

Speech bubbles can do more than just surround dialogue—style them to amplify emotions or exaggerate how the reader "hears" the voice of the character.

Text is centered

THIS IS JUST AN ORDINARY ROUND SPEECH BUBBLE...

Leave enough white space around the text so it isn't cramped

THEY ARE NOT ALWAYS A SINGLE SHAPE...

SPEECH BUBBLES CAN BE JOINED TOGETHER TO FORM BIGGER ONES!

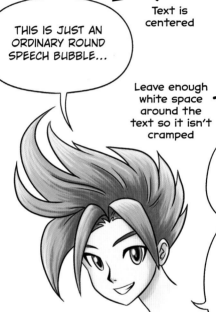

REGULAR SPEECH BUBBLE

Most speech bubbles have a simple, round shape, and are used for normal dialogue.

For greater emphasis, try enlarging the size of certain words in the bubble

WHEN A CHARACTER IS VERY EMOTIONAL AND SHOUTING, THEIR SPEECH BUBBLES COULD HAVE AN EXPLOSIVE LOOK LIKE MINE. WAAAAH!!

SHOUTING BUBBLE

Bursts or explosion-shaped bubbles show anger, frustration, or horror.

The spout of this speech bubble is slightly longer than the other points

FOR SCARY OR CREEPY CHARACTERS, TRY WIGGLY SPEECH BUBBLES WITH WISPY TAIL SPOUTS.

Make the spout longer and wispy for a haunting, trailing effect

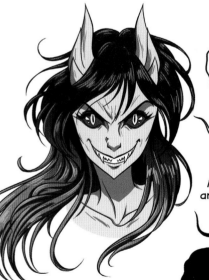

CREEPY BUBBLE

Bumpy bubbles suggest whispering or a raspy voice, perfect for monsters or ghosts!

Soft curves for a cuddly, gentle feel

TRY CUTE CURVED SPEECH BUBBLES FOR EXTRA KAWAII CHARACTERS! OR, ADD LITTLE HEARTS FOR A SUPER SWEET LOOK. AWWW!

CUTE BUBBLE

To emphasize cuteness when, for example, a character is sweet-talking her parents into buying that shiny new game console!

BOO! LOOK AT HOW THIS SPEECH BUBBLE STANDS OUT!

For dramatic, extra-spooky impact, try white text in a black speech bubble!

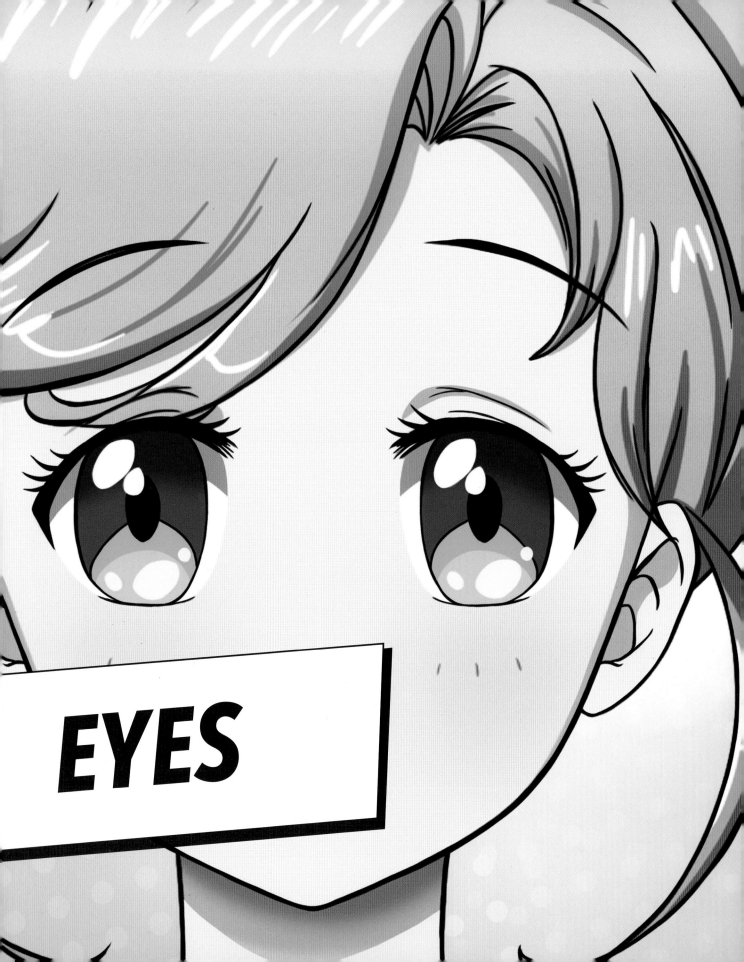

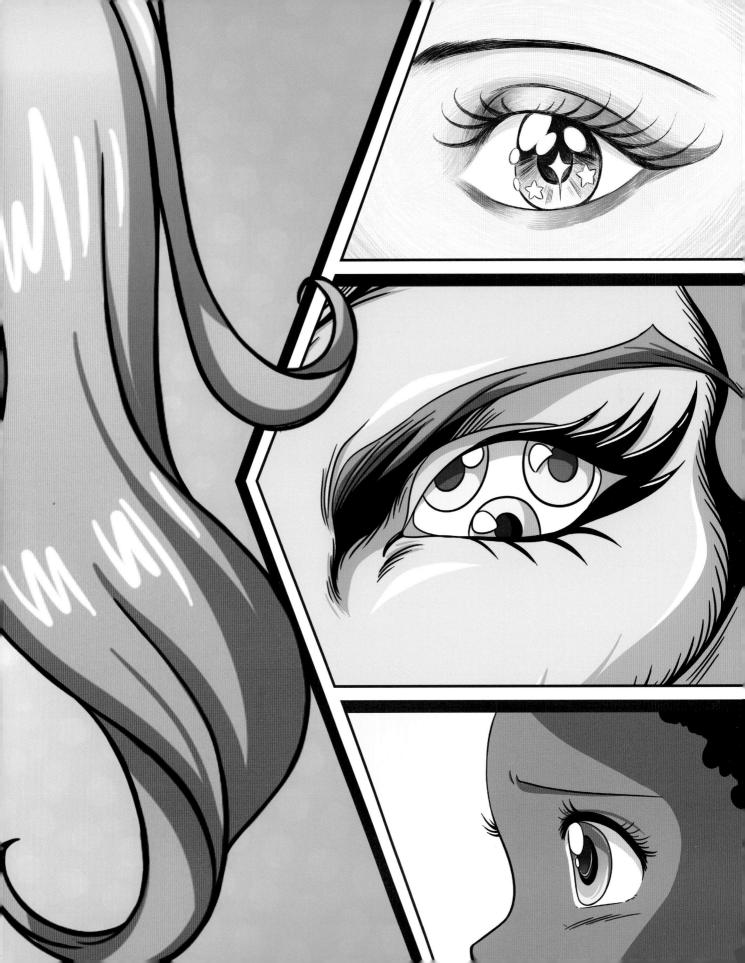

CUTE EYE

Big eyes are key to creating a cute character—they're just so expressive! Here, I'll show you how to draw an eye with a large, multi-tonal iris, complete with highlights that reveal just what your character is feeling. This gorgeous green eye will work for cute, hopeful, or dreamy characters—or even someone in love!

1 BEGIN WITH A CURVED UPPER EYELID, ANGLED SLIGHTLY SO THE LOWER POINT FORMS THE OUTER CORNER OF THE EYE. MAKE IT THICK SO THE EYE REALLY STANDS OUT.

Allow plenty of space for a large, cute eye!

2 AT THE END OF THE UPPER EYELID, DRAW A SMALL POINT COMING DOWN FROM THE CORNER OF THE EYE. THEN, ADD A SLIM, CURVED LINE FOR A BOTTOM LID.

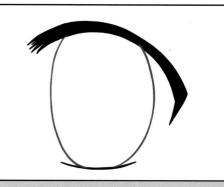

3 FILL THE SPACE BETWEEN THE LIDS WITH A LARGE OVAL FOR THE IRIS. THE TOP OF THE IRIS SHOULD BE CONCEALED BEHIND THE UPPER LID.

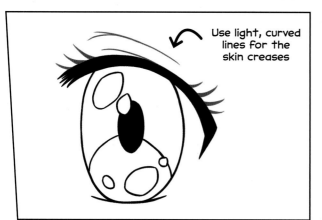

Use light, curved lines for the skin creases

6 NOW, ADD LASHES! SKETCH A FEW CURVED LINES ON BOTH SIDES OF THE EYELID. FOR MORE REALISM, DRAW ONE OR TWO LINES ABOVE THE EYELID FOR SKIN CREASES.

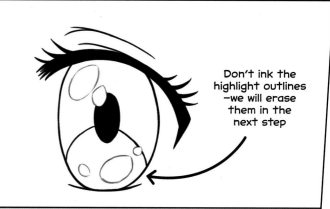

Don't ink the highlight outlines —we will erase them in the next step

7 ONCE YOU'RE HAPPY WITH THE ARTWORK, IT'S TIME TO INK THE FINAL LINES. USE AN OUTLINER OR BRUSH PEN TO GO OVER THE LINES AND THEN ERASE ANY UNNECESSARY SKETCH LINES.

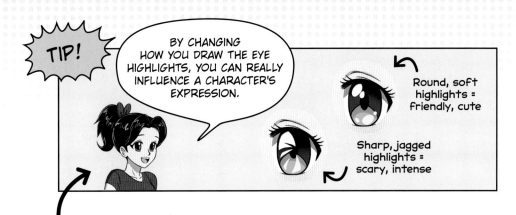

TIP!

BY CHANGING HOW YOU DRAW THE EYE HIGHLIGHTS, YOU CAN REALLY INFLUENCE A CHARACTER'S EXPRESSION.

Round, soft highlights = friendly, cute

Sharp, jagged highlights = scary, intense

The upper highlights should match where the light source nearest to your character is

Add lower highlights directly opposite the upper highlights

4 ADD SEVERAL SMALL HIGHLIGHTS INSIDE THE IRIS, AT LEAST ONE AT THE TOP AND ANOTHER AT THE BOTTOM. TRY VARYING THEIR SHAPE AND SIZE UNTIL YOU ARE HAPPY WITH THE EFFECT.

5 DRAW A SMALL, DARK OVAL IN THE CENTER OF THE IRIS FOR THE PUPIL. THE PUPIL SHOULD SIT UNDERNEATH THE HIGHLIGHTS, SO DON'T DRAW OVER THEM. THEN, ADD A CURVE GOING ACROSS THE LOWER HALF OF THE IRIS.

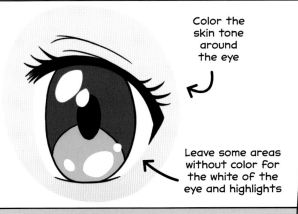

Color the skin tone around the eye

Leave some areas without color for the white of the eye and highlights

8 NOW, IT'S TIME TO ADD BASE COLORS. I'VE CHOSEN A LIGHT AND DARK SHADE OF THE SAME COLOR (GREEN!) FOR THE IRIS. THEN, ERASE THE PENCIL OUTLINES FROM AROUND THE HIGHLIGHTS.

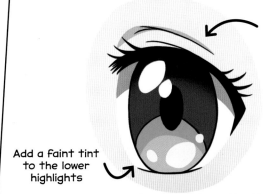

Shade over the eye creases in a deeper skin tone, extending the line farther

Add a faint tint to the lower highlights

9 FINALLY, LET'S CREATE SOME DEPTH! I'VE CHOSEN ANOTHER SHADE OF GREEN—A BRIGHTER ONE THIS TIME—TO GIVE THE LOWER IRIS SOME SHINE. THEN, SHADE THE EYE JUST BENEATH THE UPPER LID WITH A STRIP OF GRAY.

SERIOUS EYE

Next up, we're going to draw a serious-looking eye. Watch out—this character is on the lookout for anyone who wants to cause trouble! This eye style works for mature, edgy, or realistic characters. So, let's get up close and personal and draw that eye.

Outer eyelid

1 START WITH THE UPPER EYELID. MAKE IT FAIRLY LONG, QUITE THICK, AND NOT TOO CURVED AND THEN WORK UP THE OUTER EYELID SO IT POINTS UP INTO A STYLISH TIP AT THE EDGE.

2 DRAW THE LOWER LID AS A THIN, CURVED LINE. SERIOUS EYES TEND TO BE NARROW, SO KEEP THE DISTANCE BETWEEN THE EYELIDS SMALL. ADD UPPER SKIN CREASES A LITTLE ABOVE THE TOP EYELID FOR MORE REALISM.

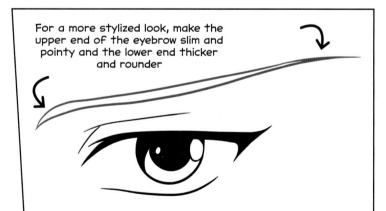

For a more stylized look, make the upper end of the eyebrow slim and pointy and the lower end thicker and rounder

6 ANGLE THE EYEBROW DOWN TOWARD THE EYE FOR A SERIOUS LOOK. EYEBROW SHAPE CAN TOTALLY TRANSFORM YOUR CHARACTER'S EXPRESSIONS. (SEE PAGES 42-43 TO LEARN MORE!)

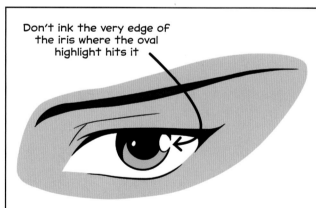

Don't ink the very edge of the iris where the oval highlight hits it

7 USE A DARK PEN, OUTLINER, OR THIN MARKER TO INK YOUR LINES. ADD THE BASE COLORS FOR THE SKIN, IRIS, AND EYEBROW. THIS BRIGHT BLUE EYE REALLY STANDS OUT.

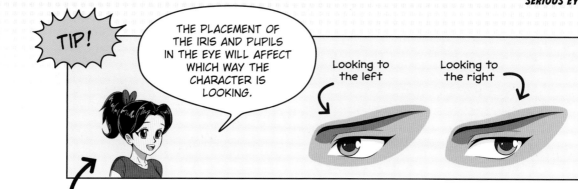

TIP!

THE PLACEMENT OF THE IRIS AND PUPILS IN THE EYE WILL AFFECT WHICH WAY THE CHARACTER IS LOOKING.

Looking to the left

Looking to the right

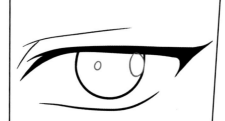

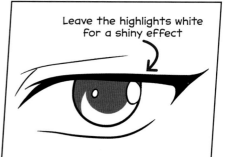

Leave the highlights white for a shiny effect

3 LET'S PLACE MOST OF A ROUND IRIS BELOW THE UPPER EYELID. THE TOP OF THE IRIS IS HIDDEN, BUT IMAGINE IT AS A FULL CIRCLE WHEN YOU CREATE THE SHAPE.

4 ADD TWO SMALL, SIMPLE HIGHLIGHTS BY DRAWING AN OVAL AT THE OUTER EDGE AND THEN A SMALL CIRCLE JUST OFF-CENTER INSIDE THE IRIS.

5 DRAW A CURVED SECTION IN THE UPPER PART OF THE IRIS. NOW, SHADE IT IN. THIS WILL BE THE PUPIL AND A DARK SECTION OF THE IRIS NEAR THE TOP.

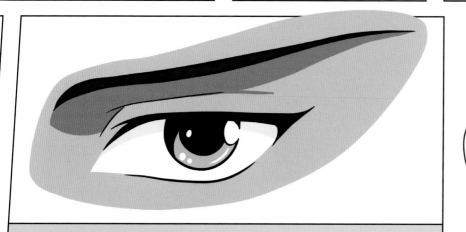

8 TO ADD DEPTH, SHADE UNDER THE EYEBROW WITH A DARKER SKIN TONE. MAKE A LINE OF LIGHT-GRAY SHADING IN THE UPPER PART OF THE WHITE OF THE EYE. FOR EXTRA SPARKLE, USE A WHITE PAINT MARKER OR GEL PEN TO ADD MORE TINY HIGHLIGHTS IN THE IRIS!

IF YOU THINK THIS EYE IS COOL, WAIT UNTIL YOU SEE A WHOLE BUNCH OF EYE-DEAL DESIGNS ON THE NEXT PAGE!

IT'S ALL IN THE EYES

By changing the shape and size of the eyelids, irises, pupils, and highlights, you can create a huge variety of eye designs! Here are some ideas for reference. Experiment with different art mediums and techniques to produce a variety of eye-catching designs and eye-opening effects!

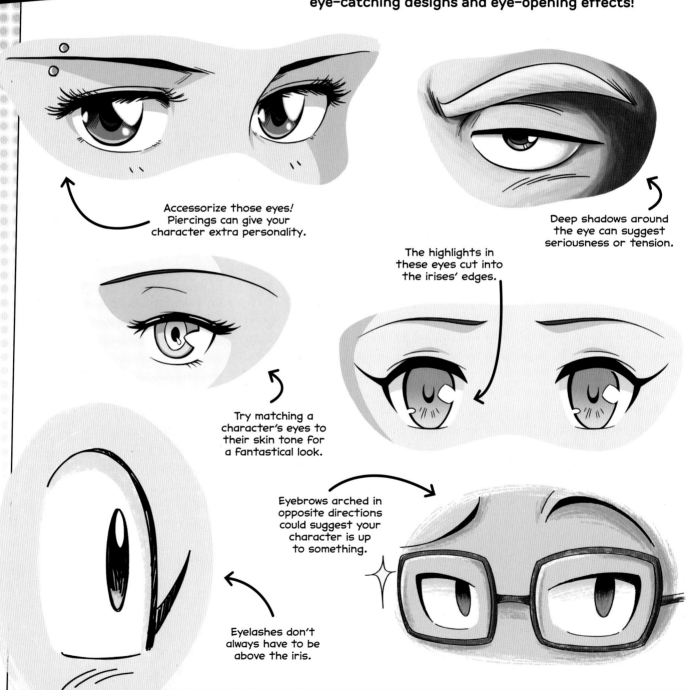

Accessorize those eyes! Piercings can give your character extra personality.

Deep shadows around the eye can suggest seriousness or tension.

The highlights in these eyes cut into the irises' edges.

Try matching a character's eyes to their skin tone for a fantastical look.

Eyebrows arched in opposite directions could suggest your character is up to something.

Eyelashes don't always have to be above the iris.

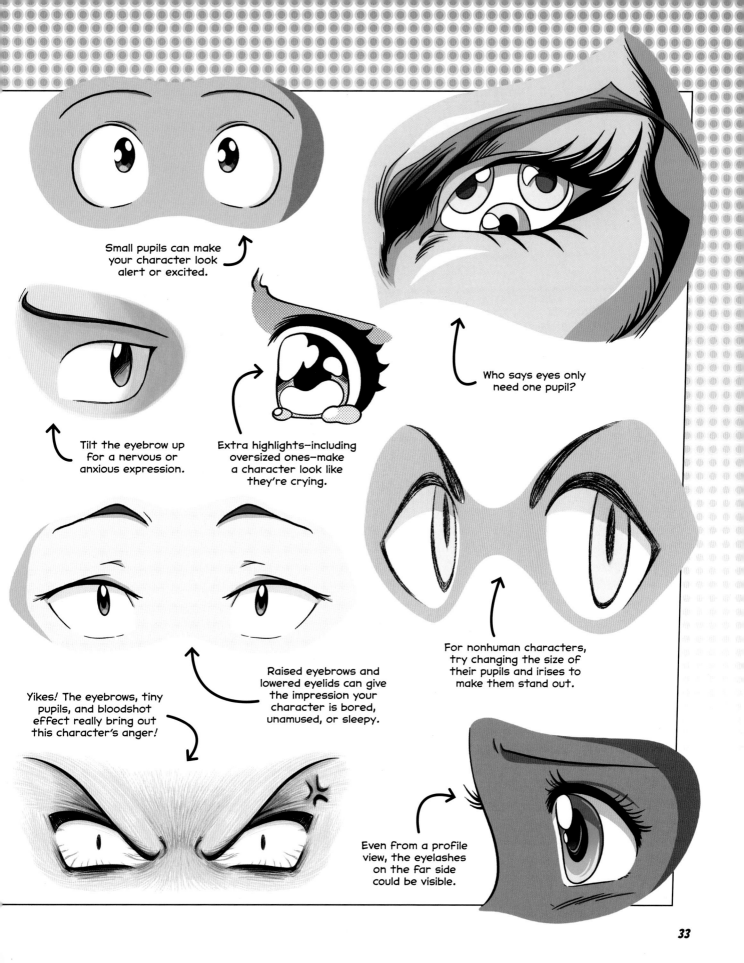

Small pupils can make your character look alert or excited.

Who says eyes only need one pupil?

Tilt the eyebrow up for a nervous or anxious expression.

Extra highlights—including oversized ones—make a character look like they're crying.

For nonhuman characters, try changing the size of their pupils and irises to make them stand out.

Raised eyebrows and lowered eyelids can give the impression your character is bored, unamused, or sleepy.

Yikes! The eyebrows, tiny pupils, and bloodshot effect really bring out this character's anger!

Even from a profile view, the eyelashes on the far side could be visible.

RAINBOW EYE

Have you ever met anyone as glamorous as this character? We're going to create a blended eyeshadow effect using colored pencils, complete with rainbow makeup and dazzling, sparkly highlights! These eyes are perfect for magical, dreamy, or fantasy characters.

Inner edge of the eye

Outer corner of the eye

1 START WITH A BIG, CURVED UPPER EYELID THAT FLOWS DOWN GENTLY INTO A THICKER POINT AT THE OUTER CORNER OF THE EYE.

For a thicker lid, increase the distance between upper lid and skin crease

2 DRAW THE LOWER EYELID AS A THIN LINE CURVING UP TO THE OUTER CORNER. FOR THE UPPER EYELID, DRAW THE SKIN CREASE FARTHER AWAY FROM THE UPPER LID. THIS HELPS GIVES THE IMPRESSION OF A DEEPER EYELID CREASE.

TIP!

THIS EYE SHAPE KIND OF LOOKS LIKE A SIDEWAYS LEAF. ALWAYS TRY TO SEE BASIC SHAPES IN DESIGNS TO HELP YOU BREAK THEM DOWN (SEE PAGES 40-41).

I JUST LOVE HOW THE COLORED PENCILS GIVE THE RAINBOW MAKEUP A BLENDED EFFECT!

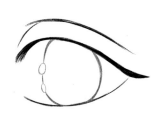

3 LET'S GIVE THE EYE A LARGE IRIS WITH TWO SMALL HIGHLIGHTS ON ONE SIDE.

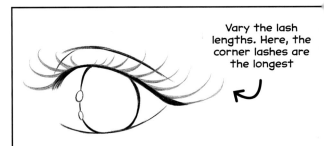

Vary the lash lengths. Here, the corner lashes are the longest

4 ADD FANCY, GLAM LASHES! I WONDER WHAT KIND OF MASCARA SHE USES?? MAKE THEM AS LONG AND CURLED AS YOU WANT. FOR MORE REALISTIC LASHES, MAKE THE BASES THICKER AND TAPER THEM INTO SHARP, FLICKY POINTS.

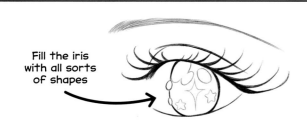

Fill the iris with all sorts of shapes

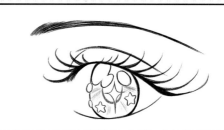

5 DRAW THE EYEBROW, TAPERING FROM THICK TO THIN. NOW, IT'S TIME TO ADD LOTS OF FUN, SPARKLY HIGHLIGHTS! TRY DIFFERENT SHAPES TO SHOW OFF YOUR CHARACTER'S PERSONALITY. I'VE GONE WITH STARS AND SPARKLES. WHAT WILL YOU CREATE?

6 DRAW THE BOTTOM OUTLINE OF THE PUPIL BEHIND THE HIGHLIGHTS AND THEN ADD THIN TEXTURE LINES IN THE IRIS. THESE SMALL DETAILS WILL HELP MAKE YOUR EYE LOOK MORE REALISTIC.

7 IT'S FINALLY TIME TO WORK ON THE AMAZING RAINBOW EYESHADOW! EXTEND THE MAKEUP BEYOND THE LINES OF THE EYELID AND BUILD UP A CAT'S-EYE FLICK AT THE CORNER. MIRROR THE EFFECT BENEATH THE EYE AND THEN ADD COLOR TO THE SKIN AROUND IT.

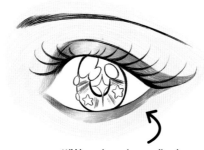

With colored pencils, have the direction of your strokes follow the curved contours of the eye

TIP!

WHEN USING COLORED PENCILS, ADD YOUR LAYERS GRADUALLY SO THE WAX FROM THE PENCILS DOESN'T BUILD UP. THIS MAKES IT EASIER TO BLEND THE COLORS INTO ONE ANOTHER.

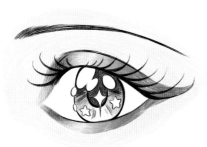

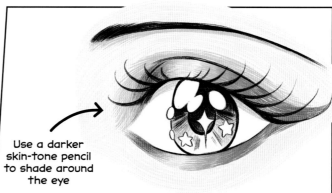

Use a darker skin-tone pencil to shade around the eye

8 USE A DARK COLOR FOR THE PUPIL AND UPPER IRIS AREA. BLEND THIS SHADE INTO A LIGHTER COLOR, TOWARD THE BOTTOM OF THE IRIS. KEEP ALL THE HIGHLIGHTS WHITE SO THEY LOOK BRIGHT AND SHINY.

9 ADD SHADING TO THE SKIN TO BRING OUT THE FORM OF THE EYE SOCKET BENEATH THE BROW. USE LIGHT GRAY TO SHADE THE WHITE OF THE EYE RIGHT UNDER THE UPPER EYELID, THEN A DARKER COLOR FOR THE PUPIL. NOW THAT'S EYE-CATCHING!

SCARY EYES

Wow, what an evil glare. Quick, let's draw this pair of scary eyes before they spot us! This time, we're drawing both eyes—notice how the left and right are similar but not identical. These eyes could be great for dangerous villains, antiheroes with attitude, or bold, brash characters.

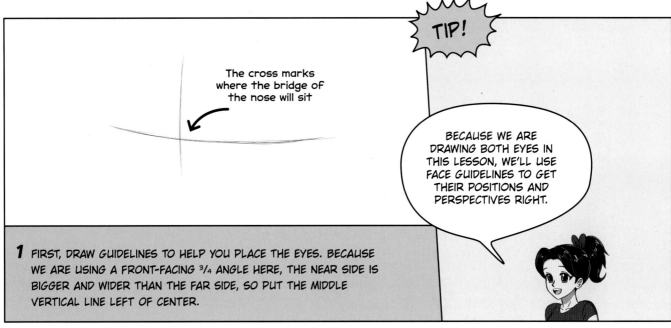

The cross marks where the bridge of the nose will sit

TIP!

BECAUSE WE ARE DRAWING BOTH EYES IN THIS LESSON, WE'LL USE FACE GUIDELINES TO GET THEIR POSITIONS AND PERSPECTIVES RIGHT.

1 FIRST, DRAW GUIDELINES TO HELP YOU PLACE THE EYES. BECAUSE WE ARE USING A FRONT-FACING ¾ ANGLE HERE, THE NEAR SIDE IS BIGGER AND WIDER THAN THE FAR SIDE, SO PUT THE MIDDLE VERTICAL LINE LEFT OF CENTER.

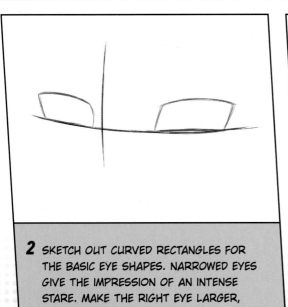

2 SKETCH OUT CURVED RECTANGLES FOR THE BASIC EYE SHAPES. NARROWED EYES GIVE THE IMPRESSION OF AN INTENSE STARE. MAKE THE RIGHT EYE LARGER, AS IT'S CLOSER.

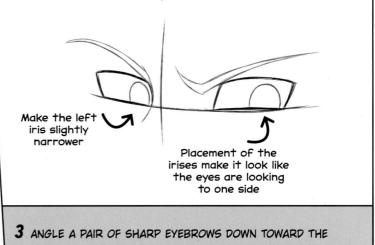

Make the left iris slightly narrower

Placement of the irises make it look like the eyes are looking to one side

3 ANGLE A PAIR OF SHARP EYEBROWS DOWN TOWARD THE VERTICAL GUIDELINE. ADD SMALL IRISES TO THE RIGHT-HAND SIDES OF THE EYES. FOR THE NOSE BRIDGE, DRAW A CURVE COMING FROM THE FAR EYEBROW AND EXTEND IT DOWN AND AROUND PAST THE FAR EYE.

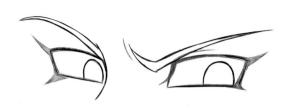

4 ONCE YOU'RE DONE PLACING THE EYES, ERASE THE GUIDELINES. NOW, MAKE THE EYES MORE STRIKING, WITH SHARP, EDGY POINTS AT THE CORNERS.

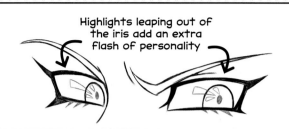

Highlights leaping out of the iris add an extra flash of personality

5 I'VE GIVEN THESE EYES COOL, JAGGED HIGHLIGHTS IN THE IRISES AND TINY PUPILS. THE SMALLER THE PUPILS, THE MORE INTENSE THE LOOK! ADD SOME SHARP LASHES TO THE BOTTOM EYELIDS.

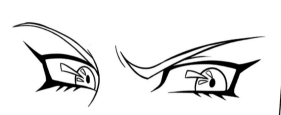

6 INK YOUR FINAL LINES. TAPER THE LINES AT THE CORNERS OR ENDS FOR A SHARP, DYNAMIC LOOK.

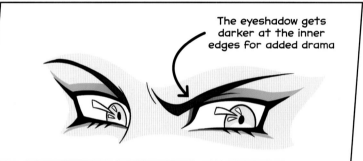

The eyeshadow gets darker at the inner edges for added drama

7 INTRODUCE BASE COLORS FOR THE SKIN, EYEBROWS, AND IRISES. ADD A LITTLE EYESHADOW AROUND THE EYES FOR EXTRA PERSONALITY!

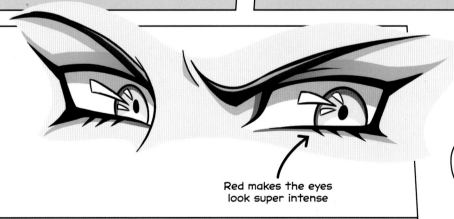

Red makes the eyes look super intense

MWA-HAHA, MY WORK HERE IS DONE!

I BET THIS GUY GETS SENT TO DETENTION ALL THE TIME!

8 ADD SHADING BENEATH THE EYEBROWS AND UPPER EYELIDS. ADD A LITTLE LIGHT BROWN TO THE TOPS OF THE EYEBROWS FOR MORE DEFINITION. FINALLY, ADD CONTRASTING IRIS COLORS TO MAKE THOSE EYES POP EVEN MORE!

MYSTERIOUS EYE

Some people always seem to give off a sense of mystery, and getting the eyes right can play a huge part in that. This character has a haunting, beautiful eye, surrounded by thick lashes. It would suit dark fantasy, goth, or emo characters.

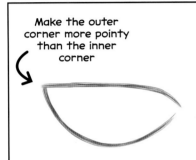

Make the outer corner more pointy than the inner corner

1 WE'RE GOING TO DRAW THE EYELID HALF CLOSED FOR THIS LESSON, WHICH GIVES A SAD, WISTFUL LOOK. SKETCH A SEMICIRCLE SHAPE AS THE BASIC EYE SHAPE.

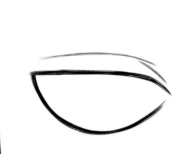

2 ADD LINES FOR THE CREASE ON TOP OF THE EYE. WE ARE GOING TO GIVE OUR CHARACTER A THICK, HEAVY EYELID.

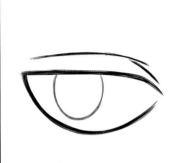

3 ADD A SMALL, ROUND IRIS JUST OFF-CENTER, WITH THE TOP SECTION HIDDEN UNDER THE EYELID.

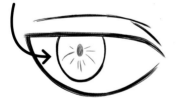

Draw small lines in the iris to add detail

4 CREATE SOME CONTRAST INSIDE THE EYE BY DRAWING THE PUPIL VERY SMALL. THIS WAY, THERE'S A LOT OF SPACE IN THE IRIS, WHICH HELPS GIVE YOUR CHARACTER AN INTENSE GAZE.

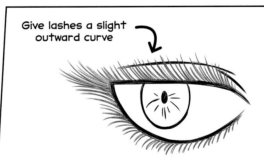

Give lashes a slight outward curve

5 LET'S GIVE OUR CHARACTER THICK, DARK LASHES TO CREATE A REALLY STRIKING LOOK. MAKE THE LASHES LONGER AT THE OUTER CORNER OF THE EYE AND DRAW THEM SHORTER AS YOU GO TOWARD THE INNER CORNER OF THE EYE.

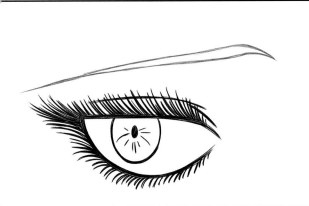

6 FOR THE EYEBROW, KEEP THE OUTER END THINNER THAN THE INNER END. ANGLE IT UP QUITE DRAMATICALLY IF YOU WANT TO ADD A THOUGHTFUL EXPRESSION, OR AS IF THE CHARACTER IS GLANCING WEARILY TO THE SIDE.

The eyelashes are so thick at the outer corner that they form a solid black cat's-eye effect

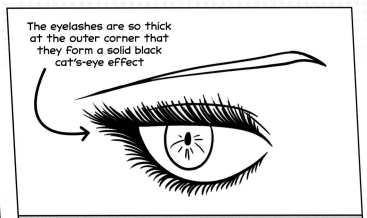

7 AFTER YOU'RE DONE SKETCHING, USE A FINE-TIPPED MARKER, OUTLINER, OR BRUSH PEN TO INK YOUR FINAL LINES.

I've used a cool color palette here, with gray undertones

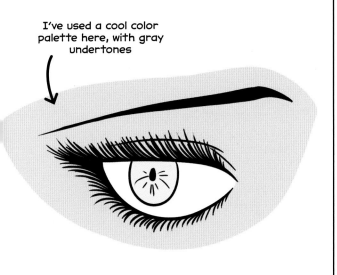

8 NOW, IT'S TIME TO ADD THE BASE COLORS. I'VE USED PALE TONES FOR BOTH THE SKIN AND IRIS. BECAUSE THE TWO COLORS ARE QUITE SIMILAR, IT GIVES THE CHARACTER A SUBTLE, ALMOST OTHERWORLDLY FEEL.

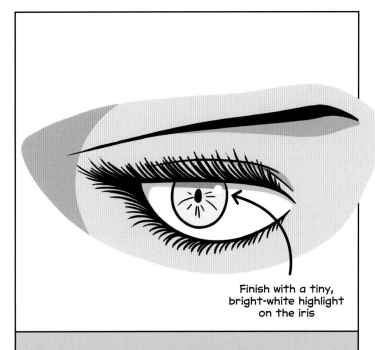

Finish with a tiny, bright-white highlight on the iris

9 ADD EXTRA DEPTH AND DIMENSION BY SHADING THE SKIN, EYE WHITE, AND IRIS WITH DARKER SHADES OF THE RESPECTIVE BASE COLORS.

EYE DETAILS

By changing certain details in the eyes you draw, you can achieve various effects to convey different emotions or moods. Even small, simple changes can have a big impact on your character's appearance.

PUPIL SIZE

Here, we have the same eye but with different pupils. The first has a large pupil that takes up most of the space in the iris. This makes the character look a little friendlier, warmer, or more receptive. Note how the second eye has a very small pupil, with lots of iris showing around it. It looks more intense, scarier, and colder. Play around with pupil size to suit your characters.

EYE, EYE, CAPTAIN!

DRAWING EYES IN PROFILE VIEW

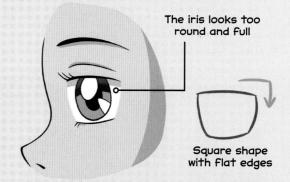

The iris looks too round and full

Square shape with flat edges

A common mistake when drawing eyes from the side is making them a square shape. This shows the eye from a front-on view, and it doesn't follow the contours of a face in profile.

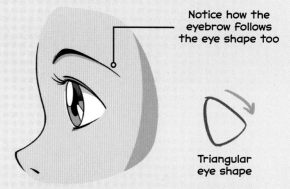

Notice how the eyebrow follows the eye shape too

Triangular eye shape

A good way to correct this mistake is by drawing the eye in a triangular shape and squishing the iris and pupil. Now, the eye looks more natural as it follows the form of the face.

EYE SHAPE

Take a look at some different manga eyes drawn in various art styles. Focus on their basic shapes. Can you see how varying the height, width, and angle of the shapes gives you a huge variety of eye designs?

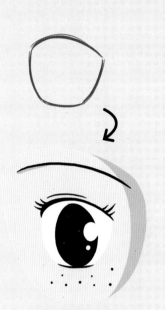

Rounded square
A classic eye shape that can be as simple or detailed as you like.

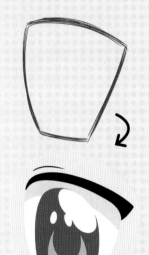

Tall wedge
A more cartoonish shape, the tall wedge has space for a huge iris and plenty of details.

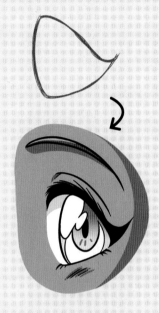

Curved triangle
A sharper corner means you can play around with eyelashes a lot more.

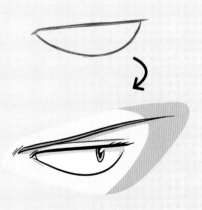

Narrow semicircle
This shape is good for suspicious or thoughtful characters.

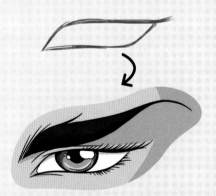

Slanted narrow rectangle
A narrowed eye is usually less cute and more serious.

THINKING OF THE EYE IN TERMS OF A SIMPLE SHAPE WILL HELP YOU GET STARTED ON YOUR DRAWING.

ANGLES AND EXPRESSIONS

Once you've mastered drawing eyes from the front, try sketching them out from different perspectives to really test your skills. And once you've got your angles down, focus on showing how your character is feeling. Highlights are a great start, but there are so many more ways to really bring out their emotions.

FRONT

This classic angle shows a pair of eyes and eyebrows that are mostly symmetrical. Shading under the brow adds depth and dimension.

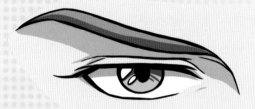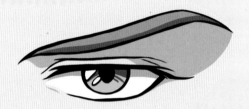

THREE-QUARTER ANGLE

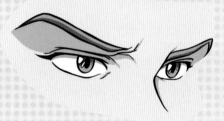

As with the scary eyes we drew on pages 36–37, a ³/₄ angle means the far eye is more squished than the near eye, giving the impression of perspective.

TILTED UPWARD

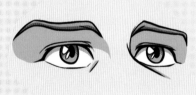

In this view, as your character gazes up, the bridge of the nose overlaps the far eye. The eyebrows are placed slightly farther away from the eyes.

PROFILE

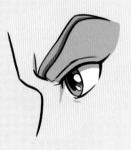

An "S"-shaped line curves around the eyebrow and past the eye to add definition to the forehead and bridge of the nose. Only one eye is visible in this pose, and it is more compact.

FEAR

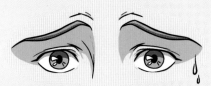

The poor guy's scared! See how the eyebrows are really angled up toward the forehead? You could also add beads of sweat beneath one eyebrow to show his anguish.

CONCERN

To give the impression of eyes closed in concentration, draw deeply angled eyebrows directly above thick, curved lines, which represent eyelids shut tight.

EMBARRASSMENT

Aww! You can almost feel this character's shame. Lightly sketch diagonal lines on the upper cheeks and shade over them in a warm pink to create an awkward blushing effect.

ANGER

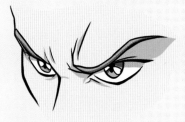

Uh-oh. You can tell how angry this character is thanks to the sharp, angular eyebrows, furrowed brow, and narrowed eyes. The pupils are very small in RAGE MODE!

SADNESS

To show this level of tragedy, it's all about the eyebrows—and tears! Curve the eyebrows right up toward the forehead and make the eyes appear almost shut as tears stream out.

WHAT CAN I SAY? I LIKE TO PUT MY CHARACTERS THROUGH ALL SORTS OF INTENSE EMOTIONAL SITUATIONS...

FACES AND EXPRESSIONS

PONYTAIL GIRL

The first face in this chapter belongs to a sweet, hopeful girl with a dreamy expression—and dreamy hair to match! She is one of my favorite characters and will pop up a few times throughout the book. For now, we're going to learn about the placement and proportion of her facial features and hair details.

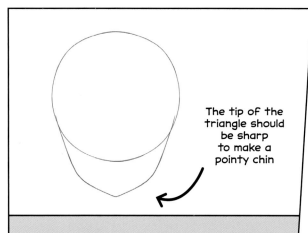

The tip of the triangle should be sharp to make a pointy chin

1 START BY DRAWING A SIMPLE CIRCLE, THEN ADD A WIDE, ROUNDED "V" SHAPE BENEATH IT. GREAT! YOU'VE COMPLETED THE BASIC HEAD SHAPE ALREADY.

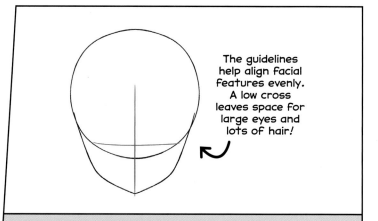

The guidelines help align facial features evenly. A low cross leaves space for large eyes and lots of hair!

2 NOW FOR THE FACIAL GUIDELINES: LIGHTLY SKETCH A CROSS IN THE CENTER OF THE FACE. PLACE THE HORIZONTAL LINE A LITTLE HIGHER THAN THE BOTTOM OF THE CIRCLE-BUT NOT TOO HIGH!

3 START SKETCHING THE BASIC SHAPES FOR THE EYES (SEE PAGES 40-41). MAKE THEM LARGE AND ROUND. THE BOTTOM EYELIDS SHOULD REST ON THE HORIZONTAL GUIDELINE. DRAW EYEBROWS PARALLEL TO THE EYELIDS, LEAVING PLENTY OF SPACE IN BETWEEN. THEN, PLACE A DOT FOR THE NOSE JUST BELOW THE CENTER OF THE GUIDELINES AND A SMALL MOUTH UNDERNEATH. FINALLY, ADD EARS EXTENDING DOWN FROM THE OUTER CORNER OF THE EYELIDS TO JUST ABOVE THE MOUTH.

Once you have the eyes in place, it's easier to position the other features

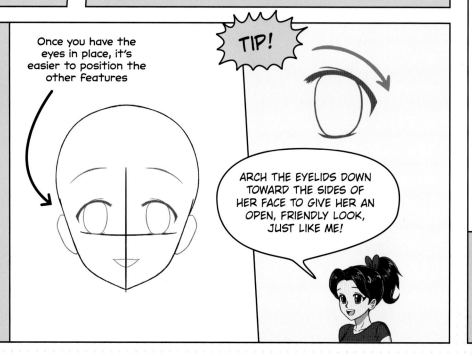

TIP!

ARCH THE EYELIDS DOWN TOWARD THE SIDES OF HER FACE TO GIVE HER AN OPEN, FRIENDLY LOOK, JUST LIKE ME!

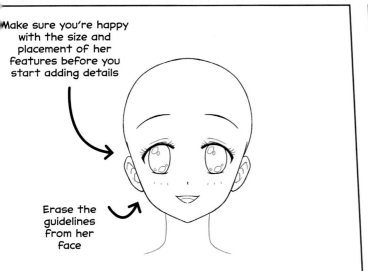

Make sure you're happy with the size and placement of her features before you start adding details

Erase the guidelines from her Face

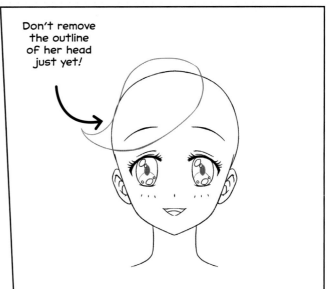

Don't remove the outline of her head just yet!

4 DRAW IN THE TONGUE, EAR FOLDS, AND A ROW OF DOTS ON EACH CHEEK. ADD TWO CURVED LINES FOR HER NECK, ROUGHLY IN LINE WITH THE INNER CORNER OF THE EYES. FINALLY, GIVE HER EYES HIGHLIGHTS AND EYELASHES.

5 FINISH THE EYES BY ADDING PUPILS AND A CURVED SHAPE ACROSS THE IRIS. AND NOW... HAIR WE GO! DRAW A LARGE LEAF SHAPE ACROSS ONE SIDE OF HER FOREHEAD.

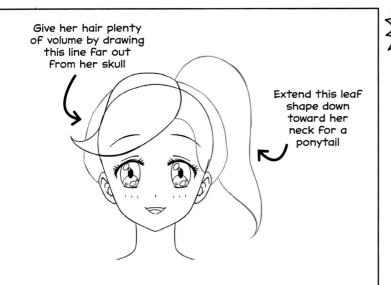

Give her hair plenty of volume by drawing this line far out from her skull

Extend this leaf shape down toward her neck for a ponytail

6 ADD A CURVED LINE AROUND EITHER SIDE OF HER SKULL, ENDING BEHIND THE EARS. ON THE OPPOSITE SIDE OF HER BANGS, DRAW A LONGER LEAF SHAPE. COMPLETE HER HAIRLINE WITH A CURVED LINE OVER HER FOREHEAD, FROM THE BANGS TO THE TOP OF HER EAR.

TIP!

A leaf doesn't look anything like hair at first, but it gives you a foundation to build on later. Use this shape to start the bangs and angle it in the direction you want the hair to flow.

USE SIMPLE SHAPES TO SKETCH THE OUTLINE OF THE HAIR BEFORE ADDING DETAIL.

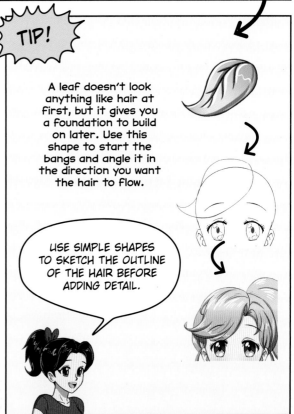

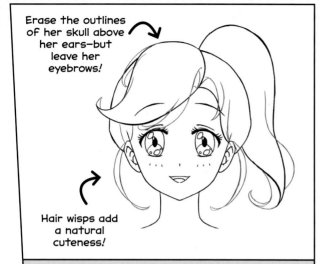

Erase the outlines of her skull above her ears—but leave her eyebrows!

Hair wisps add a natural cuteness!

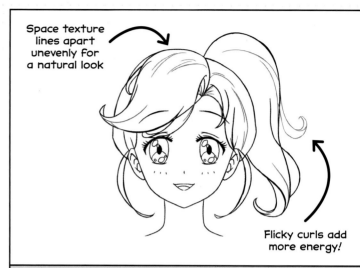

Space texture lines apart unevenly for a natural look

Flicky curls add more energy!

7 FILL OUT THE HAIR WITH MORE WISPS AND STRANDS. ADD CURLS FLICKING OUT FROM THE PONYTAIL, POINTED CURVES AROUND HER BANGS, AND THIN, CRESCENT-SHAPED STRANDS EMERGING FROM BEHIND BOTH EARS.

8 LASTLY, ADD SHORT, CURVED LINES IN HER HAIR TO GIVE IT TEXTURE AND BREAK UP THE EMPTY AREAS. THIS MAKES THE HAIR LOOK SOFTER AND MORE NATURAL. DRAW SHORTER LINES CLOSER TOGETHER AT HER PART.

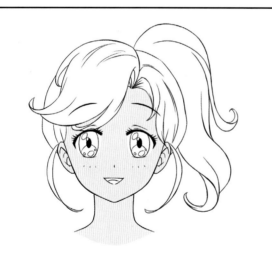

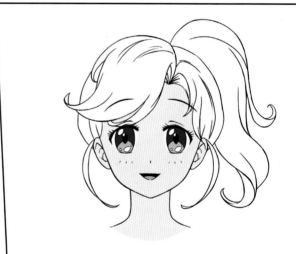

9 INK YOUR FINAL LINES. NOW, LET'S BRING HER TO LIFE WITH COLORS AND SHADING. START WITH THE BASE FOR HER SKIN. CHOOSE ANY COLOR YOU WANT—YOU'RE THE ARTIST!

10 NOW, ADD THE BASE COLORS FOR HER FACIAL FEATURES, INCLUDING THE EYES AND THE INSIDE OF HER MOUTH. WHEN COLORING HER EYES, REMEMBER TO LEAVE THE HIGHLIGHTS WHITE. WE LEARNED HOW TO DRAW THESE EYES EARLIER (ON PAGES 28-29), SO CHECK BACK THERE FOR MORE DETAILS!

11 NEXT, COLOR THE HAIR. FOR THIS CHARACTER, I'M USING A CHEERFUL PINK AND BLUE BLEND TO GIVE HER A PLAYFUL, COLORFUL APPEARANCE. ACHIEVING A BLENDED LOOK CAN BE TRICKY, AND HOW YOU DO IT DEPENDS ON THE MEDIUM YOU ARE USING FOR YOUR ARTWORK. (SEE PAGES 12-13 TO LEARN MORE!)

Add the two blend colors and then merge them gently where they meet

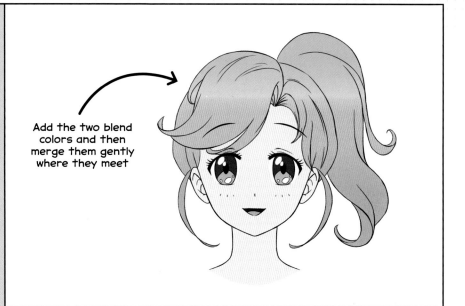

Add highlights as groups of rough, thin squiggles

Add a bit of light pink to her cheeks for some blush—aww!

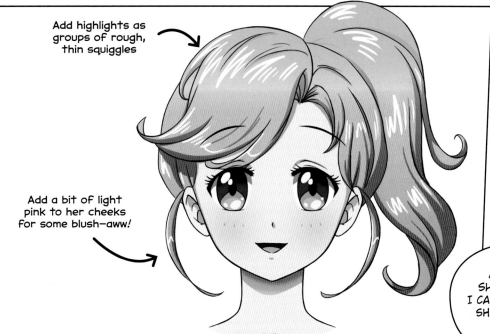

ANIME-ZING WORK! SHE LOOKS SO GREAT. I CAN'T WAIT TO SEE WHAT SHE GETS UP TO LATER ON IN THE BOOK!

12 LET'S COMPLETE HER LOOK WITH SHADING. LAYERING DARKER AND LIGHTER COLORS ON TOP OF THE BASE COLORS ADDS DEPTH AND REALISM. USE A DARKER SKIN TONE TO SHADE PARTS OF THE FACE THAT SHOULD BE IN SHADOW, SUCH AS UNDER THE HAIR, IN THE EARS, AND BENEATH THE CHIN. FOR THE HAIR, USE DARKER PINKS AND BLUES (MOSTLY) ALONG THE EDGES AND TEXTURE LINES. FOR EXTRA SHINE, DRAW SQUIGGLY LIGHT OR WHITE HIGHLIGHT LINES, LOOSELY FOLLOWING THE DIRECTION OF THE HAIR.

COOL TEEN

We're going to draw a character facing us at a three-quarter angle. He has a fairly realistic facial structure and a truly awesome hairstyle! This cool kid loves sci-fi manga, drawing, and helping out with drawing lessons like this one.

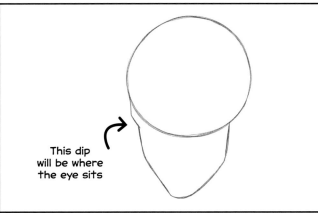

This dip will be where the eye sits

1 DRAW A CIRCLE, THEN ADD A LARGE, BUMPY TRIANGLE BELOW IT. THE BOTTOM END WILL BE THE CHIN. THE SHAPE OF THIS DETERMINES HOW SQUARE OR POINTY THE JAW WILL BE.

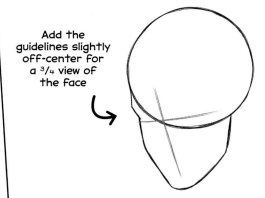

Add the guidelines slightly off-center for a 3/4 view of the face

2 DRAW THE FACE GUIDELINES. NOTE HOW HIGH UP THE EYE LINE IS ON THE FACE. THIS WILL LEAVE A LARGER JAW AREA AND A SMALLER FOREHEAD—A GOOD WAY TO MAKE A CHARACTER LOOK MORE MATURE.

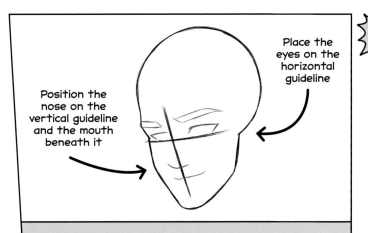

Place the eyes on the horizontal guideline

Position the nose on the vertical guideline and the mouth beneath it

3 START MAPPING OUT THE FACIAL FEATURES, USING THE GUIDELINES. DRAW THE EYES QUITE NARROW AND RECTANGULAR, WITH A POINT AT THE ENDS. MAKE THE EYEBROWS THICK AND ANGLED DOWN TOWARD THE CENTER.

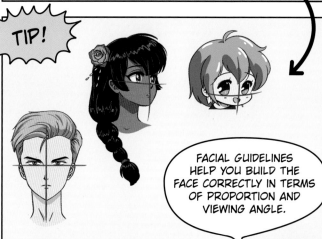

TIP!

FACIAL GUIDELINES HELP YOU BUILD THE FACE CORRECTLY IN TERMS OF PROPORTION AND VIEWING ANGLE.

For a front-on view, place the guidelines in the center. For a 3/4 angle, place the guidelines off-center. For a chibi face, place the horizontal guideline lower than normal, leaving space for a larger forehead and eyes.

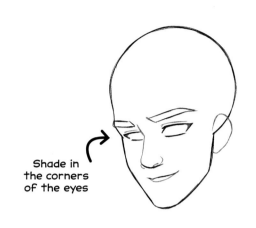

Shade in the corners of the eyes

4 ADD FINE EYELID CREASES ABOVE THE EYES AND THEN NOSE AND MOUTH DETAILS. DON'T FORGET THE EAR! START DRAWING IT ROUGHLY LEVEL WITH THE EYES AND EXTEND DOWN UNTIL IT'S IN LINE WITH THE BOTTOM OF THE NOSE.

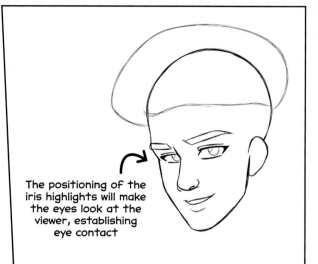

The positioning of the iris highlights will make the eyes look at the viewer, establishing eye contact

5 ROUGHLY SKETCH THE HAIR AS A BASIC ROUNDED SHAPE OVER THE TOP OF THE HEAD. IN THE EYES, DRAW SMALL, SIMPLE IRISES WITH A HIGHLIGHT IN EACH. DRAW A SMALL CURVE FOR THE BOTTOM LIP.

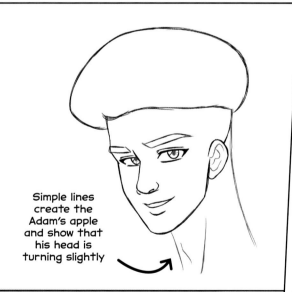

Simple lines create the Adam's apple and show that his head is turning slightly

6 LET'S ADD A THICK NECK AND SOME DEFINITION WITHIN THE EAR. IN THE IRISES, DRAW DARK PUPILS AND A COUPLE OF ACCENT LINES.

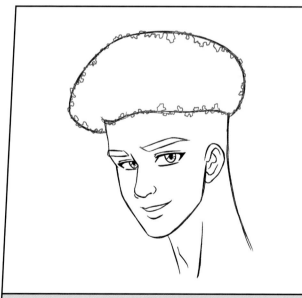

7 INSIDE THE HAIR SHAPE, DRAW LOTS OF TIGHT CURLS TO SKETCH OUT THE HAIRSTYLE DESIGN. REFER TO THE MASTERCLASS ON HAIR TEXTURE (PAGES 94–95) IF YOU WANT.

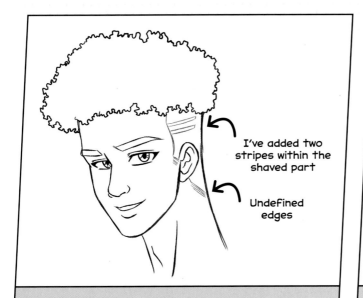

I've added two stripes within the shaved part

Undefined edges

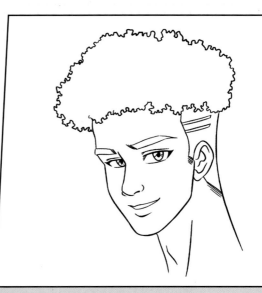

8 TO FINISH THE HAIRSTYLE, DRAW THE HAIRLINE COMING DOWN THE SIDE OF THE HEAD AND NECK. LET'S ADD SOME FUN DETAILS HERE TO MAKE THIS PART LOOK LIKE IT'S SHAVED.

9 USE A DARK PEN OR OUTLINER TO INK YOUR DRAWING AFTER YOU'RE DONE SKETCHING.

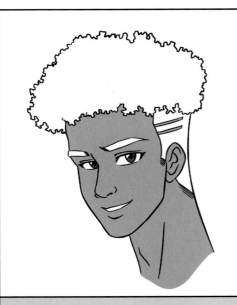

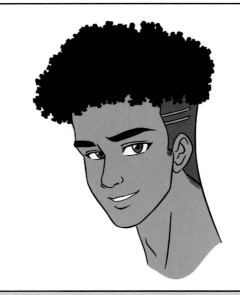

10 ADD THE BASE COLORS FOR THE SKIN AND IRISES. I'VE COLORED IN THE TWO STRIPES IN THE SHAVED PART OF HIS HAIR USING SKIN COLOR TOO.

11 NOW FOR THE HAIR AND EYEBROWS. IN THIS CASE, WE ARE GOING TO USE TWO SEPARATE BASE COLORS FOR THE HAIR—ONE FOR THE CURLS ON TOP AND ANOTHER LIGHTER ONE FOR THE SHAVED PART ON THE SIDE.

TIP!

SHADING UNDER THE EYEBROWS CAN HAVE A BIG EFFECT ON THE OVERALL LOOK OF YOUR CHARACTER'S FACE!

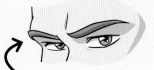

Thick ridges can make your character's face look more formed and rugged

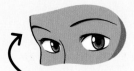

Smaller ridges give the impression of delicate features

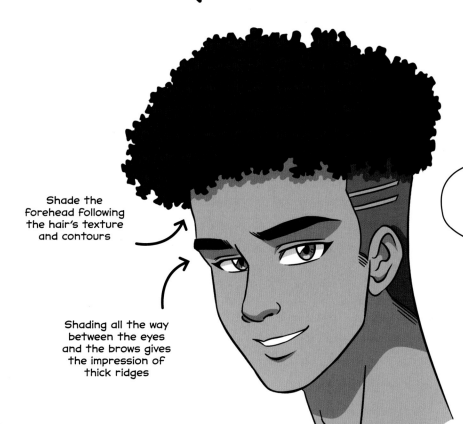

Shade the forehead following the hair's texture and contours

Shading all the way between the eyes and the brows gives the impression of thick ridges

THANKS FOR GETTING MY GOOD SIDE.

THANKS FOR MODELING FOR US!

12 USE DARKER SKIN COLORS TO ADD SHADOWS AND DEPTH TO THE FACE AND NECK. SHADE THE TOP OF THE EYE WHITES WITH GRAY AND THEN USE A DARK BROWN OR BLACK TO CREATE DIMENSION IN THE EYEBROWS AND CURLY HAIR.

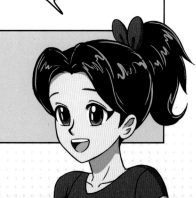

CHIBI CUTIE

The model for this lesson is also the winner of the Cutest Chibi award! Chibi characters have much shorter, rounder faces than regular manga characters, and their features are usually simple and quite compact. Let's draw her cute little face, giant eyes, and big, bouncy hair.

1 START WITH A CIRCLE FOR THE SKULL. MAKE IT BIG ENOUGH TO FIT ALL THE FACIAL FEATURES COMING UP IN THE NEXT FEW STEPS. DRAW A WIDE, ROUNDED BUMP AT THE BOTTOM FOR THE CHEEK AND JAW. DON'T MAKE THE JAW TOO LONG BECAUSE CHIBI PROPORTIONS ARE QUITE DIFFERENT THAN THOSE OF OTHER MANGA CHARACTERS!

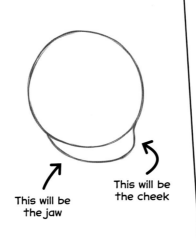

This will be the jaw

This will be the cheek

Add a short neck, too

2 ADD FACE GUIDELINES VERY LOW DOWN IN THE CIRCLE. THEN, ADD A BIG CURVE ON THE SIDE OF THE HEAD TO MARK THE EDGE OF HER HAIR.

Sketch out large, rough shapes on the sides for her pigtails

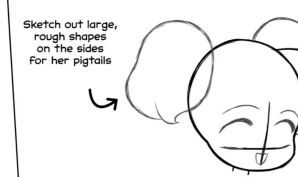

3 USE THE GUIDELINES TO HELP YOU PLACE A PAIR OF THIN EYEBROWS; A TINY NOSE; A SMALL, OPEN MOUTH; AND UPPER AND LOWER EYELIDS, LEAVING A WIDE SPACE BETWEEN THEM. ADD SHORT, ROUNDED SHAPES ON EITHER SIDE OF HER HEAD, WHICH WILL BECOME CUTE PIGTAILS.

TIP!

Higher guidelines versus lower guidelines. Can you see the difference?

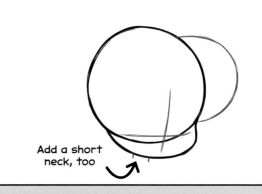

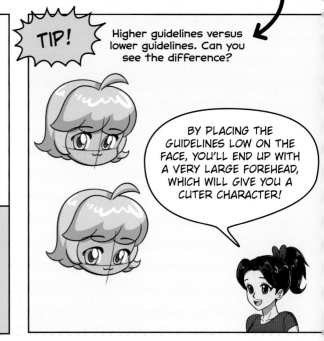

BY PLACING THE GUIDELINES LOW ON THE FACE, YOU'LL END UP WITH A VERY LARGE FOREHEAD, WHICH WILL GIVE YOU A CUTER CHARACTER!

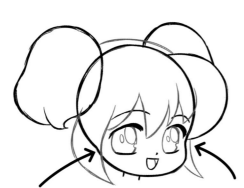

Add two highlights inside each eye—one big, one small

A third highlight overlaps the edge of each iris

4 DRAW A CURVY ZIG-ZAG ACROSS HER FOREHEAD FOR THE BANGS, THEN ADD TWO LARGE PIECES OF HAIR COMING DOWN BELOW THE PIGTAILS ON THE SIDES. GIVE HER EYES LOVELY LARGE IRISES, COMPLETE WITH HIGHLIGHTS.

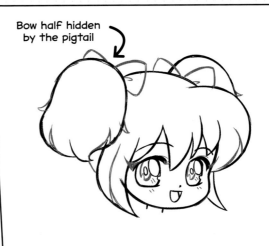

Bow half hidden by the pigtail

5 FOR EXTRA CUTENESS, LET'S PUT BOWS IN HER PIGTAILS! ADD A FEW PIECES OF CHOPPY HAIR, THEN DRAW LARGE PUPILS IN THE EYES AND FLICKY LASHES ON TOP. ADD A FEW ACCENT LINES IN AND AROUND THE EYES.

WOW! I CAN'T WAIT TO SEE MY CHIBI AWARD!

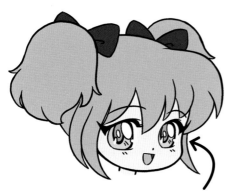

Don't outline the right-hand sides of the eyes—this way, they fit more seamlessly into the face

6 FINALIZE THE OUTLINES WITH A PEN OR MARKER. NOW, WE CAN ADD BASE COLORS! USE ANY COLOR COMBINATION YOU LIKE FOR THE SKIN, EYES, AND HAIR. PASTEL COLORS WORK ESPECIALLY WELL FOR CUTE, GENTLE CHARACTERS.

7 USE DARKER COLORS TO SHADE EACH AREA, INCLUDING UNDER AND BEHIND THE PIGTAIL, BENEATH THE BANGS, AND THE TOP PARTS OF THE IRISES AND PUPILS. THEN, USE A LIGHTER COLOR TO ADD CUTE OVAL HIGHLIGHTS THAT MAKE THE HAIR LOOK SMOOTH AND BOUNCY.

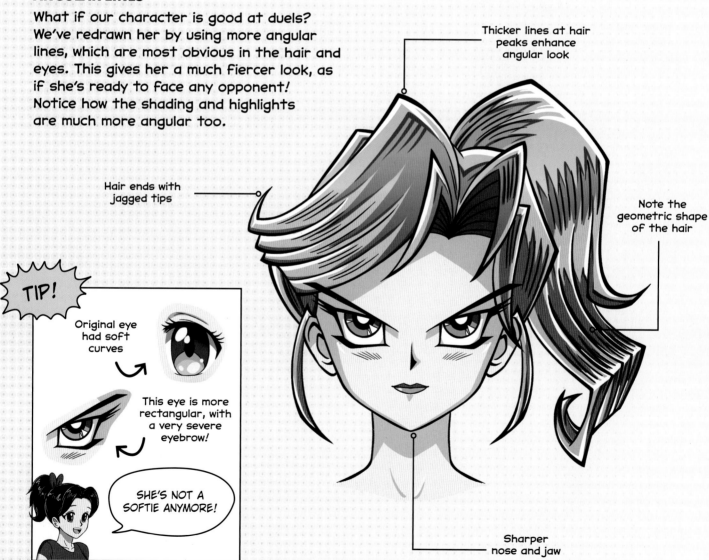

REIMAGINING MANGA STYLES

A great way to hone your skills is to draw the same character in different ways. Let's see what happens when we draw our shojo Ponytail Girl (see pages 46–49) in three shonen art styles. Use these ideas and tips to create your own unique characters!

ANGULAR LINES

What if our character is good at duels? We've redrawn her by using more angular lines, which are most obvious in the hair and eyes. This gives her a much fiercer look, as if she's ready to face any opponent! Notice how the shading and highlights are much more angular too.

Thicker lines at hair peaks enhance angular look

Hair ends with jagged tips

Note the geometric shape of the hair

TIP!

Original eye had soft curves

This eye is more rectangular, with a very severe eyebrow!

SHE'S NOT A SOFTIE ANYMORE!

Sharper nose and jaw

SOFT AND ROUND

Here, our character has softer curves. This makes her look younger, particularly thanks to her wide-eyed expression. Now, she's ready to attend a school for talented superheroes!

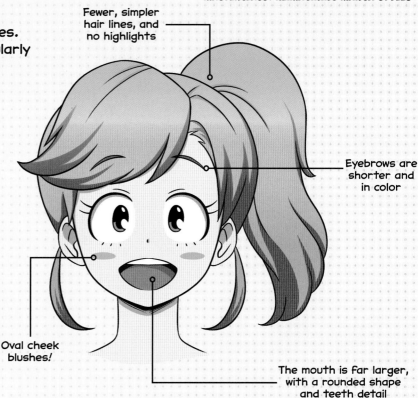

Fewer, simpler hair lines, and no highlights

Eyebrows are shorter and in color

Oval cheek blushes!

The mouth is far larger, with a rounded shape and teeth detail

TIP!

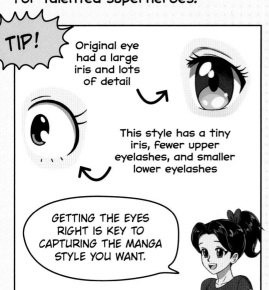

Original eye had a large iris and lots of detail

This style has a tiny iris, fewer upper eyelashes, and smaller lower eyelashes

GETTING THE EYES RIGHT IS KEY TO CAPTURING THE MANGA STYLE YOU WANT.

VARIABLE LINE WIDTHS

This version of our character uses lines that vary in thickness throughout, particularly in the hair. I can imagine her fighting monsters... or becoming one!

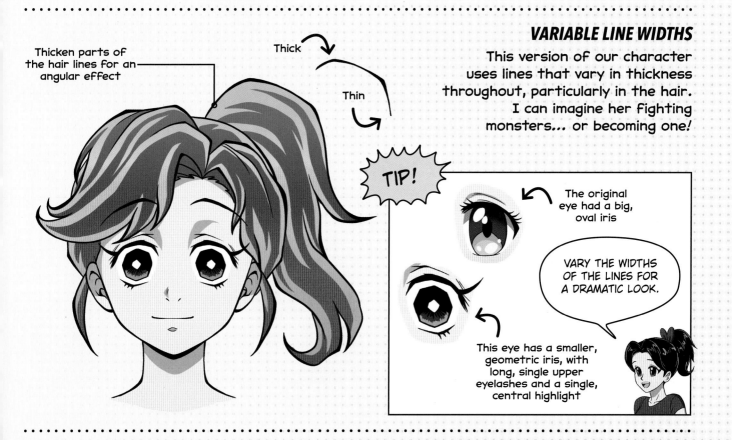

Thicken parts of the hair lines for an angular effect

Thick

Thin

TIP!

The original eye had a big, oval iris

VARY THE WIDTHS OF THE LINES FOR A DRAMATIC LOOK.

This eye has a smaller, geometric iris, with long, single upper eyelashes and a single, central highlight

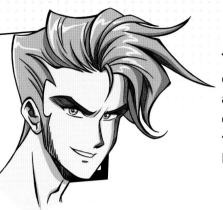

CONFIDENT VILLAIN

This is the face of a cunning, devilishly confident bad guy (with admittedly great hair). We need to draw his smirking, chiseled face to add to his Wanted poster, so let's get started!

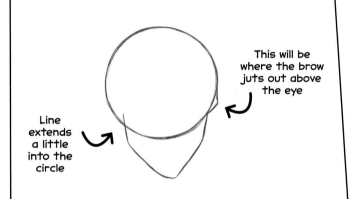

This will be where the brow juts out above the eye

Line extends a little into the circle

1 START WITH A CIRCLE AND DRAW A BUMPY TRIANGLE BENEATH IT TO GIVE A CHISELED JAW AND POINTY CHIN. A SMALLER TRIANGLE ON THE RIGHT-HAND SIDE WILL FORM THE VILLAIN'S BROW LINE.

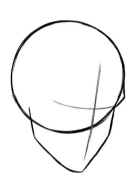

2 ADD FACIAL GUIDELINES. NOTE HOW THE HORIZONTAL LINE SITS RIGHT AT THE BOTTOM OF THE BROW TRIANGLE, AND THE VERTICAL LINE RUNS DOWN TOWARD THE CHIN.

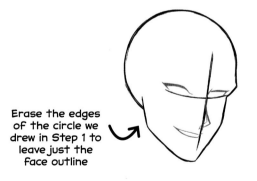

Erase the edges of the circle we drew in Step 1 to leave just the face outline

3 NOW, LET'S SKETCH IN THE FACIAL FEATURES. WE'RE GIVING HIM NARROW EYES, WHICH WORK WELL FOR EVIL OR SLY CHARACTERS. ADD A POINTY NOSE AND A SMALL, CONFIDENT SMIRK THAT SAYS, "YOU CAN'T CATCH ME!"

4 FOR VILLAINOUS EYEBROWS, MAKE THEM JAGGED AND ANGLED DOWNWARD. ADD CIRCULAR IRISES TO THE EYES, WITH OVAL HIGHLIGHTS AT THE TOP. WITNESSES SAY HE HAS AT LEAST ONE EAR!

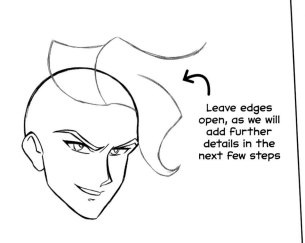

Leave edges open, as we will add further details in the next few steps

5 WE ARE GOING TO GIVE THIS VILLAIN A DISTINCTIVE, WILD HAIRSTYLE. DRAW A ROUGH, ANGULAR SHAPE AT THE TOP OF THE HEAD AND ANOTHER NEXT TO IT THAT ENDS IN A POINTY CURL. THIS WILL BE HIS BANGS.

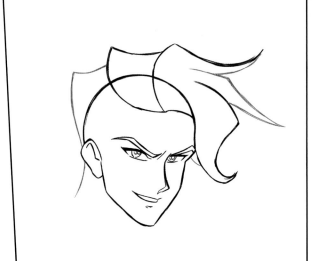

6 ADD A FEW MORE SHARP POINTS TO THE HAIR. BRING THE BACK SECTION DOWN BEHIND HIS EAR. ADD SMALL, CRESCENT-SHAPED PUPILS TO HIS EYES TOO.

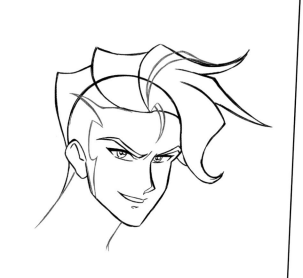

7 TO CREATE A JAGGED HAIRLINE, DRAW A SEVERE PART AND CONTINUE THE HAIRLINE DOWN THE SIDE OF HIS FACE AND INTO A LONG, STYLISH SIDEBURN. GIVE YOUR VILLAIN A THICK NECK.

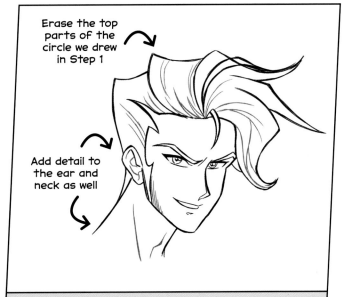

Erase the top parts of the circle we drew in Step 1

Add detail to the ear and neck as well

8 ADD TEXTURE LINES IN THE HAIR. HAVE THEM CURVE IN THE DIRECTION HIS HAIR IS STYLED, BUT DON'T MAKE THEM TOO NEAT! LET'S MAKE HIS SIDEBURN LOOK SCRUFFY BY ADDING A FEW LINES TO THE END OF IT.

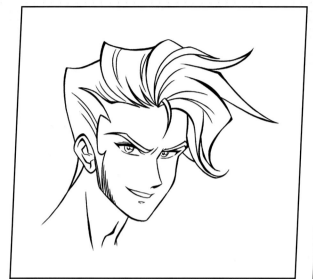

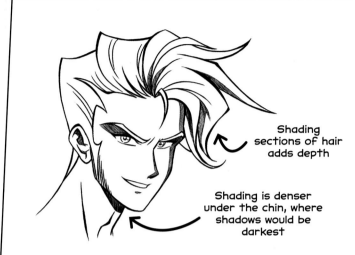

Shading sections of hair adds depth

Shading is denser under the chin, where shadows would be darkest

9 WE'RE DONE SKETCHING, SO FINALIZE YOUR OUTLINES AND ERASE ANY SKETCH MARKS.

10 WE ARE GOING TO ADD SOME SHADING WITH A PENCIL OR FINE-TIPPED MARKER TO GIVE OUR CHARACTER A UNIQUE LOOK. USE STRAIGHT, PARALLEL LINES TO SHADE IN SEVERAL AREAS OF HIS HAIR, EAR, BROWS, AND FACIAL SHADOWS.

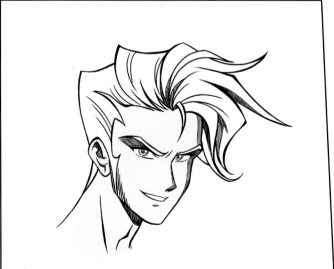

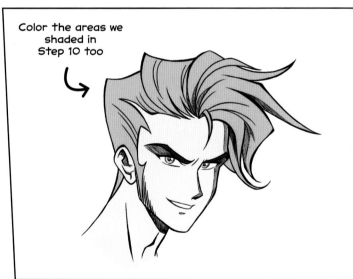

Color the areas we shaded in Step 10 too

11 NOW, LET'S ADD SOME BASE COLORS. WE'RE GOING TO GIVE HIM A PALE SKIN TONE AND ICY BLUE EYES. USE A DARKER SHADE OF BLUE IN THE PUPILS.

12 FOR HAIR COLOR, LET'S GO FOR SOMETHING BETWEEN BLOND AND RED. MAKE THE EYEBROWS SIGNIFICANTLY DARKER FOR A SEVERE LOOK.

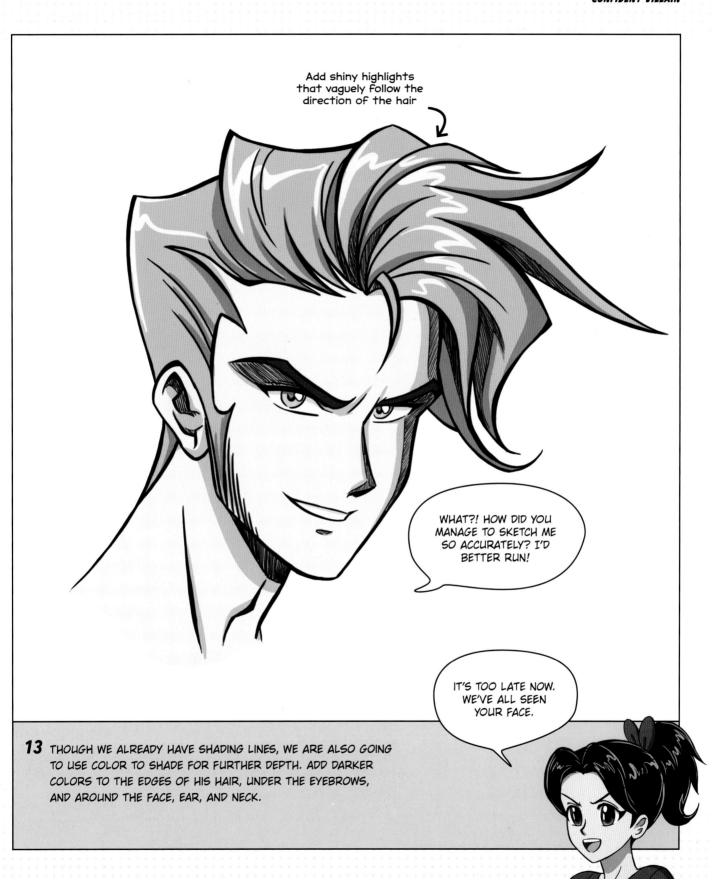

Add shiny highlights that vaguely follow the direction of the hair

WHAT?! HOW DID YOU MANAGE TO SKETCH ME SO ACCURATELY? I'D BETTER RUN!

IT'S TOO LATE NOW. WE'VE ALL SEEN YOUR FACE.

13 THOUGH WE ALREADY HAVE SHADING LINES, WE ARE ALSO GOING TO USE COLOR TO SHADE FOR FURTHER DEPTH. ADD DARKER COLORS TO THE EDGES OF HIS HAIR, UNDER THE EYEBROWS, AND AROUND THE FACE, EAR, AND NECK.

EMBARRASSED GIRL

Oh no! This girl accidentally burped in front of her crush! Poor thing, but what a wonderful expression to add to our lessons. Art inspiration can strike anywhere, anytime. We've got to capture the moment...

1 AS WE'VE DONE BEFORE, LET'S DRAW A CIRCLE FOR THE SKULL. TO CREATE A SMOOTH FACE WITH A SMALL, POINTY CHIN, WE'RE GOING TO ADD A WIDE, CURVED TRIANGLE UNDER THE CIRCLE.

2 NOW, ADD THE GUIDELINES FOR THE FACIAL FEATURES. THIS CHARACTER IS GOING TO BE LOOKING AT US HEAD-ON, SO CENTER THE GUIDELINES. DON'T PLACE THEM TOO HIGH ON HER FACE BECAUSE WE WANT TO LEAVE LOTS OF SPACE FOR A BIG FOREHEAD.

Top of the ear is roughly level with the outer corner of the eye

3 SKETCH BASIC SHAPES FOR THE EYES. MAKE THEM ROUGHLY CIRCULAR, BUT WITH POINTED OUTER CORNERS. BECAUSE THIS CHARACTER IS SO EMBARRASSED, KEEP THE EYES WIDE AND THEN DRAW SIMPLE, CURVED EARS.

Eyebrows taper to thin points at the ends

4 DRAW LARGE, OVAL IRISES INSIDE THE EYES AND REFINE THE UPPER LIDS WITH NARROW CREASES. ADD THIN EYEBROWS THAT ARCH UP TOWARD THE MIDDLE OF THE FOREHEAD FOR AN ANXIOUS, FEARFUL LOOK.

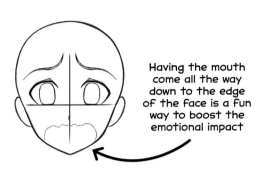

Having the mouth come all the way down to the edge of the face is a fun way to boost the emotional impact

5 PLACE A TINY NOSE ON THE VERTICAL FACE GUIDELINE, ALMOST LEVEL WITH THE BOTTOM OF THE EARS. THEN, DRAW A GAPING MOUTH—SO FAR OPEN THAT IT MEETS THE BOTTOM PART OF THE FACE!

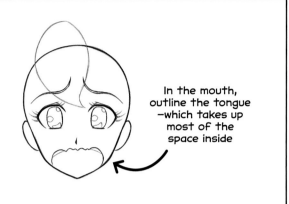

In the mouth, outline the tongue —which takes up most of the space inside

6 DRAW VARIOUS SHAPES INSIDE THE IRISES, WHICH WILL BE SPARKLY HIGHLIGHTS. ADD A FEW THICK LASHES TO THE SIDES OF EACH EYE TO ACCENTUATE THEM. THEN, START ON THE HAIR, WITH A BIG LEAF SHAPE COMING DOWN OVER THE CENTER OF THE FOREHEAD.

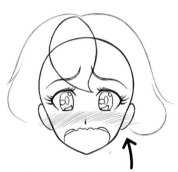

The blush lines keep on going, even beyond the outline of her face! It's good to get creative when drawing exaggerated emotions

7 ADD THOSE EMBARRASSING BLUSH LINES RIGHT ACROSS THE FACE! THE MORE YOU ADD, THE MORE EMBARRASSED SHE BECOMES. THEN, DRAW NARROW OVAL PUPILS IN THE EYES AND SOFT CURVES OF HAIR COMING DOWN ON BOTH SIDES OF THE FACE.

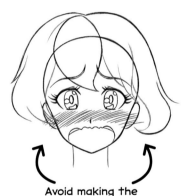

Avoid making the hair too symmetrical or it won't look natural

8 FILL OUT THE HAIR WITH MORE CURVES TO BUILD SHAPE AND MOVEMENT. THEN, GIVE YOUR CHARACTER A NECK SO SHE'S NOT JUST A FLOATING HEAD.

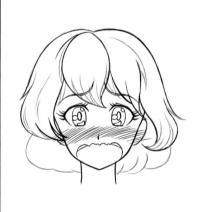

9 CONTINUE TO BUILD THE HAIR WITH LOTS OF SMALLER CURVED TEXTURE LINES. END SOFT CURVES WITH DEFINED POINTS. THEN, DRAW TWO BUMPY SHAPES FOR THE BACK PART OF THE HAIR.

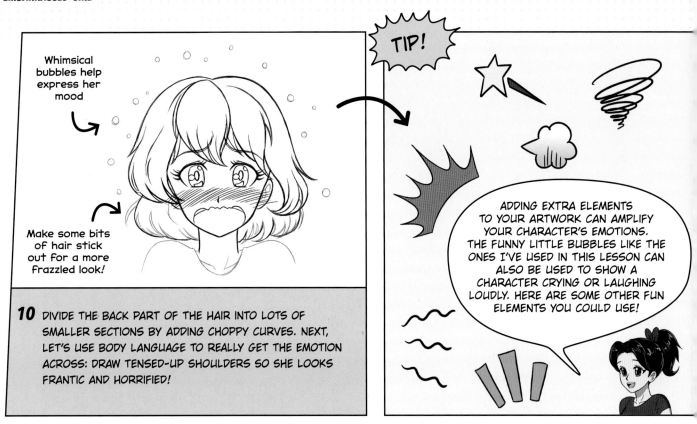

Whimsical bubbles help express her mood

Make some bits of hair stick out for a more frazzled look!

TIP!

ADDING EXTRA ELEMENTS TO YOUR ARTWORK CAN AMPLIFY YOUR CHARACTER'S EMOTIONS. THE FUNNY LITTLE BUBBLES LIKE THE ONES I'VE USED IN THIS LESSON CAN ALSO BE USED TO SHOW A CHARACTER CRYING OR LAUGHING LOUDLY. HERE ARE SOME OTHER FUN ELEMENTS YOU COULD USE!

10 DIVIDE THE BACK PART OF THE HAIR INTO LOTS OF SMALLER SECTIONS BY ADDING CHOPPY CURVES. NEXT, LET'S USE BODY LANGUAGE TO REALLY GET THE EMOTION ACROSS: DRAW TENSED-UP SHOULDERS SO SHE LOOKS FRANTIC AND HORRIFIED!

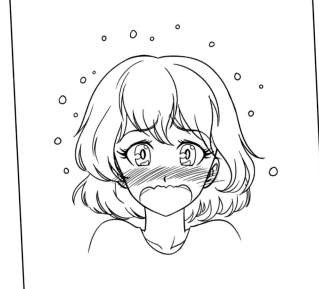

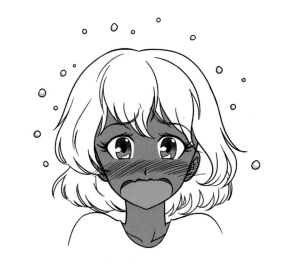

11 USE YOUR CHOICE OF A DARK PEN, OUTLINER, OR THIN MARKER TO INK YOUR FINAL LINES.

12 TIME TO FILL IN THE FACE, EYES, MOUTH, AND NECK WITH BASE COLORS! I USED A GOLDEN-BROWN GRADIENT FOR THE IRISES, SURROUNDING A DARK-BROWN PUPIL.

13 ADD BASE COLORS TO HER HAIR AND SHIRT, TOO. I WENT FOR COLORS THAT CONTRAST AND POP—THAT BOLD RED HAIR REALLY STANDS OUT FROM HER BLUE SHIRT!

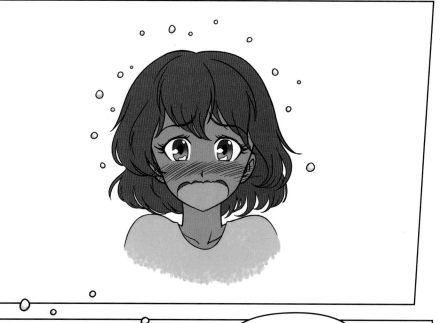

The highlights and shading have soft edges here, giving a more painterly, blended look

Use curved strokes to shade the shoulders

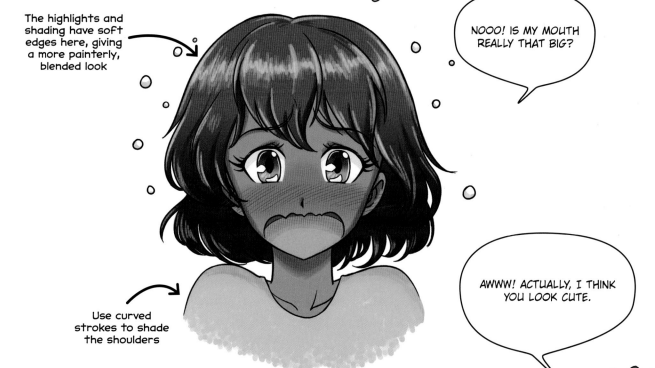

NOOO! IS MY MOUTH REALLY THAT BIG?

AWWW! ACTUALLY, I THINK YOU LOOK CUTE.

14 NOW, ADD DARKER COLORS FOR SHADING AND LIGHTER COLORS FOR HIGHLIGHTS. USE CURVED STROKES WHEN ADDING THESE COLORS TO THE HAIR AND BLEND THE PINK COLOR OF HER BLUSH ACROSS HER CHEEKS AND NOSE. FINALLY, GO OVER THE BLUSH LINES ON HER CHEEKS IN RED.

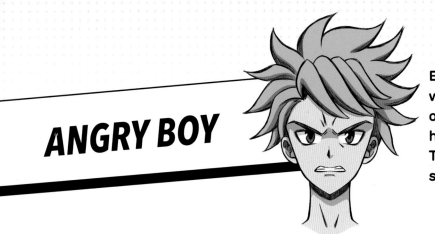

ANGRY BOY

Emotions often run high, and it's worthwhile to learn how to draw all sorts of feelings. Speaking of feelings, this boy has lost his homework, and now he's mad. This gives us a great opportunity to study an angry manga expression!

1 DRAW A CIRCLE. THIS ANGRY CHARACTER IS GOING TO HAVE A SHARP CHIN, SO LET'S ADD A POINTED TRIANGULAR SHAPE BENEATH THE CIRCLE.

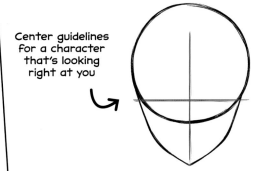

Center guidelines for a character that's looking right at you

2 ADD THE FACE GUIDELINES. AS WE'VE ALREADY SEEN, WHERE YOU PLACE THESE GUIDELINES CAN HAVE A DRASTIC EFFECT ON THE FACE YOU'RE DRAWING!

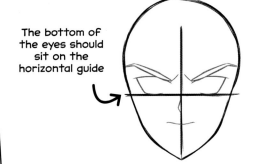

The bottom of the eyes should sit on the horizontal guide

3 TO BUILD AN ANGRY EXPRESSION, ANGLE THE EYEBROWS LOW AGAINST THE INNER CORNERS OF THE EYES. KEEP THE NOSE TRIANGULAR AND SMALL. START THE MOUTH WITH A SUBTLE FROWN.

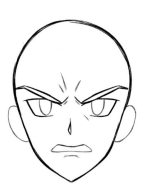

4 DRAW ACCENT LINES THAT TENSE UP THE FOREHEAD AND EYEBROWS TO ADD TO THE ANGER. ADD IRISES, EARS, AND THE LOWER PART OF THE MOUTH. THIS CHARACTER WILL BE CLENCHING HIS TEETH.

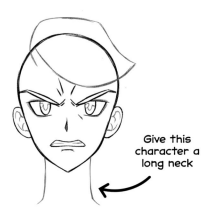

Give this character a long neck

A good way to draw teeth is to just draw two short lines going across the inside of the mouth (not connected in the middle). It's usually best to avoid drawing individual teeth because this can make your drawing too crowded.

WITH TEETH, SOMETIMES LESS IS MORE!

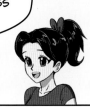

5 DARKEN THE EDGES AROUND THE EYES TO MAKE THEM EVEN MORE SERIOUS. IN EACH IRIS, DRAW A SMALL HIGHLIGHT AND THE BOTTOM EDGE OF THE PUPIL. THEN, ADD DETAIL TO THE EARS AND TEETH IN THE MOUTH. START HIS HAIR WITH A ROUGH LEAF SHAPE FOR THE BANGS.

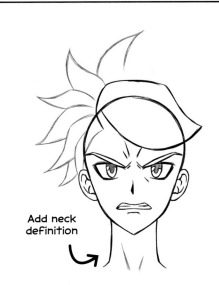

Add neck definition

6 COLOR THE PUPILS SO HIS EYES SEEM TO GLARE AT YOU. SKETCH OUT SOME SPIKY HAIR THAT COMES OUT FROM ONE SIDE OF HIS HEAD. KEEP THESE POINTY SECTIONS OF HAIR CURVED AND VARIED IN SIZE.

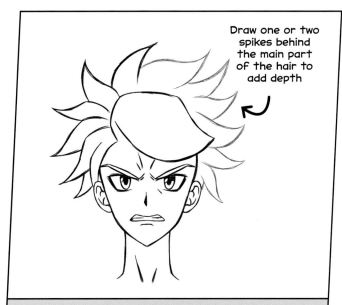

Draw one or two spikes behind the main part of the hair to add depth

7 ADD MORE SPIKY HAIR ON THE OTHER SIDE, WITH THE SPIKES POINTING IN THE OPPOSITE DIRECTION. END THE BOTTOM SPIKES BEHIND THE EARS.

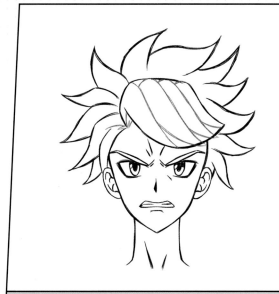

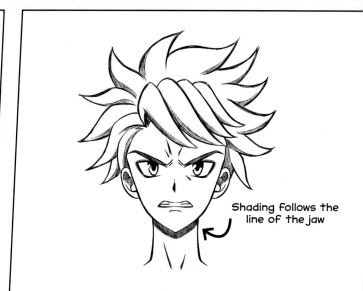

Shading follows the
line of the jaw

8 NOW, DIVIDE THE BANGS SHAPE WE DREW IN STEP 5 INTO MORE SPIKES THAT COME DOWN TOWARD HIS FACE. ERASE THE EXTRA LINES OF THE ROUGH LEAF SHAPE ONCE YOU'RE DONE.

9 COMPLETE YOUR OUTLINES AND THEN SHADE WITH A PENCIL OR PEN TO ADD A MORE DRAMATIC EFFECT! MAKE SURE THE PUPILS AND EYE OUTLINES ARE DARK SO THEY STAND OUT. SHADE UNDER THE CHIN.

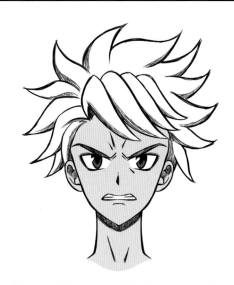

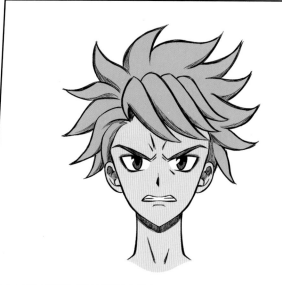

10 CHOOSE YOUR BASE COLORS FOR THE SKIN AND EYES. CONSIDER WHETHER YOU WANT TO KEEP THE EYES DARK OR MAKE THEM POP WITH A BRIGHTER COLOR.

11 FOR FUN, CHOOSE A VERY DIFFERENT COLOR FOR THE HAIR. IT DOESN'T HAVE TO BE A NATURAL HAIR COLOR. MAN MANGA CHARACTERS HAVE WILD, VIBRANT HAIR—TRY SOMETHING NEW!

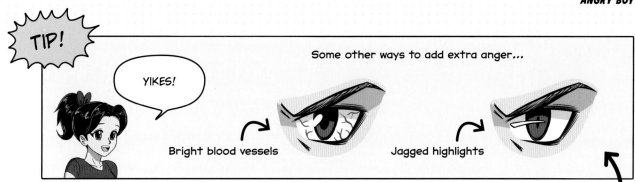

TIP!

Some other ways to add extra anger...

YIKES!

Bright blood vessels

Jagged highlights

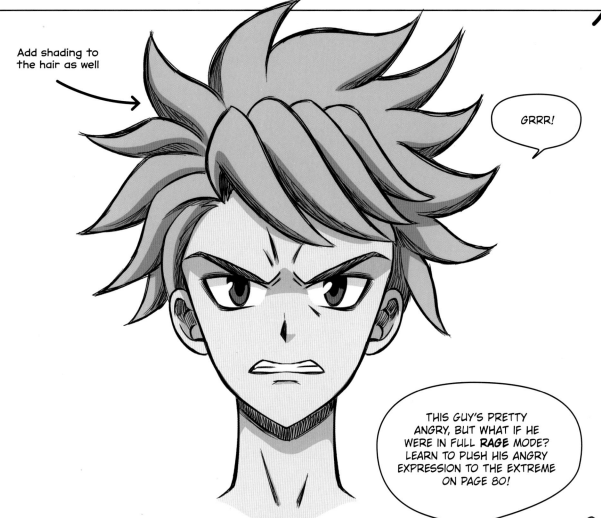

Add shading to
the hair as well

GRRR!

THIS GUY'S PRETTY
ANGRY, BUT WHAT IF HE
WERE IN FULL **RAGE** MODE?
LEARN TO PUSH HIS ANGRY
EXPRESSION TO THE EXTREME
ON PAGE 80!

12 NOW, LET'S SHADE WITH DARKER COLORS. A GREAT WAY TO DRAW MORE ATTENTION
TO AN ANGRY EXPRESSION IS TO SHADE THE EYEBROW RIDGES AND ACROSS THE
FACE, ABOVE THE NOSE. BY MAKING THIS AREA DARK, YOU FOCUS THE ATTENTION
MORE ON HIS GLARE. THE DARKER COLOR ALSO CREATES A SHADOW, WHICH CAN
MAKE YOUR CHARACTER MORE SERIOUS.

JUST FACE IT!

Creating faces and expressions for your manga characters can be one of the most fun and creative skills to practice! Don't be afraid to exaggerate eyes, mouths, eyebrows, and hair to get your character's emotions across. Here are some Manga Drawing School students, teachers, and visitors in various manga art styles.

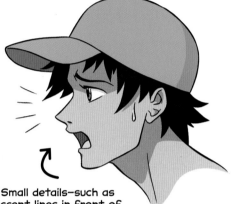

Small details—such as accent lines in front of the face and the small bead of sweat—tell you a lot about how the character feels.

Try different eye shapes and pupil styles. This character's rectangular eyes make him look fun and comical.

In extreme front ¾ views, some manga styles show the far eye almost completely hidden in shadow.

Be creative! The exaggerated crying effect here might not be realistic, but it definitely makes her look super sad!

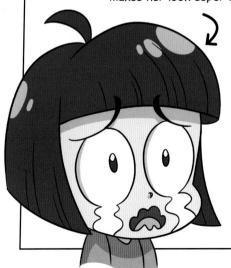

She has lots of angular edges and jagged corners, great to show her particular personality.

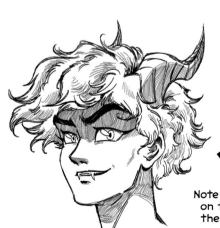

Note how the dramatic shading on the forehead and around the eyes give this character a menacing look!

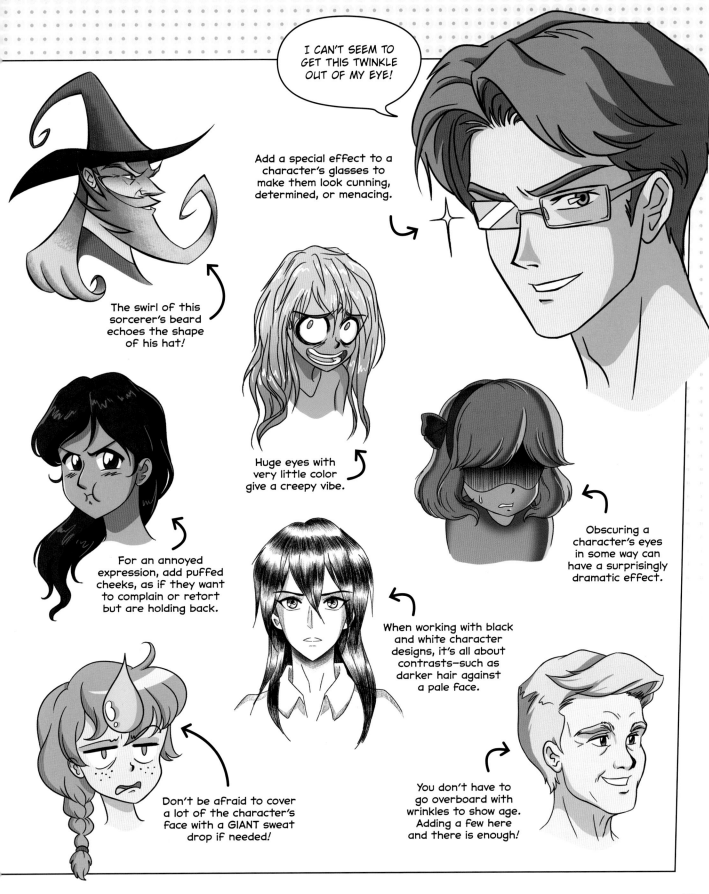

I CAN'T SEEM TO GET THIS TWINKLE OUT OF MY EYE!

Add a special effect to a character's glasses to make them look cunning, determined, or menacing.

The swirl of this sorcerer's beard echoes the shape of his hat!

Huge eyes with very little color give a creepy vibe.

For an annoyed expression, add puffed cheeks, as if they want to complain or retort but are holding back.

Obscuring a character's eyes in some way can have a surprisingly dramatic effect.

When working with black and white character designs, it's all about contrasts—such as darker hair against a pale face.

Don't be afraid to cover a lot of the character's face with a GIANT sweat drop if needed!

You don't have to go overboard with wrinkles to show age. Adding a few here and there is enough!

SASSY CAT KID

It can be tricky to pin down expressions accurately. Often, it comes down to the shape of the eyes or mouth or a raised shoulder. Look at this kid, giving off a really bold vibe. Did she just prank her bestie? Let's get up close and personal and learn how to draw her sassy expression.

This will be the cheek

1 FOR THE HEAD SHAPE, DRAW A CIRCLE WITH A WIDE TRIANGLE BENEATH IT, ANGLED SLIGHTLY TO THE LEFT.

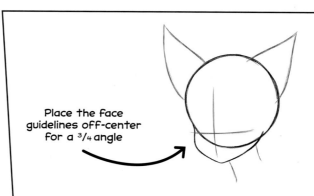

Place the face guidelines off-center for a ³/₄ angle

2 LET'S GIVE THIS CHARACTER TWO POINTY EARS TO HELP HER SENSE WHEN THE COAST IS CLEAR! THEN, ADD THE FACE GUIDELINES, QUITE LOW WITHIN THE CIRCLE, AND A NECK.

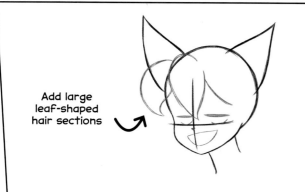

Add large leaf-shaped hair sections

3 PLACE THE EYES, NOSE, AND MOUTH, USING THE GUIDELINES. BECAUSE OF THE ³/₄ ANGLE WE'RE USING, MAKE THE NEAR EYE SLIGHTLY WIDER THAN THE FAR ONE. SHAPE THE EYES AS SEMICIRCLES TO GIVE A HALF-CLOSED LOOK AND DRAW THE MOUTH AT A SLANT FOR EXTRA CAT-ITUDE!

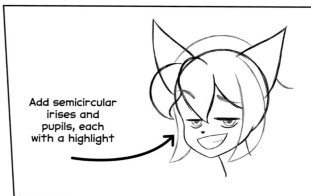

Add semicircular irises and pupils, each with a highlight

4 NOW, LET'S ADD LOTS OF THICK HAIR THAT GOES TO THE BACK AND DOWN THE SIDES OF THE FACE. AND JUST LOOK AT THOSE MISCHIEVOUS EYEBROWS! DRAW ONE RAISED AND THE OTHER CURVING DOWN AWAY FROM THE CENTER OF THE FACE.

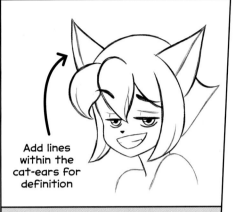

Add lines within the cat-ears for definition

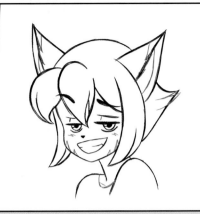

5 ADD CURVES IN HER HAIR AND A POINTY FLICK AT THE BACK. DRAW A LINE ABOVE THE EYES, WHICH WILL BE THE UPPER EYELID, LEAVING LOTS OF SPACE BENEATH SO THE EYES LOOK HALF CLOSED. SKETCH HER SHOULDERS, ONE OF WHICH IS RAISED IN A CASUAL SHRUG.

6 LET'S GIVE THIS CHARACTER SOME ZIG-ZAG EAR FUZZ AND SHORT, POINTY CAT-STRIPES ON HER JAW. ADD A FEW FINAL DETAILS, INCLUDING SOME HAIR TEXTURE, ACCENT LINES ON HER CHEEKS, AND THE NECKLINE OF HER SHIRT.

7 FINALIZE YOUR LINES WITH AN OUTLINER OR THIN MARKER AND ERASE ANY EXTRA PENCIL MARKS.

OOPSIE, I DON'T KNOW HOW THAT BUCKET OF ICE WATER GOT UP THERE...

SO WHY ARE YOU SMILING?!

8 I'M GOING BRIGHT FOR HER HAIR AND CLOTHING BASE COLORS. LET'S GIVE HER PIERCING GREEN EYES AND FILL IN THE EARS AND JAW-STRIPES TOO.

9 FINISH OFF THIS SASSY FACE WITH SHADING ON THE SKIN, CLOTHES, HAIR, EYES, AND EARS. ADD OVAL HIGHLIGHTS TO HER HAIR TO GIVE IT SOME SHINE!

HORRIFIED WOMAN

For our next lesson, we're going to draw a horrified character in a striking, black-and-white hand-drawn style, where we can use dramatic pencil shading to great effect.

1 DRAW THE CIRCLE AND TRIANGLE SHAPES FOR THE HEAD. SHE IS TILTING HER HEAD UP TO SCREAM, SO THE TRIANGLE CONNECTS TO THE CIRCLE AT AN ANGLE.

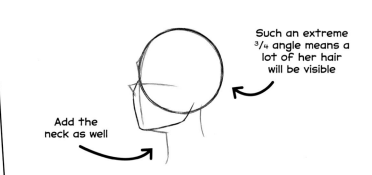

Such an extreme ¾ angle means a lot of her hair will be visible

Add the neck as well

2 WE'RE GOING TO USE AN EXTREME FRONT ¾ ANGLE HERE. IT'S ALMOST AT A PROFILE, BUT NOT QUITE. DRAW THE FACE GUIDELINES VERY CLOSE TO THE EDGE SO YOU CAN JUST SEE THE VERTICAL LINE COMING DOWN. THEN, DRAW A POINT FOR THE EYEBROW RIDGE AND A LARGER POINT FOR THE NOSE BELOW.

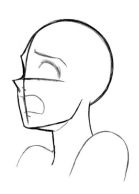

3 AT THIS ANGLE, WE CAN SEE JUST ONE EYE. DRAW IT BIG, THEN ADD A TENSE EYEBROW ABOVE IT, AND COMPLETE HER FACE WITH A WIDE OPEN MOUTH. RAISED SHOULDERS INTENSIFY HER SENSE OF FRIGHT.

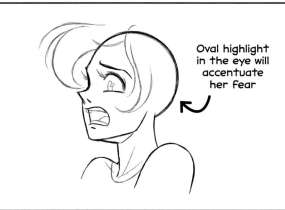

Oval highlight in the eye will accentuate her fear

4 ADD LONG EYELASHES TO BOTH EYES, AND A SMALL IRIS. THEN, DRAW IN THE DETAILS OF THE MOUTH AND NECK. START DRAWING THE HAIR AS WISPS AND CURVED LINES AROUND THE FACE.

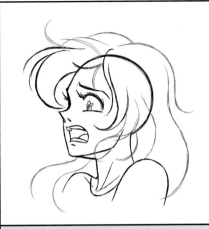

5 DRAW MORE HAIR ON THE TOP, BACK, AND SIDES. END SOME OF THE FLOWING CURVES WITH SHARP FLICKS, WHICH WILL ACCENTUATE THE LOOK OF SHOCK. ADD OVAL PUPILS TO HER EYES.

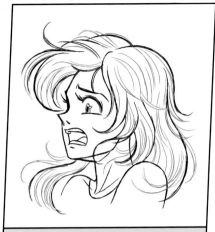

6 NOW, FILL IN THE EMPTY SPACE IN THE HAIR WITH LOTS OF DETAILED HAIR TEXTURE. START AT THE PART AND FOLLOW THE DIRECTION OF THE HAIR WITH SHORT CURVES. THEN, ADD A FEW SPIKES GOING IN DIFFERENT DIRECTIONS.

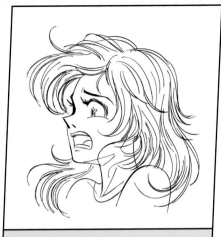

7 USE AN OUTLINER, BRUSH PEN, OR THIN MARKER TO FINALIZE YOUR DRAWING. ERASE ANY UNWANTED LINES BUT KEEP IN LOTS OF FLYAWAY SECTIONS OF HAIR TO RETAIN THAT SENSE OF MOVEMENT.

TIP!

KEEP THE SHADING NEAR THE TOP OF THE FACE AND LEAVE THE BOTTOM PART UNSHADED. THIS IS A GREAT WAY TO INVOKE A CLASSIC HORROR LOOK.

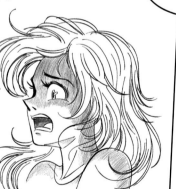

NOOOO!! SOMEONE JUST TEXTED ME SPOILERS FOR MY FAVORITE SHOW!

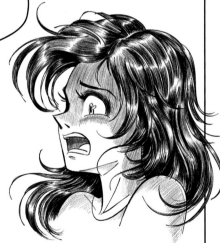

8 NOW FOR THE SHADING: USE A PENCIL (OR THIN-TIPPED PEN) TO ADD FINE LINES AROUND THE FACE AND SHOULDERS. USE THIN STROKES THAT FOLLOW THE CURVED CONTOUR OF THE FACE AND BODY TO CREATE SHADOWS.

9 BUILD UP THE HAIR WITH LOTS OF FINE LINES. USE DARK SHADING FOR MOST OF IT, BUT LEAVE SOME AREAS UNSHADED FOR SHINY HIGHLIGHTS. SHADE AROUND THE EYE TO EMPHASIZE HER FEAR.

SOLEMN HERO

Oh, look! This soccer player is deep in thought. I bet he's thinking about the upcoming game. Let's draw his solemn expression in a different manga art style, using dark, fine crosshatched shading with colors on top.

1 DRAW A CIRCLE WITH AN UNEVEN TRIANGLE BELOW. WE ARE GOING TO SHOW THE CHARACTER LOOKING DOWN, SO MAKE THE TRIANGLE SHAPE A LITTLE SMALLER THAN USUAL AND PLACE IT AT AN ANGLE.

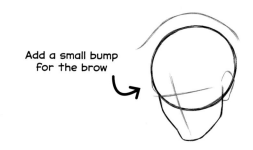

Add a small bump for the brow

2 PLACE THE FACE GUIDELINES OFF-CENTER AND SLIGHTLY TILTED, WHICH WILL HELP SHOW THE CHARACTER LOOKING DOWN. SKETCH THE EAR AND A CURVED LINE ABOVE THE SKULL FOR THE TOP OF THE HAIR.

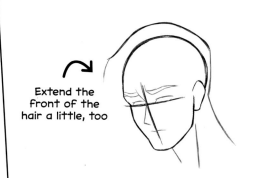

Extend the front of the hair a little, too

3 DRAW NARROW EYES AND THICK EYEBROWS THAT GO UP A BIT AT THE CENTER OF THE FACE FOR A PENSIVE LOOK AND A LONG, POINTY NOSE. MAKE THE MOUTH SMALL, WITH A SLIGHT FROWN. CONTINUE THE HAIR LINE DOWN THE BACK OF THE HEAD AND INTO A THICK NECK.

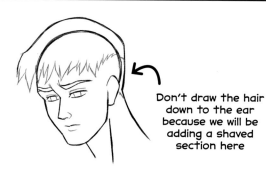

Don't draw the hair down to the ear because we will be adding a shaved section here

4 WE'RE GOING TO CREATE A SHORT, SPIKY HAIRSTYLE WITH A SERIES OF VARIED JAGGED POINTS GOING ACROSS THE HEAD. ADD THICK UPPER EYELIDS, CIRCULAR IRISES, AND MORE DETAILS AROUND THE EYEBROWS, NOSE, AND MOUTH.

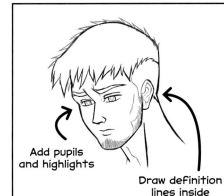

Add pupils and highlights

Draw definition lines inside the ear

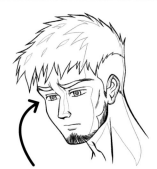

Make the pupils dark so the eyes stand out

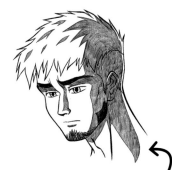

The direction of the shading lines should follow the curves and contours of the head, face, and neck

5 DRAW MORE SPIKY HAIR ON TOP OF THE HEAD AND THEN CREATE A CURVED RECTANGULAR SHAPE FOR THE SIDEBURN THAT GOES DOWN INTO A GOATEE. FOR A MORE CHISELED LOOK, ADD SOME BONE STRUCTURE LINES IN THE CHEEK AREA.

6 NOW, WE'RE GOING TO MAP OUT THE BOUNDARIES FOR THE CROSSHATCHED SHADED AREAS ON HIS HAIR, FACE, AND NECK. FOLLOW THE CONTOURS OF THE FACE AND HAIR.

7 SHADE INSIDE THE BOUNDARIES WITH A THIN-TIPPED PEN OR PENCIL. THIS WILL GIVE A ROUGH, HAND-DRAWN EFFECT. BE SURE YOUR SHADING LINES AREN'T TOO DARK SO THE LINE ART WILL REMAIN VISIBLE.

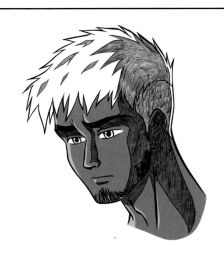

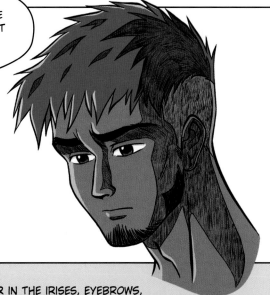

OUR SOCCER GAME GOT CANCELED. BUT THANKS FOR THE DRAWINGS!

8 ADD A BASE COLOR TO THE FACE AND USE A LIGHTER SHADE FOR SUBTLE HIGHLIGHTS. THE SHADING LINES SHOW SHADOW, SO USE THE HIGHLIGHTS OPPOSITE THEM TO SHOW WHERE THE LIGHT HITS YOUR CHARACTER.

9 NOW, COLOR IN THE IRISES, EYEBROWS, SIDEBURN, GOATEE, AND HAIR. I'VE USED A LIGHTER COLOR FOR THE SHAVED PART OF HIS HAIRSTYLE.

CRYING DEVIL

In this lesson, we are going to draw a woefully sad character. This poor, evil cutie has the saddest expression and tears in her eyes. Let's capture her grief, and then maybe we can find out what is upsetting her this time.

1 DRAW A CIRCLE AND, BELOW IT, AN ANGLED TRIANGULAR SHAPE, WHICH WILL SHOW OUR CRYING CHARACTER'S HEAD AT A FRONT ¾ VIEW.

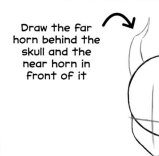

Draw the far horn behind the skull and the near horn in front of it

2 ADD TWO DEVILISH HORNS ON TOP OF HER HEAD, ENDING THEM WITH SHARP TIPS. THEN, DRAW THE FACE GUIDELINES—OFF-CENTER—AND A DELICATE NECK.

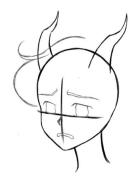

3 PLACE THE EYES, NOSE, AND WOBBLY MOUTH ON THE GUIDELINES. FOR TENSE EYEBROWS, ANGLE THEM UP TOWARD THE CENTER OF THE FOREHEAD. THEN, START OFF HER CUTE, CURLED HAIR WITH A COUPLE OF CURVES AND FLICKS.

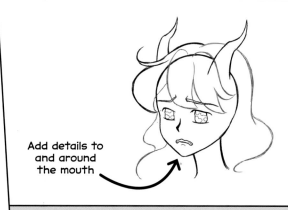

Add details to and around the mouth

4 DRAW LOTS OF HIGHLIGHTS INSIDE THE IRISES TO GIVE THE EYES A SHINY, TEARFUL LOOK. ADD MORE HAIR LINES ON EITHER SIDE, AND DRAW LEAFLIKE SHAPES FOR THE BANGS.

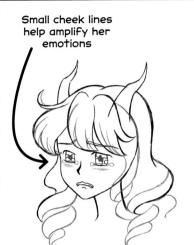

Small cheek lines help amplify her emotions

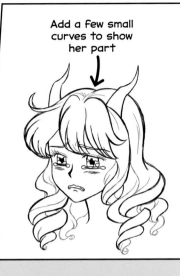

Add a few small curves to show her part

I didn't use an outline for the sides of the eyes. This way, they sit more seamlessly on the face

5 ADD DETAIL TO THE BANGS AND DRAW STACKED CURVING SHAPES OVER HER SHOULDERS, WHICH WILL LOOK LIKE FLOWING CURLS. FILL IN DARK PUPILS IN THE EYES AND DRAW WIGGLY SHAPES ON HER LOWER EYELIDS FOR TEARS.

6 ADD THE FINISHING TOUCHES TO HER LASHES AND CURLED HAIR WITH LOTS OF SMALLER LINES. MAKE THE EYELASHES THICK AND CURVED AND USE SMALL TENDRIL SHAPES TO COMPLETE THE ENDS OF THE DELICATE CURLS.

7 FINALIZE YOUR OUTLINES WITH YOUR CHOICE OF PEN OR MARKER. THEN, ADD BASE COLORS. I'VE GIVEN THIS SAD DEVIL PALE PURPLE SKIN, BRIGHT RED HORNS THAT MATCH HER EYES AND EYEBROWS, AND HAIR THAT GOES FROM BLONDE TO PINK.

OH NO... I FORGOT MY UMBRELLA. AND IT'S DRIZZLING. THIS IS THE WORST DAY EVER!

THIS CHARACTER IS PRETTY SAD, BUT WHAT IF SHE REALLY TURNED ON THE WATERWORKS? SEE HOW SHE CAN GO FROM CRYING TO FULL-ON WAILING ON THE NEXT PAGE!

8 SHADE THE HAIR, FACE, AND EYES WITH DARKER COLORS AND THEN ADD WHITE, SHINY HIGHLIGHTS TO ACCENTUATE THE TEARS.

EXTREME EXPRESSIONS

There are many fun ways to take a normal expression, such as anger or sadness, and turn it into an EXTREME version! Let's see how we can make these two characters look very different just by changing certain features.

EXTREMELY ANGRY BOY

You learned how to draw this angry face step-by-step back on pages 66-69. But he's discovered that not only is his homework missing; his backpack has been chewed up by his pet. Now, he's in full RAGE MODE!

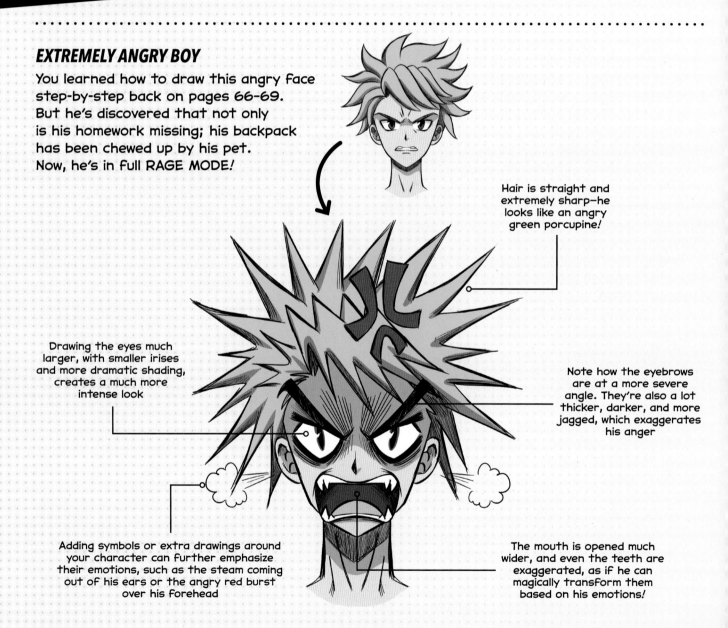

Hair is straight and extremely sharp—he looks like an angry green porcupine!

Drawing the eyes much larger, with smaller irises and more dramatic shading, creates a much more intense look

Note how the eyebrows are at a more severe angle. They're also a lot thicker, darker, and more jagged, which exaggerates his anger

Adding symbols or extra drawings around your character can further emphasize their emotions, such as the steam coming out of his ears or the angry red burst over his forehead

The mouth is opened much wider, and even the teeth are exaggerated, as if he can magically transform them based on his emotions!

EXTREME CRYING DEVIL

All right, it's time to truly let it all out. You just learned to draw her sad expression on the previous page. Now, let's see how to turn her tears into twin waterfalls.

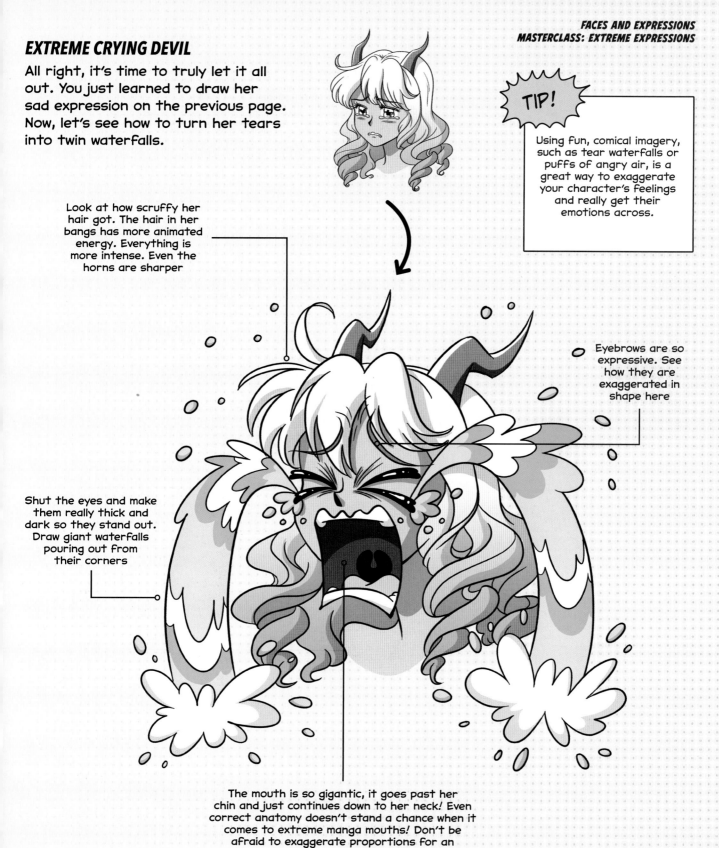

TIP!

Using fun, comical imagery, such as tear waterfalls or puffs of angry air, is a great way to exaggerate your character's feelings and really get their emotions across.

Look at how scruffy her hair got. The hair in her bangs has more animated energy. Everything is more intense. Even the horns are sharper

Eyebrows are so expressive. See how they are exaggerated in shape here

Shut the eyes and make them really thick and dark so they stand out. Draw giant waterfalls pouring out from their corners

The mouth is so gigantic, it goes past her chin and just continues down to her neck! Even correct anatomy doesn't stand a chance when it comes to extreme manga mouths! Don't be afraid to exaggerate proportions for an impactful or memorable effect

LONG FLOWING HAIR

It's school picture day, which means everyone wants to look their very best. This character has decided to let her hair down! We learned how to draw faces in the previous chapter, so let's practice drawing her long, brown locks on a ready-drawn face outline.

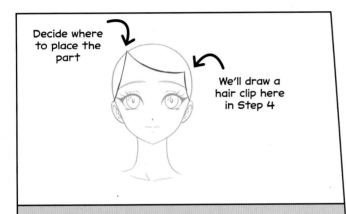

Decide where to place the part

We'll draw a hair clip here in Step 4

1 ONCE THE FACE IS OUTLINED, ADD THREE CURVED LINES THAT FRAME YOUR CHARACTER'S FOREHEAD.

2 NOW, DRAW ONE LONG, FLOWING LINE FROM THE TOP OF THE HEAD (WHERE THE PART IS) ALL THE WAY DOWN. ALLOW THE LINE TO BE SLIGHTLY WAVY, EVEN FOR STRAIGHT HAIR. YOUR DESIGN WILL LOOK LESS STIFF AND MUCH MORE NATURAL.

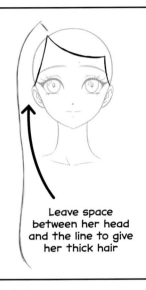

Leave space between her head and the line to give her thick hair

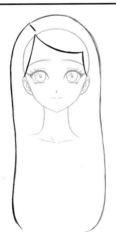

BECAUSE WE'LL BE FOCUSING ON HAIR IN THIS CHAPTER, THESE LESSONS WILL HAVE THE FACES ALREADY DRAWN. LEARN HOW TO DRAW COMPLETE FACES FROM ALL DIFFERENT ANGLES IN THE PREVIOUS CHAPTER!

3 ADD ANOTHER LONG LINE FOR THE OTHER SIDE. IT SHOULD ALMOST MIRROR THE FIRST ONE—BUT NOT QUITE! REAL HAIR DOESN'T FALL SYMMETRICALLY.

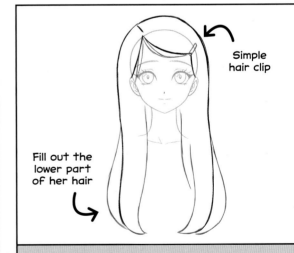

Simple hair clip

Fill out the lower part of her hair

4 ADD EXTRA SECTIONS OF HAIR AROUND THE NECK AND SHOULDERS. USE FLOWING LINES THAT END WITH SLIGHT CURVES. DRAW STRANDS OF HAIR GOING ACROSS HER FOREHEAD, AND GIVE HER A SMALL HAIR CLIP.

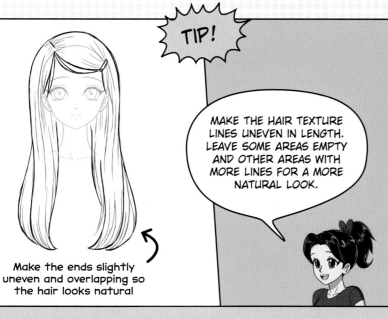

TIP!

MAKE THE HAIR TEXTURE LINES UNEVEN IN LENGTH. LEAVE SOME AREAS EMPTY AND OTHER AREAS WITH MORE LINES FOR A MORE NATURAL LOOK.

Make the ends slightly uneven and overlapping so the hair looks natural

5 BREAK UP THE EMPTY SPACE WITH LOTS OF FLOWING LINES. THE MORE LINES YOU ADD, THE FINER THE HAIR TEXTURE BECOMES. DRAW LINES THAT GO IN THE DIRECTION OF THE HAIR, ESPECIALLY WHERE THE HAIR GOES INTO AND OUT FROM THE HAIR CLIP.

6 ONCE YOU'RE HAPPY WITH THE DESIGN, FINALIZE YOUR LINES.

7 CHOOSE A BASE COLOR FOR THE HAIR, THEN USE A CONTRASTING COLOR FOR THE HAIR CLIP.

Lighter colors add shine effect

Darker colors add depth and shadow

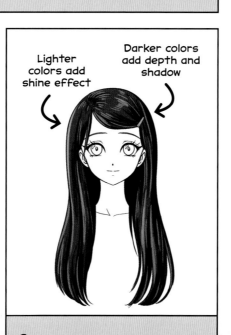

8 ADD SHADING TO BUILD DIMENSION. WE'RE USING A FAIRLY "SKETCHY" MANGA STYLE HERE, SO THE STROKES HAVE ROUGHER EDGES.

OOH, I LOVE HOW MY HAIR CLIP MATCHES MY EYES!

9 FINALLY, COLOR AND SHADE THE FACE AND NECK. WHAT COLOR WILL YOU CHOOSE FOR HER LOVELY BIG EYES?

CUTE SHORT HAIR

If you're looking to draw a classic manga hairstyle, we've got just the one. It's messy but not too messy, stylish but not overly styled, and cute but not too cute. And this blue-eyed, blue-haired pop star wears it so well! Let's draw his hairstyle before he goes onstage.

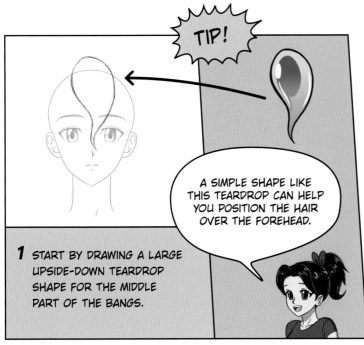

TIP!

A SIMPLE SHAPE LIKE THIS TEARDROP CAN HELP YOU POSITION THE HAIR OVER THE FOREHEAD.

1 START BY DRAWING A LARGE UPSIDE-DOWN TEARDROP SHAPE FOR THE MIDDLE PART OF THE BANGS.

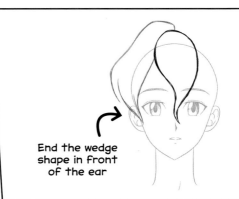

End the wedge shape in front of the ear

2 SKETCH A CURVED WEDGE SHAPE FOR ONE SIDE OF THE HAIR. BE SURE TO LEAVE QUITE A DISTANCE BETWEEN THE SKULL AND THE UPPER EDGE OF THE HAIR SO THERE'S ENOUGH SPACE TO GIVE OUR CHARACTER A FULL HEAD OF HAIR!

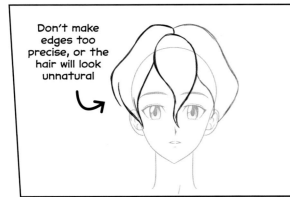

Don't make edges too precise, or the hair will look unnatural

3 NOW REPEAT A SIMILAR—BUT NOT COMPLETELY SYMMETRICAL—SHAPE ON THE OTHER SIDE OF THE HEAD. TRY TO MAKE IT BULGE OUTWARD AND THEN GO DOWN TOWARD THE EAR.

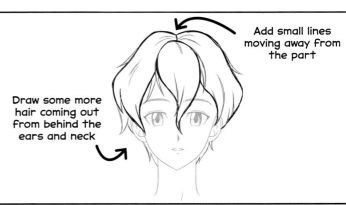

Add small lines moving away from the part

Draw some more hair coming out from behind the ears and neck

4 YOU'VE DRAWN THE MAJOR HAIR SHAPES. NOW, ADD SMALLER LINES TO BREAK THEM UP. USE SMALL, SHARP POINTS OF HAIR THAT COME OUT HERE AND THERE FOR A CUTE, SLIGHTLY MESSY LOOK. ADD TEXTURE LINES AS CURVES INSIDE THE HAIR.

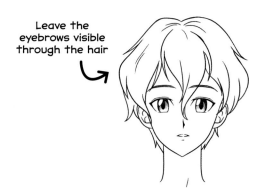

Leave the eyebrows visible through the hair

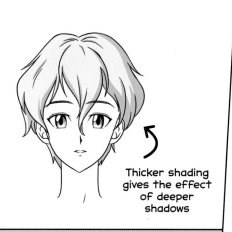

Thicker shading gives the effect of deeper shadows

5 AFTER FINISHING THE ROUGH DRAWING, GO OVER YOUR FINAL LINES WITH AN OUTLINER, PEN, OR THIN-TIPPED MARKER. DON'T OUTLINE THE FULL TEARDROP AND WEDGE SHAPES FROM STEPS 1-3—INSTEAD, LEAVE SOME GAPS SO THE HAIR ISN'T SPLIT INTO SECTIONS.

6 NOW FOR COLORS! PICK A BASE COLOR FOR THE HAIR. I'VE PICKED LIGHT BLUE, WHICH LOOKS COOL AND CALM. NEXT, ADD SHADOWS WITH A DARKER COLOR ALONG MANY OF THE OUTLINES.

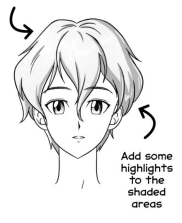

Use a gel pen or paint marker to add highlights on top of the base color

Add some highlights to the shaded areas

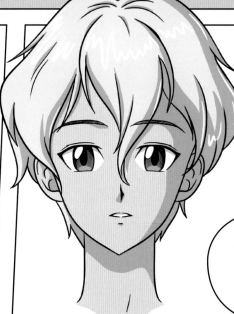

UH-OH. IS THAT A STAMPEDE OF SCREAMING FANS I HEAR?

YEAH... AND MAKE SURE TO CHECK OUT THEIR AMAZING RANGE OF HAIRSTYLES ON THE NEXT PAGE!

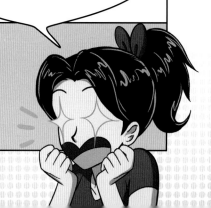

7 ADD SOME SHINE TO THE HAIR WITH WHITE SQUIGGLY LINES. CREATE A "HIGHLIGHT RING" AROUND THE TOP OF THE HEAD AND THEN ADD A FEW MORE HERE AND THERE.

8 NOW, COLOR AND SHADE THE FACE. WHY NOT MATCH HIS EYE COLOR TO HIS HAIR COLOR TO MAKE HIM EVEN MORE DREAMY?

HAIR COME SOME MORE!

Here are the finalists for Best Manga Hairstyle. You can see how the distinct hairstyles are created by altering shape and texture and by using different art styles, coloring techniques, color schemes, and highlights. These hairdos truly show their characters' energy and personality!

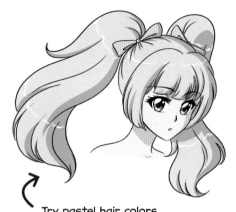

Try pastel hair colors for cute, kawaii, or gentle characters.

A hood drawn around the head tells us more about her character.

Simple highlights around the crown of the head make the hair look super thick and glossy.

Add elegant wisps to make hair look especially beautiful!

Start the hair off as a large, tilted flame shape.

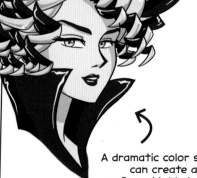

A dramatic color scheme can create an unforgettable hairdo!

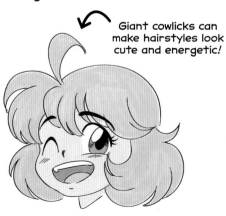

Giant cowlicks can make hairstyles look cute and energetic!

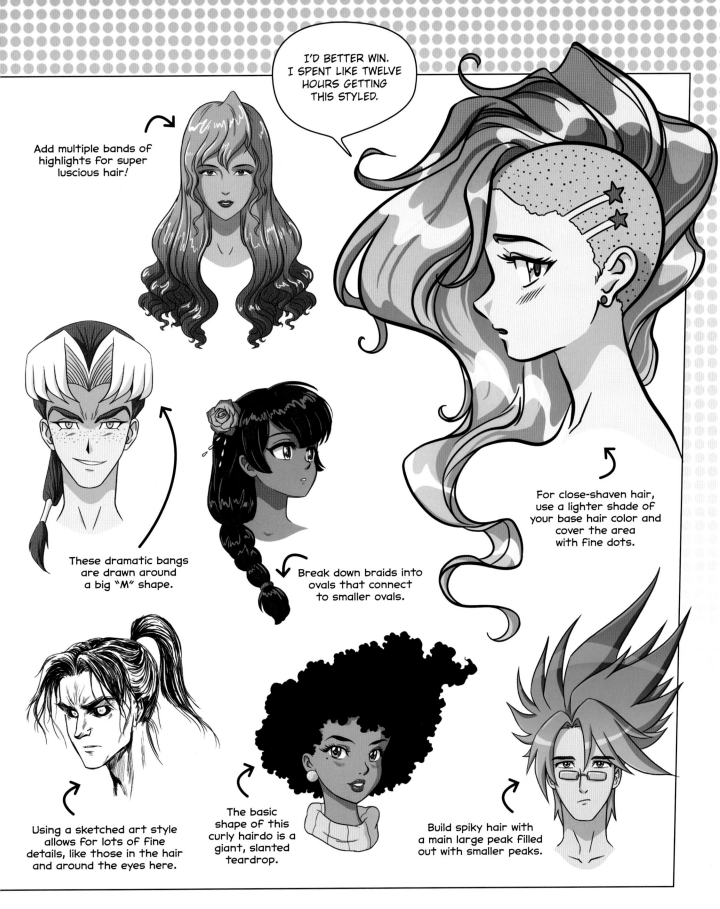

Add multiple bands of highlights for super luscious hair!

I'D BETTER WIN. I SPENT LIKE TWELVE HOURS GETTING THIS STYLED.

These dramatic bangs are drawn around a big "M" shape.

Break down braids into ovals that connect to smaller ovals.

For close-shaven hair, use a lighter shade of your base hair color and cover the area with fine dots.

Using a sketched art style allows for lots of fine details, like those in the hair and around the eyes here.

The basic shape of this curly hairdo is a giant, slanted teardrop.

Build spiky hair with a main large peak filled out with smaller peaks.

SHORT BOUNCY HAIR

Here's another short hairstyle, but this one is choppy and buoyant, with a cool pink and orange fade. It's perfect for all your cute, energetic characters. And to make it a bit different, we're going to draw this hairstyle from the side!

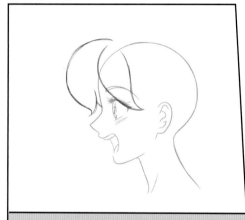

1 START WITH TWO CURVED, SEMI-CIRCULAR CHUNKS OF HAIR AT THE FRONT, WHICH END IN POINTS.

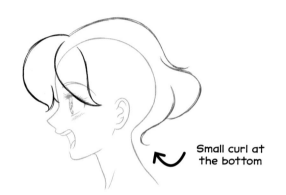

Small curl at the bottom

2 FOR A CUTESY, BUBBLY LOOK, MAKE THE HAIR POOF OUT AT THE BACK. THIS GIVES IT A BOUNCY FEEL AND WILL MAKE YOUR CHARACTER LOOK LIVELIER. BE SURE TO LEAVE LOTS OF DISTANCE BETWEEN THE SKULL AND THE HAIR FOR PLENTY OF THICK VOLUME.

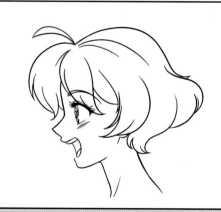

5 ONCE YOU'RE HAPPY, ERASE ANY UNNECESSARY LINES. USE YOUR CHOICE OF OUTLINER TO CREATE THE LINE ART.

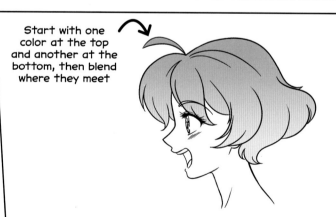

Start with one color at the top and another at the bottom, then blend where they meet

6 TIME FOR COLORS! CHOOSE A COLOR SCHEME (SEE PAGES 18-19), THEN BLEND TWO OR THREE COLORS TOGETHER TO CREATE A UNIQUE LOOK.

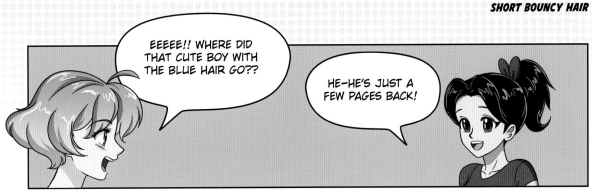

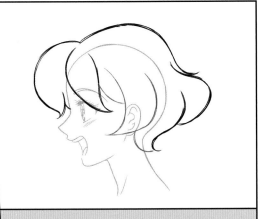

3 DRAW POINTED CURVES GOING FORWARD AND BACKWARD TO CREATE DYNAMIC CONTRAST OVER THE EAR.

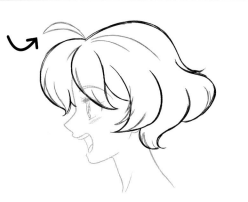

For fun, add a piece of hair sticking out on top as a cowlick

4 NOW THAT YOU'VE COMPLETED THE MAJOR SHAPES, SOFTEN THEM BY ADDING SMALLER POINTS AND SECTIONS OF HAIR. FOLLOW THE FLOW OF THE HAIR WHEN YOU'RE DRAWING THESE CURVED POINTS.

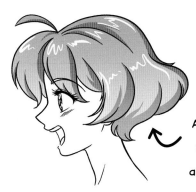

Add the darker colors on the undersides of the hair and around the back of the head

7 ADD DARKER COLORS AROUND THE OUTLINES FOR SHADING AND WHITE SQUIGGLY HIGHLIGHTS ACROSS THE HAIR FOR SHINE.

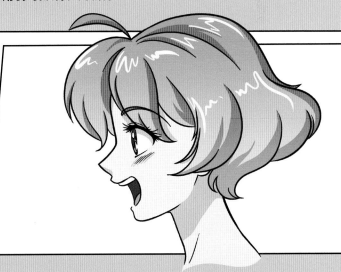

8 FINALLY, COLOR AND SHADE THE FACE. SHADING THE NECK UNDER THE CHIN AND JAW IS A QUICK AND EASY WAY TO ADD DEPTH.

SPIKY HAIR

For hair that is sure to impress, take a look at this guy. His cool spikes seem to defy gravity! Let's draw his fiery, over-the-top hairstyle, which you can use for all your confident, stylish-hair characters.

1 THIS HAIRSTYLE IS EXTREME, SO KEEP YOUR LINES SHARP AND JAGGED. START WITH A CROWNLIKE SHAPE FOR THE SWEEPING BANGS. MAKE THE BOTTOM OF THE SHAPE CURVED AND THE TOPS POINTED.

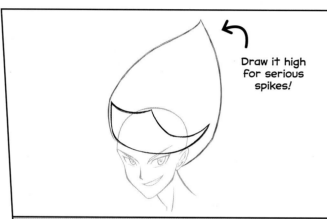

Draw it high for serious spikes!

2 NOW, ADD A GIANT FLAME SHAPE. THIS IS THE GENERAL SHAPE FOR ALL THE SPIKES ON TOP. BE SURE IT GOES AROUND HIS WHOLE HEAD AND ENDS BEHIND THE EAR. WE'LL DIVIDE THIS INTO SMALLER SPIKES NEXT.

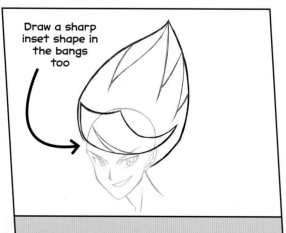

Draw a sharp inset shape in the bangs too

3 DRAW JAGGED SPIKES INSIDE THE FLAME SHAPE. KEEP THE CENTRAL ONE THE LONGEST, SO THERE'S A FOCAL POINT TO THE HAIR.

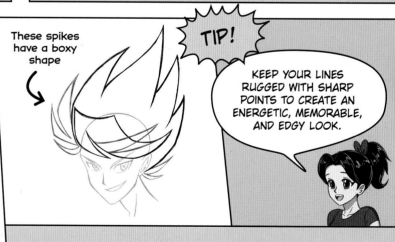

These spikes have a boxy shape

TIP!

KEEP YOUR LINES RUGGED WITH SHARP POINTS TO CREATE AN ENERGETIC, MEMORABLE, AND EDGY LOOK.

4 ERASE THE LARGE FLAME SHAPE AND WHERE THE BANGS INSET MEETS THE EDGE. ADD SECONDARY SPIKES ALONG THE FRONT AND BACK OF THE HEAD. SWEEP SOME SPIKES UP IN THE BANGS.

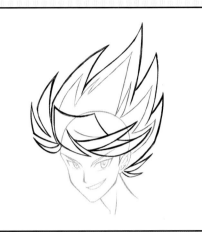

5 DRAW A SECOND LAYER OF SPIKES INSIDE THE LARGE ONES ON TOP OF THE HEAD. WE WILL USE THESE LINES TO COLOR DIFFERENT SECTIONS OF THE HAIR.

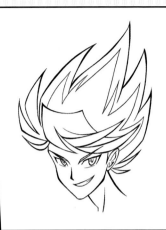

6 ERASE EXTRA LINES AND THEN USE AN OUTLINER OR THIN MARKER TO CREATE YOUR FINAL LINE ART. GIVE THE EXTERNAL LINES A THICKER FINISH THAN THE INTERNAL HAIR LINES.

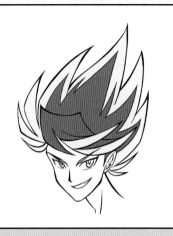

7 HE'S ON FIRE! GIVE HIS HAIR THE STRIKING BASE COLORS IT DESERVES. DIFFERENTIATE BETWEEN THE "INNER" SECTIONS AND THE "OUTER" SECTIONS.

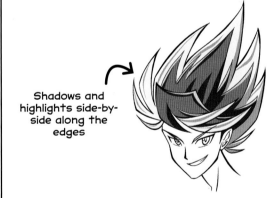

Shadows and highlights side-by-side along the edges

8 USE DARKER AND LIGHTER COLORS TO CREATE SHADOWS AND HIGHLIGHTS. A GREAT WAY TO EMPHASIZE EDGES IS TO HAVE A SLIM AREA WITH A DARKER COLOR THAT'S RIGHT BESIDE THE HIGHLIGHT AREA, SUCH AS ALONG THE OUTER EDGES OF THE HAIR.

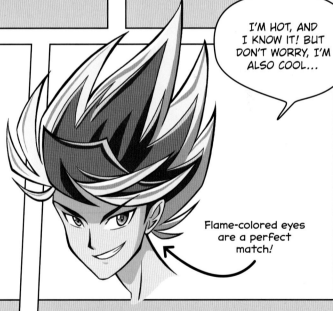

I'M HOT, AND I KNOW IT! BUT DON'T WORRY, I'M ALSO COOL...

Flame-colored eyes are a perfect match!

9 TO FINISH YOUR CHARACTER, COLOR AND SHADE HIS FACE TO COMPLEMENT HIS EXTREME HAIRSTYLE.

HAIR TEXTURE

What's the difference between neat, messy, straight, wavy, or curly hair anyway? Well, quite a lot actually! Let's take a look at how the shapes of your lines and the intensity of your shading can have a huge effect on your character's hairstyle!

TO BRUSH OR NOT TO BRUSH?

Whether hair is neat or messy can make all the difference to your character's appearance—and how others react to them.

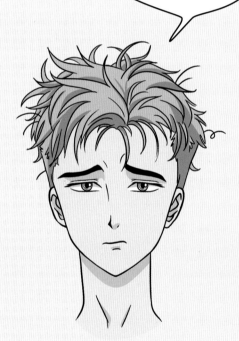

GREAT. MY DATE DIDN'T SHOW UP, IT STARTED RAINING, THIS CROW WANTED TO NEST IN MY HAIR, AND NOW I'VE LOST MY KEYS.

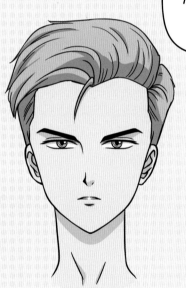

I'VE NEVER BEEN MORE READY FOR A DATE IN MY LIFE!

Neat hair
This guy's hairstyle falls in a classic shape. The edges are smooth, and not many hair pieces jut out, apart from a couple of strands here and there. His bangs are brushed in a uniform direction to the side, and the shading generally follows straight lines, giving the hair a smooth look.

Messy hair
Something must have happened to our character because now he has pieces of hair sticking out all over the place! Curved spikes poke up and out at various points, while the shading goes in all directions to emphasize the hair's messy layers. Note how a silly spiral line juts out from the side in a comical way.

WHERE'S THE CURL, GIRL?

Let's take a look at one of our students,
who never tires of changing her hairstyle.
Note how her hair looks completely different
as a result of changing the shapes of the lines!

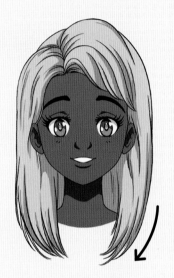

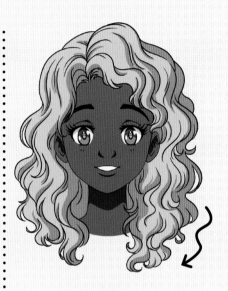

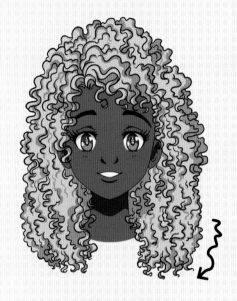

The pointed ends
of her hair curve
inward slightly

Small flicks and twists
jut out from the hair
to emphasize her
wavy curls

Build her bangs by
using wavy lines that
spread out from the
part in all directions

Straight hair
This hairstyle is drawn mostly
with straight-ish lines that have
slight curves. Only a few lines
are added within the outlines of
the hair, and the shading is
mostly done as straight or
slightly curved lines.

Wavy hair
Wavy lines are used here, with
little curves that go in and out.
Some curves are bigger than
others to give a more natural
look. There are quite a few curls
and twists within the hair
outlines, and these are
shaded with wavy lines.

Curly hair
The curves of the lines are
tightened here to create curly hair.
The less space you leave between
each back-and-forth curve, the
tighter the curl will be. There are
many more lines drawn inside the
hair, and the shading is much
closer together as well.

HAIR VERSUS THE ELEMENTS

MASTERCLASS!!

Hair is one of the most versatile aspects of your character, and it can tell a lot about where they're coming from or what they've been doing. Take a look at this wonderful—and brave—shojo volunteer, who is going to show us how hair can react to different elements and situations!

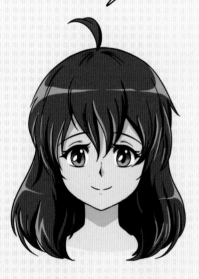

NATURAL HAIR

This character's straight hair has a natural loose wave and medium volume. One piece of hair always sticks up at the top, and that's how she likes it!

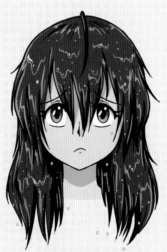

WET HAIR

Wet hair is heavy and won't have as much volume as dry hair. Draw the hair lines closer to the skull (but still not lying flat). Use blue and white highlights across the hair to show sheets of water droplets.

WINDY HAIR

Wind pushes hair in the direction it's blowing. Hair being blown against the face will follow the round contours and general shape of the head. As with straight hair, the hair lines should have slight curves to show natural movement.

96

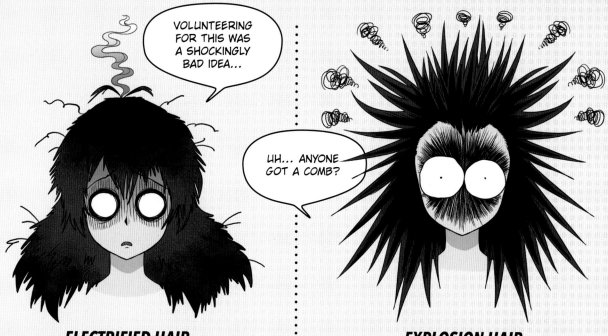

ELECTRIFIED HAIR

Lightning (or being hit by spells or superpowers) would leave a character's hair frizzy, staticky... and a little bit fried. Try making it look rough and singed. Or we could take things even further...

EXPLOSION HAIR

Explosions are another fun way to give a character—and their hair—a very dramatic look! Draw the hair sticking straight out at all angles for maximum impact.

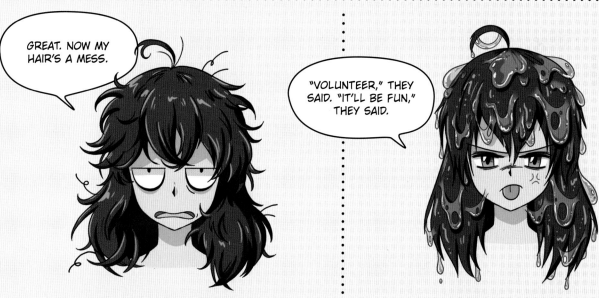

BAD HAIR DAY

Messy hair can be comical, especially when you add ruffled hair going in all directions. Have random hairs and little spirals poke out at odd angles for a greater effect.

STUCK IN GOO

If a character gets stuck in goo or slime, weigh the hair down (similar to wet hair), but add lots of three-dimensional blobs of gross stuff! Be sure to add plenty of highlights to the goo so it looks extra-shiny.

HANDS AND FEET

PALM TO YOU

Raise your hand if you want to learn how to draw hands! Oh, you! Great! In fact, that's the perfect pose to start with. Let's draw it in a classic front-on pose, where the basic structure is clearly visible.

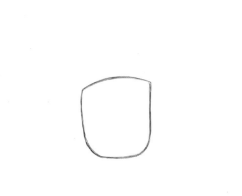

1 START WITH A SIMPLE ROUNDED SQUARE FOR THE PALM. DRAW THE TOP OF THE SQUARE CURVED SLIGHTLY UPWARD.

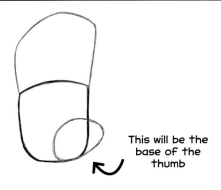

This will be the base of the thumb

2 FOR THE FINGERS, WE'LL JUST DRAW A BASIC SHAPE FOR NOW AND DIVIDE IT INTO INDIVIDUAL FINGERS LATER. START THE BASE OF THE THUMB WITH A MUSCULAR OVAL.

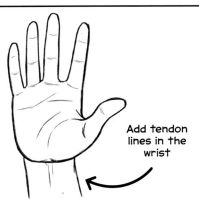

Add tendon lines in the wrist

5 ERASE UNNECESSARY STRUCTURE LINES, THEN DRAW CREASES AND FOLD LINES IN THE PALM AND FINGERS. THE FOLDS IN THE FINGERS INDICATE WHERE THE JOINTS ARE. THE CREASES IN THE PALM SHOW THE CONTOURS AND FLESHY BASE OF THE THUMB.

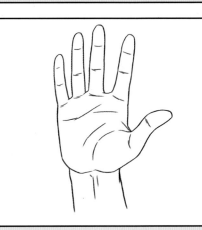

6 FINALIZE YOUR LINE ART WITH AN OUTLINER OR FINE-TIPPED MARKER. LOOKING GOOD!

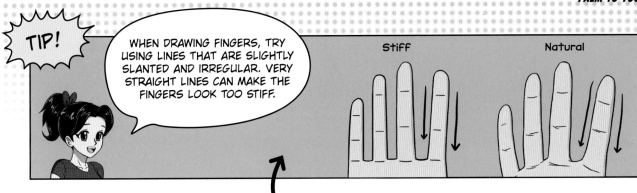

TIP!

WHEN DRAWING FINGERS, TRY USING LINES THAT ARE SLIGHTLY SLANTED AND IRREGULAR. VERY STRAIGHT LINES CAN MAKE THE FINGERS LOOK TOO STIFF.

Stiff Natural

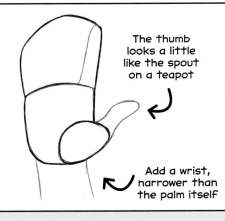

The thumb looks a little like the spout on a teapot

Add a wrist, narrower than the palm itself

3 DRAW THE THUMB STICKING OUT FROM THE OVAL. IN THE LARGE FINGER SHAPE, DRAW A LINE TO THE PALM, WHICH WILL BE THE INDEX FINGER.

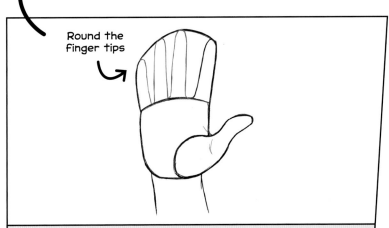

Round the finger tips

4 DRAW THE OTHER FINGERS, USING THE LARGER SHAPE AS A GUIDE. KEEP THE LINES SLIGHTLY CURVED, SO THE FINGERS DON'T LOOK RIGID. DRAW A SMALL PIECE OF SKIN TO CONNECT THE THUMB TO THE PALM.

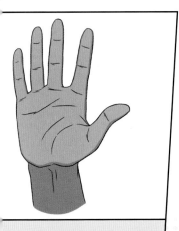

7 FILL IN THE HAND WITH A BASE COLOR OF YOUR CHOICE.

8 SHADE THE EDGES AND DEEPER CREASES OF THE PALM WITH A DARKER SHADE OF YOUR CHOSEN SKIN TONE TO ADD DEPTH. THINK ABOUT WHERE THE LIGHT SOURCE IS, SO THAT YOUR SHADING IS CONSISTENT.

GOOD JOB! HIGH FIVE!

HOLDING A PENCIL

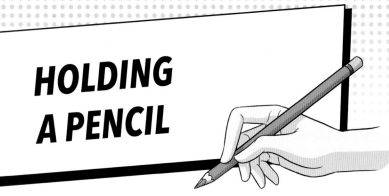

In this handy lesson, we are going to draw my own hand holding my favorite pink pencil. Pay careful attention—you wouldn't want to get my hand wrong!

1 START WITH A ROUNDED RECTANGLE SHAPE. THIS WILL BE THE PALM FROM A LOW PROFILE ANGLE. NOTICE HOW IT SITS AT A SLANT.

2 BECAUSE WE ARE GOING TO SHOW THE HAND AT A PROFILE ANGLE, THE MUSCULAR THUMB BASE SHOULD BE IN THE MIDDLE OF THE PALM SHAPE. DRAW IT AS A LARGE, ASYMMETRICAL OVAL. THEN, DRAW THE WRIST.

TIP!

I LIKE TO PICTURE THE BASIC SHAPE OF THE THUMB BASE AS AN EGG.

HOPE I'M DRAWING SOMETHING GOOD!

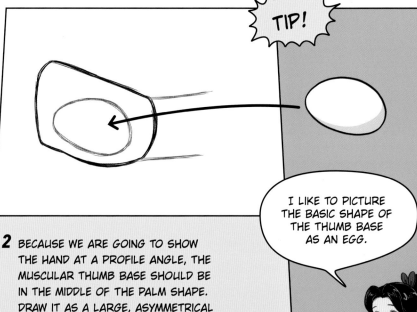

Thumb joint sits roughly at edge of palm shape

3 DRAW IN THE SHAPE OF A BENT THUMB, WITH THE TIP POINTING DOWN. NOTE HOW THE TIP IS ROUNDED AT THE BOTTOM BUT MORE SQUARE AT THE TOP. THIS IS BECAUSE THAT'S WHERE THE NAIL WOULD BE.

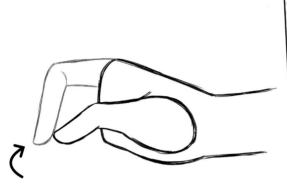

Like with the thumb, make this corner less rounded than the other bottom corner

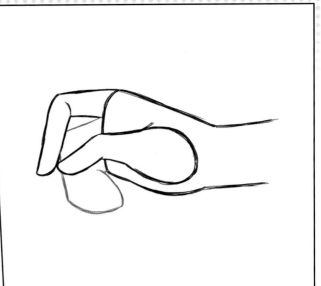

4 NOW, ADD THE BENT INDEX FINGER COMING OUT FROM THE TOP OF THE PALM SHAPE. MAKE THE TIP VERY CLOSE TO THE TIP OF THE THUMB. DRAW IN A CREASE AT THE JOINT.

5 GROUP THE OTHER FINGERS AS A FOLDED SHAPE BEHIND THE THUMB AND INDEX FINGER FOR NOW. DRAW THE SHAPE BENDING AROUND AND COMING OUT BENEATH THE THUMB.

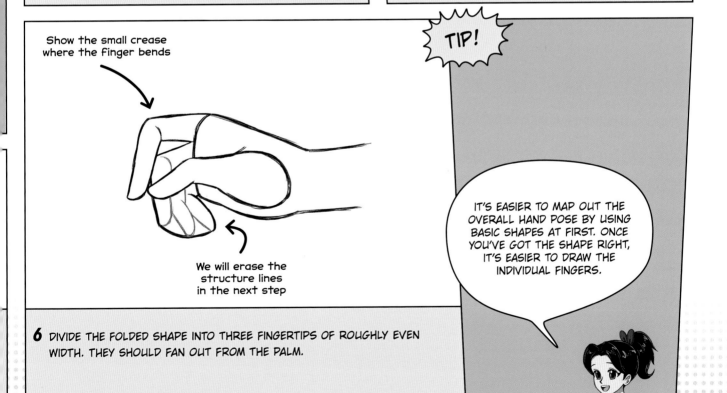

Show the small crease where the finger bends

We will erase the structure lines in the next step

6 DIVIDE THE FOLDED SHAPE INTO THREE FINGERTIPS OF ROUGHLY EVEN WIDTH. THEY SHOULD FAN OUT FROM THE PALM.

TIP!

IT'S EASIER TO MAP OUT THE OVERALL HAND POSE BY USING BASIC SHAPES AT FIRST. ONCE YOU'VE GOT THE SHAPE RIGHT, IT'S EASIER TO DRAW THE INDIVIDUAL FINGERS.

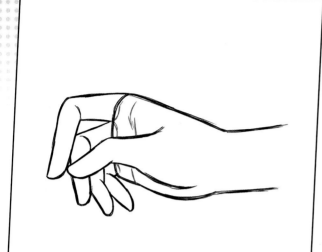

7 ERASE THE GENERAL FINGER SHAPE LINES AND THEN ADD SOME CREASES IN THE PALM AT THE BASES OF THE FINGERS, FOLLOWED BY ANOTHER SET IN THE MIDDLE. USE SMALL, CURVED LINES.

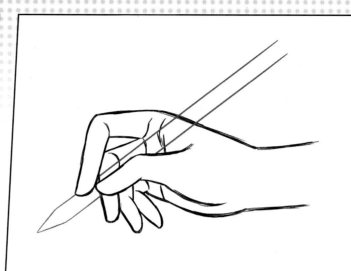

8 NOW, LET'S ADD THE PENCIL! USE A RULER TO HELP DRAW THE STRAIGHT LINES IF YOU NEED TO. BE SURE THE PENCIL IS THICK ENOUGH THAT THE THUMB TIP AND INDEX FINGER TIP BOTH FIT INSIDE.

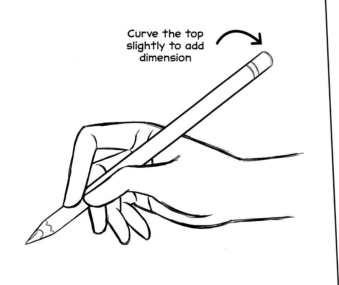

9 ERASE THE LINES OF THE HAND THAT ARE VISIBLE THROUGH THE PENCIL AND THEN ADD THE FINISHING DETAILS TO THE PENCIL.

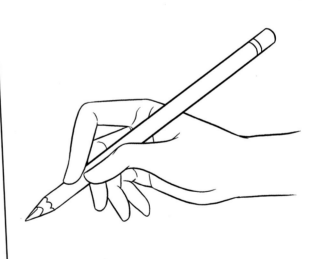

10 USE AN OUTLINER OR FINE-TIPPED MARKER TO GO OVER THE FINAL LINE ART.

11 ADD THE BASE COLORS
TO THE SKIN AND THE PENCIL.
MY FAVORITE PENCIL IS A
PINK ONE—WHAT'S YOURS?

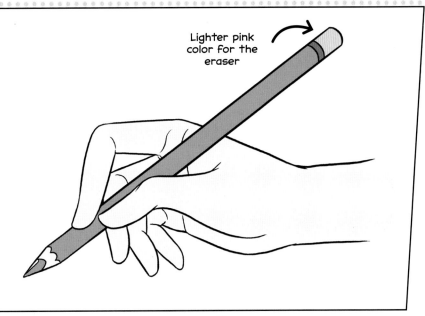

Lighter pink
color for the
eraser

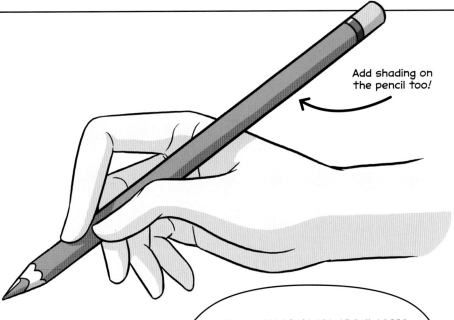

Add shading on
the pencil too!

WHEN I TEACH MANGA ART CLASSES,
I OFTEN DRAW WITH A PINK PENCIL
INSTEAD OF A BLACK ONE. IT'S
BECAUSE I LOVE THE PALE COLOR
FOR SKETCHING MY ROUGH DRAWINGS.
I CAN CORRECT ANYTHING EASILY,
BEFORE I INK MY ART. ALSO,
I LOVE THE COLOR PINK!

12 CREATE DEPTH BY ADDING DARKER COLORS.
SHADE THE LOWER PARTS OF THE HAND
AS WELL AS THE AREA WHERE THE PENCIL
WOULD CAST A SHADOW.

FIST COMING AT YOU

Watch out, there's a great fist pose coming at you—so quick, let's draw it before we get hit! We're going to use a different manga technique for this lesson, using cross-hatching to add detail and shadow.

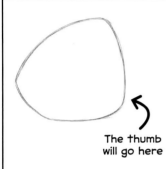

The thumb will go here

1 DRAW THE MAIN SHAPE OF THE HAND LIKE A ROUNDED WEDGE, WITH ONE SIDE MUCH WIDER THAN THE OTHER.

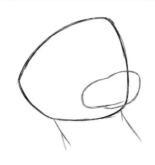

2 NEAR THE BOTTOM OF THE WEDGE SHAPE, DRAW THE THICK, FOLDED THUMB JUTTING OUT A LITTLE ON THE SIDE. ADD THE WRIST, MAKING IT THICK, WITH SLIGHTLY CURVED LINES.

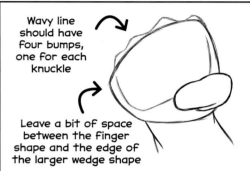

Wavy line should have four bumps, one for each knuckle

Leave a bit of space between the finger shape and the edge of the larger wedge shape

3 DRAW A BASIC SHAPE FOR THE FOUR FINGERS OVER THE TOP SECTION OF THE WEDGE. MAKE THE TOP OF THIS SHAPE WAVY. IT'S AN EFFECTIVE WAY TO SHOW THE KNUCKLES FROM THIS PERSPECTIVE.

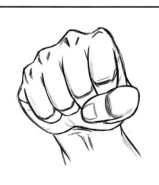

6 DRAW FURTHER DETAILS BY USING FINE LINES INSIDE THE FINGERS, PALM, AND WRIST. ADD A NAIL TO THE TIP OF THE THUMB.

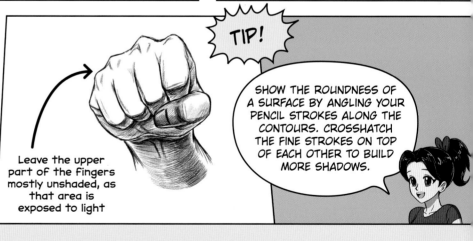

Leave the upper part of the fingers mostly unshaded, as that area is exposed to light

TIP!

SHOW THE ROUNDNESS OF A SURFACE BY ANGLING YOUR PENCIL STROKES ALONG THE CONTOURS. CROSSHATCH THE FINE STROKES ON TOP OF EACH OTHER TO BUILD MORE SHADOWS.

7 NOW FOR THE CROSS-HATCHING! USE A SHARP PENCIL TO SHADE WITH LOTS OF FINE LINES THAT CRISS-CROSS EACH OTHER. MAKE CERTAIN AREAS DARKER, SUCH AS THE JOINTS OF THE FINGERS, AND WHERE THE WRIST CONNECTS WITH THE PALM.

TIP!

FOR THIS CROSSHATCHED STYLE, ADD DETAILS TO THE ARTWORK AS SEVERAL FINE OVERLAPPING LINES. THIS WILL GIVE A HAND-DRAWN EFFECT WHEN COMPARED TO THE SIMPLE, SMOOTH LINES THAT ARE USED IN OTHER MANGA STYLES.

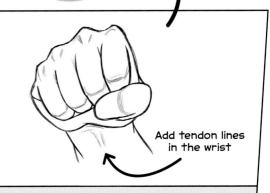

Smooth style hand

This small line marks the palm crease

Add a small line here to connect the thumb to the palm

Add tendon lines in the wrist

4 DIVIDE THE SHAPE YOU JUST DREW INTO CURLED FINGERS BY USING CURVED LINES. THEN, DRAW THE BOTTOM PART OF THE MUSCULAR PALM AS A WIDE, SHALLOW UPSIDE DOWN "V" UNDER THE THUMB.

5 TO MAKE IT LOOK LIKE THE FINGERS ARE COMING TOWARD YOU, DRAW BLOCKY EDGES ON THE JOINTS. ADD SEVERAL LINES IN THE KNUCKLES AS WELL, TO SHOW THE STRUCTURE OF THE BONES UNDERNEATH.

8 FINISH OFF THIS POWERFUL PUNCH BY ADDING COLOR ON TOP OF THE CROSS-HATCHING. I'VE USED A LIGHTER AND DARKER TONE OF THE SKIN COLOR TO FURTHER AMPLIFY THE SHADING.

The flat front of the hand is lighter in color

EPIC FIST BUMP!!

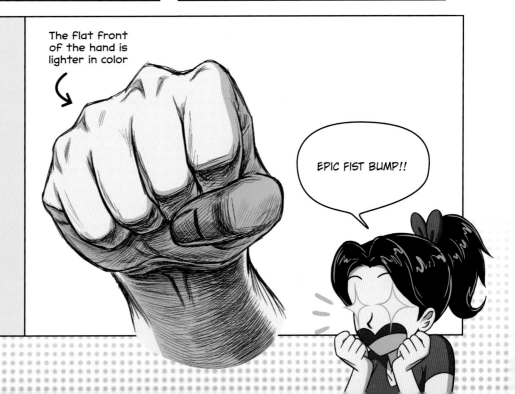

HAND ON HIP

I love this hand pose. It's elegant and confident, perfect when drawing a model, someone who's taking a selfie, or a character impatiently telling off uninvited guests. Let's go!

1 DRAW THE CURVED HIP FIRST. WE NEED SOMETHING FOR THE HAND TO BE PLACED ON.

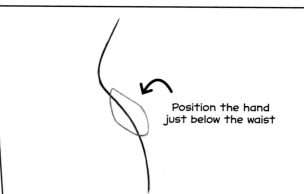

Position the hand just below the waist

2 START THE HAND BY DRAWING A SLANTED OVAL SHAPE WITH A POINTED TOP, HALF ON AND HALF OFF THE HIP. THIS WILL BE THE MAIN PART OF THE HAND.

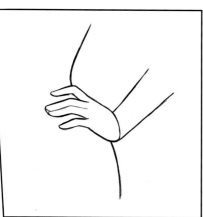

5 ERASE THE BASIC FINGER SHAPE OUTLINE AND THEN DIVIDE THE MIDDLE SECTION INTO TWO FINGERS.

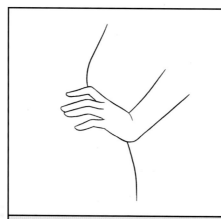

6 ERASE THE UNNECESSARY WRIST LINE BEFORE INKING THE FINAL OUTLINES.

7 LET'S ADD THE BASE COLORS FIRST. CHOOSE ANY SKIN TONE AND CLOTHING COLOR YOU LIKE.

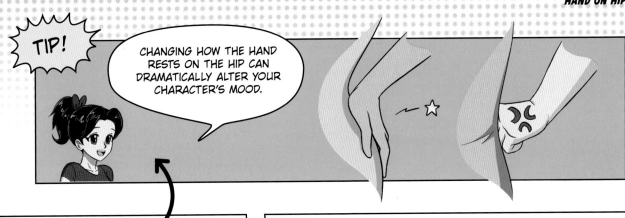

TIP!

CHANGING HOW THE HAND RESTS ON THE HIP CAN DRAMATICALLY ALTER YOUR CHARACTER'S MOOD.

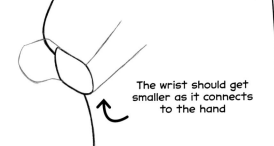

The wrist should get smaller as it connects to the hand

3 DRAW THE LOWER ARM AND THEN SKETCH THE BASIC OUTLINE OF THE FINGERS AS A SINGLE SHAPE THAT BENDS UP AND THEN DOWN. DON'T WORRY ABOUT INDIVIDUAL FINGERS FOR THIS STEP.

4 DIVIDE THE BASIC FINGER SHAPE INTO SMALLER SECTIONS. DRAW THE INDEX FINGER ON THE UPPER EDGE OF THE SHAPE, LEAVE A GAP, AND THEN GROUP THE NEXT TWO FINGERS TOGETHER. LEAVE ANOTHER GAP AND DRAW THE SHORT PINKIE FINGER.

8 SHADE THE HAND AND CLOTHING WITH DARKER COLORS TO CREATE SHADOWS. ADD A LARGE SHADED AREA TO THE CLOTHING, RIGHT UNDERNEATH WHERE THE HAND RESTS.

OOPS, WERE YOU WAITING FOR ME? SORRY I'M LATE—IT WON'T HAPPEN AGAIN!

HANDY POSES

Look! We've found an enthusiastic bunch of models who are willing to lend us a hand so we can learn about hand structure, different poses, and fun features. Raise a hand if you're ready. Let's go!

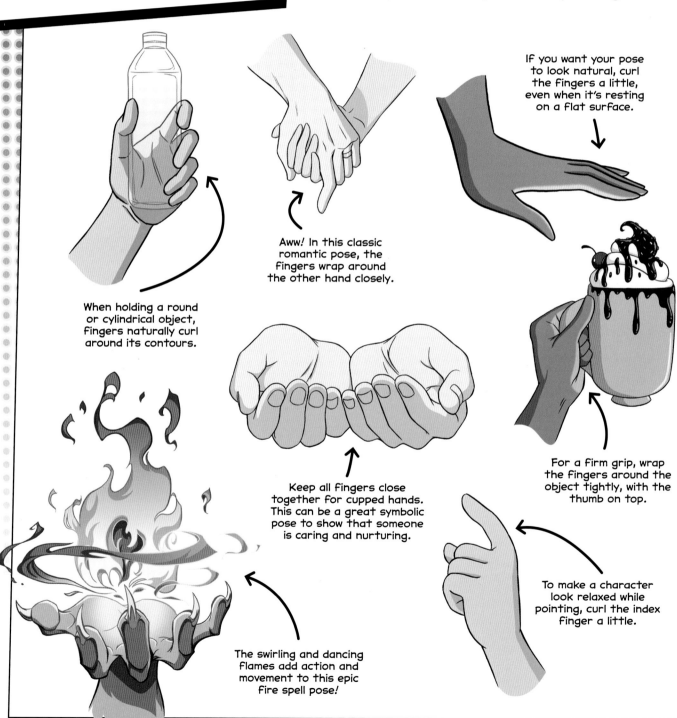

When holding a round or cylindrical object, fingers naturally curl around its contours.

Aww! In this classic romantic pose, the fingers wrap around the other hand closely.

If you want your pose to look natural, curl the fingers a little, even when it's resting on a flat surface.

Keep all fingers close together for cupped hands. This can be a great symbolic pose to show that someone is caring and nurturing.

For a firm grip, wrap the fingers around the object tightly, with the thumb on top.

To make a character look relaxed while pointing, curl the index finger a little.

The swirling and dancing flames add action and movement to this epic fire spell pose!

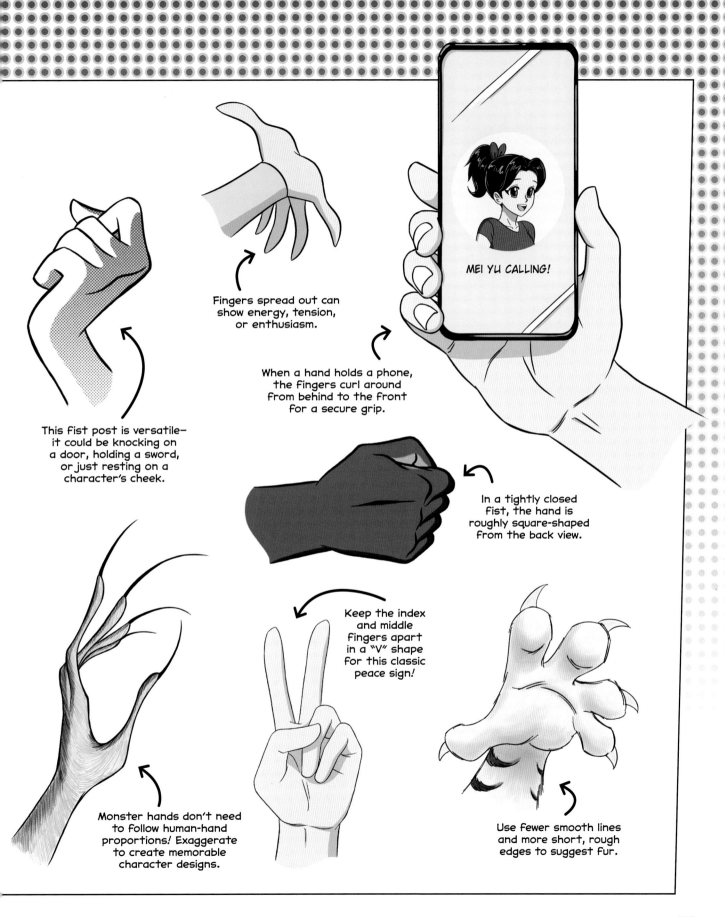

This fist post is versatile—
it could be knocking on
a door, holding a sword,
or just resting on a
character's cheek.

Fingers spread out can
show energy, tension,
or enthusiasm.

MEI YU CALLING!

When a hand holds a phone,
the fingers curl around
from behind to the front
for a secure grip.

In a tightly closed
fist, the hand is
roughly square-shaped
from the back view.

Keep the index
and middle
fingers apart
in a "V" shape
for this classic
peace sign!

Monster hands don't need
to follow human-hand
proportions! Exaggerate
to create memorable
character designs.

Use fewer smooth lines
and more short, rough
edges to suggest fur.

FRONT FOOT

Now let's head down, down, down... to the feet! It's time to dip our toes in and learn how to draw natural-looking feet. Here comes someone walking toward us—what a great opportunity to draw a fabulous front-view foot.

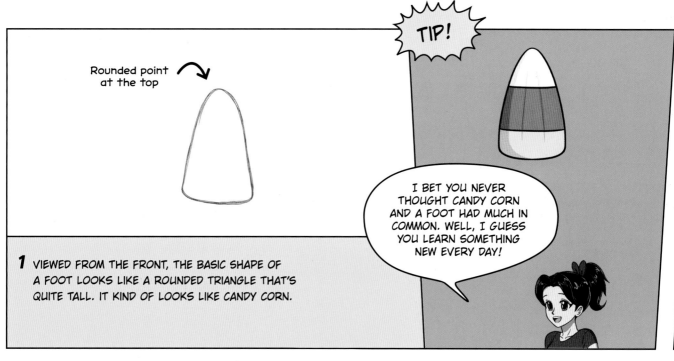

Rounded point at the top

TIP!

I BET YOU NEVER THOUGHT CANDY CORN AND A FOOT HAD MUCH IN COMMON. WELL, I GUESS YOU LEARN SOMETHING NEW EVERY DAY!

1 VIEWED FROM THE FRONT, THE BASIC SHAPE OF A FOOT LOOKS LIKE A ROUNDED TRIANGLE THAT'S QUITE TALL. IT KIND OF LOOKS LIKE CANDY CORN.

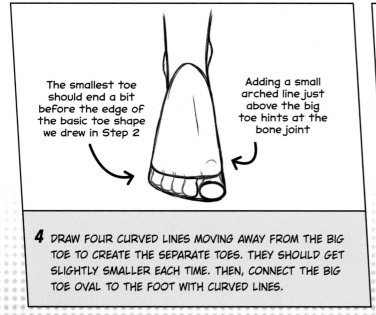

The smallest toe should end a bit before the edge of the basic toe shape we drew in Step 2

Adding a small arched line just above the big toe hints at the bone joint

4 DRAW FOUR CURVED LINES MOVING AWAY FROM THE BIG TOE TO CREATE THE SEPARATE TOES. THEY SHOULD GET SLIGHTLY SMALLER EACH TIME. THEN, CONNECT THE BIG TOE OVAL TO THE FOOT WITH CURVED LINES.

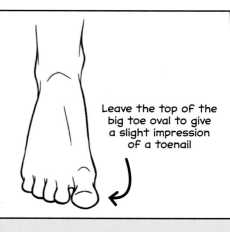

Leave the top of the big toe oval to give a slight impression of a toenail

5 ERASE THE EXTRA LINES, BUT KEEP SOME AROUND THE ANKLES TO SHOW THE FOOT'S STRUCTURE. THEN, INK YOUR FINAL LINES.

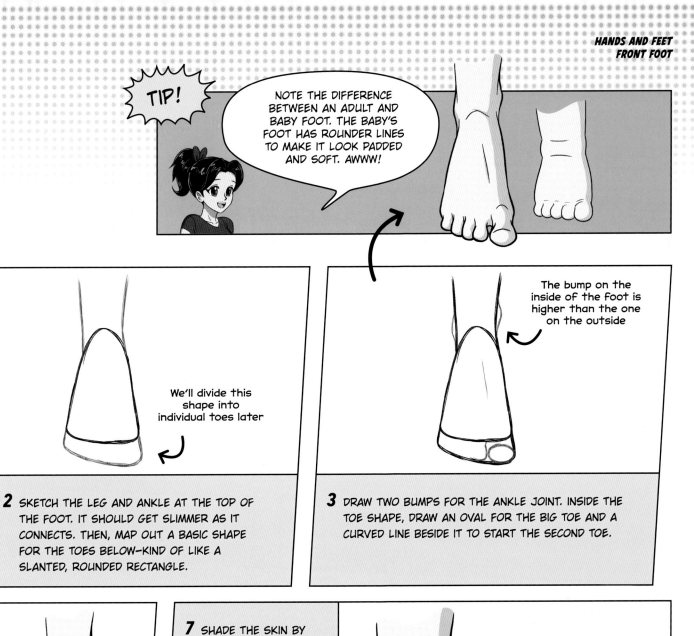

TIP!

NOTE THE DIFFERENCE BETWEEN AN ADULT AND BABY FOOT. THE BABY'S FOOT HAS ROUNDER LINES TO MAKE IT LOOK PADDED AND SOFT. AWWW!

We'll divide this shape into individual toes later

The bump on the inside of the foot is higher than the one on the outside

2 SKETCH THE LEG AND ANKLE AT THE TOP OF THE FOOT. IT SHOULD GET SLIMMER AS IT CONNECTS. THEN, MAP OUT A BASIC SHAPE FOR THE TOES BELOW—KIND OF LIKE A SLANTED, ROUNDED RECTANGLE.

3 DRAW TWO BUMPS FOR THE ANKLE JOINT. INSIDE THE TOE SHAPE, DRAW AN OVAL FOR THE BIG TOE AND A CURVED LINE BESIDE IT TO START THE SECOND TOE.

6 ADD YOUR BASE COLOR TO THE WHOLE FOOT.

7 SHADE THE SKIN BY USING A DARKER COLOR. JUST LIKE WITH THE HANDS, FOLLOW THE CONTOURS OF THE FOOT TO SHOW ITS FULL SHAPE AND ADD DEPTH, ESPECIALLY AROUND THE TOES.

TOE-TALLY AWESOME! NEXT, WE'LL DRAW A FOOT FROM THE SIDE.

SIDE FOOT

Here's another essential foot pose—the side view. It shows the whole foot and big toe, while the other toes peek out from behind! This pose really lets us see the full shape of the foot, including the heel and arch.

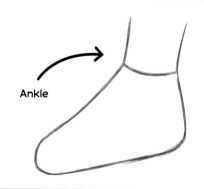

Ankle

1 SKETCH THE ANKLE AREA, SHAPED LIKE A CYLINDER WITHOUT A TOP. DRAW THE GENERAL SHAPE OF THE FOOT BENEATH IT, AS A LOPSIDED, CURVED TRIANGLE WITH A VERY WIDE BASE.

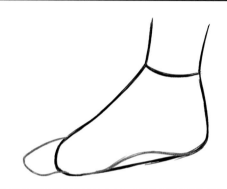

2 ADD THE ARCH OF THE FOOT INSIDE THE TRIANGLE AS A GENTLE CURVE. THEN, DRAW A ROUNDED SHAPE IN FRONT OF THE TRIANGLE FOR THE TOES. WE'LL DIVIDE THIS INTO INDIVIDUAL TOES NEXT.

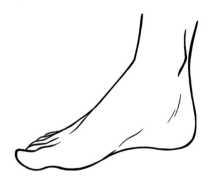

5 GO OVER THE FINAL LINES. TRY TO VARY THE LINE WIDTHS THROUGHOUT YOUR DRAWING FOR A MORE ORGANIC FEEL. AS YOU CAN SEE, THE STRUCTURE LINES ARE THINNER THAN THE FOOT OUTLINE.

TIP!

UNLESS YOU SPECIFICALLY WANT UNIFORM LINES AS PART OF YOUR ART STYLE, MAKING SOME OF THE LINES THINNER THAN OTHERS CAN ADD NUANCE AND REALISM TO YOUR DRAWINGS. EXPERIMENT! REFER BACK TO PAGES 16-17 FOR DIFFERENT TYPES OF LINE ART STYLES YOU CAN TRY.

TIP!

LET'S COMPARE THIS REGULAR MANGA FOOT WITH CHIBI FEET! CHIBI FEET ARE MUCH SHORTER AND SIMPLER IN SHAPE. DEPENDING ON YOUR ART STYLE, YOU CAN EVEN SKIP THE TOES!

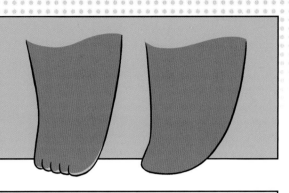

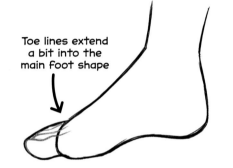

Toe lines extend a bit into the main foot shape

3 IN THIS SIDE VIEW, YOU WON'T SEE TOO MUCH OF THE TOES ASIDE FROM THE BIG ONE, WHICH IS CLOSEST TO US. USE CURVED LINES TO DIVIDE THE TOE SHAPE AND SHOW A LITTLE BIT OF THE TOPS OF THE OTHER TOES.

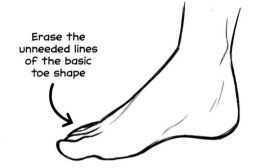

Erase the unneeded lines of the basic toe shape

4 NOW, ADD THE ANKLE BUMP AND THEN DRAW SIMPLE LINES IN THE FOOT TO SHOW THE BONE AND MUSCLE STRUCTURE. THESE DETAILS WILL HELP MAKE THE FOOT LOOK MORE REALISTIC.

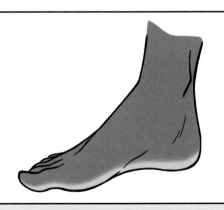

ON THE NEXT PAGE, WE'LL DRAW A FOOT FROM THE OTHER SIDE!

6 TIME TO ADD THE BASE COLORS. I'VE USED A DARK BROWN FOR THE SKIN, WITH A LIGHTER COLOR AT THE SOLE.

7 SHADE WITH A DARKER COLOR, FOCUSING MAINLY ON THE ANKLE JOINT AND AROUND THE TOES.

ON TIPPY TOES

This is such a cute pose! I love how it shows off the beautiful curves of the foot as the character balances on their toes. It makes me imagine someone doing ballet, trying to reach a cookie jar on a high shelf, or sneaking toward a friend.

1 DRAW THE ANKLE AREA IN THE SHAPE OF AN OPEN CYLINDER. THE ANKLE END GETS SLIGHTLY NARROWER.

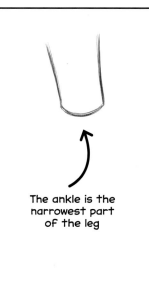

The ankle is the narrowest part of the leg

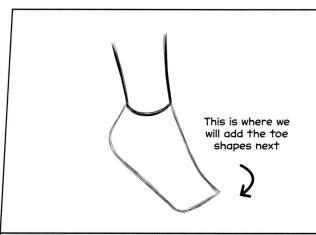

This is where we will add the toe shapes next

2 BENEATH THE ANKLE, START SKETCHING OUT THE BASIC FOOT SHAPE. IT'S LIKE A CURVED WEDGE WITH A FLAT END. TILT IT DOWN QUITE SHARPLY TO GET A HIGHER TIPPY TOE.

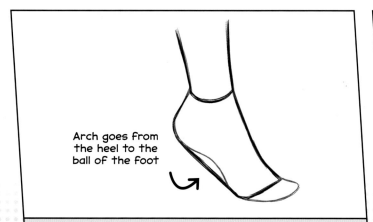

Arch goes from the heel to the ball of the foot

3 DRAW AN ELEGANT ARCH TO THE FOOT INSIDE THE CURVED WEDGE. THEN, DRAW A ROUNDED TOE SHAPE ON THE FLAT END.

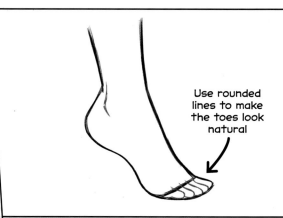

Use rounded lines to make the toes look natural

4 ERASE THE EXTRA LINES AROUND THE HEEL AND ARCH AND THEN DRAW THE CURVED ANKLE JOINT. DIVIDE THE TOE SHAPE INTO INDIVIDUAL TOES BY USING FOUR CURVED LINES.

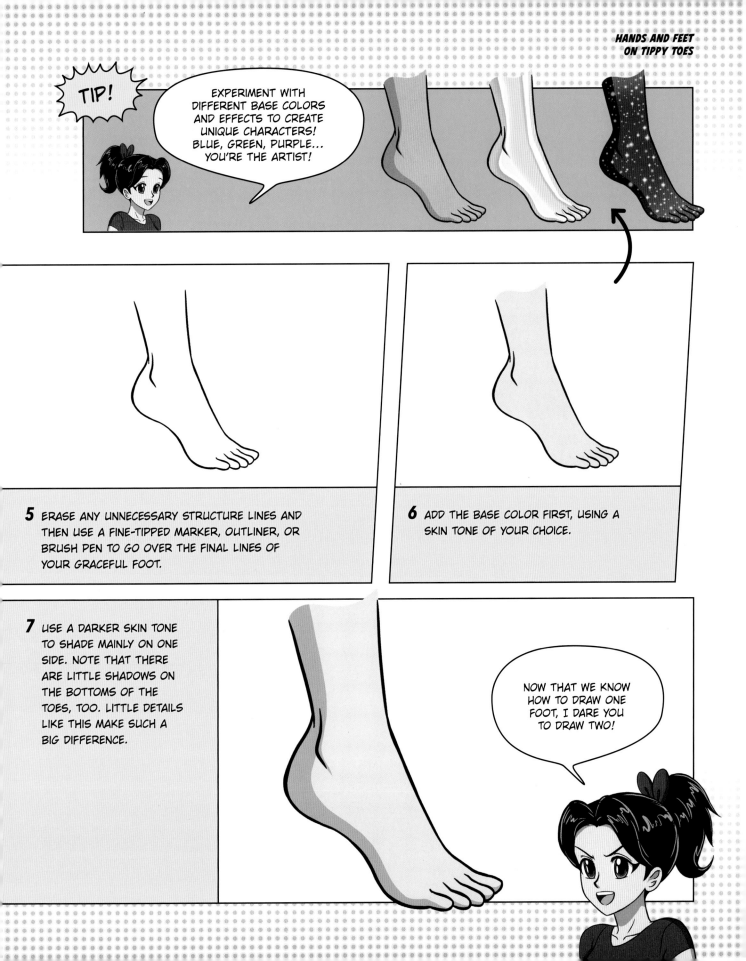

TIP!

EXPERIMENT WITH DIFFERENT BASE COLORS AND EFFECTS TO CREATE UNIQUE CHARACTERS! BLUE, GREEN, PURPLE... YOU'RE THE ARTIST!

5 ERASE ANY UNNECESSARY STRUCTURE LINES AND THEN USE A FINE-TIPPED MARKER, OUTLINER, OR BRUSH PEN TO GO OVER THE FINAL LINES OF YOUR GRACEFUL FOOT.

6 ADD THE BASE COLOR FIRST, USING A SKIN TONE OF YOUR CHOICE.

7 USE A DARKER SKIN TONE TO SHADE MAINLY ON ONE SIDE. NOTE THAT THERE ARE LITTLE SHADOWS ON THE BOTTOMS OF THE TOES, TOO. LITTLE DETAILS LIKE THIS MAKE SUCH A BIG DIFFERENCE.

NOW THAT WE KNOW HOW TO DRAW ONE FOOT, I DARE YOU TO DRAW TWO!

WALKING FEET

Let's step it up and draw both feet this time! Here's a pair of feet walking toward us. Ooh, they're wearing slides. I wonder if they've just come from a spa or if they're heading to the beach! Let's draw them before they walk on by...

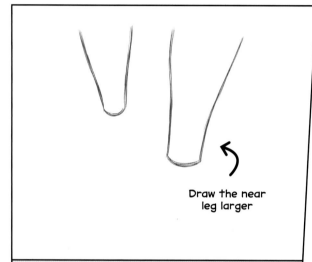

Draw the near leg larger

1 DRAW THE LOWER LEGS AND ANKLES FIRST. THE UPPER PARTS ARE THICKER AND MORE MUSCULAR THAN THE SLIM ANKLE AREAS. THE LEG ON THE LEFT IS FARTHER BACK, SO MAKE IT A LITTLE BIT SMALLER.

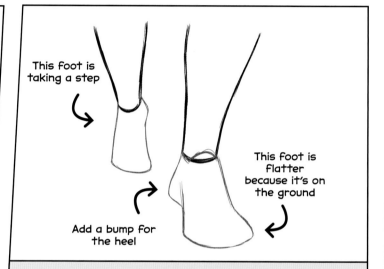

This foot is taking a step

This foot is flatter because it's on the ground

Add a bump for the heel

2 LET'S DRAW THE FEET BEFORE WE ADD THE SLIDES. SKETCH OUT THE BASIC SHAPES FOR BOTH FEET. THE CLOSER FOOT IS LIKE A LARGE WEDGE SHAPE, WITH A WIDE FRONT END. THE BACK FOOT HAS A SMALLER, MORE UPRIGHT WEDGE SHAPE.

3 DRAW BUMPS FOR THE ANKLE JOINTS ON BOTH FEET. THEN, ADD WIDE SHAPES TO THE FRONT OF EACH FOOT FOR THE TOES.

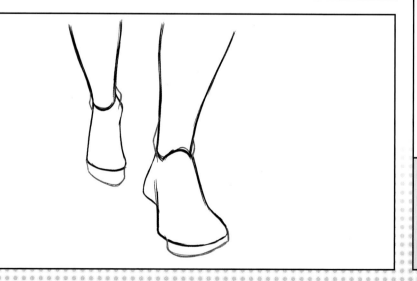

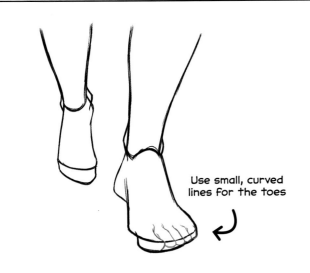

Use small, curved lines for the toes

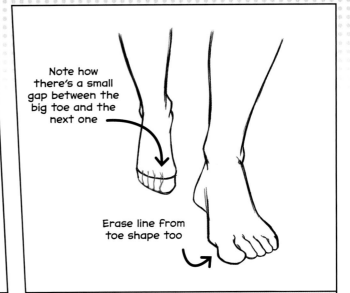

Note how there's a small gap between the big toe and the next one

Erase line from toe shape too

4 ON THE CLOSER FOOT, DIVIDE THE TOE SHAPE INTO INDIVIDUAL TOES. THE BIG TOE IS CLOSEST TO US, SO LET'S MAKE THAT QUITE A BIT LARGER. THE OTHER TOES THEN RECEDE.

5 ERASE ANY UNNECESSARY LINES, SUCH AS AROUND THE ANKLES. NOW, LET'S ADD TOES TO THE BACK FOOT. THE BIG TOE IS A LOT SMALLER BACK THERE, BUT IT'S STILL BIGGER THAN THE OTHER TOES.

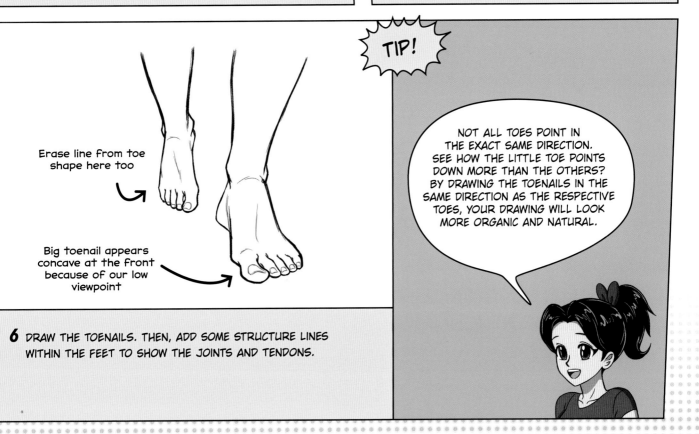

Erase line from toe shape here too

Big toenail appears concave at the front because of our low viewpoint

6 DRAW THE TOENAILS. THEN, ADD SOME STRUCTURE LINES WITHIN THE FEET TO SHOW THE JOINTS AND TENDONS.

TIP!

NOT ALL TOES POINT IN THE EXACT SAME DIRECTION. SEE HOW THE LITTLE TOE POINTS DOWN MORE THAN THE OTHERS? BY DRAWING THE TOENAILS IN THE SAME DIRECTION AS THE RESPECTIVE TOES, YOUR DRAWING WILL LOOK MORE ORGANIC AND NATURAL.

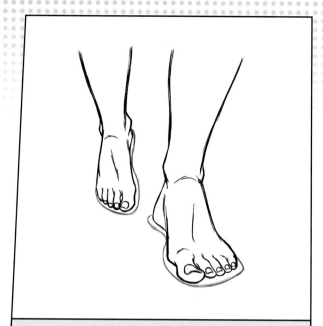

7 NOW, LET'S GIVE THESE FEET SOME SLIDES! BEGIN WITH THE SOLES AS FLAT SHAPES AROUND THE BOTTOMS OF THE FEET.

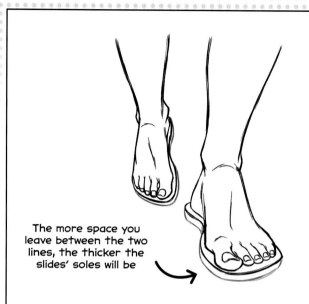

The more space you leave between the two lines, the thicker the slides' soles will be

8 MAKE THE SOLES THICKER BY DRAWING A SECOND SHAPE AROUND THE LINES WE DREW IN THE LAST STEP. LEAVE A GAP IN BETWEEN THE TWO SOLE LINES.

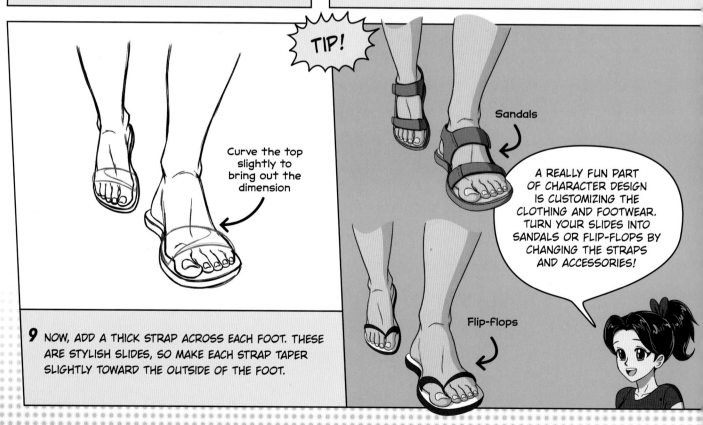

Curve the top slightly to bring out the dimension

TIP!

Sandals

Flip-flops

A REALLY FUN PART OF CHARACTER DESIGN IS CUSTOMIZING THE CLOTHING AND FOOTWEAR. TURN YOUR SLIDES INTO SANDALS OR FLIP-FLOPS BY CHANGING THE STRAPS AND ACCESSORIES!

9 NOW, ADD A THICK STRAP ACROSS EACH FOOT. THESE ARE STYLISH SLIDES, SO MAKE EACH STRAP TAPER SLIGHTLY TOWARD THE OUTSIDE OF THE FOOT.

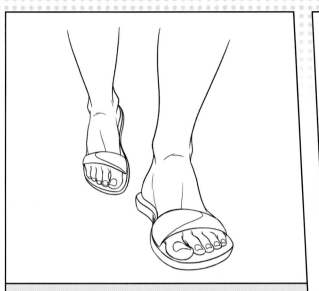

10 ERASE ANY EXTRA LINES, ESPECIALLY WHERE THE FEET ARE VISIBLE WITHIN THE SLIDE STRAPS, AND THEN FINALIZE YOUR OUTLINES.

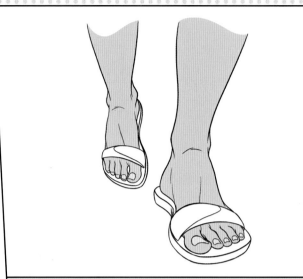

11 ADD THE BASE COLORS TO THE SKIN AND NAILS. THE TOENAILS SHOULD BE A LIGHTER VERSION OF THE SKIN TONE—UNLESS YOUR CHARACTER HAS PAINTED TOENAILS, OF COURSE!

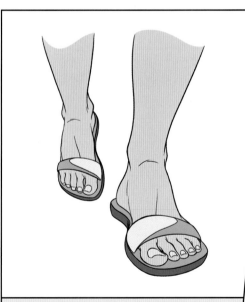

12 NEXT, ADD BASE COLORS TO THE SLIDES. I'VE GONE FOR BLUE, WHICH CONTRASTS WITH THE SKIN SO THE SLIDES STAND OUT. I'VE USED THREE DIFFERENT SHADES FOR A COOL, RELAXING LOOK.

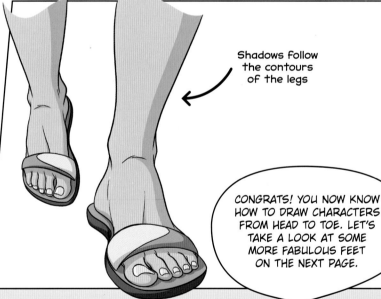

Shadows follow the contours of the legs

13 USE DARKER COLORS TO SHADE THE SKIN AND SLIDES. BE SURE TO SHADE THE TOES RIGHT UNDER THE SLIDE STRAPS. SIMILARLY, SHADE THE SLIDE SOLES THAT ARE DIRECTLY UNDER THE TOES.

CONGRATS! YOU NOW KNOW HOW TO DRAW CHARACTERS FROM HEAD TO TOE. LET'S TAKE A LOOK AT SOME MORE FABULOUS FEET ON THE NEXT PAGE.

BEST FOOT FORWARD

You're a pro at drawing them—but don't put your feet up just yet. Check out this collection of fabulous foot drawings. It's time to step up your game! Which one will you try next?

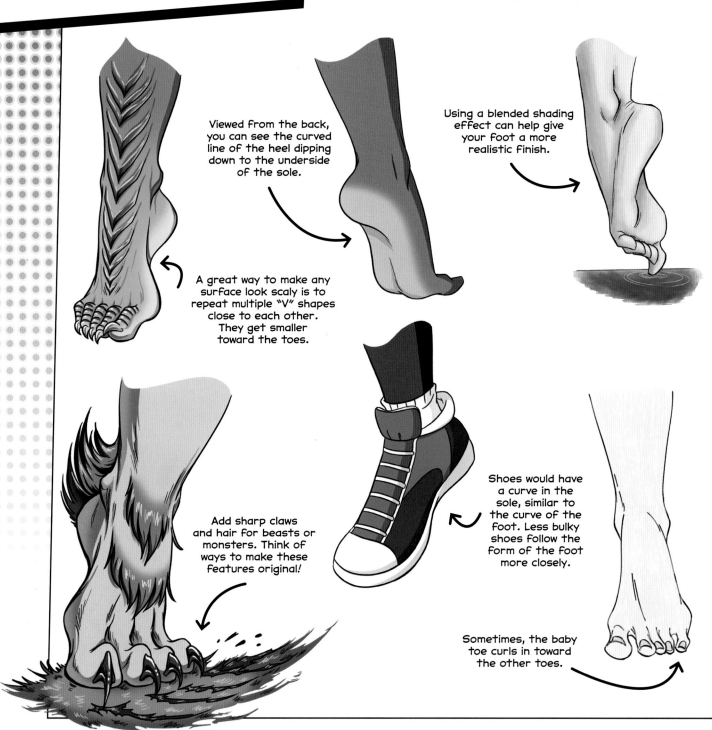

Viewed from the back, you can see the curved line of the heel dipping down to the underside of the sole.

Using a blended shading effect can help give your foot a more realistic finish.

A great way to make any surface look scaly is to repeat multiple "V" shapes close to each other. They get smaller toward the toes.

Add sharp claws and hair for beasts or monsters. Think of ways to make these features original!

Shoes would have a curve in the sole, similar to the curve of the foot. Less bulky shoes follow the form of the foot more closely.

Sometimes, the baby toe curls in toward the other toes.

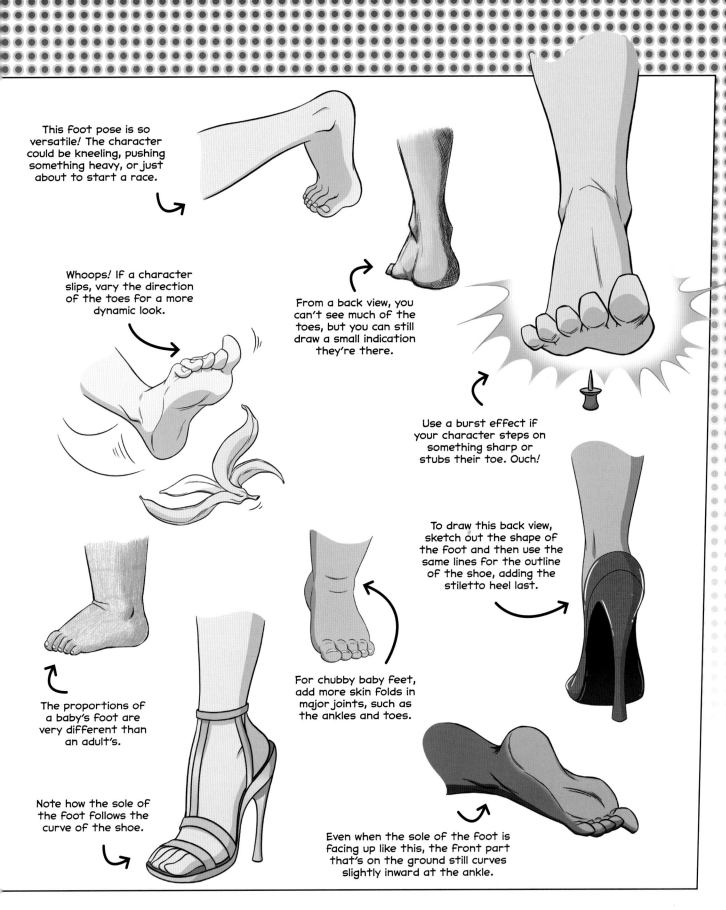

This foot pose is so versatile! The character could be kneeling, pushing something heavy, or just about to start a race.

Whoops! If a character slips, vary the direction of the toes for a more dynamic look.

From a back view, you can't see much of the toes, but you can still draw a small indication they're there.

Use a burst effect if your character steps on something sharp or stubs their toe. Ouch!

To draw this back view, sketch out the shape of the foot and then use the same lines for the outline of the shoe, adding the stiletto heel last.

The proportions of a baby's foot are very different than an adult's.

For chubby baby feet, add more skin folds in major joints, such as the ankles and toes.

Note how the sole of the foot follows the curve of the shoe.

Even when the sole of the foot is facing up like this, the front part that's on the ground still curves slightly inward at the ankle.

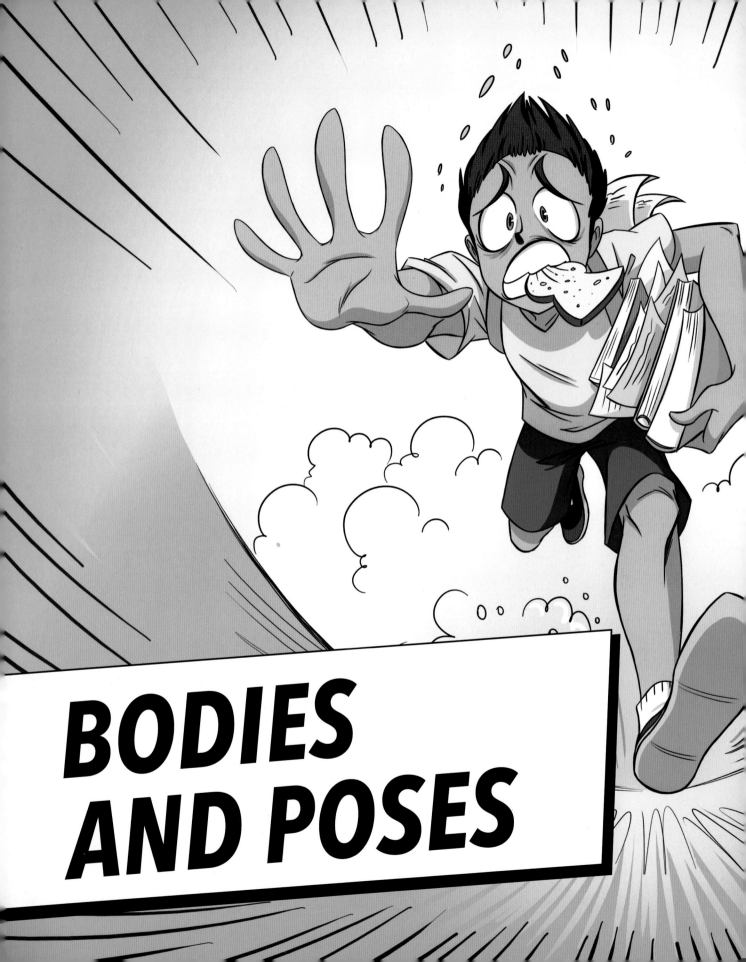

BODIES AND POSES

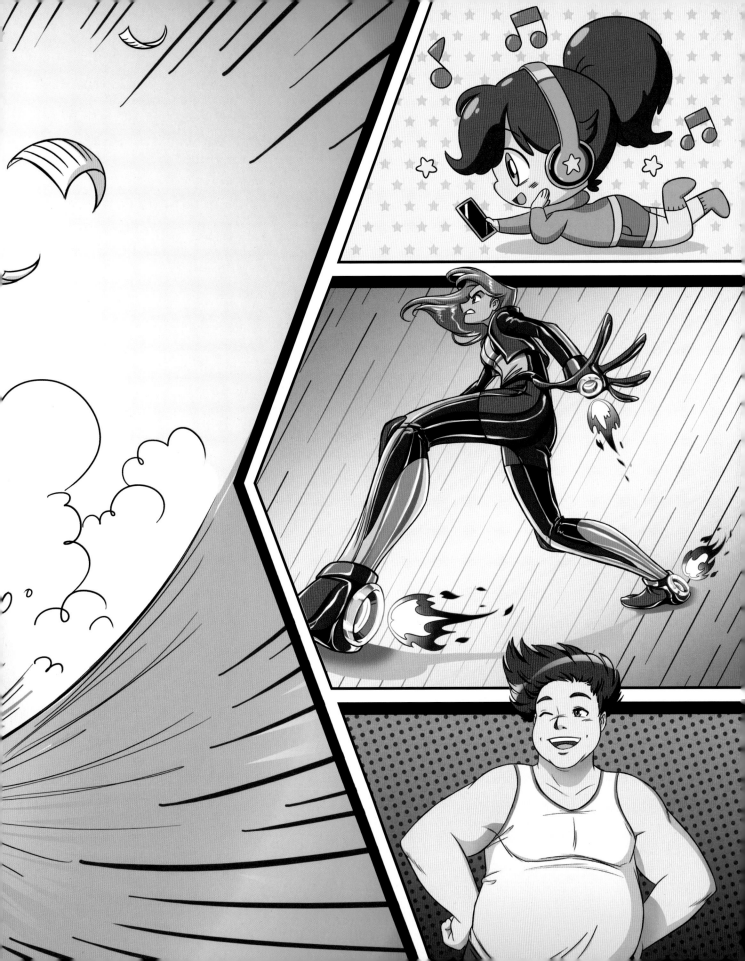

WAVING GOODBYE

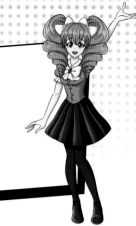

Awww! This character's heading off for her first day at a new job. Here she is, posing for a photo in her new dress! Let's learn how to draw her face, hair, body structure, and outfit as she waves in this cheerful pose.

1 START WITH TWO BASIC SHAPES TO MAKE THE HEAD. SHE WILL BE LOOKING STRAIGHT AT US, SO MAKE THE HEAD MOSTLY SYMMETRICAL. LEAVE ENOUGH ROOM BENEATH IT FOR THE REST OF HER BODY.

2 PLACE THE FACIAL GUIDELINES AND THEN DRAW TWO CONNECTED SHAPES FOR THE TORSO: A TAPERED RECTANGLE WITH A CURVED SIDE FOR THE CHEST AND A ROUNDED WEDGE FOR THE HIPS. ADD GUIDELINES TO THE TORSO AS WELL, WHICH WILL HELP WHEN DRAWING HER CLOTHES LATER ON.

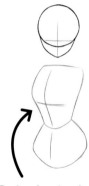

Body stands at a slight angle, so draw the guidelines off-center

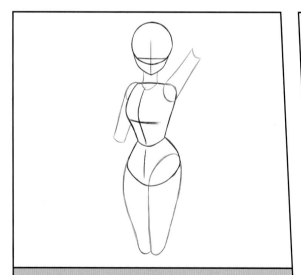

3 DRAW THE UPPER ARMS AS SLIM CYLINDERS. ONE IS RAISED IN A WAVE. ADD THE UPPER LEGS AS ELONGATED OVALS THAT TAPER AT THE KNEE. CONNECT THE HEAD TO THE TORSO WITH A SLIM NECK.

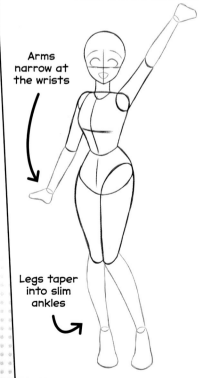

Arms narrow at the wrists

Legs taper into slim ankles

4 START THE FACE BY SKETCHING OUT EYE SHAPES, EYEBROWS, A TINY NOSE, AND A WIDE, SMILING MOUTH. ADD CYLINDRICAL LOWER ARMS AND BASIC WEDGE-SHAPED HANDS. DRAW THE LOWER LEGS AS CURVED CYLINDERS THAT CONNECT TO SHOES, WHICH ARE SHAPED A BIT LIKE AVOCADOS!

TIP!

TO CREATE RINGLETS IN YOUR CHARACTER'S HAIR, BUILD RINGS OF HAIR THAT DECREASE IN SIZE AS THEY GO DOWN. FINISH THEM AT THE BOTTOM WITH AN "S"-SHAPED CURL.

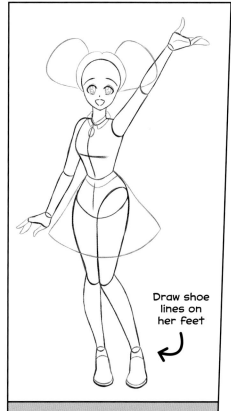

Draw shoe lines on her feet

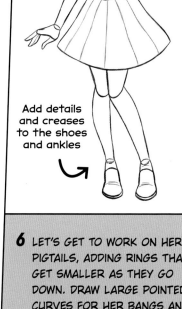

Split finger shapes into individual fingers

Add details and creases to the shoes and ankles

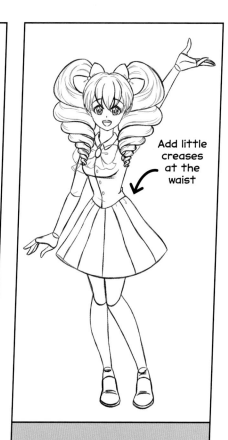

Add little creases at the waist

5 MAP OUT THE DESIGN OF HER CUTE HAIR WITH LARGE CURVES AROUND THE SKULL AND EVEN BIGGER CURVED SHAPES TO START HER PIGTAILS. DRAW IRISES WITH LOTS OF HIGHLIGHTS AND GIVE HER SOME FINGERS ON EACH HAND. FOR HER OUTFIT, BEGIN WITH THE COLLAR AND THEN ADD A FLARED SHAPE FOR HER SKIRT.

6 LET'S GET TO WORK ON HER PIGTAILS, ADDING RINGS THAT GET SMALLER AS THEY GO DOWN. DRAW LARGE POINTED CURVES FOR HER BANGS AND THEN GIVE HER TWO ADORABLE BOWS. ADD PUPILS IN HER EYES AND A LINE FOR TEETH IN HER MOUTH. AS FOR HER OUTFIT, LINES THAT RADIATE OUT FROM HER WAIST WILL BECOME FOLDS IN THE FABRIC.

7 COMPLETE HER THICK HAIR WITH CURVED LINES THAT FOLLOW THE SHAPE OF HER HAIR. DON'T FORGET EYELASHES! THEN, GIVE HER DRESS PUFFY SLEEVES THAT PEEK OUT FROM BEHIND HER PIGTAILS. DRAW A LARGE BOW ON THE FRONT OF HER DRESS AS WELL AS CREASES, BUTTONS, AND FOLDS AT THE END OF THE SKIRT.

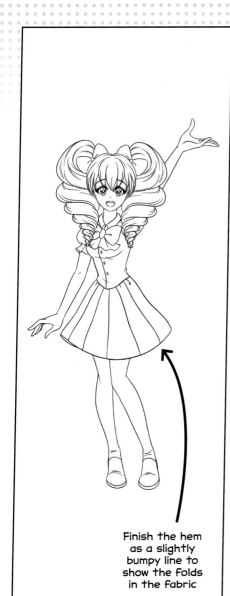

Finish the hem
as a slightly
bumpy line to
show the folds
in the fabric

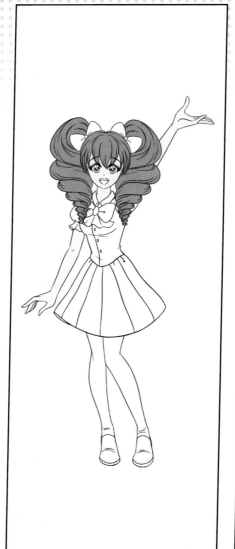

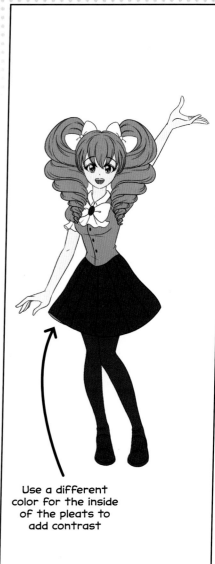

Use a different
color for the inside
of the pleats to
add contrast

8 CAREFULLY FINALIZE YOUR OUTLINES! ERASE ANY LINES YOU DON'T NEED, SUCH AS THE BASIC HAND SHAPES, THE TIP OF THE COLLAR BENEATH THE BOW, AND THE FLARED WEDGE SHAPE OF HER SKIRT.

9 ADD COLORS TO BRING YOUR CHARACTER TO LIFE! WE'LL START WITH THE HAIR, A BRILLIANT RED COLOR THAT WILL CERTAINLY HELP HER STAND OUT FROM THE CROWD. LET'S ALSO ADD THE BASE SKIN TONE.

10 NEXT UP, LET'S ADD COLOR TO HER FACIAL FEATURES AND OUTFIT. I'VE USED BLUES, DARK GRAY, AND WHITES TO GIVE A SMART, PROFESSIONAL LOOK: DARK AND MEDIUM BLUES FOR HER TOP, SKIRT, AND SHOES; BLACK FOR HER TIGHTS; AND WHITE FOR ACCENTS.

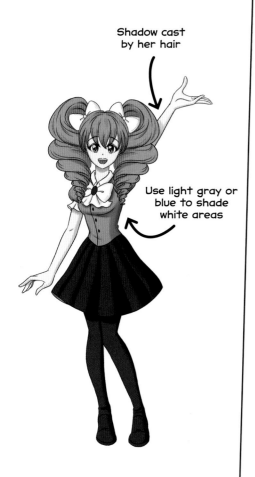

Shadow cast by her hair

Use light gray or blue to shade white areas

OKAY, I'M OFF—WISH ME LUCK!

Highlights curve around the edges of the shoes

WITH HAIR THAT PERFECT, YOU DON'T EVEN NEED IT!

11 SHADE THE SKIN, HAIR, AND CLOTHING WITH DARKER COLORS. CONSIDER WHERE THE LIGHT SOURCE IS AND ADD SHADOW IN RELATION TO IT. THE LARGEST SHADED AREAS WILL BE THE TOP OF THE NECK AND THE LEGS JUST BELOW THE SKIRT.

12 NOW, ADD HIGHLIGHTS TO REALLY GIVE YOUR DRAWING DEPTH. THIS CHARACTER'S HAIR HAS BEAUTIFUL ORANGE HIGHLIGHTS AT THE OUTER CURVES. THE FOLDS OF HER SKIRT ARE ACCENTUATED WITH STRIPS OF LIGHT BLUE, WHILE THE HIGHLIGHTS ON HER SHOES HELP SHOW THEIR SHAPE.

LATE FOR SCHOOL

Wait... there's someone running toward us! I know this kid—he is always late for school. Look at how he's sprinting along, clutching his books, and waving for someone to hold that door open. He might be speeding past, but quick, let's draw him!

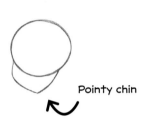

Pointy chin

1 START HIS HEAD WITH A BASIC CIRCLE AND TRIANGLE. THE TRIANGLE SHAPE IS UNEVEN BECAUSE WE ARE GOING TO DRAW THE FACE AT A ¾ ANGLE.

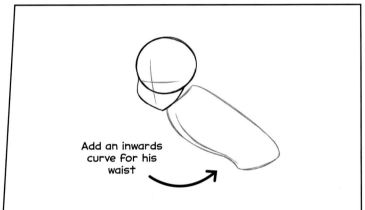

Add an inwards curve for his waist

2 THIS BOY IS RUNNING SO FAST—JUST LOOK AT HOW HIS BODY LEANS FORWARD. DRAW IT LIKE A TILTED RECTANGLE, ADDING A VERTICAL GUIDELINE NEAR THE FAR EDGE. ADD FACE GUIDELINES TOO.

3 LET'S ADD HIS LIMBS AS SIMPLE SHAPES FOR NOW. MAKE THE FAR ARM AND NEAR LEG REACH FORWARD AND THE OPPOSITE LIMBS EXTEND BEHIND HIM. START HIS HAIR WITH A LARGE POINT ON TOP OF HIS HEAD.

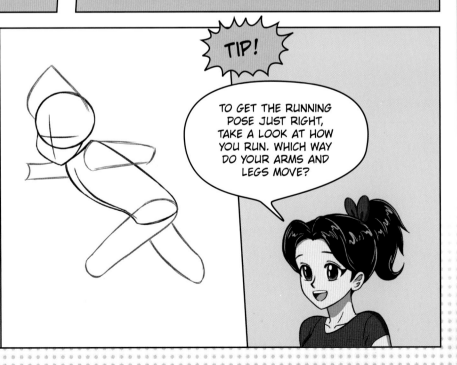

TIP!

TO GET THE RUNNING POSE JUST RIGHT, TAKE A LOOK AT HOW YOU RUN. WHICH WAY DO YOUR ARMS AND LEGS MOVE?

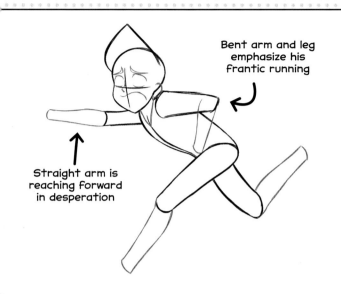

Bent arm and leg
emphasize his
frantic running

Straight arm is
reaching forward
in desperation

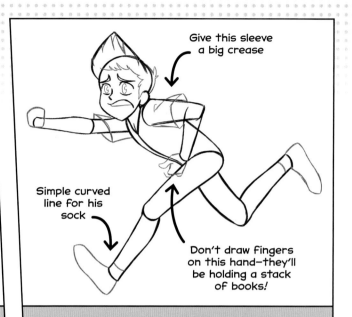

Give this sleeve
a big crease

Simple curved
line for his
sock

Don't draw fingers
on this hand—they'll
be holding a stack
of books!

4 LET'S DRAW HIS ANXIOUS FACE WITH WIDE EYES AND A
MOUTH IN A LARGE, OPEN YELP. TILT UP HIS EYEBROWS
TOWARD THE CENTER OF HIS FOREHEAD. GIVE HIM AN
EAR, A NOSE, AND A TINY NECK THAT'S HALF HIDDEN BY
HIS RAISED SHOULDER. DRAW THE REST OF HIS LIMBS
LIKE LONG, CURVED CYLINDERS.

5 FILL OUT HIS HAIR WITH SPIKES AND ADD A MESSY
COWLICK AT THE BACK. (THERE'S NO TIME TO
BRUSH YOUR HAIR WHEN YOU'RE THIS LATE!)
ADD IRISES, A LINE FOR HIS TEETH, AND SHIRT
SLEEVES OVER HIS UPPER ARMS. THEN, DRAW
SIMPLE SHAPES FOR HIS HANDS AND FEET.

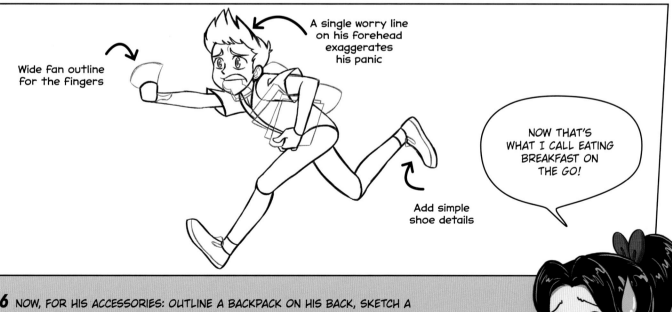

A single worry line
on his forehead
exaggerates
his panic

Wide fan outline
for the fingers

Add simple
shoe details

NOW THAT'S
WHAT I CALL EATING
BREAKFAST ON
THE GO!

6 NOW, FOR HIS ACCESSORIES: OUTLINE A BACKPACK ON HIS BACK, SKETCH A
STACK OF SQUARE SHAPES UNDER HIS ARM FOR BOOKS, AND THEN GIVE HIM
A PIECE OF TOAST HANGING OUT OF HIS MOUTH. LARGE PUPILS IN HIS EYES
SHOW JUST HOW SCARED HE IS OF GETTING DETENTION.

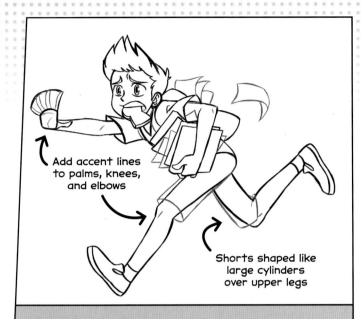

Add accent lines to palms, knees, and elbows

Shorts shaped like large cylinders over upper legs

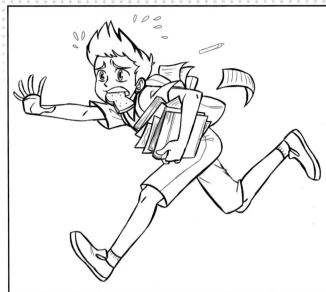

7 DIVIDE THE BASIC HAND SHAPE INTO FINGERS. ADD MORE PIECES OF HOMEWORK STICKING OUT OF THE PILE HE HOLDS, AND EVEN SOME FLYING OUT OF HIS BAG! DRAW THE BACKPACK STRAPS OVER HIS SHOULDERS AND THEN HIS SHORTS.

8 NOW, ADD ALL THE FINISHING TOUCHES LIKE SWEAT DROPS, TEXTURE ON THE TOAST, SCRIBBLED LINES ON HIS HOMEWORK, AN ESCAPING PENCIL, CLOTHING WRINKLES, AND SOCK DETAILS.

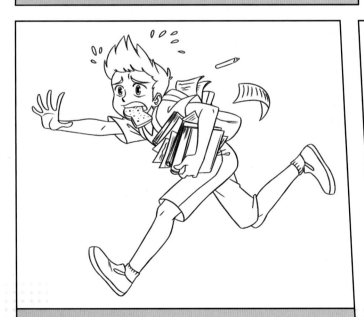

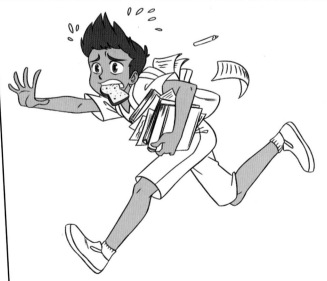

9 INK YOUR FINAL LINE ART AFTER YOU'VE ERASED ANY EXTRA LINES.

10 ADD BASE COLORS TO HIS HAIR, EYES, SKIN, AND TOAST.

11 NOW, COLOR EVERYTHING ELSE. I'VE USED A RANGE OF PALE COLORS FOR THE PAPERS AND PAGES OF HIS BOOKS TO ADD INTEREST. I'VE ALSO USED BOLD CONTRASTING COLORS FOR HIS SHIRT AND BACKPACK.

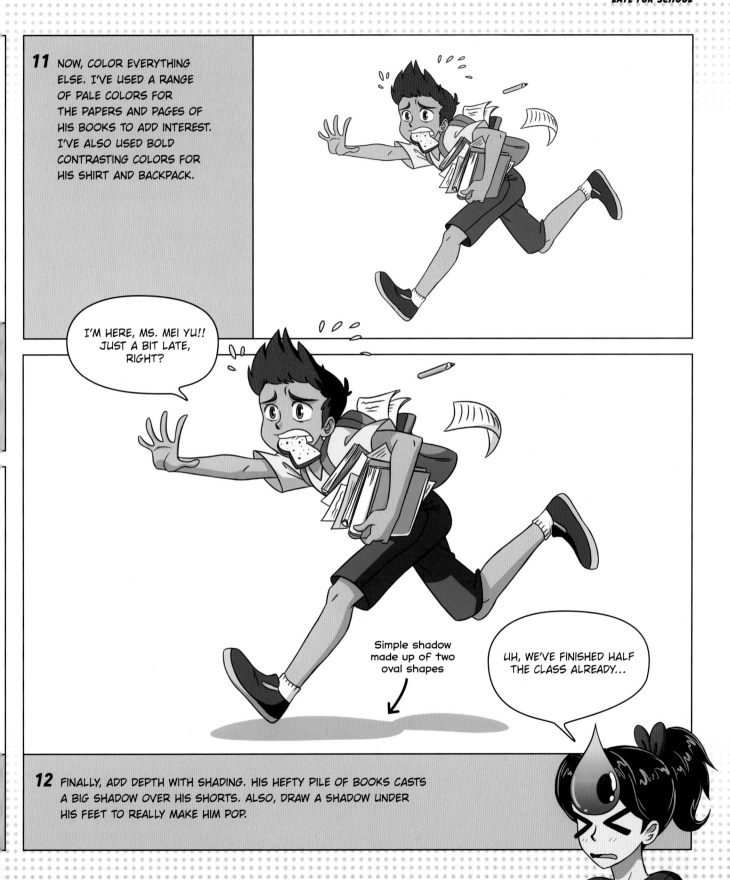

I'M HERE, MS. MEI YU!! JUST A BIT LATE, RIGHT?

Simple shadow made up of two oval shapes

UH, WE'VE FINISHED HALF THE CLASS ALREADY...

12 FINALLY, ADD DEPTH WITH SHADING. HIS HEFTY PILE OF BOOKS CASTS A BIG SHADOW OVER HIS SHORTS. ALSO, DRAW A SHADOW UNDER HIS FEET TO REALLY MAKE HIM POP.

BODY SHAPE VARIATIONS

In this Masterclass, we're looking at different body shapes and how to develop them into characters. There are endless body types you can use for character design. Here are six examples and tips on how to develop them.

APPLE-SHAPED

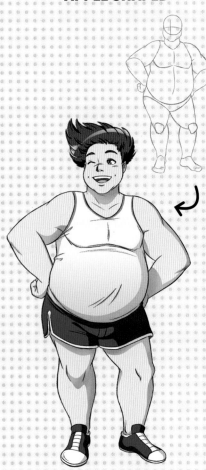

This relaxed character's weight is centered in his belly and hips. His limbs are muscular and sturdy, with wide bases and smaller wrists and ankles.

CURVY

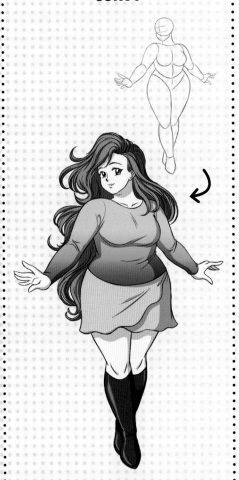

This glamorous gal is curvy and tall. Her strong legs taper in at the knees and again at the ankles. Her torso is shorter than her legs and pinches in at the waist a little. The hips are full, creating an hourglass shape.

SLENDER

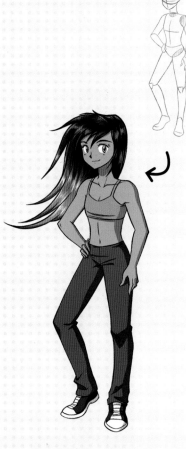

This body type is lean, with a small chest and very slight curves at the waist and hips. Their limbs are shaped like long, narrow cylinders with slight curves to show their muscular upper arms.

PEAR-SHAPED

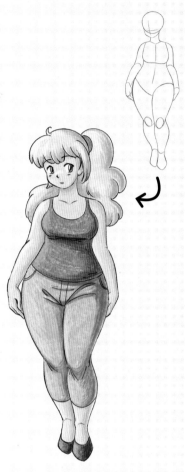

This character's hips are much wider than her shoulders. Unlike the curvy figure, her waist does not pinch in but flares out into the hips (taking on the rough shape of a pear). Her legs are thick and sturdy, while her arms are slimmer yet curvy.

SHORT AND MUSCULAR

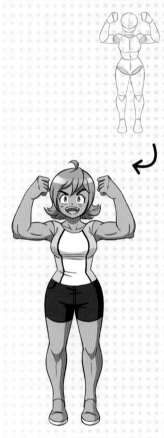

This character has legs that are only slightly longer than her torso and head, giving this body type a shorter appearance. The shapes of her limbs are muscular rather than thin, with deeper shadows around the calves and knees. Her chest and shoulders are wide, and her hips are equally wide, with the waist pinched in between them.

TALL AND SLIM

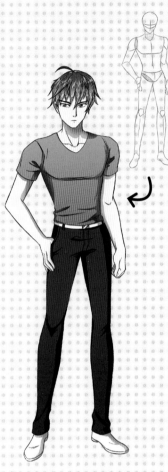

This tall character's shoulders and chest are broad, while the rest of his body is thinner. His hips are narrow, and his limbs are slim and long, with less muscle definition. His head is smaller in comparison to his body than the other body shapes on this page. This makes him look even taller.

LEARN MORE ABOUT HEAD-TO-BODY PROPORTIONS ON PAGE 155.

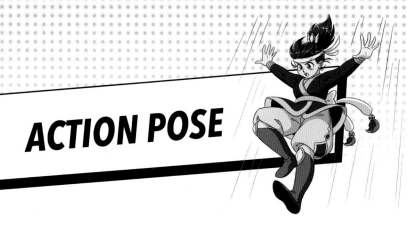

ACTION POSE

Watch out, this martial arts master is practicing her action moves! She loves reenacting her favorite scenes from historical fantasy manga almost as much as she loves her purple gi. She's holding this pose for us—which is not easy, believe me—so let's get started!

Leave space below for the rest of her body

1 DRAW THE TWO BASIC HEAD SHAPES IN PREPARATION FOR A FRONT ¾ POSE. KEEP THE SHAPES SMALLER THAN USUAL BECAUSE THIS CHARACTER'S LOWER BODY WILL BE BIGGER TO GIVE THE DRAMATIC PERSPECTIVE THAT WE ARE LOOKING UP AT HER.

Place vertical guidelines on her body as well

2 SKETCH A BASIC BODY SHAPE AS TWO ROUNDED PARTS. DRAW THE TOP PART A LITTLE BEHIND THE CHIN TO HELP CREATE THE RIGHT PERSPECTIVE. ADD HER FACE GUIDELINES ANGLED DOWN BECAUSE SHE'S LOOKING DOWN TOWARD THE GROUND.

3 THIS CHARACTER'S COOL ACTION POSE SEES HER ARMS FLYING OUT AT BOTH SIDES. DRAW EACH ARM AS TWO CYLINDERS CONNECTED TOGETHER. ADD PUFFY SHORTS THAT ARE LARGE AND ROUND AT THE BOTTOM.

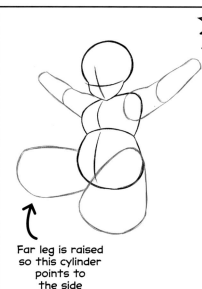

Far leg is raised so this cylinder points to the side

TIP!

The more you exaggerate the size of the nearest parts of the body, the more dramatic the perspective will be!

YOU CAN FIND OUT MORE ABOUT CREATING PERSPECTIVE ON PAGES 154-157.

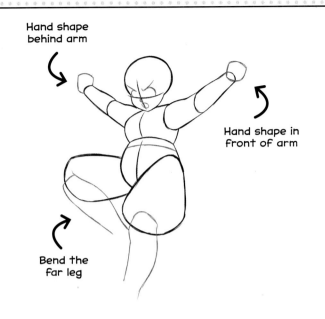

Hand shape behind arm

Hand shape in front of arm

Bend the far leg

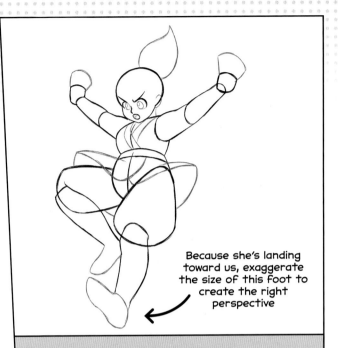

Because she's landing toward us, exaggerate the size of this foot to create the right perspective

4 START HER FOCUSED FACE, WITH TENSE EYEBROWS, LARGE OPEN EYE SHAPES, A SMALL NOSE, AND AN OPEN MOUTH. MAKE THE HANDS SQUARES FOR NOW, ADD A BELT, AND DRAW HER LOWER LEGS WITH KNEES PROTRUDING FROM THE BOTTOM OF THE SHORTS.

5 USE A FLAME SHAPE FOR HER GIANT PONYTAIL THAT TRAILS BEHIND AS SHE JUMPS. THIS ADDS A GREAT SENSE OF MOVEMENT. DRAW DETAILS ON HER GI, INCLUDING OVERLAPPING LAPELS AND FLOWING TUNIC ENDS. ADD FAN SHAPES TO HER HANDS AND END THE LEGS WITH BASIC FEET.

6 LET'S GIVE THIS LEAPING WARRIOR A HEADBAND, KNEEPADS, AND MORE DETAILS ON HER GI. ALSO ADD FINGER OUTLINES, DRAW CREASES AND WRINKLES ON HER CLOTHING, AND DEFINE THE SOLE OF HER CLOSER FOOT.

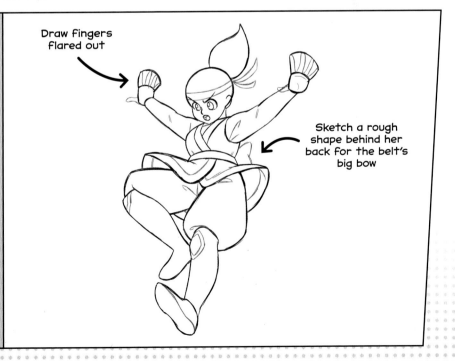

Draw fingers flared out

Sketch a rough shape behind her back for the belt's big bow

7 DRAW BANGS FLYING UP ABOVE THE HEADBAND AS WELL AS SMALL, FLOWING WISPS OF HAIR COMING OUT FROM UNDER IT. FILL IN HER IRISES AND PUPILS. THEN, ADD DETAILS TO HER CLOTHING, INCLUDING A DIAMOND PATTERN ON THE SHORTS, CREASES AND WRINKLES, AND FANCY BELT ENDS FLYING OUT BEHIND HER.

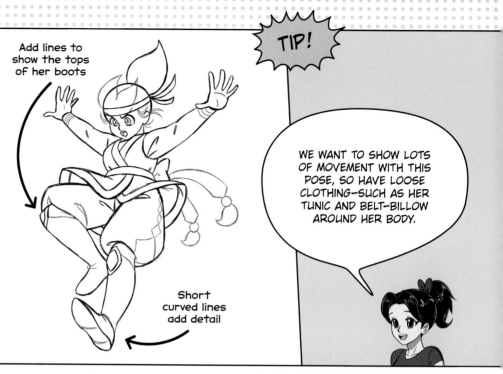

Add lines to show the tops of her boots

Short curved lines add detail

TIP!

WE WANT TO SHOW LOTS OF MOVEMENT WITH THIS POSE, SO HAVE LOOSE CLOTHING—SUCH AS HER TUNIC AND BELT—BILLOW AROUND HER BODY.

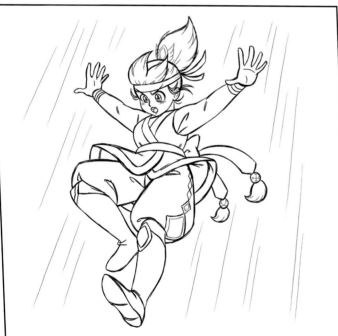

8 FINALLY, LET'S DRAW FINE DETAILS IN HER HAIR, FACE, AND CLOTHING. I'VE ADDED A WINGED HAIR CLIP TO HER PONYTAIL AND LINES BENEATH HER EYES TO INTENSIFY HER EXPRESSION. THEN, BUILD A SIMPLE YET DYNAMIC BACKGROUND WITH LOTS OF ACTION LINES!

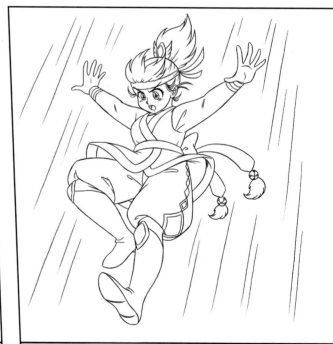

9 GO OVER YOUR OUTLINES WITH A FINE-TIPPED MARKER OR BRUSH PEN. PAY CLOSE ATTENTION TO THE ENDS OF THE BELT, WHICH WILL NEED SOME LINES ERASED TO GET THAT FLUFFY SHAPE!

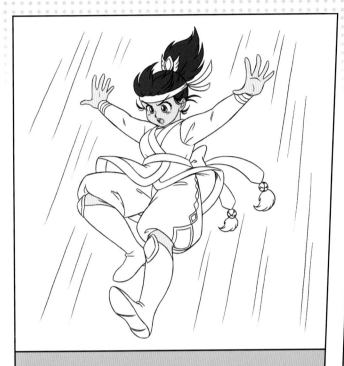

10 FILL IN THE SKIN, FACE, AND HAIR WITH FLAT BASE COLORS.

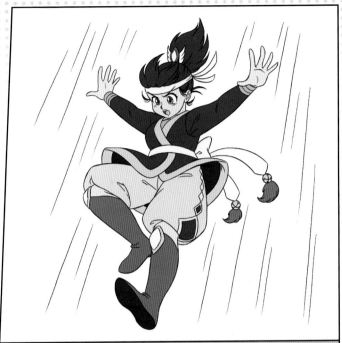

11 NOW, LET'S WORK ON HER GI. THIS CHARACTER LOVES PURPLE, SO I'VE USED THREE SHADES OF IT FOR HER OUTFIT, PLUS YELLOWS FOR CONTRAST ON THE TRIM AND ACCESSORIES.

12 USE DARKER COLORS TO SHADE, FOLLOWING THE CONTOURS OF THE BODY OR CREASES AND FOLDS IN THE CLOTHING AND HAIR. SHADE THE SHORTS WHERE OTHER PARTS OF THE GI WOULD CAST SHADOWS. THEN, GIVE HER HAIR SOME SHINY, SQUIGGLY HIGHLIGHTS WITH A WHITE PEN OR GEL PEN.

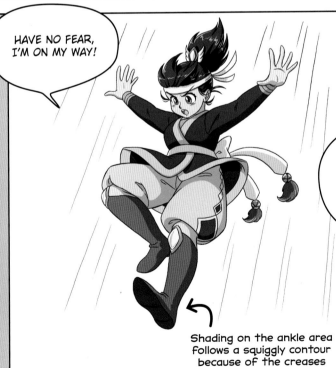

HAVE NO FEAR, I'M ON MY WAY!

IF ANY EVILDOERS ARE WONDERING WHAT HAPPENS WHEN THIS WARRIOR'S POSE BECOMES EXTREME, THEN CHECK OUT PAGE 157!

Shading on the ankle area follows a squiggly contour because of the creases

ARMS CROSSED

Uh-oh, someone is very mad. I wonder why? While we try to find out, let's admire his great pose. As well as the angry face, his body language really tells a story. Let's create this character by using colored pencils, which will give a more textured look to the artwork.

End the triangle shape with a flat base to make a square chin

1 DRAW THE CIRCLE AND TRIANGULAR SHAPE FOR THE HEAD. THIS CHARACTER IS LOOKING AT US HEAD-ON, SO MAKE IT MOSTLY SYMMETRICAL. HIS FACE IS GOING TO BE ANGULAR, SO GIVE THE JAW AND CHIN SHARPER EDGES.

2 FOR A TALL CHARACTER, MAKE THE TORSO SHAPE BIGGER COMPARED TO THE HEAD. THE SHOULDER AREA SHOULD BE WIDER THAN THE HIPS TO GIVE THE IMPRESSION OF A THIN BODY SHAPE. ADD FACE GUIDELINES IN THE CENTER OF HIS HEAD. INCLUDE A SHORT LINE BELOW THE HORIZONTAL GUIDE FOR HIS NOSE GUIDE.

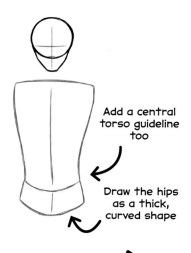

Add a central torso guideline too

Draw the hips as a thick, curved shape

3 ADD QUITE A WIDE NECK, THEN LONG UPPER ARMS AND LEGS LIKE STRETCHED-OUT OVALS AND CYLINDERS. KEEP THE ARMS CLOSE TO THE BODY FOR THIS CROSSED-ARMS POSE. THE UPPER SECTIONS CAN EVEN OVERLAP THE EDGES OF THE TORSO.

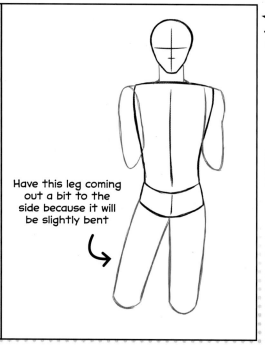

Have this leg coming out a bit to the side because it will be slightly bent

TIP!

THE SMALLER THE HEAD IS COMPARED TO THE BODY, THE TALLER A CHARACTER CAN LOOK. SEE THE MASTERCLASS ON PAGE 155 FOR MORE DETAIL ON PROPORTIONS.

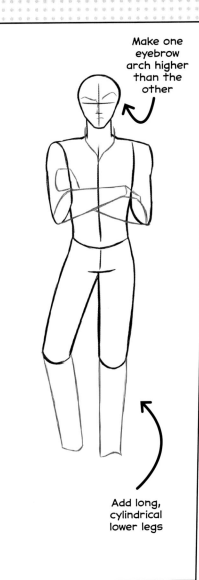

Make one eyebrow arch higher than the other

Add long, cylindrical lower legs

Draw shoes as two basic shapes for now

Draw short lines for belt buckle and loops

Trouser creases at the ankle add realism

4 BEGIN HIS UNAMUSED EXPRESSION WITH ARCHED EYEBROWS AND GIVE HIM A "V"-SHAPED SHIRT COLLAR. THEN, BEGIN ON HIS LOWER ARMS. DRAW THE FRONT ARM AS A TAPERED TRIANGLE. THEN, ADD THE BACK ARM BESIDE IT. NOW FOR THE HANDS: TUCK THE FRONT ONE INSIDE THE OPPOSITE ELBOW, THEN MAKE THE HAND OF THE BACK ARM STICK OUT.

5 ADD WAVY HAIR WITH LARGE, UNEVEN, CURVED LINES THAT RADIATE OUT FROM HIS PARTING. HIS EYES ARE NARROWED IN DISGUST, AND ONE BROW IS CREASED. DRAW FINGERS ON HIS VISIBLE HAND, COMPLETE HIS COLLAR, AND GIVE HIS CLOTHING A FEW DETAILS.

6 WE'RE ADDING LOTS OF DETAILS NOW: TEXTURE LINES AND EXTRA SECTIONS TO THE HAIR, PUPILS TO THE EYES, DEFINITION LINES TO THE NECK AND ELBOWS, BUTTONS AND ROLLED-UP SLEEVES TO HIS SHIRT, AND PLENTY OF CREASES AND WRINKLES TO HIS CLOTHING AND SHOES.

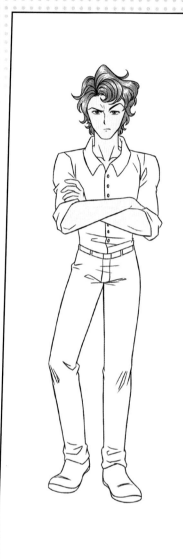

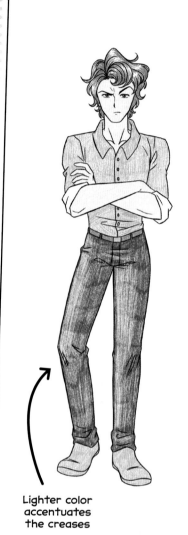

Lighter color
accentuates
the creases

7 ONCE YOU'VE FINISHED
DRAWING, ERASE STRUCTURE
LINES IN THE ARMS AND
LEGS BEFORE INKING YOUR
FINAL ARTWORK WITH A
FINE-TIPPED MARKER,
OUTLINER, OR BRUSH PEN.

8 USING COLORED PENCILS, LET'S
START ADDING COLOR AND
TEXTURE. START WITH HIS SKIN
AND HAIR. FOLLOW THE SHAPE
OF HIS VARIOUS HAIR SECTIONS
AND LEAVE A FEW AREAS
WHITE, WHICH WILL ACT AS
SHINY HIGHLIGHTS.

9 COLOR THE CLOTHING, AGAIN
FOLLOWING THE SHAPES AND
CONTOURS. HIS JEANS HAVE
SOME DARKER PATCHES OF
PENCIL, WHICH GIVE THEM
AN EFFECTIVE DENIM LOOK.
IF YOU LOOK CLOSELY, YOU'LL
SEE LIGHTER BLUE PENCIL
LINES ON THE TROUSERS,
TOO, WHICH ADD HIGHLIGHTS,
PARTICULARLY UNDER THE
HORIZONTAL CREASES.

10 BUILD DIMENSION BY USING DARKER COLORS AND BY ADDING SHADOWS. IN THIS DRAWING, I HAVEN'T BLENDED THE PENCIL MARKS TOGETHER FOR A SMOOTH LOOK. INSTEAD, I WANT INDIVIDUAL PENCIL LINES TO BE VISIBLE, WHICH GIVES THIS ANGRY GUY A COOL, HAND-DRAWN STYLE.

TIP!

Rough strokes give a hand-drawn look

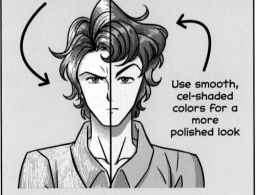

Use smooth, cel-shaded colors for a more polished look

HERE IS A CLOSE-UP COMPARISON SHOWING THE DIFFERENCE BETWEEN TWO COLORING TECHNIQUES: THE HAND-DRAWN STYLE USED FOR THIS CHARACTER, AND THE SMOOTHER STYLE THAT I USE IN VARIOUS OTHER LESSONS.

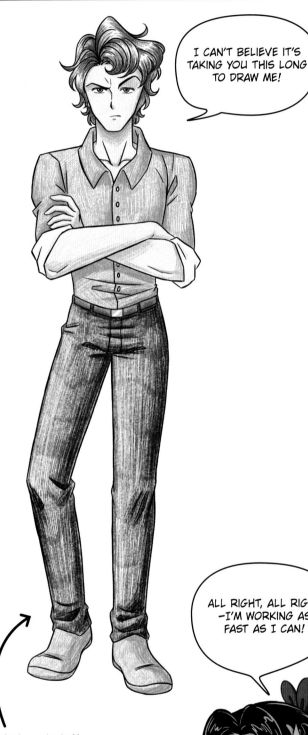

I CAN'T BELIEVE IT'S TAKING YOU THIS LONG TO DRAW ME!

Note how dark the shading is at the crease lines

ALL RIGHT, ALL RIGHT —I'M WORKING AS FAST AS I CAN!

CHIBI CHILLING

Hello over there! Hello! Hello...? Can you hear me?? Hello?! I guess she can't hear us. Let's draw this cute chibi in side profile while she's lost in her own little world.

Leave space to the right for the rest of her body

1 START BY DRAWING HER FACE IN PROFILE, AS A SLIGHTLY SQUISHED CIRCLE WITH A SMALL BUMP FOR THE NOSE, LOW ON THE FACE.

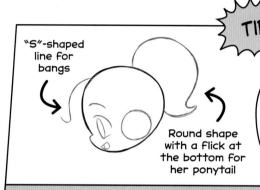

"S"-shaped line for bangs

Round shape with a flick at the bottom for her ponytail

2 ADD A SIMPLE EYE AND MOUTH VERY LOW ON THE FACE. THEN, START HER HAIR AND HER ENORMOUS HEADPHONE.

TIP!

DON'T GET TOO HUNG UP ON REALISM. A MANGA CHARACTER CAN HAVE THEIR ENTIRE MOUTH ON ONE SIDE OF THEIR FACE IN PROFILE VIEW. IT'S THE MAGIC OF MANGA ANATOMY!

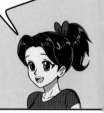

3 FINISH DRAWING THE BANGS ACROSS HER FOREHEAD, ALL THE WAY BACK TO THE HEADPHONE. ADD A THIN OVAL PUPIL AND LARGE HIGHLIGHT TO THE EYE. DRAW A SMALL BEAN SHAPE FOR HER LITTLE BODY. (SEE PAGE 155 FOR MORE DETAILS ON CHIBI BODY PROPORTIONS!)

4 CONTINUE THE HEADPHONES WITH A BAND OVER THE HEAD. THEN, ADD SHORT, CHUBBY LIMBS THAT END WITH SIMPLE, ROUNDED HANDS AND FEET. THE NEAR ARM AND NEAR LEG ARE BOTH RAISED AS SHE RELAXES ON THE FLOOR.

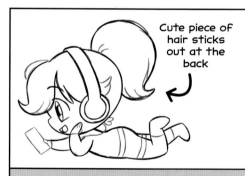

Cute piece of hair sticks out at the back

5 ADD MORE HAIR POINTS AND TEXTURE LINES. DRAW A LITTLE HOOD ON HER HOODIE AND OUTLINE THE EDGES OF HER TOP, SHORTS, AND SOCKS. ADD FINGERS TO HER HAND SHAPES AND DON'T FORGET HER PHONE—I'VE NEVER SEEN THIS KID AWAY FROM IT FOR MORE THAN TWO SECONDS!

White stripes add shine to her phone screen

6 LET'S ADD SOME FUN DETAILS, INCLUDING A STAR PATTERN ON HER HEADPHONES, ACCENT LINES ON HER CHEEK, HER PHONE SCREEN, SHORTS POCKETS, AND SOCK LINES. THEN, DRAW LOUD MUSIC NOTES AND STARS ALL AROUND TO SHOW HOW LOUD HER MUSIC IS!

7 ONCE YOU'RE HAPPY WITH YOUR DRAWING, INK THE FINAL LINES.

8 TIME FOR THE BASE COLORS. IT SEEMS THAT SHE LIKES TO MATCH HER SOCKS WITH HER HOODIE! HER PURPLE HAIR AND TWO-TONE BLUE EYE COMPLEMENT THE COLORS OF HER CLOTHING.

THIS MUSIC ROCKS! TOO BAD NO ONE ELSE CAN HEAR IT.

TIP!

Gold ring

A GOOD WAY TO MAKE PLASTIC OR METALLIC SURFACES—LIKE THE HEADPHONE BAND—LOOK SMOOTH AND SHINY IS TO COLOR A HIGHLIGHT AREA AND THEN ADD A THIN, DARK STRIPE RIGHT NEXT TO IT, LIKE THESE TWO EXAMPLES.

Metal spoon

Highlights make even the music notes look bouncy!

UH... EVERYONE CAN HEAR IT.

9 FINALLY, SHADE HER HAIR, FACE, AND CLOTHING AND ADD A SHADOW BENEATH HER BODY. GIVE HER HAIR OVAL HIGHLIGHTS TO MAKE IT LOOK SMOOTH AND BOUNCY AND ADD HIGHLIGHTS TO THE HEADPHONES TOO.

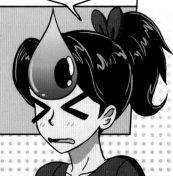

READING UNDER A TREE

There's nothing like a good book! Our next character is sitting under a tree, totally immersed in her favorite book. This relaxed, reclining pose works for kids watching TV at home, students chatting in a school hallway, or superheroes taking a well-earned break after battle!

1 START BY DRAWING THE HEAD, USING A CIRCLE WITH A WIDE TRIANGLE BENEATH IT. TILT THE TRIANGLE TO THE SIDE FOR A ¾ ANGLE.

2 ADD FACIAL GUIDELINES, THEN, SKETCH THE BASIC BODY SHAPES: USE ROUNDED SQUARES FOR THE CHEST AND HIPS. PLACE GUIDELINES ON THE CHEST SO WE CAN GET THE ANGLES OF HER BODY RIGHT LATER ON.

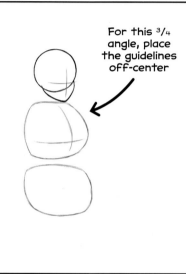

For this ¾ angle, place the guidelines off-center

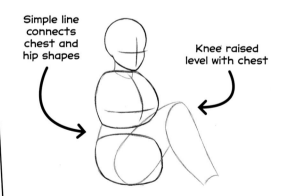

Simple line connects chest and hip shapes

Knee raised level with chest

3 TO SHOW THAT SHE'S SITTING ON THE GROUND WITH HER KNEES UP, DRAW THE UPPER LEG SHAPE RAISED AND THE LOWER LEG SHAPE COMING BACK DOWN. ADD A NECK AND ANOTHER LINE FOR THE WAIST.

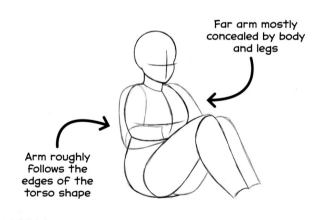

Far arm mostly concealed by body and legs

Arm roughly follows the edges of the torso shape

4 DRAW THE FAR LEG IN A SIMILAR POSE. ADD SHORT CYLINDERS AS ARMS. MAKE THE CLOSER ARM BENT TOWARD HER LAP BECAUSE SHE'LL BE HOLDING A BOOK THERE, BALANCED ON HER LEGS.

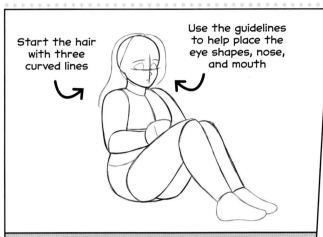

Start the hair with three curved lines

Use the guidelines to help place the eye shapes, nose, and mouth

5 DRAW THE BASIC SHAPES FOR THE CLOSER HAND AND FEET. THEN, ADD FACIAL DETAILS AND HAIR. DRAW A RED LINE UNDER THE CLOSER ARM TO COMPLETE THE OUTLINE OF HER SWEATER.

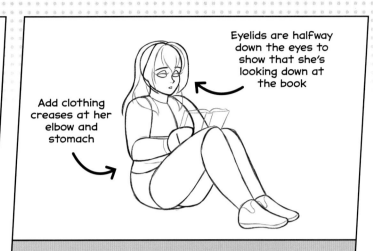

Eyelids are halfway down the eyes to show that she's looking down at the book

Add clothing creases at her elbow and stomach

6 ADD MORE DETAILS, INCLUDING EYELIDS, HAIR TEXTURE, AND SHOE OUTLINES. DRAW THE OPEN BOOK AS A SERIES OF SLANTED RECTANGLES, TOPPED WITH CURVED SHAPES FOR THE PAGES.

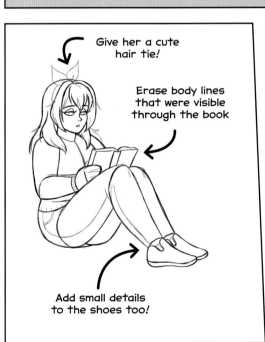

Give her a cute hair tie!

Erase body lines that were visible through the book

Add small details to the shoes too!

7 BREAK UP THE LARGE SHAPES OF HAIR INTO SMALLER, NATURAL-LOOKING SECTIONS. DRAW SMALL IRISES IN THE EYES AND THEN DIVIDE THE HAND WEDGE SHAPE INTO FINGERS. ADD CLOTHING DETAILS, INCLUDING SEAM LINES, POCKETS, AND FOLDS.

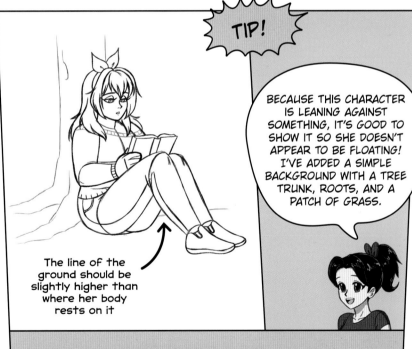

TIP!

BECAUSE THIS CHARACTER IS LEANING AGAINST SOMETHING, IT'S GOOD TO SHOW IT SO SHE DOESN'T APPEAR TO BE FLOATING! I'VE ADDED A SIMPLE BACKGROUND WITH A TREE TRUNK, ROOTS, AND A PATCH OF GRASS.

The line of the ground should be slightly higher than where her body rests on it

8 IN THE EYES, ADD TINY HIGHLIGHTS AND PUPILS. COMPLETE HER TOP WITH A WIDE COLLAR FOR AN OPEN-SHOULDER LOOK. SKETCH A BASIC TREE TRUNK BEHIND HER BACK.

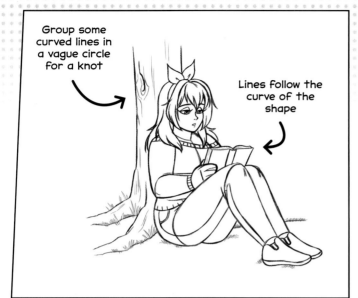

Group some curved lines in a vague circle for a knot

Lines follow the curve of the shape

9 ADD THIN LINES TO BREAK UP THE EMPTY PAGE SHAPES ON HER BOOK. THEN, USE UNEVEN LINES WITH BUMPY CURVES TO ADD ORGANIC-LOOKING TEXTURE TO THE TREE. DRAW IN SOME GRASS ALONG THE TREE ROOTS AND AROUND WHERE SHE'S SITTING.

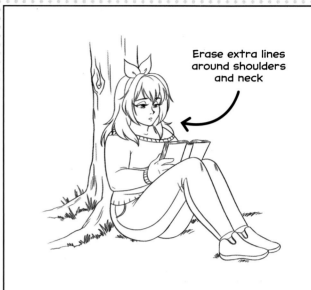

Erase extra lines around shoulders and neck

10 ONCE YOU'VE FINISHED THE ROUGH DRAWING, GO OVER YOUR FINAL LINES WITH AN OUTLINER, BRUSH PEN, OR YOUR PREFERRED ART TOOL. ERASE ANY EXTRA STRUCTURE LINES.

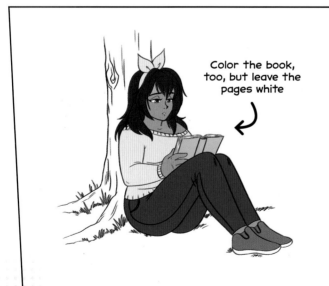

Color the book, too, but leave the pages white

11 CHOOSE YOUR BASE COLORS FOR HER BODY AND CLOTHING. I'VE USED DARK BLUE FOR JEANS AND A PALE PINK FOR HER SWEATER AND BOW.

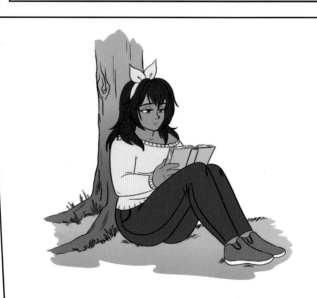

12 ADD BASE COLORS TO THE TREE AND GRASS. I'VE USED GRADIENTS ON BOTH TO ADD SOME NATURAL VARIATION AND DEPTH.

13 NOW, SHADE THE CHARACTER BY USING DARKER COLORS. USE CURVED LINES THAT FOLLOW THE CONTOURS OF HER BODY TO OUTLINE THE SHADED AREAS FIRST AND THEN FILL THEM IN. USE A LIGHTER COLOR TO ADD SHINE TO THE HAIR WITH HIGHLIGHTS.

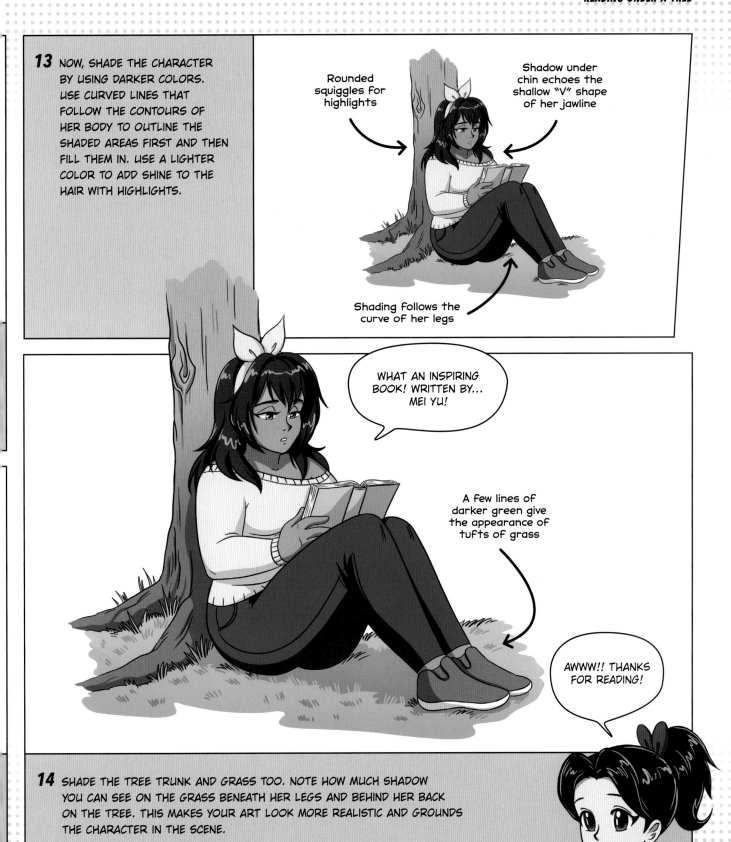

Rounded squiggles for highlights

Shadow under chin echoes the shallow "V" shape of her jawline

Shading follows the curve of her legs

WHAT AN INSPIRING BOOK! WRITTEN BY... MEI YU!

A few lines of darker green give the appearance of tufts of grass

AWWW!! THANKS FOR READING!

14 SHADE THE TREE TRUNK AND GRASS TOO. NOTE HOW MUCH SHADOW YOU CAN SEE ON THE GRASS BENEATH HER LEGS AND BEHIND HER BACK ON THE TREE. THIS MAKES YOUR ART LOOK MORE REALISTIC AND GROUNDS THE CHARACTER IN THE SCENE.

SITTING PRETTY

Look at this fashionista. She's waiting to review the latest in manga style trends. I heard she used to be a model for josei manga covers. Let's draw her in her favorite pose, sitting patiently, with her long legs crossed.

1 BEGIN WITH THE TWO BASIC HEAD SHAPES. SHE'LL BE TURNED TO THE SIDE A LITTLE, SO WE'RE GOING TO DRAW HER AT A FRONT ¾ ANGLE. TILT THE TRIANGULAR JAW SHAPE SLIGHTLY.

2 PLACE THE FACE GUIDELINES AND THEN DRAW HER BODY AS TWO SHAPES CONNECTED AT A NARROW WAIST. ADD TORSO GUIDELINES TOO. SHE IS GOING TO LEAN FORWARD A LITTLE, SO THE TORSO GUIDELINES SHOULD BE LOW, AND THE VERTICAL LINE SHOULD BEND QUITE SEVERELY.

Leave plenty of space below for the rest of her!

3 CONNECT HER HEAD TO HER TORSO WITH A LONG, THIN NECK. THEN, DRAW ROUND PUFFY SLEEVES AT HER SHOULDERS. SHAPE THE LEGS LIKE STRETCHED OVALS. SHE'S CROSSING HER LEGS, SO DRAW THE NEAR OVAL TILTED UP AND IN FRONT OF THE FAR ONE.

TIP!

THIS CHARACTER'S BODY IS SHAPED LIKE A PEANUT. IF YOU WANT TO DRAW HER WITH A CURVIER BODY, TRY PICTURING A WIDER PEANUT SHAPE.

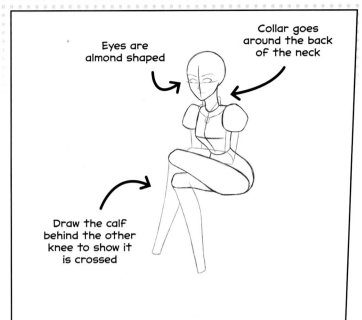

Eyes are almond shaped

Collar goes around the back of the neck

Draw the calf behind the other knee to show it is crossed

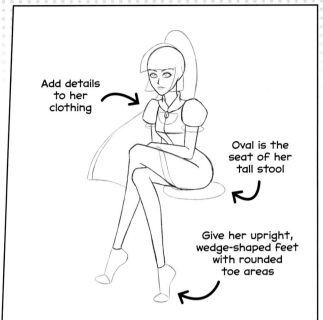

Add details to her clothing

Oval is the seat of her tall stool

Give her upright, wedge-shaped feet with rounded toe areas

4 DRAW NATURALLY PROPORTIONED EYES, NOSE, AND THE START OF HER MOUTH AND SKETCH OUT HER COLLAR. EXTEND THE ARMS DOWN, COMING OUT FROM THE PUFFY SLEEVES. ONE RESTS ON HER LAP, BEHIND HER LEG. THEN, CONTINUE THE LEGS, USING SLIM, CURVED CYLINDERS. THE CLOSER LEG COMES DOWN BEHIND THE BACK LEG TO SHOW THEY ARE CROSSED.

5 ADD DETAILS TO HER FACE, INCLUDING EYE CREASES, IRISES, AND LIPS. BEGIN HER LONG, STYLISH HAIR WITH CURVED, FLOWING LINES AROUND HER HEAD THAT END IN SEVERE, FLAT BANGS AND SIDE SECTIONS. DRAW THE FLOWING SHAPE OF HER LONG PONYTAIL AT THE TOP OF HER HEAD AND AS IT CONTINUES TO FAN OUT AT HER SIDE.

6 COMPLETE THE STRIKING EYES WITH PUPILS, HIGHLIGHTS, AND THICK LASHES. ADD LONG LINES IN HER HAIR TO BREAK UP THE EMPTY SHAPES AND GIVE HER A PRETTY BUTTERFLY HAIR CLIP. LET'S HAVE HER IN HEELS! (SEE PAGES 122-123 -FOR MORE SHOE INSPIRATION.)

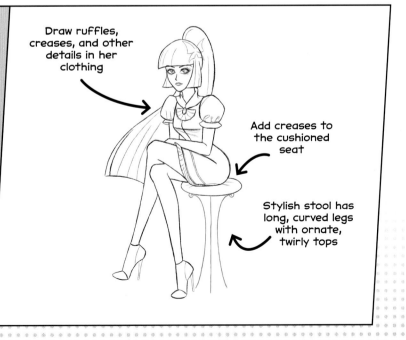

Draw ruffles, creases, and other details in her clothing

Add creases to the cushioned seat

Stylish stool has long, curved legs with ornate, twirly tops

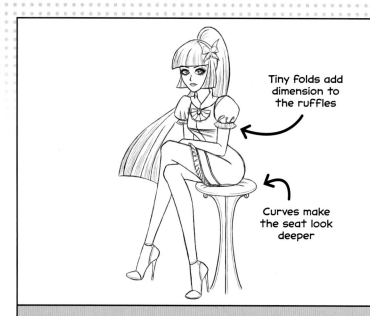

Tiny folds add dimension to the ruffles

Curves make the seat look deeper

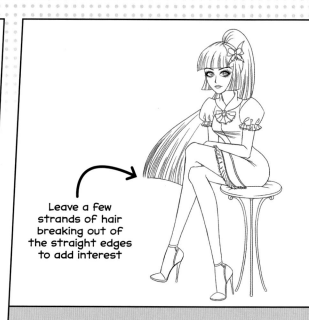

Leave a few strands of hair breaking out of the straight edges to add interest

7 KEEP BREAKING UP THE HAIR SHAPES WITH MORE TEXTURE LINES TO MAKE HER HAIR LOOK FINER. ADD DETAIL TO THE BUTTERFLY HAIR CLIP AND COMPLETE THE CLOTHING FOLDS AND RUFFLES WITH FINE LINES. ADD A SECOND LAYER OF LINES TO THE SHOES AND STOOL.

8 ERASE ANY UNNECESSARY LINES. PAY SPECIAL ATTENTION TO THE EDGES OF THE SLEEVES AND SKIRT RUFFLES SO THEY BREAK OUT OF THEIR ORIGINAL BASIC SHAPES. THEN, INK YOUR LINE ART WITH YOUR CHOICE OF ART TOOL.

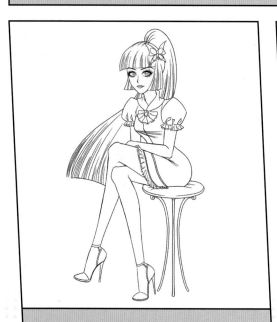

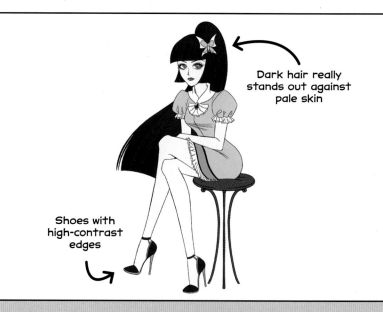

Dark hair really stands out against pale skin

Shoes with high-contrast edges

9 ADD A BASE COLOR TO HER SKIN. I'VE USED A VERY PALE SKIN TONE TO GIVE THE CHARACTER A UNIQUE, ALMOST OTHERWORLDLY LOOK.

10 FOR HER HAIR, FACIAL FEATURES, AND CLOTHING COLORS, USE A COMBINATION OF DARK, MEDIUM, AND LIGHT VERSIONS OF THE SAME COLOR. THIS CHARACTER'S FAVORITE COLORS ARE BLUES AND TEALS. NO ONE CAN SAY SHE ISN'T A PRO AT PUTTING TOGETHER AN EYE-CATCHING OUTFIT!

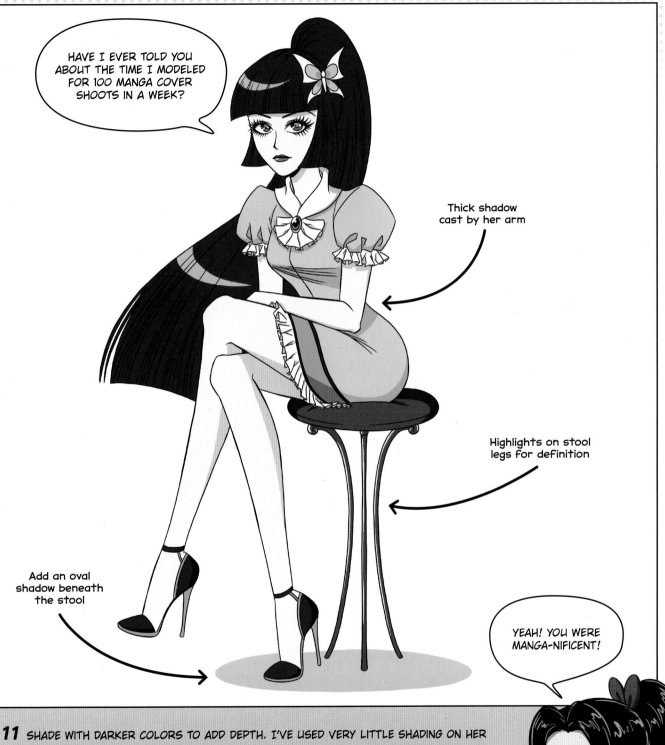

11 SHADE WITH DARKER COLORS TO ADD DEPTH. I'VE USED VERY LITTLE SHADING ON HER FACE TO GIVE IT A FLAT LOOK, TYPICAL OF SOME JOSEI MANGA STYLES. SIMILARLY, HER UNIQUE HAIR STYLE HAS NO SHADING EITHER. THE ONLY HIGHLIGHTS I'VE ADDED ARE SHARP BLUE CURVES IN HER HAIR, WHICH GIVE THE IMPRESSION OF SLEEK SHINE.

PERSPECTIVES AND PROPORTIONS

Once you've mastered various body types and poses, you can think about using body proportion and perspective to really enhance your characters and help you tell their stories in a more exciting and dramatic way!

PUTTING THINGS IN PERSPECTIVE

Playing around with perspective can make your drawings really dynamic. If you get it right, you can show your characters reaching, leaning, leaping, or soaring in dramatic poses. Here are a pair of archenemies. One of them is drawn from above and the other from below. Let's learn how to achieve such cool perspectives.

Large forehead accentuates the angle of this pose

Body (apart from the closer leg) tapers to the point of the back foot

Wind-Rider

In this extreme perspective, Wind-Rider's upper body and knee are closest to you. They are much larger than the hands and other leg, which are farther away. The back foot is tiny, which really emphasizes the distance between it and the viewer. This type of perspective is perfect to incorporate into action poses and fight scenes.

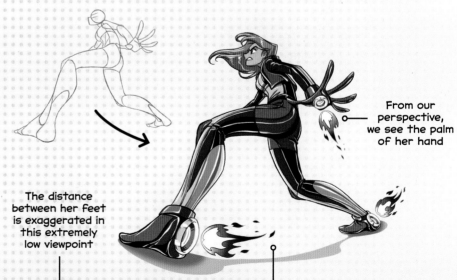

Flame-Flyer

Flame-Flyer stands in a cool upshot from a low angle. You're looking up at her, so the closer foot and leg are the biggest. The back leg is farther away, so the back foot is quite a lot smaller. And the head is even farther away, so it appears very small indeed. This is a dramatic stance for a character who's just sensed danger is preparing to fend off an enemy.

From our perspective, we see the palm of her hand

The distance between her feet is exaggerated in this extremely low viewpoint

GET YOUR HEAD AROUND PROPORTION

Here are three characters with very different body proportions.
One of the best ways to think about body proportion is the
head-to-body ratio. How big is their head in relation to the
rest of their body? You can see how dramatically different
a character can look when the head-to-body ratio changes!

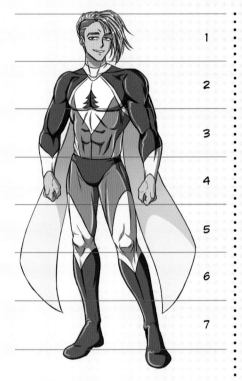

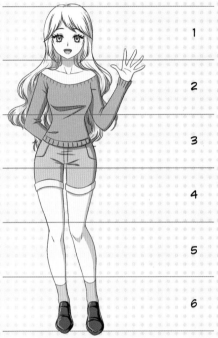

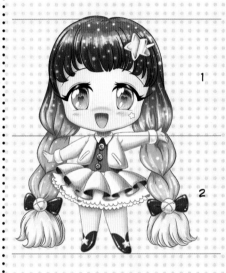

Heroic proportion

A superhero who fights for all
green causes—and wears a suit
to match—this character stands
about seven heads high. His low
head-to-body ratio makes him
appear tall and, thanks to his
muscular build, he has a "heroic"
wide frame.

Regular proportion

This library volunteer has agreed to
pose for us. She stands at six heads
tall, which I consider a "regular" body
proportion, representative of most
real-world characters. Note that a
child would have a slightly larger head
compared to their body—usually
standing four or five heads tall.

Chibi proportion

Chibi characters are known for
their exaggerated cuteness, which
comes from their oversized head
and eyes. This character has an
extreme head-to-body ratio: She is
only two heads tall, and you can see
that this gives her a much shorter
—and way cuter—appearance!

THESE HEAD-TO-BODY RATIO EXAMPLES
ARE JUST FOR REFERENCE—THERE ARE NO
STRICT RULES! YOU MIGHT HAVE SEEN SOME MANGA
CHARACTERS WITH EXTREMELY LONG LEGS OR HEADS
THAT ARE WAY BIGGER THAN THEIR BODIES! WHEN
CREATING YOUR CHARACTERS, YOU HAVE PLENTY
OF FREEDOM TO MIX THINGS UP. IT ALL DEPENDS
ON WHAT KIND OF CHARACTER YOU WANT
TO CREATE AND THE OVERALL LOOK
YOU'RE TRYING TO ACHIEVE.

EXAGGERATED POSES

MASTERCLASS!!

We've drawn both of these characters before, but now we're going to push them to the MAX! Let's see how frantic the kid who's late for school gets when he spots the principal locking the front doors. And let's find out what happens when our martial arts warrior leaps into battle from an even greater height! By changing certain elements, we can create highly exaggerated—and exciting—poses.

LATER THAN EVER

Watch out! By switching from a side view to a low-down, head-on front view, the dramatic tension in this pose leaps right out at us. The outstretched hand is closest and biggest, followed by his front foot. Everything else trails behind, including his homework. His panicked expression is a lot more intense, with enormous bulging eyes conveying how he feels. The dust cloud, action lines, and warped floor combine to pack a powerful punch.

Sweat drops fly up and away from us

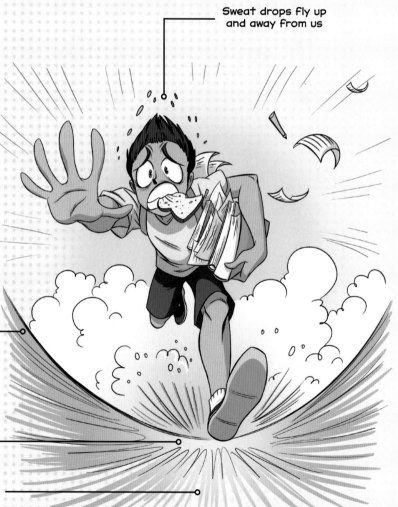

Curved ground offers a warped lens perspective

Lines around his foot show the impact of his racing steps

Radiating lines add a sense of movement

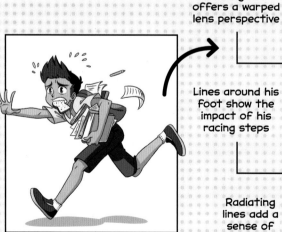

LEAP INTO ACTION

Woo-hoo! Look how changing the angle of the pose and exaggerating the perspective of the closer leg have given us a much more extreme version of this character. Everything is heightened—the energy in the hair and clothes flying up, the angle of the arms, the intensity of the action lines in the background... even her fierce expression! For a more dramatic effect, you can even add an impact as her foot strikes the ground.

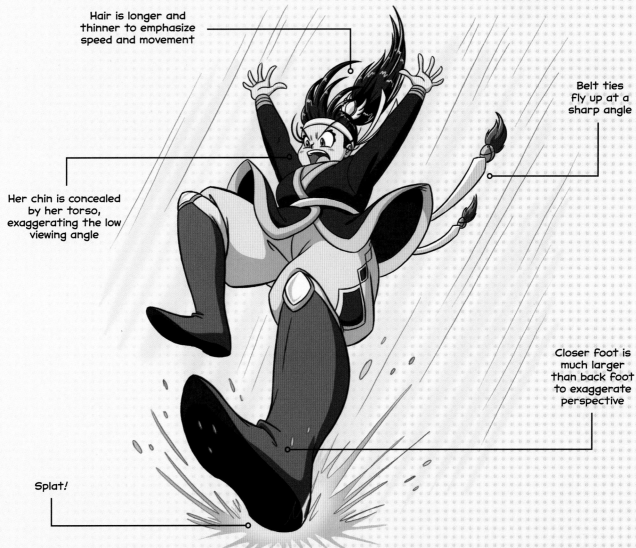

Hair is longer and thinner to emphasize speed and movement

Belt ties fly up at a sharp angle

Her chin is concealed by her torso, exaggerating the low viewing angle

Closer foot is much larger than back foot to exaggerate perspective

Splat!

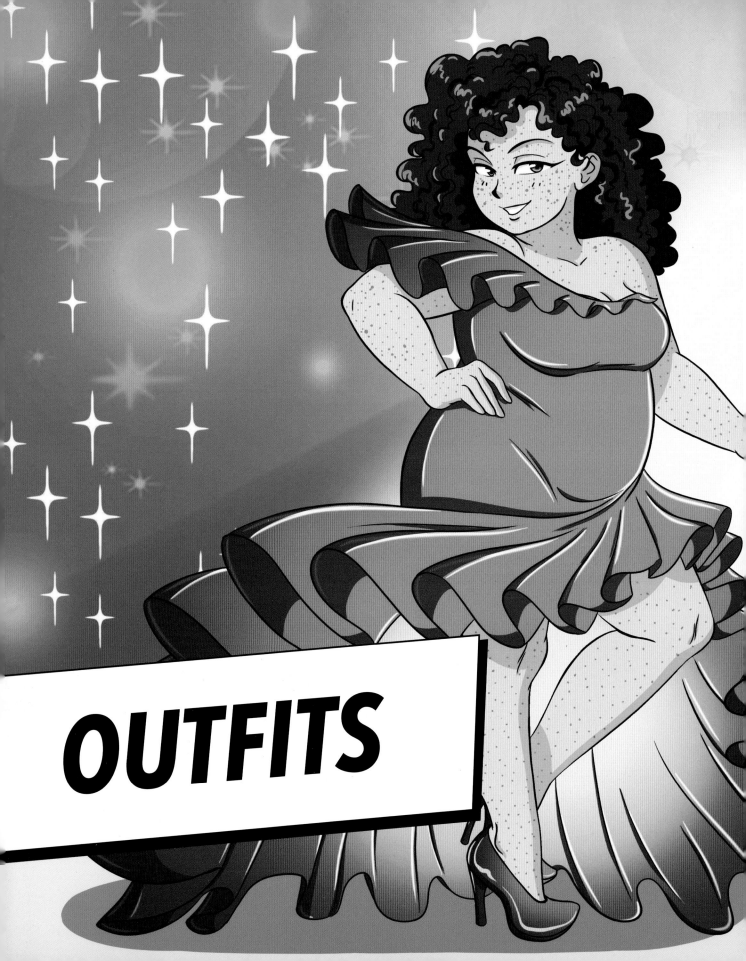

OUTFITS

SCHOOL UNIFORM

The Manga Fashion Show is coming up! I can't wait to see all the amazing outfits. First up is a cute Japanese school uniform —a popular staple in shojo manga. This design is based on one of the body templates from the back of the book (see page 249).

Continue the collar over to her back

1 THIS DESIGN STARTS WITH A BIG "V" FOR THE COLLAR. BECAUSE THE BODY TEMPLATE IS AT A ¾ ANGLE, THE COLLAR'S NEAR SIDE IS BIGGER THAN THE FAR SIDE.

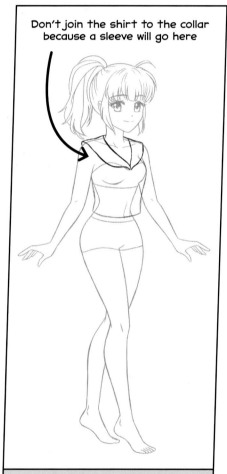

Don't join the shirt to the collar because a sleeve will go here

2 DRAW THE START OF THE SHIRT AROUND THE TORSO, LIKE A CURVED SQUARE. TO MAKE IT LOOK LOOSE AT THE WAIST, LEAVE SOME SPACE BETWEEN THE BODY TEMPLATE AND THE SHIRT.

3 ADD SHORT, ROUNDED SLEEVES AND DRAW THE BEGINNINGS OF A KNOTTED TIE THAT WILL COME OUT FROM UNDER THE COLLAR.

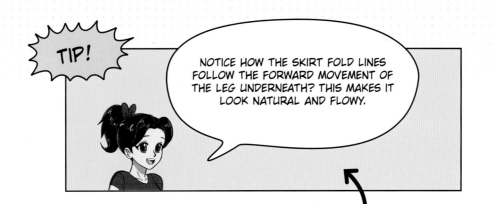

TIP!

NOTICE HOW THE SKIRT FOLD LINES FOLLOW THE FORWARD MOVEMENT OF THE LEG UNDERNEATH? THIS MAKES IT LOOK NATURAL AND FLOWY.

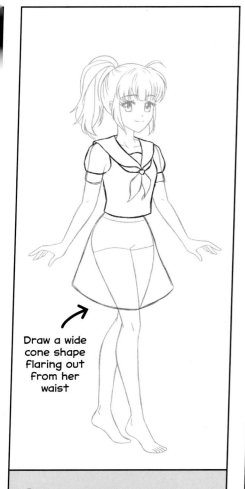

Draw a wide cone shape flaring out from her waist

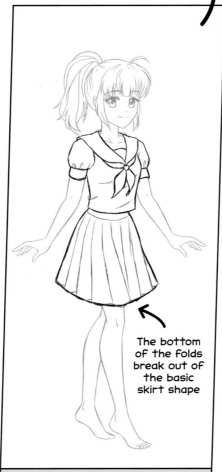

The bottom of the folds break out of the basic skirt shape

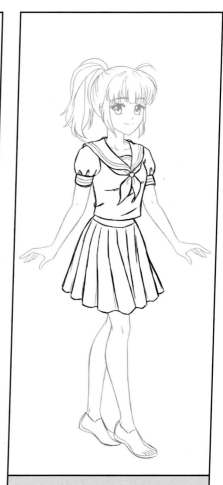

4 END THE SLEEVES WITH CURVED LINES THAT ARE TIGHT TO HER UPPER ARMS. DRAW THE POINTED ENDS OF THE TIE FLOWING DOWN BENEATH THE KNOT. THEN, BEGIN THE SKIRT.

5 CREATE A PLEATED SKIRT DESIGN BY DRAWING REPEATED LINES TO SHOW FOLDS IN THE FABRIC. ADD SMALL WRINKLES AND CREASES TO THE SHIRT AND SLEEVES.

6 DRAW STRIPES ON THE SLEEVES AND COLLAR AND THEN ADD SOME CREASES TO THE KNOTTED TIE. GIVE THE SKIRT SOME MORE TEXTURE WITH A FEW STRAIGHT LINES ALONG THE FOLDS. BEGIN TO OUTLINE HER SHOES.

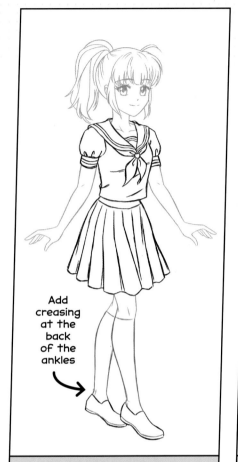

Add creasing at the back of the ankles

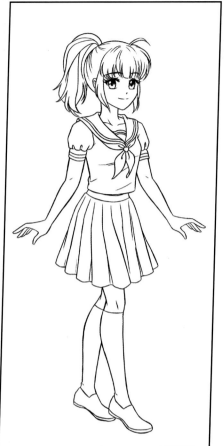

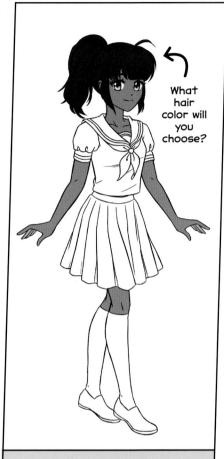

What hair color will you choose?

7 ERASE EXTRA LINES AROUND THE FEET AND DRAW SOLES ON THE SHOES. LET'S GIVE HER SNUG KNEE-HIGH SOCKS BY DRAWING LINES EXACTLY OVER HER LOWER LEGS.

8 ERASE STRUCTURAL LINES THAT YOU DON'T NEED AND THEN GO OVER YOUR FINAL LINES WITH A FINE-TIPPED PEN OR OUTLINER.

9 TIME FOR COLOR! ADD BASE COLORS TO THE SKIN, HAIR, AND EYES. I'VE GONE WITH DARK PURPLE HAIR AND BRIGHT GOLDEN EYES.

TIP!

YOU DON'T HAVE TO STICK TO A TRADITIONAL SCHOOL-UNIFORM DESIGN! HERE'S AN ALTERNATIVE LOOK FOR THE SAME CHARACTER. DON'T BE AFRAID TO EXPERIMENT WITH DIFFERENT STYLES AND COLORS!

Checked trousers instead of a skirt

School blazer with emblem on the front

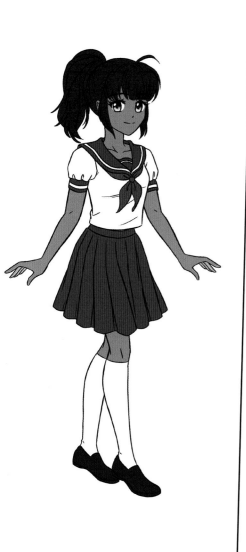

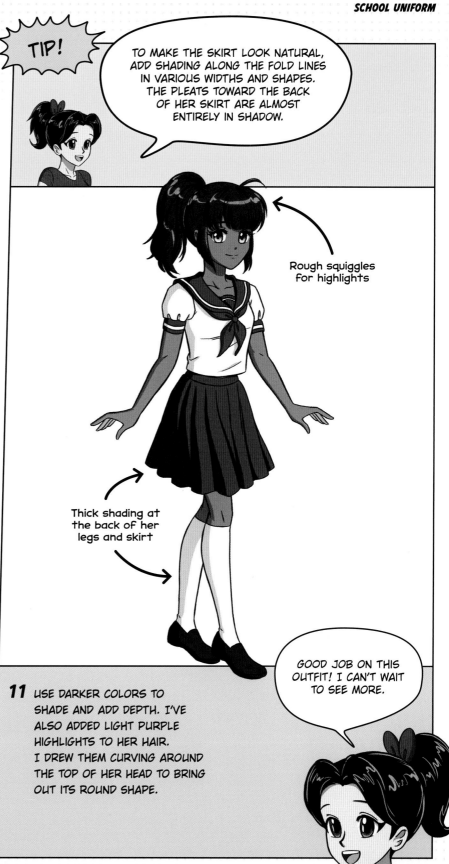

TIP!

TO MAKE THE SKIRT LOOK NATURAL, ADD SHADING ALONG THE FOLD LINES IN VARIOUS WIDTHS AND SHAPES. THE PLEATS TOWARD THE BACK OF HER SKIRT ARE ALMOST ENTIRELY IN SHADOW.

Rough squiggles for highlights

Thick shading at the back of her legs and skirt

GOOD JOB ON THIS OUTFIT! I CAN'T WAIT TO SEE MORE.

10 NOW, ADD BASE COLORS TO THE UNIFORM. I'VE CHOSEN A TRADITIONAL BLUE-AND-WHITE COLOR SCHEME, TYPICAL IN MANY MANGA STORIES. I'VE ADDED A POP OF COLOR BY USING RED FOR THE TIE.

11 USE DARKER COLORS TO SHADE AND ADD DEPTH. I'VE ALSO ADDED LIGHT PURPLE HIGHLIGHTS TO HER HAIR. I DREW THEM CURVING AROUND THE TOP OF HER HEAD TO BRING OUT ITS ROUND SHAPE.

FANTASY VILLAIN

Next up, we have a dark fantasy villain showing off his edgy outfit, complete with dramatic collar, shoulder spikes, and jagged cape. He is rarely seen without his magical floating fire gem. This dramatic outfit is based on the template from page 251.

1 AS IN OUR PREVIOUS LESSON, LET'S START WITH THE COLLAR. IT'S HIGH AND TRIANGULAR WITH SPIKED TIPS. IT COMES TOGETHER ON HIS CHEST WITH A POINTY DIAMOND SHAPE IN THE CENTER.

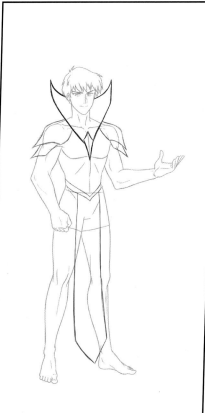

2 THIS VILLAIN WEARS SHARP ARMORED PLATES TO PROTECT HIS SHOULDERS, ENDING IN POINTY TIPS. NEXT, DRAW A THIN, SHALLOW "V" AROUND HIS WAIST, WITH A LONG STRIP OF FABRIC GOING DOWN THE FRONT.

Add a smaller internal collar

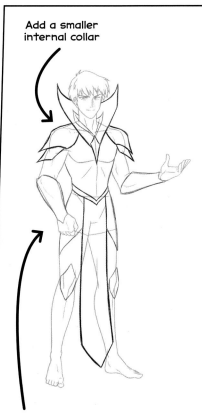

End the gauntlets with a pointed tip

3 FOR A TIGHT-FITTING SUIT, DRAW THE OUTFIT ALONG THE LINES OF THE BODY. HERE, WE'RE ADDING THE TORSO AND HIP SECTIONS, WHICH EXTEND DOWN OVER HIS THIGHS, PLUS GAUNTLETS ON HIS LOWER ARMS AND KNEE GUARDS.

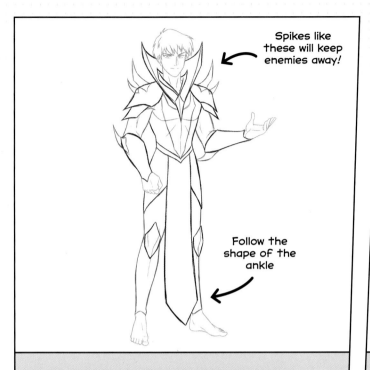

Spikes like these will keep enemies away!

Follow the shape of the ankle

4 COMPLETE THE UPPER ARMS AND LEGS OF THE TIGHT-FITTING SUIT AND THEN ADD A BUNCH OF WICKED SPIKES TO MAKE THE WHOLE OUTFIT LOOK MENACING. SKETCH THE OUTLINE OF A DRAGON HEAD ON THE FRONT OF HIS CHEST.

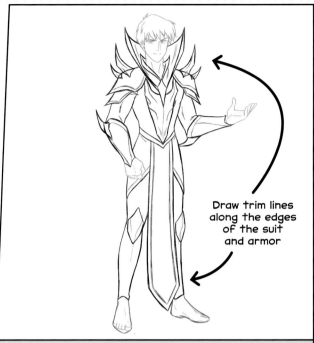

Draw trim lines along the edges of the suit and armor

5 ADD FINE DETAILS TO THE SUIT AND SPIKES. SKETCH BASIC SHAPES FOR HIS POINTY SHOES. REFINE THE DRAGON HEAD ON HIS CHEST WITH EYES, NOSTRILS, AND A FEW BONY LINES.

6 ADD MORE DETAIL AND ACCENT LINES TO THE SUIT. CONTOUR LINES IN THE KNEE GUARDS DEFINE THEIR APPEARANCE AS ARMOR. NOW, START ON THE ELABORATE CAPE, USING LONG LINES AND SWIRLS COMING FROM BEHIND THE VILLAIN'S BACK. THEN, GIVE HIM A GEMSTONE, FLOATING MENACINGLY ABOVE HIS RAISED HAND. DRAW JAGGED LINES WITHIN THE GEM TO SHOW ITS SHARP EDGES.

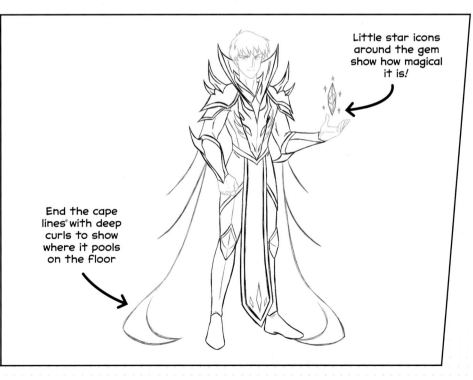

Little star icons around the gem show how magical it is!

End the cape lines with deep curls to show where it pools on the floor

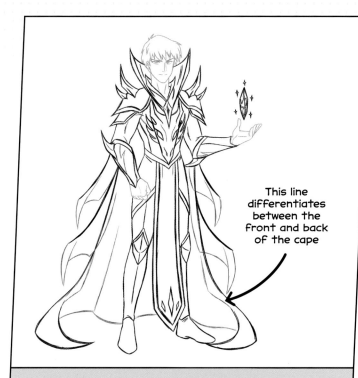

This line differentiates between the front and back of the cape

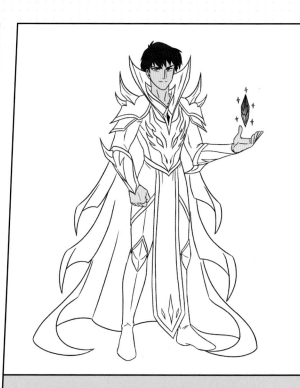

7 ADD THE FINAL DETAILS: A DIAMOND AT THE COLLAR, BROW LINES IN THE DRAGON EMBLEM, JAGGED SHAPES IN THE GAUNTLETS, AND THE REST OF THE CAPE, COMPLETE WITH POINTY PIECES OF FABRIC!

8 FINALIZE YOUR OUTLINES AND THEN ADD COLOR TO THE BODY, FACE, HAIR, AND FLOATING GEM—I'VE USED FIERY COLORS.

9 FOR THE VILLAIN'S SUIT, I'VE CHOSEN A STRIKING GREEN-AND-GOLD COLOR COMBO. THE SPIKES, GAUNTLETS, AND KNEE GUARDS ARE GRAY METAL. AND THE DRAGON'S EYES REALLY STAND OUT IN A DARK RED.

WHAT A WICKED VILLAIN DESIGN—HE COULD BE A GREAT ADDITION TO A SHONEN SERIES!

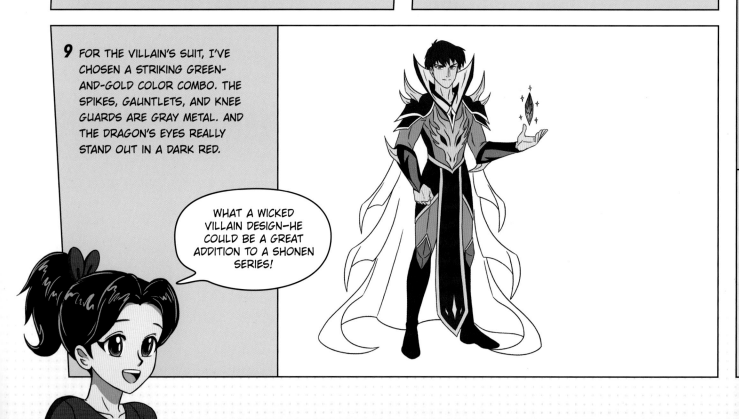

10 WOW! LOOK AT THAT CAPE! BRILLIANT YELLOW IS A GREAT CHOICE FOR THE INSIDE OF THE FABRIC, AS IT REALLY STANDS OUT. I'VE ALSO COLORED THE DIAMOND AT THE BASE OF THE COLLAR TO MATCH HIS FLOATING GEM.

11 SHADING CAN REALLY HELP GIVE A DRAMATIC—OR EVEN MENACING—EFFECT. ADD BROWNS AND GOLDS TO THE YELLOWS ON HIS SUIT, RESULTING IN A GOLDEN EFFECT. NOTE THE SHOULDER ARMOR TRIM: BY ADDING STRIPES OF DIFFERENT TONES CLOSE TOGETHER, IT GIVES A METALLIC EFFECT.

Stripes of yellows and browns give a metallic effect

SHARP HIGHLIGHTS IN THE DARK BOOTS AND GAUNTLETS BRING OUT THEIR SHAPE. THESE HIGHLIGHTS CAN ALSO HELP PRESERVE DETAIL IN THESE DARK AREAS.

TIP!

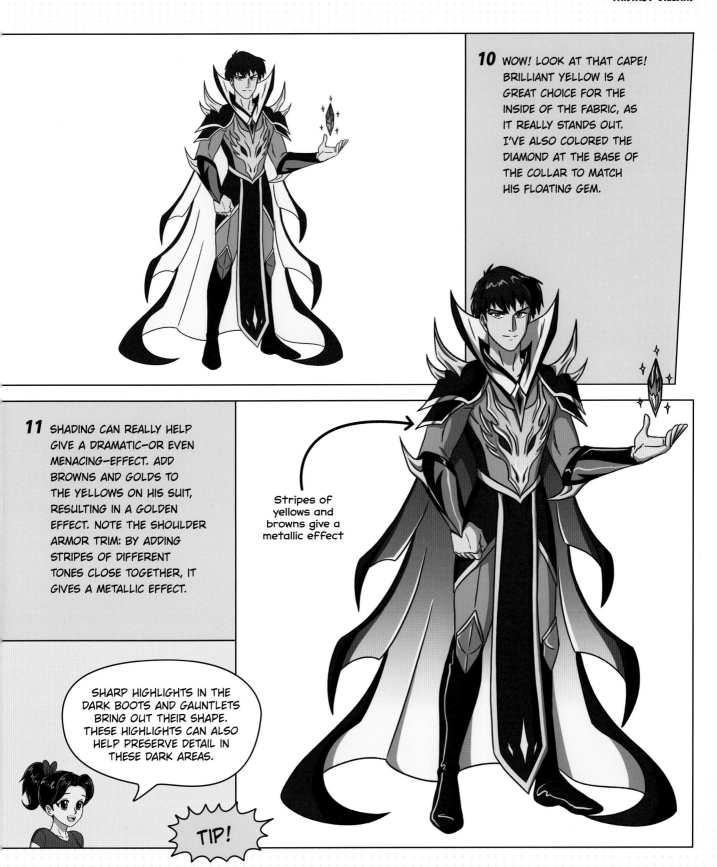

FIT AND FLOW

MASTERCLASS!!

How characters wear their outfits can tell us an awful lot about what they're up to or even how they're feeling! It's useful to understand how to adjust the fit of your character's clothing and also where and how to draw in the wrinkles and creases of the fabric.

TIGHTEN UP

Let's take a look at how to draw loose clothing compared to tight-fitting clothing. With just a few tweaks, you can drastically change the look of an outfit!

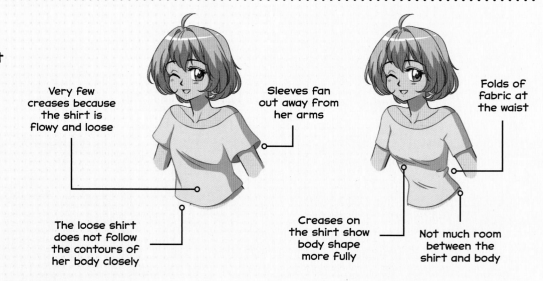

Very few creases because the shirt is flowy and loose

The loose shirt does not follow the contours of her body closely

Sleeves fan out away from her arms

Folds of fabric at the waist

Creases on the shirt show body shape more fully

Not much room between the shirt and body

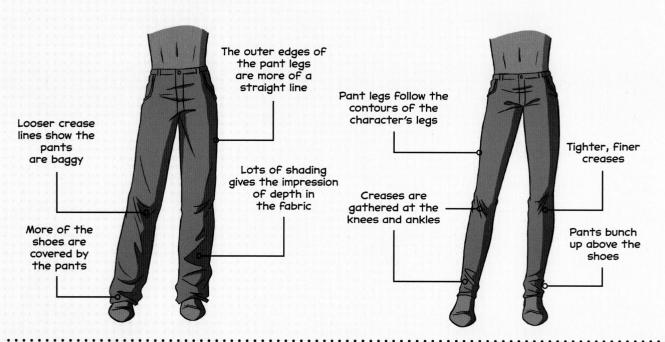

The outer edges of the pant legs are more of a straight line

Looser crease lines show the pants are baggy

Lots of shading gives the impression of depth in the fabric

More of the shoes are covered by the pants

Pant legs follow the contours of the character's legs

Tighter, finer creases

Creases are gathered at the knees and ankles

Pants bunch up above the shoes

FABRIC FLOW

Creases, wrinkles, and folds in clothing occur because the fabric twists in response to the movements of the body. This will be most visible around the joints: shoulders, elbows, waist, and knees. These drawings show how the creases follow the contours of the body underneath and respond to the body's movement.

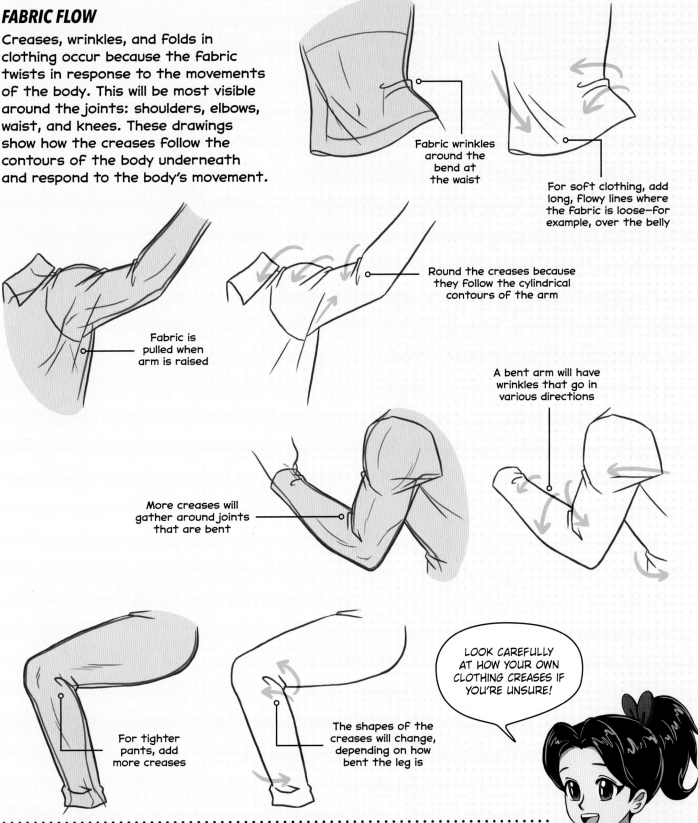

Fabric wrinkles around the bend at the waist

For soft clothing, add long, flowy lines where the fabric is loose—for example, over the belly

Fabric is pulled when arm is raised

Round the creases because they follow the cylindrical contours of the arm

A bent arm will have wrinkles that go in various directions

More creases will gather around joints that are bent

For tighter pants, add more creases

The shapes of the creases will change, depending on how bent the leg is

LOOK CAREFULLY AT HOW YOUR OWN CLOTHING CREASES IF YOU'RE UNSURE!

FANCY GALA DRESS

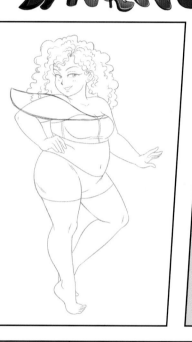

Our next model wears a fancy gala dress that is perfect for an evening on the dance floor. This outfit gives a real sense of movement thanks to the ruffles and the way the dress is drawn—as if the model is mid-twist! (See page 248 for the body template.)

1 LET'S START THIS GLAM DRESS BY DRAWING AN OFF-THE-SHOULDER SLEEVE THAT GOES RIGHT ACROSS THE CHEST AND AROUND HER SHOULDER. LEAVE ENOUGH SPACE ON THE LEFT-HAND SIDE OF THE BODY FOR HER FLOWING DRESS.

2 MAKE THE BODICE FIT SNUGLY AROUND THE TORSO. BECAUSE THIS PART OF THE OUTFIT IS TIGHT-FITTING, ADD SOME CREASE MARKS TO SHOW THE BODY SHAPE. (SEE PAGES 168–169 FOR MORE ON HOW CLOTHES FIT.)

3 FOR THE HEM OF THE DRESS, BEGIN BY DRAWING A LONG, FLOWING RECTANGLE ARCHING AROUND THE FRONT OF THE LEGS AND ENDING UP A GOOD DISTANCE AWAY FROM THE BODY. NOTICE HOW IT FLICKS UP ON THE RIGHT AND FLOWS DOWN TO A CURVED EDGE ON THE LEFT.

Flowing section should reach the floor

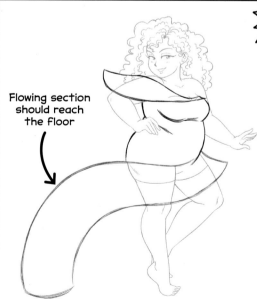

TIP!

THINK ABOUT HOW BODY MOVEMENT AFFECTS THE SHAPE OF THE DRESS. THE RUFFLE FLICKING UP ON THE RIGHT IS A RESULT OF HER RAISED KNEE.

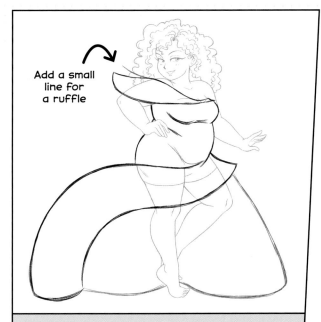

Add a small line for a ruffle

4 SKETCH THE OTHER SIDE OF THE DRESS AS IT FLOWS OUT AND DOWN TO THE RIGHT. CURVED LINES FORM THE BASE OF THE DRESS SHAPE BEHIND HER LEGS.

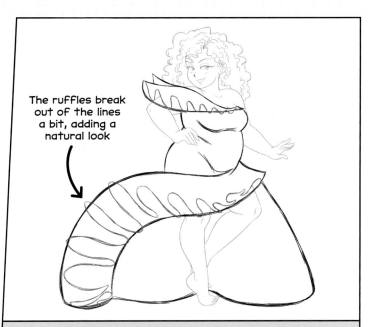

The ruffles break out of the lines a bit, adding a natural look

5 NOW, RUFFLES! DRAW SQUIGGLY, WAVY LINES ACROSS BOTH THE SHOULDER AND HEM OF THE DRESS THAT START SMALL ON ONE SIDE AND GROW BIGGER AS THEY FLOW AWAY FROM THE BODY.

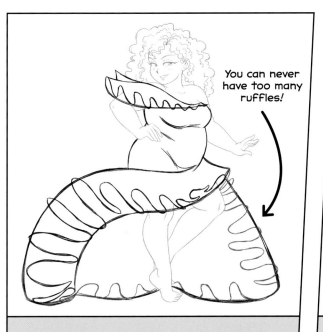

You can never have too many ruffles!

6 NOW, DRAW EVEN MORE RUFFLES ALONG THE EDGES OF THE REST OF THE SKIRT SECTION. THEY DON'T NEED TO BE UNIFORM IN SIZE AND SHAPE!

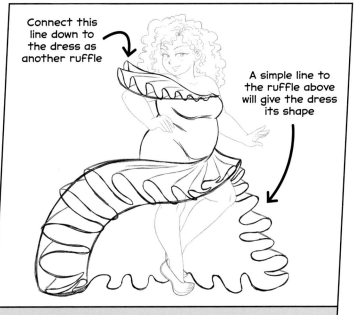

Connect this line down to the dress as another ruffle

A simple line to the ruffle above will give the dress its shape

7 DRAW A LINE FROM THE TOP OF EACH RUFFLE ARCH INTO THE DRESS. DON'T ADD LINES TO THE BOTTOM HEM, THOUGH—WE WON'T SEE THESE, AS THEY'D BE ON THE BACK. DRAW CURVED WEDGES FOR SHOES.

8 ERASE EXTRA OUTLINES AROUND THE RUFFLES. NOW, YOU CAN REALLY SEE THEIR SHAPE! FOR THE INSIDE PART OF THE DRESS, ADD LONG, FINE LINES THAT CURVE UP. NICE HEELS!

9 INK YOUR FINAL ARTWORK, MAKING SURE THE RUFFLE LINES ARE SMOOTH AND FLOWING.

10 ADD THE BASE COLORS FOR YOUR CHARACTER'S HAIR, EYES, AND SKIN.

11 NOW, FOR THE DRESS. START WITH A CUTE PINK ON THE BODICE, BLENDING INTO A DARKER PURPLE AROUND THE EDGES. FOR EXTRA CONTRAST, ADD A BRIGHT, LIGHT YELLOW INSIDE THE SKIRT.

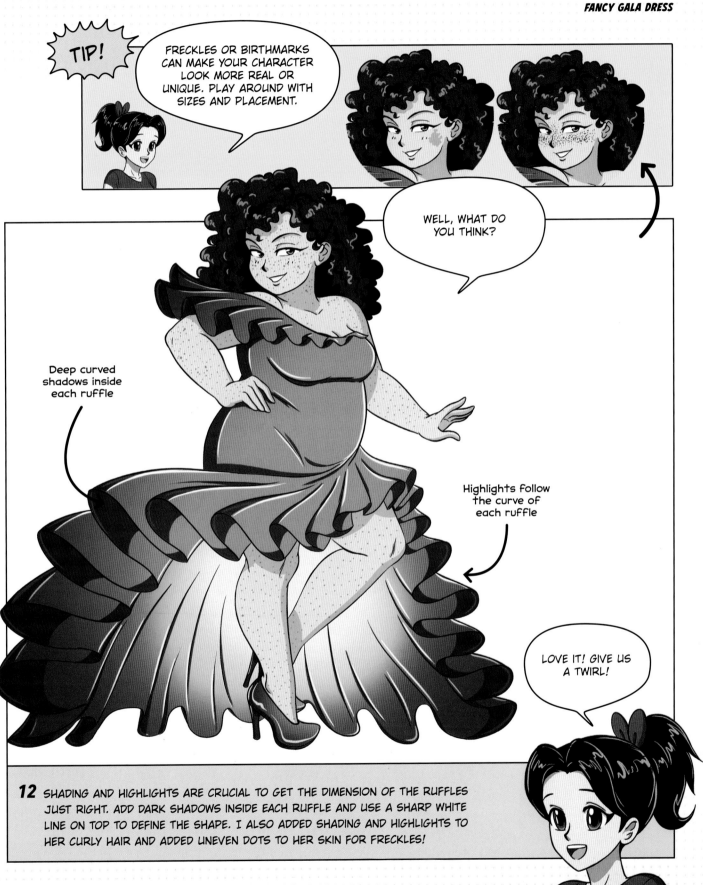

TIP!

FRECKLES OR BIRTHMARKS CAN MAKE YOUR CHARACTER LOOK MORE REAL OR UNIQUE. PLAY AROUND WITH SIZES AND PLACEMENT.

WELL, WHAT DO YOU THINK?

Deep curved shadows inside each ruffle

Highlights follow the curve of each ruffle

LOVE IT! GIVE US A TWIRL!

12 SHADING AND HIGHLIGHTS ARE CRUCIAL TO GET THE DIMENSION OF THE RUFFLES JUST RIGHT. ADD DARK SHADOWS INSIDE EACH RUFFLE AND USE A SHARP WHITE LINE ON TOP TO DEFINE THE SHAPE. I ALSO ADDED SHADING AND HIGHLIGHTS TO HER CURLY HAIR AND ADDED UNEVEN DOTS TO HER SKIN FOR FRECKLES!

COOL STREETWEAR

Not all outfits need to be fancy. Take a look at this shonen character. His everyday streetwear is decidedly understated yet effortlessly cool. Learning to draw clothes like this is very useful for your everyday characters—or for the alter-egos of superheroes and villains!

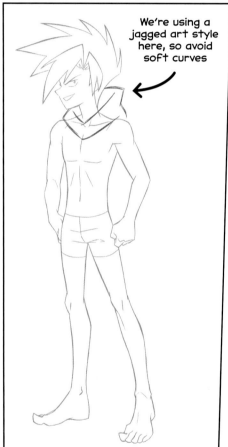

We're using a jagged art style here, so avoid soft curves

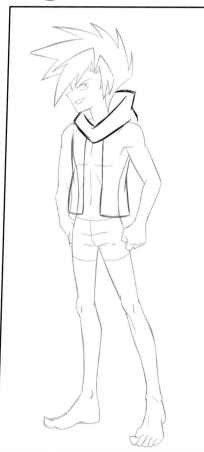

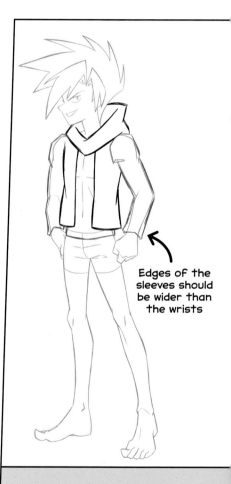

Edges of the sleeves should be wider than the wrists

1 LET'S START WITH THE HOODIE. DRAW THE HOOD GOING AROUND THE NECK AND CONTINUING DOWN HIS BACK.

2 THIS TEEN IS GOING TO LAYER A SLIM-FIT JACKET ON TOP OF HIS FITTED HOODIE. DRAW THE JACKET SIDES COMING DOWN FROM HIS SHOULDERS LIKE NARROW RECTANGLES THAT GO IN SLIGHTLY IN THE MIDDLE.

3 DRAW THE SLEEVES OF THE JACKET SNUGLY ALONG THE ARMS. ADD THE BOTTOM EDGE OF THE HOODIE PEEKING OUT FROM UNDER THE JACKET.

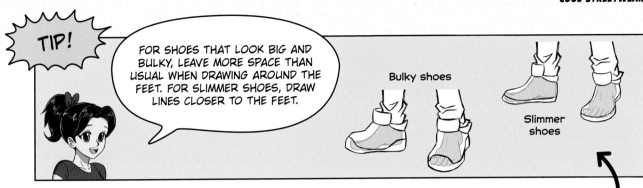

TIP!

FOR SHOES THAT LOOK BIG AND BULKY, LEAVE MORE SPACE THAN USUAL WHEN DRAWING AROUND THE FEET. FOR SLIMMER SHOES, DRAW LINES CLOSER TO THE FEET.

Bulky shoes

Slimmer shoes

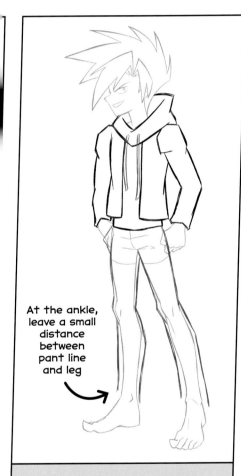

At the ankle, leave a small distance between pant line and leg

4 ADD TWO UNEVEN STRIPS AS THE HOODIE'S DRAWSTRINGS. NEXT, START ON THE SLIM-FIT PANTS BY DRAWING THEM CLOSELY FOLLOWING THE LINES OF THE LEGS. THE FAR HAND WILL BE INSIDE THE POCKET, SO DRAW A TRIANGULAR SHAPE COVERING THAT HAND.

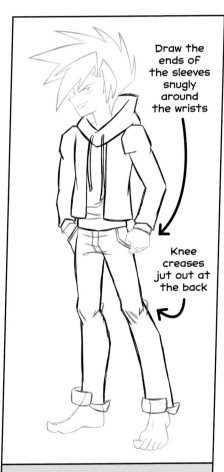

Draw the ends of the sleeves snugly around the wrists

Knee creases jut out at the back

5 ADD JAGGED DETAILS AND WRINKLES TO THE FABRIC OF THE HOODIE SO IT LOOKS SOFT AND TO THE PANTS SO THEY LOOK NATURAL. START ON HIS TRENDY SHOES BY DRAWING THEIR TOP PARTS FIRST.

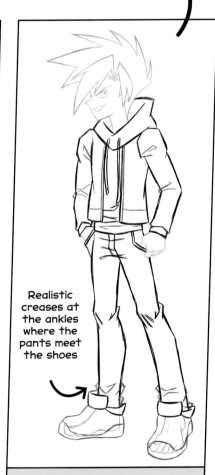

Realistic creases at the ankles where the pants meet the shoes

6 ADD MORE CREASES AROUND THE SHOULDER AND ELBOW JOINTS. DRAW SOME DETAILS ON THE FRONT OF THE JACKET. FOR THE SHOES, MAKE BASIC WEDGE SHAPES OVER THE FEET AND THEN GIVE THEM CHUNKY SOLES.

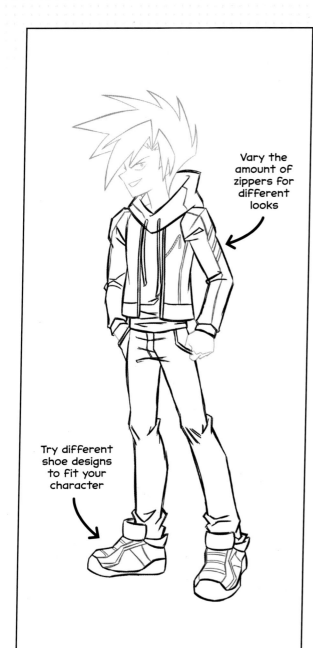

Vary the amount of zippers for different looks

Try different shoe designs to fit your character

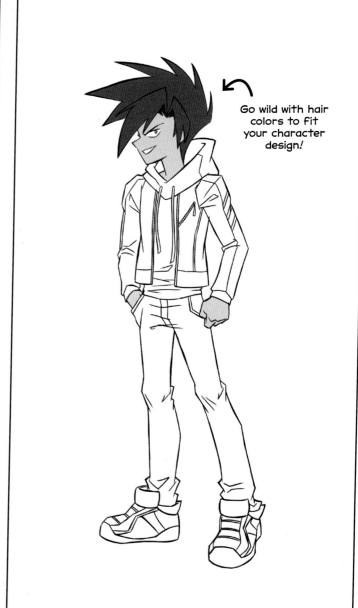

Go wild with hair colors to fit your character design!

7 NOW, FOR THE FINE DETAILS. ADD SEAM LINES, STRIPES, AND ZIPS TO THE JACKET. THEN, COMPLETE THE SHOE DESIGN WITH LACES AND A PATTERN ON THE SIDES.

8 THE FINAL LINES ARE LOOKING GOOD! THE OVERSIZED SHOES CONTRAST WITH THE SLIM-FIT PANTS, AND THE JACKET-OVER-HOODIE LOOK GIVES THIS OUTFIT A COOL FINISH. FINALIZE YOUR OUTLINES AND THEN ADD BASE COLORS TO THE HAIR, SKIN, AND FACE. I'VE USED A WILD HAIR COLOR TO COMPLEMENT THE WILD HAIRSTYLE!

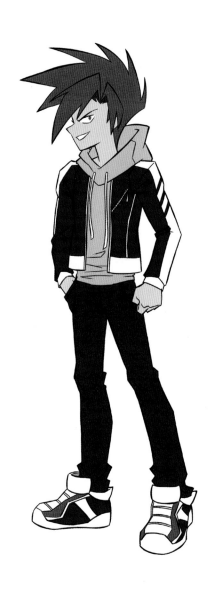

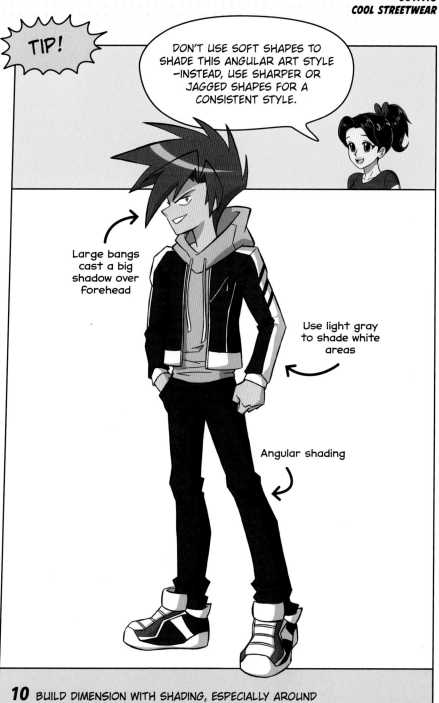

TIP!

DON'T USE SOFT SHAPES TO SHADE THIS ANGULAR ART STYLE —INSTEAD, USE SHARPER OR JAGGED SHAPES FOR A CONSISTENT STYLE.

Large bangs cast a big shadow over forehead

Use light gray to shade white areas

Angular shading

9 FOR THE OUTFIT, I'VE USED DARKER COLORS BUT KEPT SOME WHITE SECTIONS FOR A COOL CONTRAST. THE JACKET IS A VERY DARK GRAY TO ALLOW FOR BLACK SHADING IN THE NEXT STEP. THE SHOES HAVE STRIPES OF RED TO MATCH HIS HAIR.

10 BUILD DIMENSION WITH SHADING, ESPECIALLY AROUND THE CLOTHING CREASES. A PALE-RED CURVED SPIKE ACROSS THE HAIR WORKS AS A HIGHLIGHT.

WHAT A GREAT LOOK! I WONDER WHERE I CAN BUY THAT JACKET.

CASUAL CHIBI

You might think of chibi characters as being over-the-top cute, and you'd be right! This character, however, is bucking the trend with her cool, casual outfit. I think we can all agree, though, she still looks rather sweet!

1 LET'S START WITH A SIMPLE CROP TOP, WHICH BEGINS WITH TWO CURVED LINES GOING ACROSS THE FRONT OF HER BODY.

Curve the line around her shoulder for an off-the-shoulder look

2 FINISH THE SHIRT WITH RECTANGULAR SHORT SLEEVES THAT FOLLOW THE LINES OF HER UPPER ARMS. ADD A ZIG-ZAG CREASE IN THE MIDDLE OF HER SHIRT.

SUPER COOL –BUT SHE'S STILL A CUTIE!

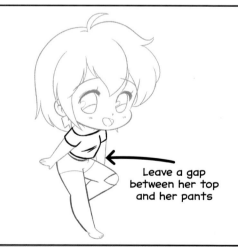

Leave a gap between her top and her pants

3 DRAW TIGHT-FITTING PANTS ALONG HER LEGS, LEAVING A SHARP GAP OVER HER BENT KNEE, WHICH WILL BECOME A RIP IN HER JEANS.

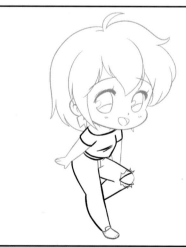

4 ADD FRAYED EDGES AROUND THE KNEE RIP AND DRAW EXTRA DETAILS ON THE JEANS. THEN, DRAW HER SHOE, MAKING IT REALLY TINY AND ADORABLE, AS BEFITS A CHIBI FOOT!

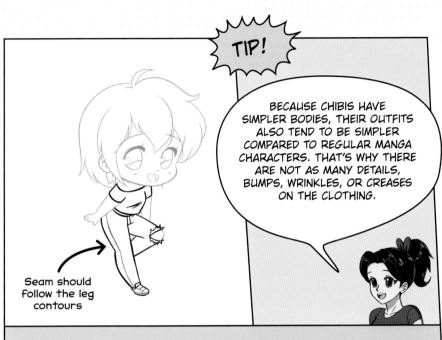

Seam should follow the leg contours

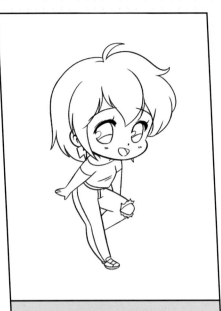

TIP!

BECAUSE CHIBIS HAVE SIMPLER BODIES, THEIR OUTFITS ALSO TEND TO BE SIMPLER COMPARED TO REGULAR MANGA CHARACTERS. THAT'S WHY THERE ARE NOT AS MANY DETAILS, BUMPS, WRINKLES, OR CREASES ON THE CLOTHING.

5 DRAW A SEAM GOING DOWN THE LEG OF THE PANTS, WHICH MAKES THEM LOOK MORE LIKE JEANS (SEE THE MASTERCLASS ON PAGE 181). THEN, ADD SIMPLE LINES TO COMPLETE THE DESIGN OF THE SHOE.

6 INK YOUR FINAL LINES. IT'S LOOKING GREAT, BUT ONCE WE ADD THE COLORS, SHE'LL COME ALIVE!

Strip of white on earring gives metallic shine

Lighter color accentuates the frayed edges

7 COLOR THE CHIBI'S SKIN, FACE, HAIR, AND EARRING FIRST. GIVE HER A STRIKING BLUE HAIRDO, DARK- AND LIGHT-BLUE EYES, AND A METALLIC LIGHTNING-SHAPED DANGLY EARRING!

8 FILL IN THE OUTFIT COLORS. USE DARKER, MUTED TONES INSTEAD OF BRIGHTS TO AVOID GOING OVERBOARD WITH CUTENESS.

9 SHADE USING DARKER COLORS IN CHUNKY ROUNDED SECTIONS. KEEP THE LINES SIMPLE. ADD CURVED, OVAL HIGHLIGHTS TO THE HAIR, WHICH WILL REALLY BRING OUT THE VOLUME.

FABRICS AND TEXTURES

We've learned how to draw various outfits. Now, let's compare different fabrics and textures so you can adapt and update your character's outfits however you choose!

THICK VERSUS THIN FABRIC

As seasons change, your characters may want to choose between thicker and thinner fabrics. There are several easy ways to differentiate between a warm, thick sweater and a thin, stretchy top.

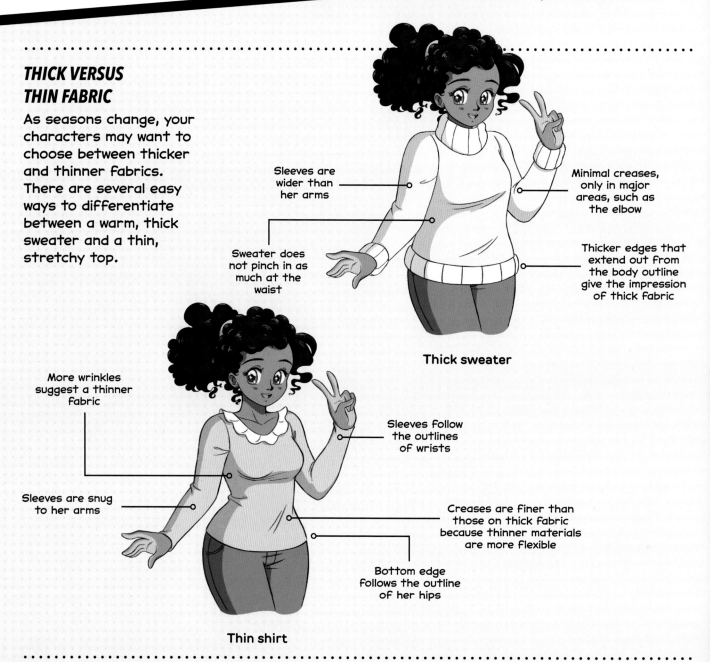

Sleeves are wider than her arms

Sweater does not pinch in as much at the waist

Minimal creases, only in major areas, such as the elbow

Thicker edges that extend out from the body outline give the impression of thick fabric

Thick sweater

More wrinkles suggest a thinner fabric

Sleeves are snug to her arms

Sleeves follow the outlines of wrists

Creases are finer than those on thick fabric because thinner materials are more flexible

Bottom edge follows the outline of her hips

Thin shirt

CLOTHING MATERIALS

Your characters probably take their time when choosing their outfits, so why shouldn't you? Knowing how to draw a range of materials can help add detail or even personality to your character. Do they love relaxing at home in cozy knit sweaters, or would they prefer a cool leather jacket to make a statement?

Denim

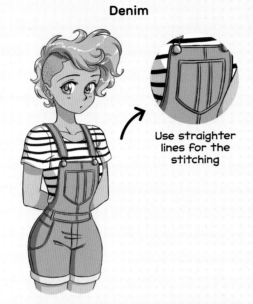

Use straighter lines for the stitching

These denim overalls have a lot of seams and stitching. The way the shorts end slightly away from the edges of her legs show the overalls are thicker than the red cotton T-shirt (below). Overlapping pockets, metal clasps, and other structural details reinforce the denim look.

Leather

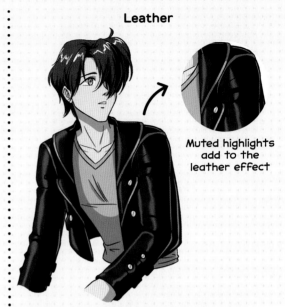

Muted highlights add to the leather effect

Leather jackets can make anyone look *cool!* Often, the folds and creases are fewer and softer in shape because leather is quite thick. The folds we do see are mainly clustered at the major joints. To achieve a realistic leather shine, shading and lighting are key.

Cotton

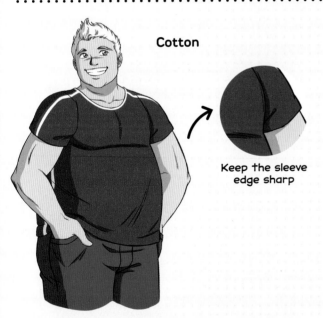

Keep the sleeve edge sharp

This character wears a typical cotton T-shirt. The fabric is thin and stretchy, so it follows his body's contours closely. The creases in the shirt help make the fabric look soft.

Wool

For a cable-knit pattern, draw two thick, soft zig-zags, one going over the other

The fabric of this cozy cable-knit sweater is thick and structured, so it contours to her body more loosely. There aren't many wrinkles or folds, just a couple around the underarm and elbow bends. The cable-knit pattern easily identifies the fabric, while the thick shading around the cabling makes it look chunky and heavy.

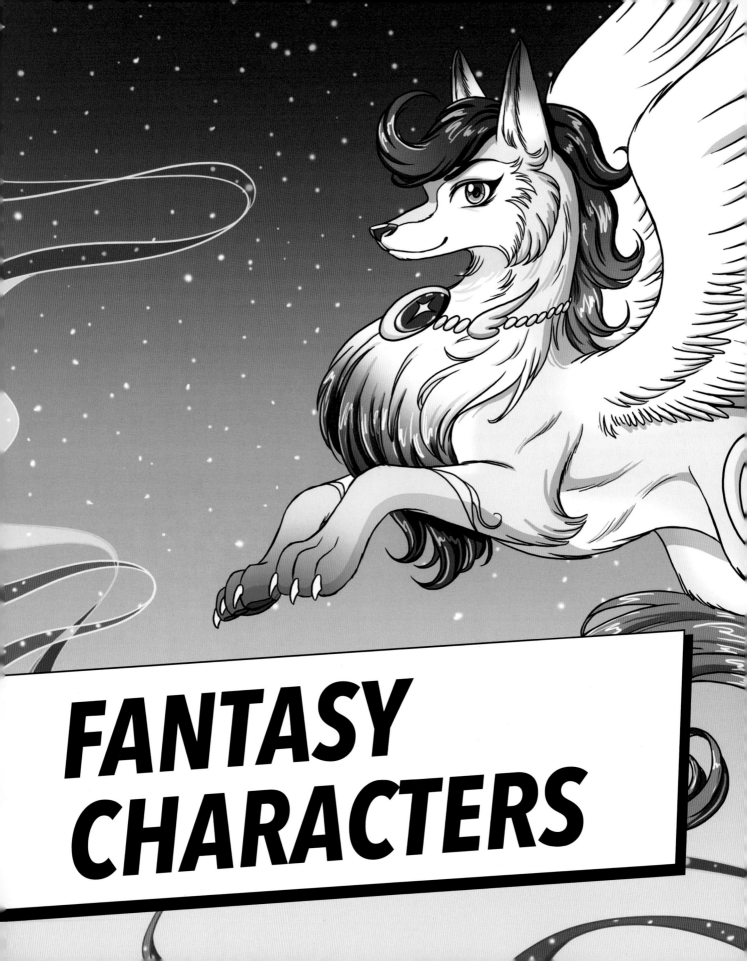

FANTASY CHARACTERS

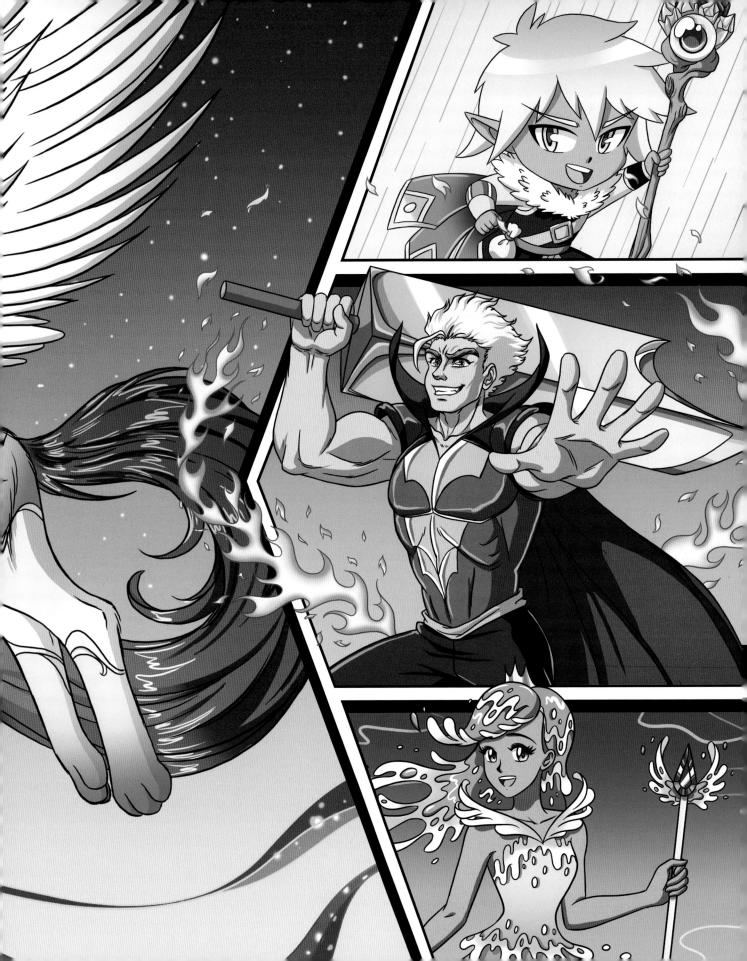

CHIBI PRINCE

In this chapter, we are going to create characters to populate your fantastical stories. And where better to start than with a character setting off on a quest? With his fine robes and scepter, this chibi prince is ready for adventure.

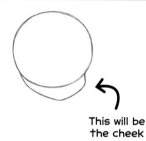

This will be the cheek

1 START WITH THE TWO BASIC SHAPES FOR THE HEAD. OUR PRINCE IS A CHIBI CHARACTER, SO THE ROUND FOREHEAD SHOULD BE BIG COMPARED TO THE SMALL CHEEK AND CHIN.

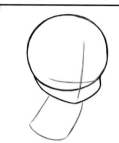

2 DRAW THE FACE GUIDELINES REALLY LOW IN THE CIRCLE AND ADD A SMALL RECTANGLE AT AN ANGLE, WHICH WILL BE HIS LITTLE TORSO.

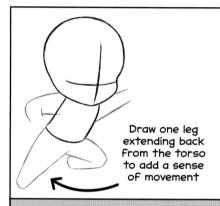

Draw one leg extending back from the torso to add a sense of movement

3 WE'RE GOING TO DRAW THIS CHARACTER IN AN ACTION POSE! ADD SHORT, STOCKY ARMS AND LEGS EXTENDING OUT FROM THE TORSO.

4 SKETCH A DETERMINED EXPRESSION ON HIS FACE, WITH ANGLED EYEBROWS, A CONFIDENT SMILE, AND LARGE, POINTED EYE SHAPES. THEN, ADD HANDS, FEET, AND BASIC DETAILS TO HIS CLOTHING— INCLUDING A NECKLINE, BELT, AND THE TOPS OF HIS BOOTS.

We're going all out with the ears, but you can only see one at this angle

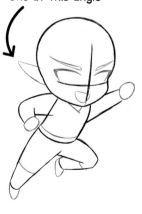

5 ADD OVAL IRISES AND PUPILS TO THE EYES AND LINES FOR THE TEETH AND TONGUE. OUTLINE HIS HAIR, USING LARGE, POINTY LEAF SHAPES DRAPED OVER HIS HEAD. THEN, DRAW MORE OF HIS OUTFIT DETAILS.

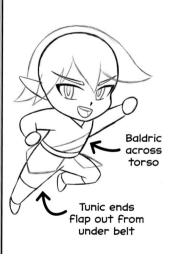

Baldric across torso

Tunic ends flap out from under belt

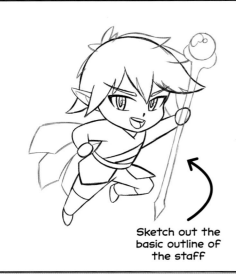

Sketch out the basic outline of the staff

6 BUILD UP THE VOLUME OF HIS HAIR WITH MORE CURVED POINTS. ADD PUPIL HIGHLIGHTS AND EAR DETAILS AND THEN DRAW THREE JAGGED SECTIONS COMING FROM BEHIND HIS BODY TO START HIS CAPE.

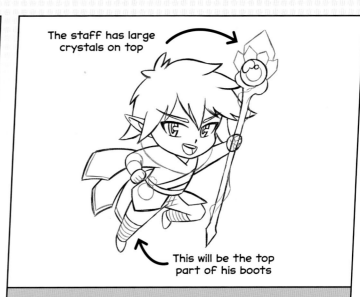

The staff has large crystals on top

This will be the top part of his boots

7 DIVIDE THE HANDS INTO FINGERS. ON THE OUTSTRETCHED HAND, HIS FINGERS SHOULD ENCIRCLE THE SCEPTER. DRAW A SIMPLE COIN PURSE ON ONE SIDE OF HIS BELT AND THEN ADD A BIG COLLAR. ADD MORE DETAILS TO THE CLOTHING.

8 ADD A FLUFFY TEXTURE TO THE COLLAR WITH CLUMPS OF CURVED LINES. THEN, SKETCH IN MORE DETAIL TO THE OUTFIT WITH ACCENT LINES, INCLUDING A BUCKLE ON THE BALDRIC AND PANT CREASES WHERE THEY TUCK INTO THE BOOTS.

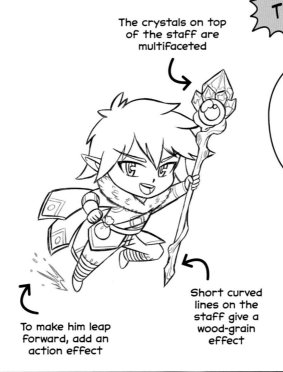

The crystals on top of the staff are multifaceted

To make him leap forward, add an action effect

Short curved lines on the staff give a wood-grain effect

TIP!

FOR THE STAFF'S WOODEN TEXTURE, KEEP A COUPLE LINES CLOSE TO EACH OTHER HERE AND THERE TO SUGGEST A BUMPY SURFACE. SPREAD THESE GROUPS OF LINES THROUGHOUT TO KEEP THE TEXTURE CONSISTENT.

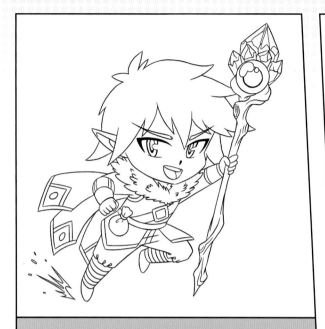

9 ERASE ANY EXTRA LINES AND GO OVER YOUR LINE ART BEFORE WE START ADDING OUR BASE COLORS.

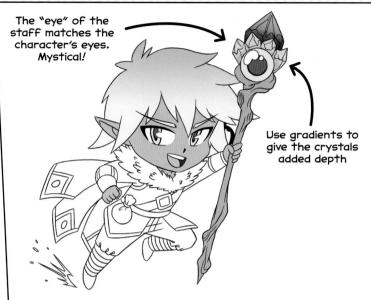

The "eye" of the staff matches the character's eyes. Mystical!

Use gradients to give the crystals added depth

10 COLOR THE SKIN, EYES, HAIR, AND STAFF. WE'RE GIVING THIS CHIBI PRINCE MINT-GREEN HAIR ON THE TOP, FADING TO A VERY PALE COLOR AT THE BOTTOM.

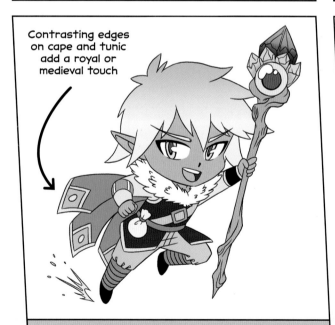

Contrasting edges on cape and tunic add a royal or medieval touch

11 FILL IN THE COLORS OF THE CHARACTER'S OUTFIT. I'VE GONE WITH GREENS TO MATCH HIS HAIR AND GOLDS AND BROWNS TO ADD CONTRAST.

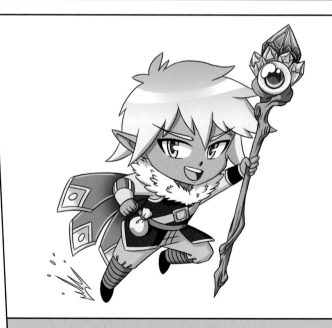

12 USE DARKER AND LIGHTER COLORS TO CREATE SHADING AND HIGHLIGHTS. ADD SOME DEEP SHADOWS ON THE STAFF AND LOTS OF UNEVEN SHADOWS AND HIGHLIGHTS TO THE CRYSTALS TO REALLY BRING THEM OUT.

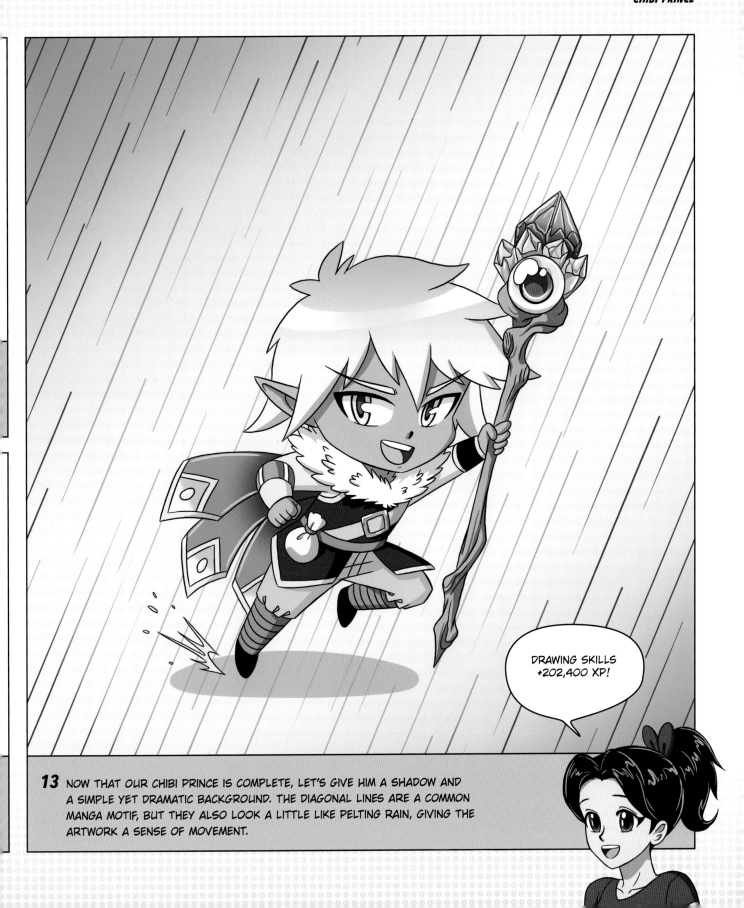

DRAWING SKILLS
+202,400 XP!

13 NOW THAT OUR CHIBI PRINCE IS COMPLETE, LET'S GIVE HIM A SHADOW AND
A SIMPLE YET DRAMATIC BACKGROUND. THE DIAGONAL LINES ARE A COMMON
MANGA MOTIF, BUT THEY ALSO LOOK A LITTLE LIKE PELTING RAIN, GIVING THE
ARTWORK A SENSE OF MOVEMENT.

QUEEN OF WATER

What if the oceans had a ruler—the Queen of Water? She'd obviously make a splash, wearing all the blue colors, but how would her hair look? What would she wear? Let's draw this glamorous guardian with her flowing, watery gown!

Leave plenty of space below for her body

1 DRAW HER FACE AS A CIRCLE WITH AN ASYMMETRICAL TRIANGLE BENEATH IT.

2 DRAW THE FACE GUIDELINES LEFT OF CENTER AND THEN SKETCH HER TORSO AS A PINCHED RECTANGLE. HER FACE WILL LOOK TO THE LEFT WHILE HER BODY MOVES TO THE RIGHT, SO PLACE THE BODY GUIDELINES RIGHT OF CENTER.

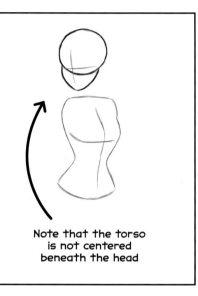

Note that the torso is not centered beneath the head

3 PLACE CIRCULAR EYE SHAPES, A SMALL NOSE, AND A SOFT, TRIANGULAR MOUTH. THEN, ADD AN EAR AND A LONG, GRACEFUL NECK. DRAW THE UPPER LEGS AS STRETCHED OVALS THAT TAPER GENTLY DOWN INTO HER KNEES.

Leave a small gap in lower lip

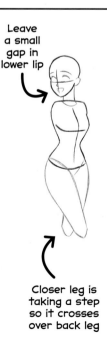

Closer leg is taking a step so it crosses over back leg

4 START THE QUEEN'S WATERY HAIR AS AN EXAGGERATED TEARDROP SHAPE AT THE FRONT. DRAW IN BASIC LINES FOR THE HAIRLINE AND LONG, FLOWING HAIR. ADD FACE DETAILS AND THEN BUILD THE ARMS AND LOWER LEGS WITH MORE TAPERED CYLINDERS.

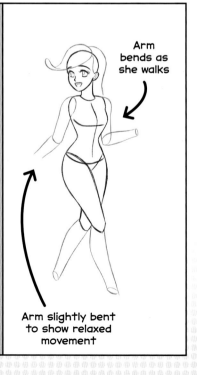

Arm bends as she walks

Arm slightly bent to show relaxed movement

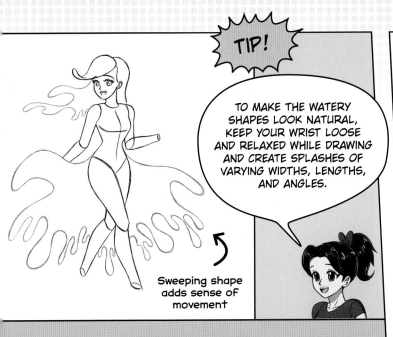

TIP!

TO MAKE THE WATERY SHAPES LOOK NATURAL, KEEP YOUR WRIST LOOSE AND RELAXED WHILE DRAWING AND CREATE SPLASHES OF VARYING WIDTHS, LENGTHS, AND ANGLES.

Sweeping shape adds sense of movement

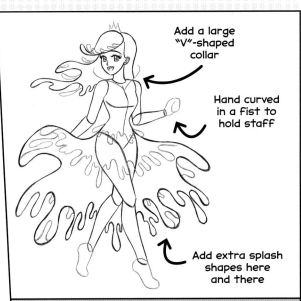

Add a large "V"-shaped collar

Hand curved in a fist to hold staff

Add extra splash shapes here and there

5 COMPLETE THE BASIC OUTLINE OF THE HAIR, WITH WATERY SHAPES SWEEPING AWAY FROM HER FACE. CREATE HER DRESS, USING SPLASH SHAPES WITH LOTS OF CURVES AND WAVES. WE'LL DIVIDE THE DRESS INTO SMALLER SECTIONS IN THE NEXT STEP.

6 DIVIDE THE HAIR AND DRESS BY USING SIMILAR SPLASH SHAPES AND THEN ADD EXTRA PIECES COMING OUT FROM THE SIDES. GIVE HER A SIMPLE CROWN, FILL IN HER EYES, AND ADD SHOE SHAPES.

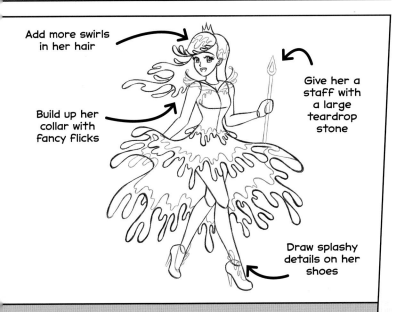

Add more swirls in her hair

Build up her collar with fancy flicks

Give her a staff with a large teardrop stone

Draw splashy details on her shoes

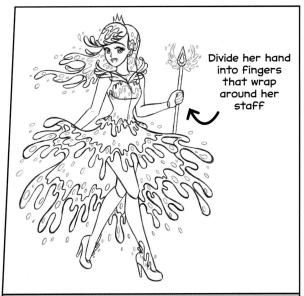

Divide her hand into fingers that wrap around her staff

7 ERASE THE LEG STRUCTURE LINES UNDERNEATH THE FRONT OF THE DRESS SO WE CAN SEE ITS SHAPE MORE CLEARLY. DRAW A BORDER AT THE EDGE OF EACH DRESS LAYER AND THEN COMPLETE THE COLLAR AND NECKLINE OF THE BODICE.

8 DRAW SMALL OVAL WATER DROPLETS ALL OVER HER DRESS, HAIR, AND SHOES. ADD EVEN MORE COMING AWAY SO SHE SPLASHES AS SHE WALKS! LET'S GIVE HER STAFF SOME WATERY WINGS AS WELL.

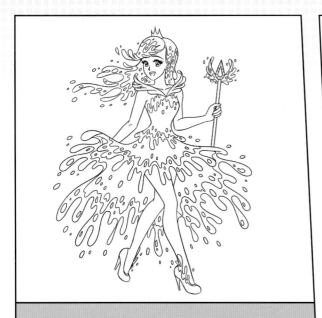

9 FINALIZE YOUR OUTLINES, TAKING CARE TO KEEP TRACK OF WHICH LINES WILL FORM THE EDGES OF HER DRESS AND HAIR. THEN, INK THE LINES WITH A BRUSH PEN OR OUTLINER.

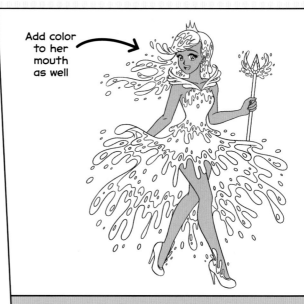

Add color to her mouth as well

10 LET'S COLOR HER FACE AND BODY FIRST. BECAUSE HER DRESS AND HAIR WILL HAVE ALL BLUE TONES, I'VE PICKED A CONTRASTING GOLDEN YELLOW FOR HER EYES. THEY MATCH HER CROWN TOO!

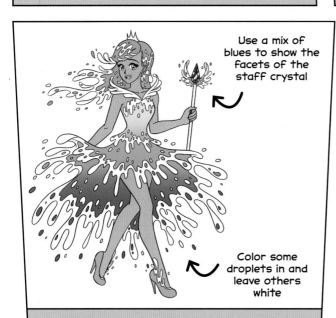

Use a mix of blues to show the facets of the staff crystal

Color some droplets in and leave others white

11 NOW, FOR THE BLUES. I'VE USED A MEDIUM BLUE AS THE HAIR BASE COLOR AND A GRADIENT GOING FROM LIGHT DOWN TO DARK IN HER DRESS. THE BORDERS ARE WHITE TO LOOK LIKE SEAFOAM!

Splashes of foam on the shoes too!

12 USE DARKER AND LIGHTER COLORS TO BUILD DIMENSION. ADD WHITE HIGHLIGHTS TO THE DRESS, HAIR, AND SHOES TO EMPHASIZE THE WATER'S SHINY SURFACE. THEN, USE DARKER HUES TO SHADE. I'VE BLENDED SOME LIGHT BLUE INTO THE FOAM AREAS AS WELL.

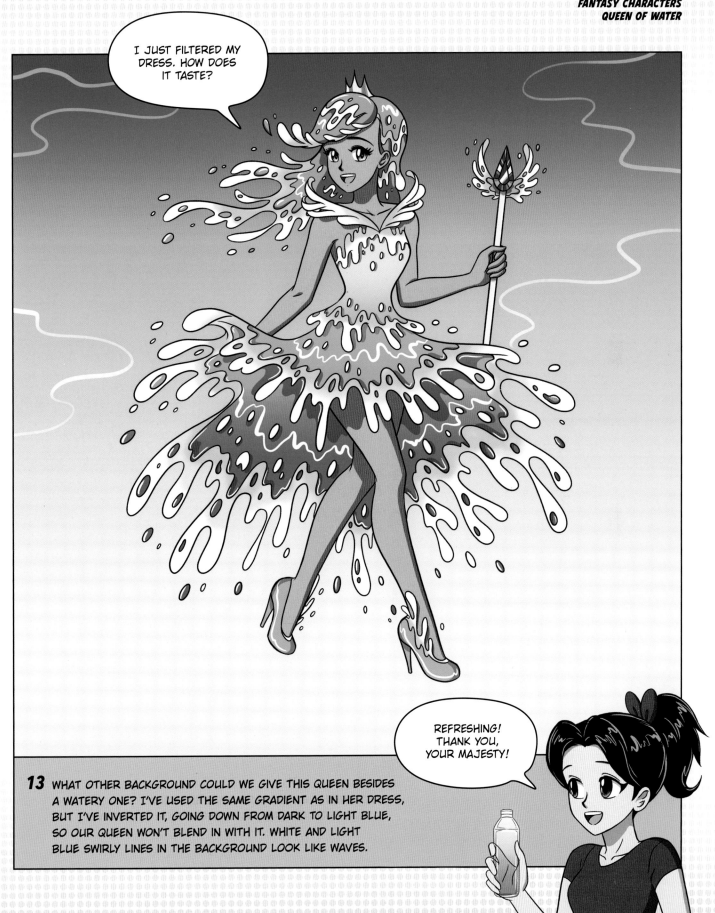

13 WHAT OTHER BACKGROUND COULD WE GIVE THIS QUEEN BESIDES A WATERY ONE? I'VE USED THE SAME GRADIENT AS IN HER DRESS, BUT I'VE INVERTED IT, GOING DOWN FROM DARK TO LIGHT BLUE, SO OUR QUEEN WON'T BLEND IN WITH IT. WHITE AND LIGHT BLUE SWIRLY LINES IN THE BACKGROUND LOOK LIKE WAVES.

TEEN SUPERHERO

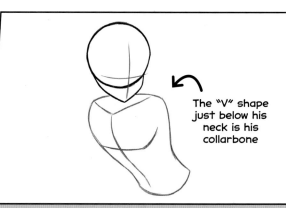

This shonen superhero has been real fired up lately! He has some truly super features, including a head of flames, a whirling burst of special powers, and a cool superhero pose that he's obviously been practicing.

1 DRAW THE HEAD SHAPE USING A CIRCLE AND A WIDE, SHALLOW TRIANGLE BENEATH IT. LEAVE A LOT OF SPACE TO THE RIGHT OF THE CHARACTER FOR THE POSE AND SUPERPOWERS.

The "V" shape just below his neck is his collarbone

2 FOR A DYNAMIC POSE, ANGLE THE TORSO DOWN QUITE DRAMATICALLY. DRAW GUIDELINES ON THE FACE, AND IT'S ALSO HELPFUL HERE TO ADD GUIDELINES ON THE BODY.

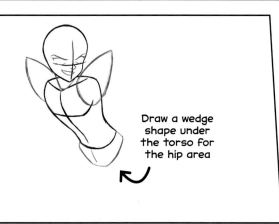

Draw a wedge shape under the torso for the hip area

3 THIS SUPERHERO OUTFIT WILL HAVE GIANT SHOULDER PIECES. SHAPE THEM LIKE BIG TEARDROPS. THEN, START DRAWING THE FACE WITH A CONFIDENT GRIN AND DETERMINED EYEBROWS.

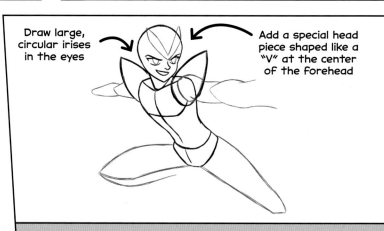

Draw large, circular irises in the eyes

Add a special head piece shaped like a "V" at the center of the forehead

4 THERE'S SOME DRAMATIC PERSPECTIVE GOING ON IN THIS POSE. MAKE THE CLOSER ARM MUCH BIGGER THAN THE BACK ARM, WHICH IS RECEDING. SKETCH THE LEGS AS LONG, CURVED RECTANGLES.

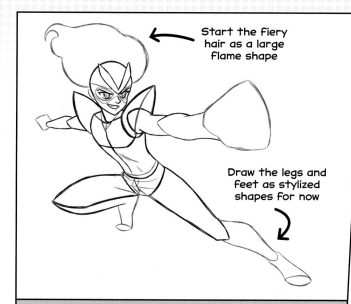

Start the fiery hair as a large flame shape

Draw the legs and feet as stylized shapes for now

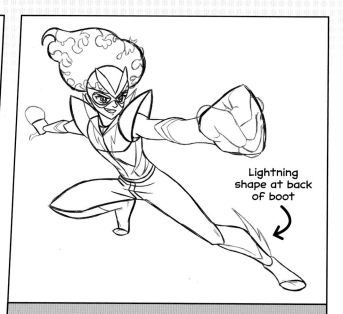

Lightning shape at back of boot

5 DRAW A LARGE, BUMPY WEDGE FOR THE CLOSER FIST. MAKE THE OTHER HAND A SMALL DIAMOND. BUILD THE FACIAL FEATURES AND EARS AND ADD A MASK AROUND THE EYES. THEN, SKETCH EDGES AND CREASES INTO HIS SUPERHERO SUIT.

6 LET'S FINISH THE CLOSER HAND WITH CLENCHED FINGERS. THE BACK HAND WILL HAVE FINGERS SPREAD OUT. DRAW FLAME-SHAPED CURVES AND POINTS IN THE HAIR. THEN, ADD JAGGED STRIPES AND OTHER COOL DETAILS TO HIS SUIT.

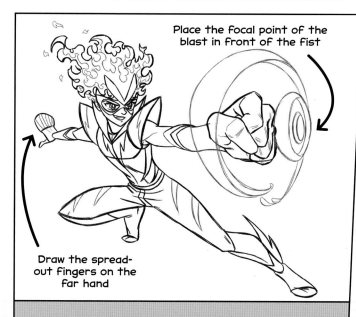

Place the focal point of the blast in front of the fist

Draw the spread-out fingers on the far hand

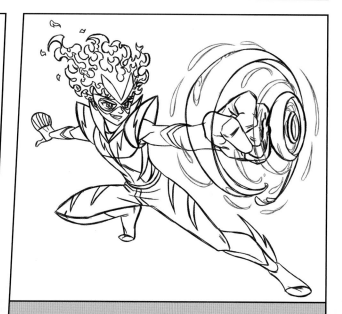

7 FILL OUT THE HAIR WITH MORE SQUIGGLY LINES AND JAGGED TIPS AND DRAW MORE STRIPES ON THE SUIT. ADD CREASES TO THE CLOSER HAND AND SKETCH CIRCULAR LINES TO SHOW THE SUPERCHARGED ENERGY BLAST COMING FROM HIS FIST.

8 TO MAKE THE BLAST LOOK MORE POWERFUL, CREATE ADDITIONAL LAYERS OF MAGICAL WISPS AND CIRCULAR SHAPES. TAPER THESE SHAPES AT ONE END TO ADD DIRECTION: IT'S A SWIRLING VORTEX—BADDIES, WATCH OUT!

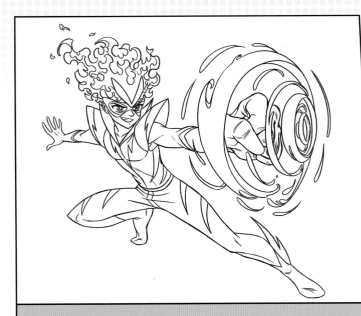

9 ERASE EXTRA LINES, ESPECIALLY WHERE THE CLOSER HAND IS OBSCURED BY THE ENERGY BLAST. USE A FINE-TIPPED MARKER OR BRUSH PEN TO GO OVER YOUR FINAL OUTLINES.

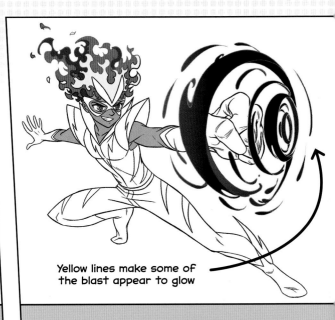

Yellow lines make some of the blast appear to glow

10 COLOR THE BODY, HAIR, AND SWIRLING VORTEX. I'VE USED FIERY COLORS FOR THE HAIR—AND EYES TO MATCH—AND DEEPER, MORE MAGICAL MAGENTA COLORS FOR THE ENERGY BLAST.

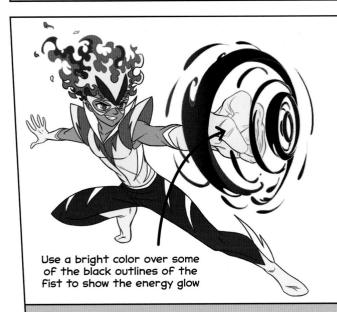

Use a bright color over some of the black outlines of the fist to show the energy glow

11 NEXT, ADD BASE COLORS TO THE COSTUME. I'VE USED THE SAME COLORS AS THE HERO'S FLAMING HAIR TO GIVE HIM A SUPER-FIERY APPEARANCE!

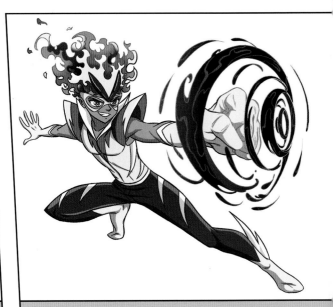

12 NOW, ADD SHADING AND HIGHLIGHTS EVERYWHERE TO ADD DEPTH AND REALISM. USE BRIGHT COLORS TO DRAW SQUIGGLY LINES OF MAGICAL ENERGY COURSING THROUGH THE ENERGY BLAST.

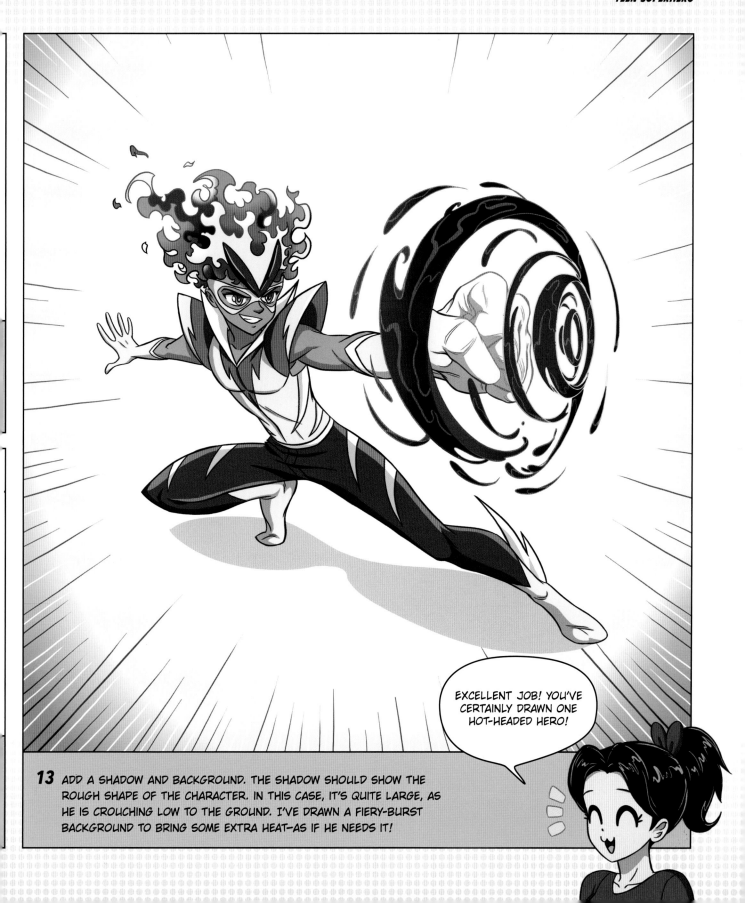

EXCELLENT JOB! YOU'VE CERTAINLY DRAWN ONE HOT-HEADED HERO!

13 ADD A SHADOW AND BACKGROUND. THE SHADOW SHOULD SHOW THE ROUGH SHAPE OF THE CHARACTER. IN THIS CASE, IT'S QUITE LARGE, AS HE IS CROUCHING LOW TO THE GROUND. I'VE DRAWN A FIERY-BURST BACKGROUND TO BRING SOME EXTRA HEAT—AS IF HE NEEDS IT!

EPIC WARRIOR

Check it out, a seinen fantasy warrior with a flowing cape and epic sword has come to visit. We're going to draw his chiseled face and muscular body, complete with shiny armor and cape! These techniques are useful for drawing all sorts of warriors, superheroes, and other fantasy characters.

1 BEGIN WITH THE TWO HEAD SHAPES AND GUIDELINES. FOR A LARGE, SQUARE JAW, MAKE THE TRIANGULAR SHAPE BIG AND BUMPY, WITH A FLAT CHIN. THEN, SKETCH A BLOCKY TORSO, LIKE A CURVED SQUARE. MAKE THE CHEST WIDE AND ADD GUIDELINES. LEAVE A SHORT DISTANCE AND THEN DRAW THE HIP SHAPE BENEATH IT. TRY TO TILT BOTH SHAPES SLIGHTLY TO GIVE THE POSE A MORE FLUID LOOK.

Position guidelines to the side for a front ³/₄ angle

2 CONNECT THE HEAD TO THE CHEST WITH A SHORT, THICK NECK. THEN, DRAW A WAIST, CONNECTING THE TORSO TO THE HIPS. START THE LARGE LEGS AS ROUNDED CYLINDERS THAT NARROW INTO KNEES AND THEN ANKLES.

This irregular shape will become a hand coming right at you!

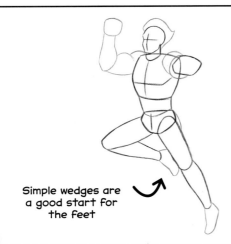

Simple wedges are a good start for the feet

3 DRAW A BASIC HAIR OUTLINE WITH A FLICK AT THE BACK. BEGIN ON THE MUSCULAR ARMS WITH A SERIES OF CURVED SHAPES. LET'S DRAW HIS BACK HAND RAISED.

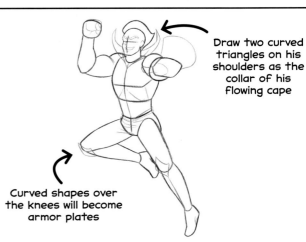

Draw two curved triangles on his shoulders as the collar of his flowing cape

Curved shapes over the knees will become armor plates

4 ADD THICK EYEBROWS ANGLING DOWN TOWARD A STURDY NOSE AND WIDE GRIN. DRAW HAND DETAILS, INCLUDING THUMBS AND FINGER SECTIONS. THEN, SKETCH WRINKLES AND FOLDS IN HIS CLOTHING.

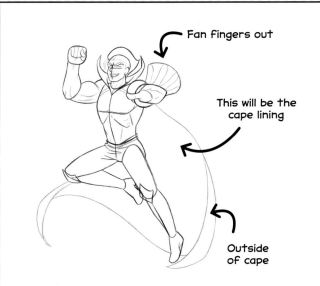

Fan fingers out

This will be the cape lining

Outside of cape

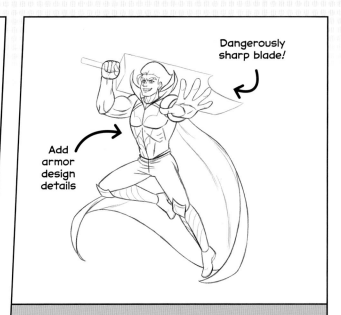

Dangerously sharp blade!

Add armor design details

5 DIVIDE THE HAND SHAPES INTO INDIVIDUAL FINGERS. ADD A HAIRLINE, EYES, AND OTHER DETAILS TO THE BODY TO SHOW MUSCLE AND BONE STRUCTURE. DRAW FOUR LARGE, CURVED TRIANGULAR SHAPES AS THE OUTLINE OF HIS CAPE.

6 SKETCH THE BASIC SHAPE OF HIS SWORD. THE SLIM HANDLE STICKS OUT PAST THE FINGERS OF THE RAISED HAND. ADD GLARING PUPILS, EAR LINES, AND FINGER DEFINITION. THEN, DRAW MORE CLOTHING AND CAPE DETAILS.

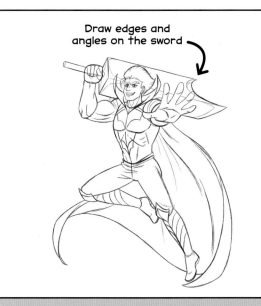

Draw edges and angles on the sword

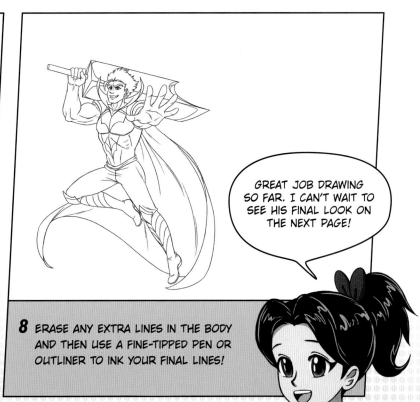

GREAT JOB DRAWING SO FAR. I CAN'T WAIT TO SEE HIS FINAL LOOK ON THE NEXT PAGE!

7 GIVE THE HAIR A DETAILED, NATURAL EDGE. THEN, ADD MORE CREASES AND DETAILS TO THE COSTUME, SLEEVES, CAPE, AND SWORD.

8 ERASE ANY EXTRA LINES IN THE BODY AND THEN USE A FINE-TIPPED PEN OR OUTLINER TO INK YOUR FINAL LINES!

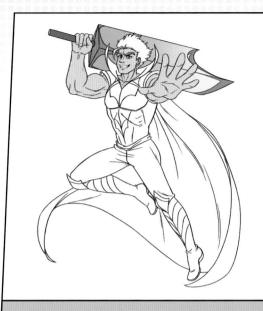

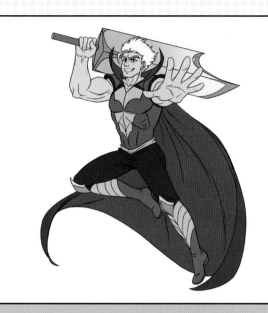

9 COLOR THE SKIN, HAIR, EYES, AND SWORD. I'VE USED A BLUE GRADIENT FOR THE BLADE, WHICH WILL REALLY STAND OUT AGAINST THE COLORS WE'RE GOING TO ADD LATER ON.

10 FILL IN THE CLOTHING, ARMOR, AND CAPE WITH COLORS OF YOUR CHOICE. I'VE USED A BRIGHT RED FOR THE CAPE'S DRAMATIC LINING, WHICH CONTINUES UP THE INSIDE OF THE COLLAR.

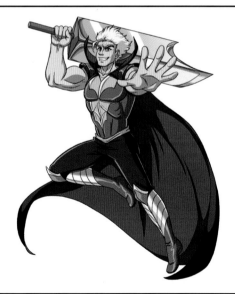

11 CREATE A STRIKING LOOK FOR OUR HERO WITH SEVERE SHADING. A LARGE DARK SHADOW ON THE CAPE BEHIND THE BODY GIVES A DRAMATIC LIGHTING EFFECT. THEN, USE LIGHTER COLORS TO CREATE SHINY HIGHLIGHTS ON THE ARMOR, BOOTS, AND SWORD.

TIP!

thin, turquoise blue area

white diagonal highlight

TO MAKE THE SWORD'S BLADE LOOK REALISTIC, ADD WHITE DIAGONAL HIGHLIGHTS. THEN, PLACE SLIM TURQUOISE LINES RIGHT ALONG THE SIDES OF THE HIGHLIGHTS TO HELP ACHIEVE A DAZZLING, METALLIC LOOK.

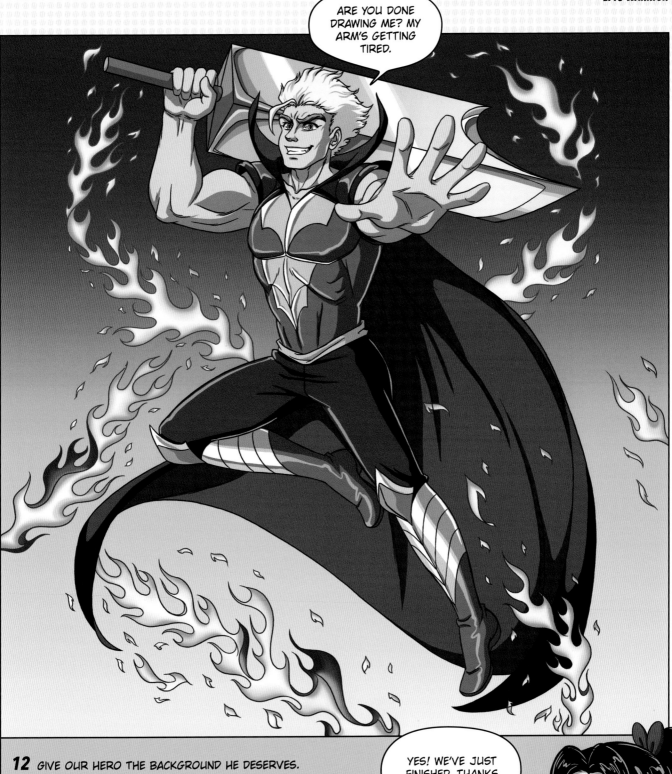

12 GIVE OUR HERO THE BACKGROUND HE DESERVES. CRACKLING FLAMES GIVE IT AN EPIC FINISHING TOUCH. I'VE USED THE WARM COLORS OF THE FLAMES IN THE BACKGROUND AS WELL, WHICH MAKES A PERFECT SUNSET HE CAN SOAR OFF INTO.

PONYTAIL ANGEL

Next up, we're going to draw a pretty, floating angel, whose big, expressive eyes and angelic appearance give off adorable shojo manga vibes. We've already drawn this character's eye on pages 28–29 and her face on pages 46–49. So, now let's draw her in full!

1 START WITH THE HEAD SHAPES. DRAW THE TRIANGLE WIDE BUT QUITE FLAT. DON'T FORGET A CUTE, POINTY CHIN!

2 THIS CHARACTER IS GOING TO BE LOOKING RIGHT AT US, SO PLACE THE FACE GUIDELINES IN THE CENTER. SKETCH HER TORSO AND HIPS AS A SINGLE PINCHED RECTANGLE WITH GUIDELINES THAT ARE SLIGHTLY OFF-CENTER TO MAKE HER BODY AT A SLIGHT ANGLE.

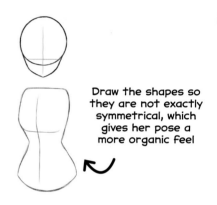

Draw the shapes so they are not exactly symmetrical, which gives her pose a more organic feel

3 ADD FACIAL FEATURES, INCLUDING HUGE CIRCULAR EYE OUTLINES AND A SMALL, SMILING MOUTH. RAISE HER EYEBROWS HIGH ON HER HEAD FOR LOTS OF CHEERFUL ENERGY. CONNECT THE HEAD TO THE TORSO WITH A SLIM NECK.

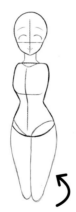

Add upper legs as large, stretched ovals

4 USE A LEAF SHAPE AS THE OUTLINE FOR THE FRONT OF HER HAIR. THEN, ADD MORE FACIAL DETAILS, INCLUDING LOTS OF EYE HIGHLIGHTS. DRAW ARMS AS SLIM CYLINDERS THAT TAPER INTO NARROW WRISTS. SIMILARLY, TAPER THE LOWER LEG SHAPES INTO HER ANKLES.

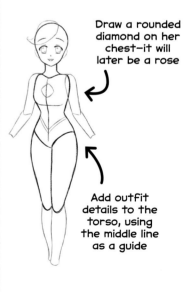

Draw a rounded diamond on her chest—it will later be a rose

Add outfit details to the torso, using the middle line as a guide

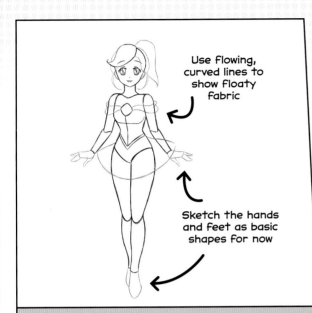

Use Flowing, curved lines to show floaty fabric

Sketch the hands and feet as basic shapes for now

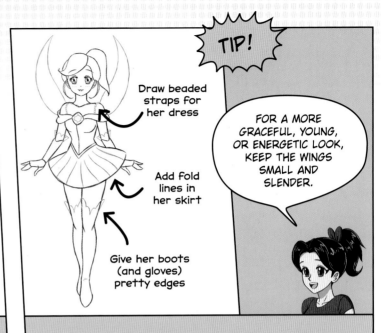

Draw beaded straps for her dress

Add fold lines in her skirt

Give her boots (and gloves) pretty edges

TIP!

FOR A MORE GRACEFUL, YOUNG, OR ENERGETIC LOOK, KEEP THE WINGS SMALL AND SLENDER.

5 DRAW MORE OF HER HAIR AND PONYTAIL, PLACE PUPILS IN HER EYES, AND THEN ADD BASIC SHAPES FOR HER OUTFIT. LET'S GIVE HER A SOFT, OFF-THE-SHOULDER TOP AND A SKIRT THAT FLARES OUT WIDE.

6 AN ANGEL ISN'T COMPLETE WITHOUT HER WINGS! DRAW THEM AS POINTED CURVES. ADD SUBTLE BLUSH LINES TO HER CHEEKS AND LOTS OF OUTFIT DETAILS. START A LAYER OF PETALS ALONG THE INSIDE EDGES OF THE DIAMOND ON HER CHEST.

Add dimension to the skirt by drawing small loops that curl around at the end of each fold line

Divide the basic hand shapes into fingers

7 ADD WISPS AND CURLED TIPS TO THE HAIR. DRAW A CURVED LINE THROUGH THE WINGS (ROUGHLY IN THE CENTER) AND SKETCH FEATHERS BENEATH IT. THEN, ADD MORE DETAIL TO THE OUTFIT WITH SKIRT FOLDS AND OTHER LINES.

8 LAYER MORE FEATHERS IN THE WINGS, FOLLOWING THE INNER CURVED LINES. ADD TEXTURE TO THE HAIR AND THEN DRAW MORE FINE DETAILS INTO HER DRESS AND THE ROSE ON HER CHEST.

9 ERASE ALL THE EXTRA LINES AND FINALIZE YOUR LINE ART. MAKE THE EDGES OF THE ROSE ON HER CHEST LOOK MORE REALISTIC BY BREAKING OUT SLIGHTLY FROM THE BASIC DIAMOND SHAPE WE DREW EARLIER.

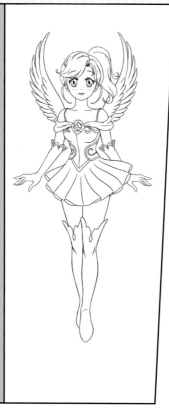

10 ADD BASE COLORS TO HER SKIN, HAIR, AND FACE. I'VE USED A CANDY-COLORED GRADIENT FOR HER PONYTAIL HAIRSTYLE AND CONTRASTING GREEN EYES WITH BRIGHT-GREEN OVERTONES. THEY REALLY POP!

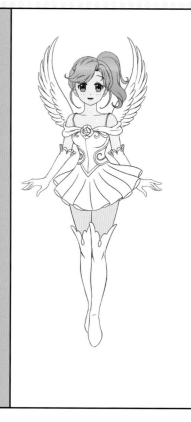

11 LET'S GIVE THIS CHARACTER A PASTEL COLOR PALETTE, INCLUDING PINKS, YELLOWS, AND BLUES. HOW CUTE THAT HER SKIRT HAS A SIMILAR PINK-TO-BLUE EFFECT TO MATCH HER HAIR!

Use a light-blue fade effect to bring out the edges of her white boots and gloves

12 CREATE DEPTH AND DIMENSION BY ADDING SHADOWS WITH DARKER COLORS. DRAW THIN WHITE LINES IN HER HAIR FOR SHINY HIGHLIGHTS AND AN IRREGULAR STRIPED PATTERN OF YELLOWS AND WHITE ON THE WAISTBAND OF HER DRESS FOR A METALLIC EFFECT.

Shading helps show the direction of the light source in your illustration

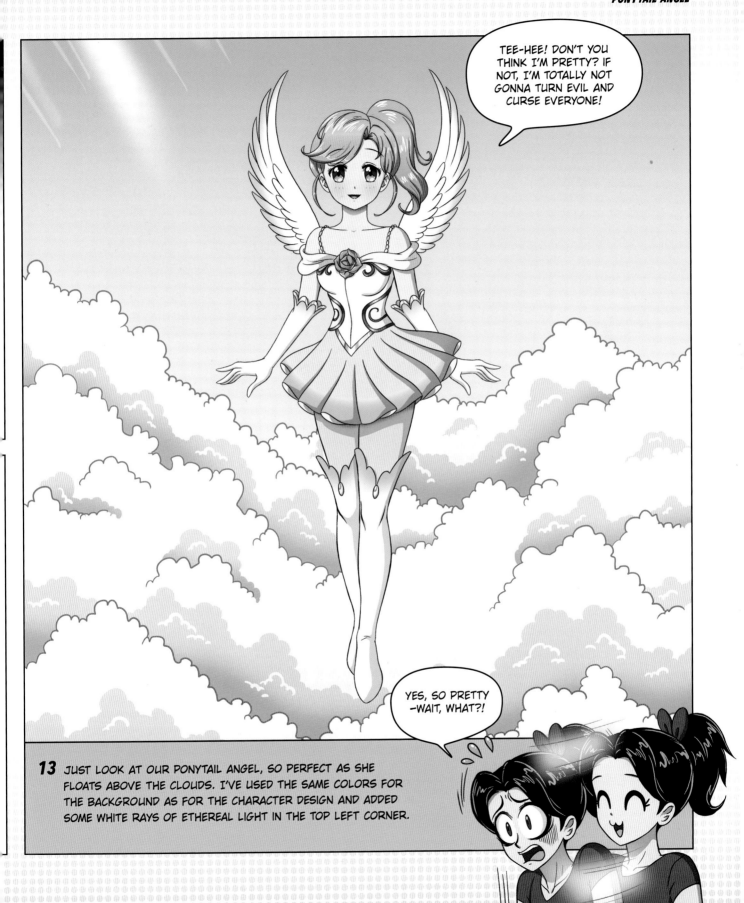

13 JUST LOOK AT OUR PONYTAIL ANGEL, SO PERFECT AS SHE FLOATS ABOVE THE CLOUDS. I'VE USED THE SAME COLORS FOR THE BACKGROUND AS FOR THE CHARACTER DESIGN AND ADDED SOME WHITE RAYS OF ETHEREAL LIGHT IN THE TOP LEFT CORNER.

WOLF MOON GUARDIAN

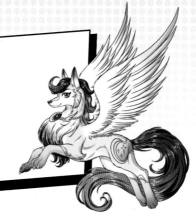

It's time to draw a fantasy manga animal now. And just look at how sweet! This otherworldly white wolf is a mystical flying Moon Guardian, complete with feathered wings, sleek, long hair, a magical pendant, and a knowing smile.

Leave plenty of space for the body

1 FOR THE HEAD, WE'LL START WITH OUR USUAL TWO SHAPES, THOUGH THE CONFIGURATION IS DIFFERENT. ON ONE SIDE OF THE CIRCLE, DRAW A ROUNDED TRIANGLE FOR THE SNOUT, A LITTLE LIKE A DUCK'S BEAK.

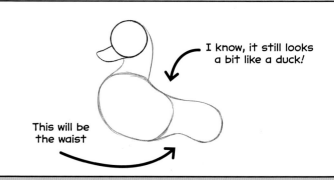

I know, it still looks a bit like a duck!

This will be the waist

2 GET STARTED ON THE BASIC BODY STRUCTURE WITH A LARGE, OVAL CHEST SHAPE. MAKE THE NECK GRACEFUL AND CURVED, WITH THE BASE THICKER THAN THE TOP. FOR THE WAIST AND HIPS, DRAW A SMALLER CURVED SHAPE.

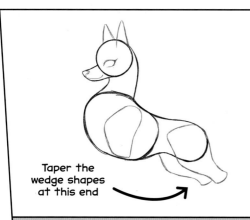

Taper the wedge shapes at this end

3 DRAW UPRIGHT POINTY EARS IN THE SHAPE OF THE LETTER "M" AND THEN SKETCH AN EYE, NOSE, AND MOUTH. USE WEDGE SHAPES TO START ON THE LIMBS.

4 OUTLINE A FANCY MANE THAT ENDS IN LOTS OF CURLED TIPS. THEN, ADD A BANGS SECTION WITH ONE EXTRA-LARGE FLICK! PLACE AN IRIS IN THE EYE (WITH A LITTLE HIGHLIGHT) AND THEN DRAW SOME CHEEK FUR UNDER HER JAW AND A LARGE, POINTED WING EXTENDED BEHIND HER.

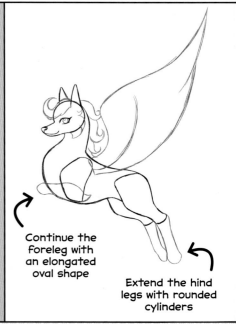

Continue the foreleg with an elongated oval shape

Extend the hind legs with rounded cylinders

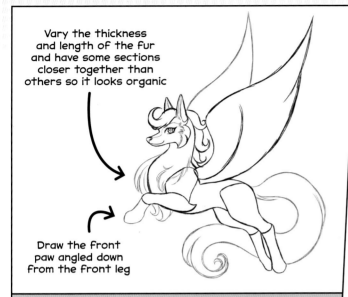

Vary the thickness and length of the fur and have some sections closer together than others so it looks organic

Draw the front paw angled down from the front leg

5 ADD THE OTHER WING AND THEN WORK ON THE FUR. DRAW CLOSELY PACKED FURRY EDGES ON THE FACE AND EARS. CONTINUE THE LUSCIOUS FUR DOWN THE NECK AND CHEST. SKETCH THE TAIL—LONG, FLOWING, AND WELL-GROOMED!

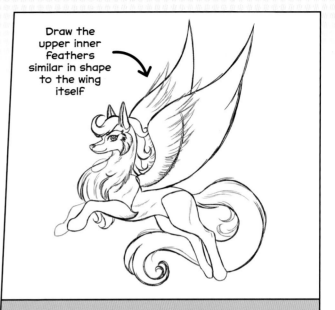

Draw the upper inner feathers similar in shape to the wing itself

6 SKETCH THE FAR FORELEG AND DRAW FUR TEXTURE LINES OVER THE BODY TO ADD REALISM. THEN, START ON THE INNER LAYER OF WING FEATHERS AND ADD AN OVAL ON THE CHEST—IT WILL BECOME A DECORATIVE MOON ELEMENT.

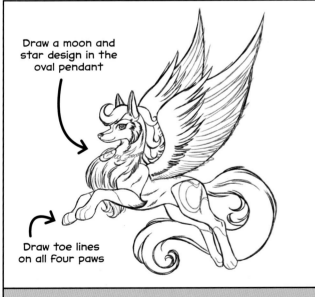

Draw a moon and star design in the oval pendant

Draw toe lines on all four paws

7 COMPLETE THE LARGE OUTER LAYER OF WING FEATHERS. KEEP TO THE OUTLINE GUIDE, BUT MAKE A FEW POKE OUT FOR A REALISTIC FINISH. DRAW DECORATIVE JEWELS AS A CHAIN AROUND HER NECK. THEN, ADD MAGICAL SWIRLS TO HER BODY.

8 ADD THE FINAL DETAILS: FINE LINES IN THE MANE AND TAIL FOR FLOWING TEXTURE AND TO MAKE THE HAIR LOOK SOFT. DRAW SPARKLY STARS ON THE HIP AND SWIRLY SHAPES ON THE LIMBS AND THEN ADD CLAWS TO THE FRONT PAWS.

9 FINALIZE YOUR DRAWING WITH A THIN MARKER, FINE-TIPPED PEN, OR OUTLINER. ERASE ANY EXTRA PENCIL LINES.

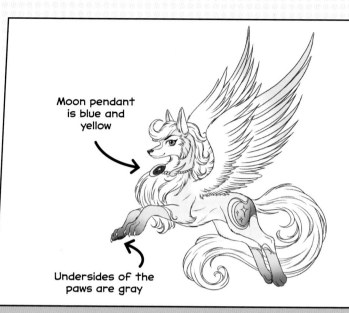

Moon pendant is blue and yellow

Undersides of the paws are gray

10 ADD BASE COLORS TO THE MAIN PART OF THE BODY. I'VE GIVEN THIS WOLF LIGHT GRAYISH-BLUE FUR WITH DARKER PATCHES ON HER PAWS AND HIP AREA. HER WINGS HAVE A BLUE TINGE AT THE TIPS, AND HER EYES ARE A SPARKLING BLUE.

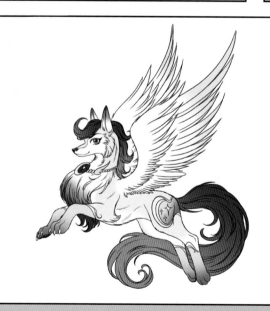

11 THIS CREATURE'S CARETAKER MUST BE A PRO AT LOOKING AFTER HER LUSCIOUS, SHINY HAIR. LOOK AT THOSE GLORIOUS PINK AND PURPLE COLORS!

12 SHADE THE WINGS AND BODY WITH DARKER BLUES. FOR THE LONG HAIR, USE DARKER PURPLES AND MAGENTAS FOR SHADE AND THEN CREATE SHINY HIGHLIGHTS ON TOP WITH BRIGHT-BLUE AND WHITE SQUIGGLES. HOW MAGICAL!

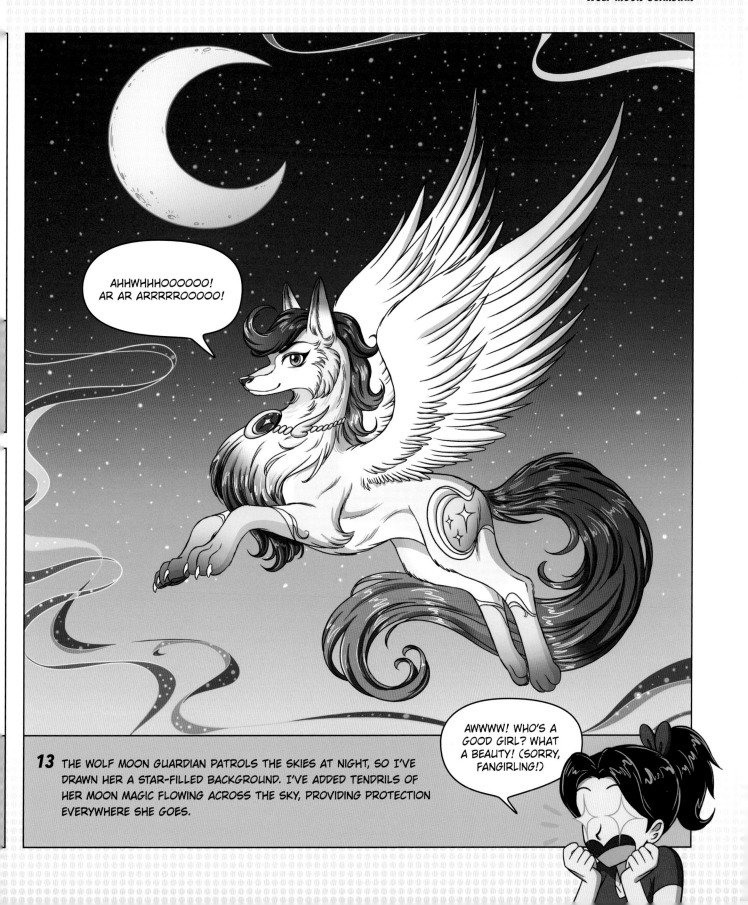

13 THE WOLF MOON GUARDIAN PATROLS THE SKIES AT NIGHT, SO I'VE DRAWN HER A STAR-FILLED BACKGROUND. I'VE ADDED TENDRILS OF HER MOON MAGIC FLOWING ACROSS THE SKY, PROVIDING PROTECTION EVERYWHERE SHE GOES.

CHARACTERS
REIMAGINED

WATER KING

Now, we're going to have some fun and reinvent a few of the characters we've drawn before! Let's reimagine the Queen of Water (from pages 188–191) as the... Water King in an awesome gender-swap lesson. We're going to keep some features recognizable, while adding a few cool twists.

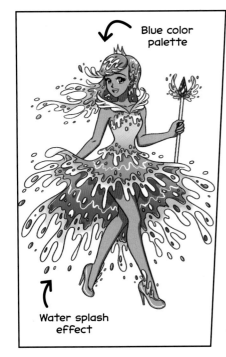

Blue color palette

Water splash effect

1 START HIS HEAD WITH A CIRCLE AND A WIDE, ANGULAR TRIANGLE SHAPE BENEATH IT.

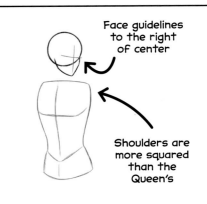

Face guidelines to the right of center

Shoulders are more squared than the Queen's

2 THE KING'S HEAD WILL BE LOOKING RIGHT, AND HIS BODY WILL BE FACING LEFT. DRAW A PINCHED RECTANGLE FOR HIS BROAD TORSO. THEN, ADD FACE AND TORSO GUIDELINES.

3 PLACE NARROW EYES ON THE FACE GUIDELINES, THEN A SHARP NOSE AND SIMPLE MOUTH. CONNECT THE HEAD TO THE TORSO WITH A THICK NECK AND THEN ADD ROUNDED RECTANGLES FOR THE UPPER LEGS.

4 GIVE HIM MUSCULAR ARMS THAT TAPER AT THE ELBOWS AND WRISTS. ADD LOWER LEGS, TOO, IN WALKING POSES. START THE HAIR WITH A FEW BASIC LINES, INCLUDING A LARGE, CURVED BANGS SHAPE–IT LOOKS LIKE A MINI TIDAL WAVE!

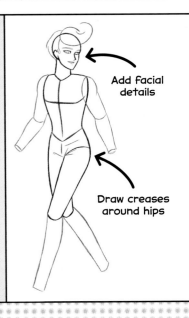

Add facial details

Draw creases around hips

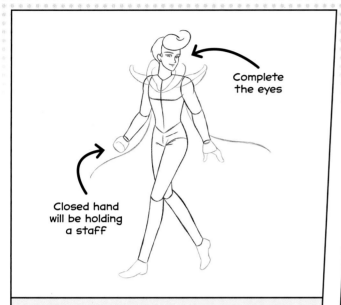

Complete
the eyes

Closed hand
will be holding
a staff

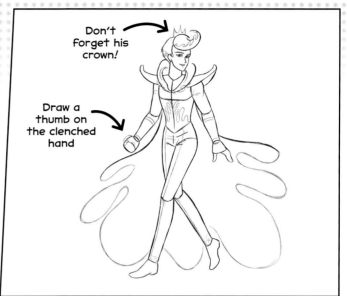

Don't
forget his
crown!

Draw a
thumb on
the clenched
hand

5 DRAW A LARGE, ROUNDED COLLAR AROUND HIS
NECK, WITH EXTRAVAGANT SHOULDER PIECES.
START HIS WATERY CAPE WITH TWO FLOWING
LINES. THEN, SKETCH BASIC SHAPES FOR HIS
HANDS AND FEET.

6 MAP OUT THE WATER-SPLASH SHAPE OF HIS CAPE,
USING LOOSE, SWIRLY LINES. ITS SHAPE IS SIMILAR TO
THE QUEEN'S DRESS. DRAW MORE WAVY SQUIGGLES IN
THE HAIR, COLLAR, AND ON THE TORSO. ADD DETAILS
TO HIS CLOTHING.

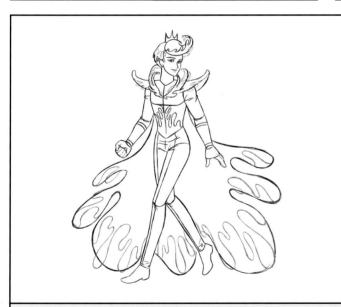

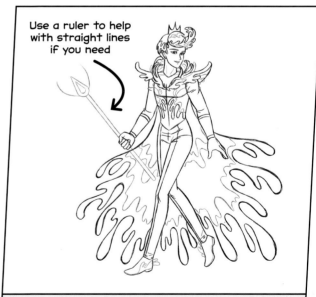

Use a ruler to help
with straight lines
if you need

7 DRAW MORE SPLASHY LINES AROUND THE CAPE'S
EDGE. VARY THE LENGTH, WIDTH, AND SHAPE OF
THE CURVES. DO THE SAME THING FOR THE COLLAR,
SHOULDER PIECES, AND HAIR. DRAW INDIVIDUAL
FINGER LINES IN THE HANDS.

8 ERASE STRUCTURE LINES AS YOU GO, INCLUDING
THE BASIC CAPE OUTLINE. NOW, ADD MORE WAVY
LINES TO THE CAPE, DRAW SPLASH DESIGNS ON
HIS SHOES, AND GIVE HIM A STAFF TO HOLD.

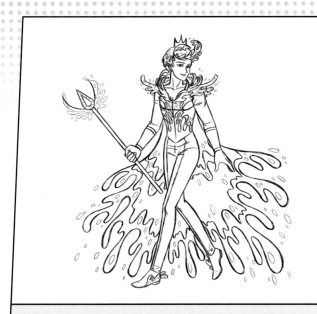

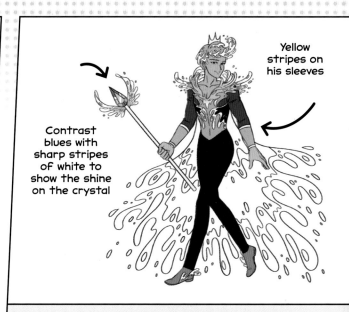

Contrast blues with sharp stripes of white to show the shine on the crystal

Yellow stripes on his sleeves

9 NOW FOR LOTS OF WATER DROPLETS! THESE CREATE A GREAT SENSE OF MOVEMENT. DRAW THEM ON HIS CLOTHING AND HAIR, WITH SEVERAL FLYING OFF. ADD WATER WINGS AND CRYSTAL FACETS TO THE TOP PART OF THE STAFF.

10 GO OVER THE FINAL LINES WITH AN OUTLINER. NOW, IT'S TIME FOR SOME COOL, WATERY BASE COLORS! FILL IN HIS BODY, HAIR, OUTFIT, AND STAFF. THROW IN POPS OF YELLOW TO BREAK UP THE BLUES.

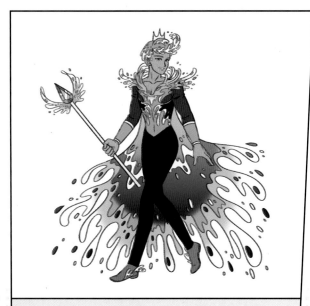

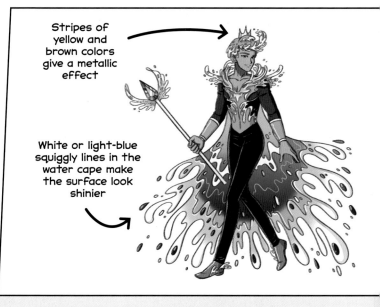

Stripes of yellow and brown colors give a metallic effect

White or light-blue squiggly lines in the water cape make the surface look shinier

11 MAKE SOME PARTS OF THE CAPE DARKER THAN OTHERS SO IT LOOKS LIKE THOSE AREAS OF WATER ARE DEEPER. MIX LIGHT BLUE INTO THE WHITE FOAM LAYERS FOR A BLENDED LOOK.

12 USE WHITE AND LIGHT BLUES TO ADD HIGHLIGHTS. THIS ADDS REALISM, BUT IT'S ALSO A GREAT WAY TO PRESERVE DETAILS IN DARKER SECTIONS, SUCH AS THE PANTS. THEN, ADD DARKER COLORS TO SHADE THE SKIN, OUTFIT, STAFF, AND CROWN.

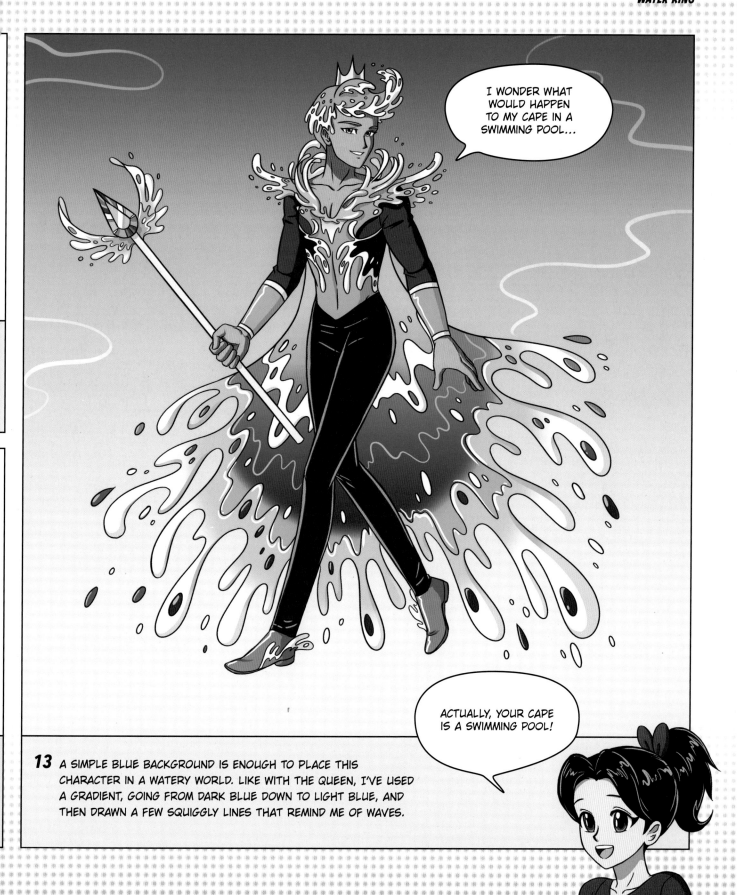

13 A SIMPLE BLUE BACKGROUND IS ENOUGH TO PLACE THIS
CHARACTER IN A WATERY WORLD. LIKE WITH THE QUEEN, I'VE USED
A GRADIENT, GOING FROM DARK BLUE DOWN TO LIGHT BLUE, AND
THEN DRAWN A FEW SQUIGGLY LINES THAT REMIND ME OF WAVES.

ANIMAL ALTER-EGO

Remember our Teen Superhero (from pages 192–195)? What if he had a second superpower—animal transformation? Imagine him surprising his foes mid-battle by turning into a horse!

Hair of flames

Striped superhero suit

Keep the nose area rounded at the end

1 START WITH FOUR SIMPLE SHAPES TO BUILD A SIDE VIEW OF THE HEAD, NECK, AND CHEST. BECAUSE THIS CHARACTER IS A HORSE, IT WILL BE VERY DIFFERENT IN SHAPE THAN OUR HUMAN CHARACTERS!

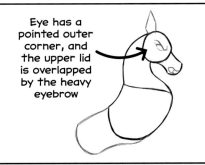

Eye has a pointed outer corner, and the upper lid is overlapped by the heavy eyebrow

2 DRAW THE WAIST SLOPING DOWN TOWARD THE HIP AREA. THEN, ADD A POINTY EAR, A DETERMINED-LOOKING EYE AND EYEBROW, AND AN OPEN MOUTH.

Erase unnecessary lines from the face

3 DRAW LINES IN THE CHEEK TO SHOW THE FACIAL MUSCLES. ADD AN IRIS IN THE EYE, A CURLY NOSTRIL, AND DETAILS TO THE MOUTH. USE WEDGE SHAPES TO START OFF THE MUSCULAR SHOULDERS AND LEGS.

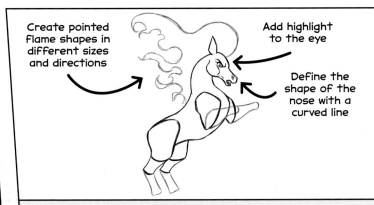

Create pointed flame shapes in different sizes and directions

Add highlight to the eye

Define the shape of the nose with a curved line

4 DRAW A WILD, FLAMING MANE COMING OUT FROM THE HEAD AND NECK. THIS IS A GREAT CALLBACK TO THE HERO'S HUMAN FORM AND HIS FLAMING HAIR! EXTEND THE LEGS WITH NARROW CYLINDERS.

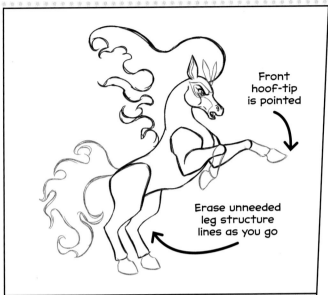

Front
hoof-tip
is pointed

Erase unneeded
leg structure
lines as you go

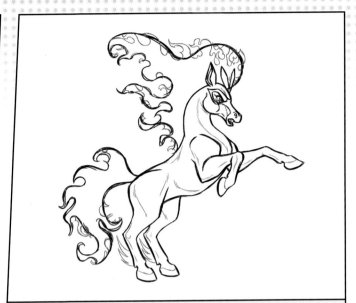

5 FINISH THE LEGS AND ADD HOOVES. PINCH IN EACH HOOF AS IT CONNECTS TO THE LEG. DRAW A FLAMING TAIL TO MATCH THE MANE AND THEN GIVE THE HEROIC HORSE A FACIAL PIECE THAT RESEMBLES HIS HUMAN MASK.

6 REPEAT THE FLAME SHAPES ALONG THE EDGES OF THE MANE AND TAIL TO CREATE A MORE INTRICATE OUTLINE. ADD TEXTURE LINES IN THE BODY TO SHOW MUSCLES AND JOINTS. DRAW A RIDGE IN EACH HOOF AND ADD FEATHER WINGS ON THE HIND LEGS.

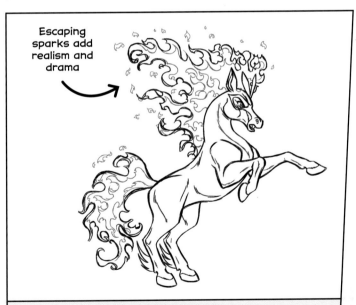

Escaping
sparks add
realism and
drama

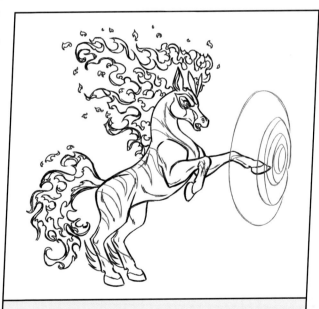

7 ERASE ANY EXTRA LINES WITHIN THE MANE AND TAIL AND THEN DRAW EVEN MORE FLICKERING FLAMES INSIDE. THESE WILL MAKE YOUR FIRE LOOK MORE NATURAL—AND POWERFUL! ADD SPARKS AND EMBERS FLYING OFF.

8 DRAW JAGGED STRIPES OVER THE BODY. THESE ECHO THE DESIGN OF THE HUMAN SUPERHERO SUIT. THEN, ADD THE SAME SPINNING VORTEX, USING LOTS OF CIRCULAR SHAPES IN FRONT OF AND OVER THE RAISED HOOF.

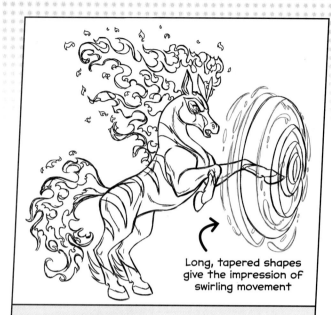

Long, tapered shapes give the impression of swirling movement

9 CONTINUE BUILDING THE SWIRLS OF THE ENERGY VORTEX WITH MORE LAYERS. ADD MAGICAL WISPS FLYING AROUND. SHOW THEIR DIRECTION BY MAKING ONE SIDE WIDER THAN THE OTHER.

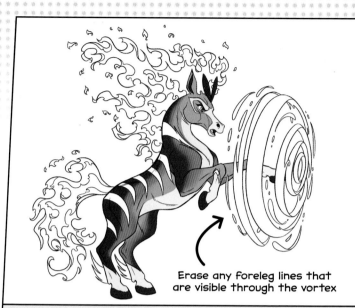

Erase any foreleg lines that are visible through the vortex

10 INK YOUR FINAL LINES AND THEN ADD BASE COLORS TO THE HORSE'S BODY. I'VE USED THE SAME COLORING AS THE HUMAN'S BODY AND SUIT BECAUSE IT'S A SIMPLE WAY TO BRING ELEMENTS OF THE ORIGINAL TO THE REIMAGINED CHARACTER.

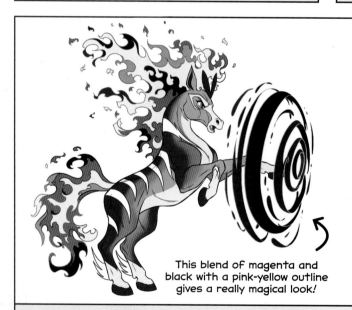

This blend of magenta and black with a pink-yellow outline gives a really magical look!

11 NOW, COLOR THE FIERY MANE AND TAIL AND THE SPINNING VORTEX. AS WITH THE HUMAN VERSION, I'VE USED DEEPER, MAGICAL COLORS FOR THE VORTEX, COMBINED WITH BRIGHT LINE ART INSTEAD OF BLACK OUTLINES.

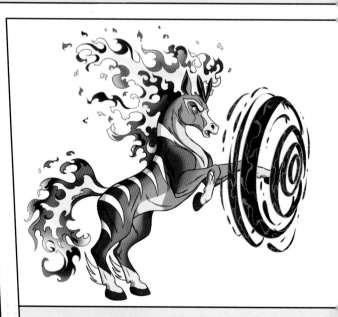

12 ADD SHADING AND HIGHLIGHTS. NOTE THE THICK STRIP OF SHADOW ALONG THE HORSE'S BACK. DRAW SQUIGGLY LINES OF POTENT ENERGY IN THE VORTEX SWIRLS. WHAT A POWERFUL HORSE!

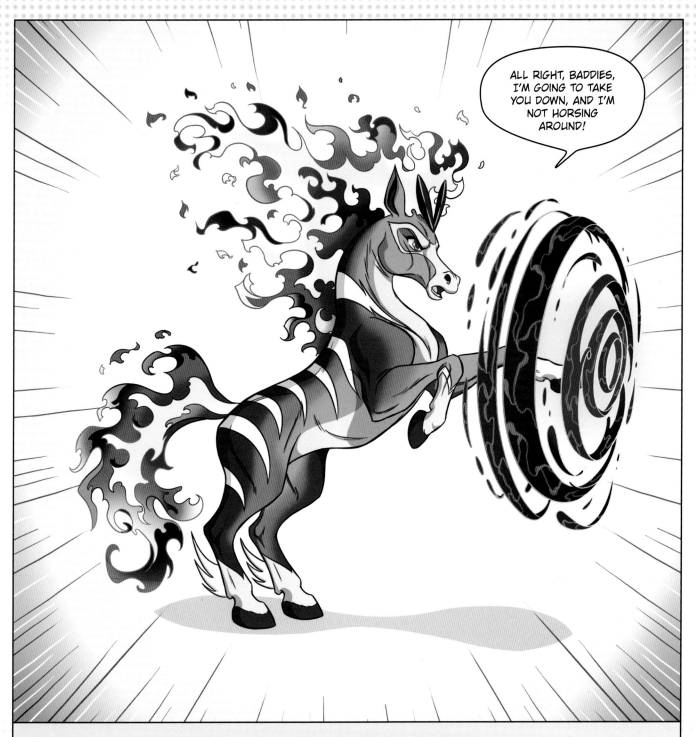

13 DRAMATIC LINES OF ENERGY EMANATE FROM OUR HERO HORSE! I'VE USED FIERY COLORS TO ECHO HIS FLAMES, BUT I'VE KEPT THE CENTRAL SPACE (BEHIND THE HORSE) ALMOST WHITE SO HE REALLY POPS! DON'T FORGET TO ADD HIS SHADOW.

EVIL PONYTAIL GIRL

Oh no!! Our Ponytail Angel (from pages 200–203) really does have a devilish side! She looks so different, yet she still reminds me of the original character. Let's see what's changed and what's stayed the same during her transformation from good to evil.

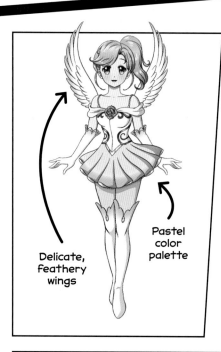

Delicate, feathery wings

Pastel color palette

1 DRAW THE HEAD IN THE USUAL WAY, WITH A CIRCLE AND TRIANGLE SHAPE BENEATH IT. MAKE THE CHIN VERY, VERY POINTY. WE'RE KEEPING HER BODY AND EVEN HER POSE THE SAME AS BEFORE, SO DRAW AN ASYMMETRICAL PINCHED RECTANGLE FOR HER TORSO, COMPLETE WITH OFF-CENTER GUIDELINES.

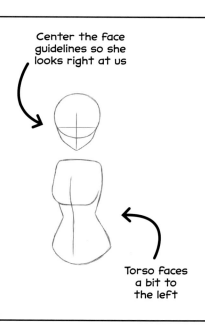

Center the face guidelines so she looks right at us

Torso faces a bit to the left

2 AH! THE FIRST SIGN OF HER EVIL TRANSFORMATION... GIVE HER THIN EYEBROWS THAT ARCH DOWN TOWARD HER NOSE. DRAW HER MOUTH IN A SEVERE GRIN WITH POINTY CORNERS. THEN, SKETCH HER NECK AND CYLINDRICAL UPPER LEGS.

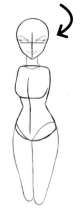

Add dark, striking lashes at the outer corner of her eyes

3 THE FRONT OF HER HAIR STILL SWEEPS TO THE SIDE, BUT IT'S A LOT SHARPER, WITH HARSHER EDGES NOW. DRAW SMALL IRISES WITH UNUSUAL FLAT HIGHLIGHTS. THERE USED TO BE A ROSE ON HER CHEST, BUT THIS TIME, WE'RE GIVING HER A DEVILISH SKULL SHAPE. CONTINUE HER LEGS AND ARMS WITH TAPERED CYLINDER SHAPES.

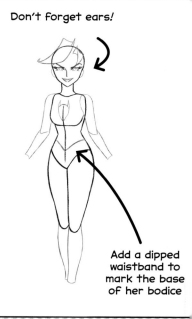

Don't forget ears!

Add a dipped waistband to mark the base of her bodice

4 FILL OUT HER HAIR WITH MORE JAGGED SECTIONS AND GIVE HER EYES ANGULAR PUPILS. INSTEAD OF A SOFT PIECE OF FABRIC ACROSS HER SHOULDERS, LET'S DRAW SOMETHING A LOT THORNIER! ADD A SPIKE TO HER WIDE SKIRT TOO. EVEN HER BOOTS END IN DANGEROUS-LOOKING POINTS.

Hair still has some curves, but they are interrupted with jagged points

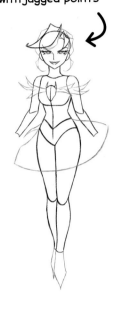

5 WE'RE GOING TO LET THIS CHARACTER KEEP HER SIGNATURE PONYTAIL, BUT INSTEAD OF MAKING IT BOUNCY, GIVE IT LOTS OF HARD ANGLES AND SHARP CURLS. BUILD UP HER SKIRT WITH LAYERS OF JAGGED, UNEVEN SPIKES. SERIOUSLY, WHERE DOES SHE SHOP FOR SUCH SCARY-LOOKING FABRIC?

Add more spikes in front of and behind existing ones

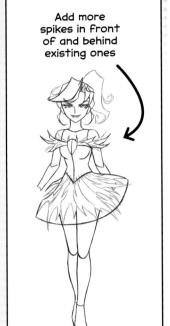

6 ANGELIC WINGS NO MORE—LET'S MAKE THEM GNARLY, WITH SHARP POINTS AND EDGES. ADD TEXTURE LINES TO HER HAIR AND EARS AND MAKE THAT SKULL ON HER CHEST AS CREEPY AS YOU CAN. DRAW IN BASIC HAND SHAPES AND THE TOPS OF HER BOOTS.

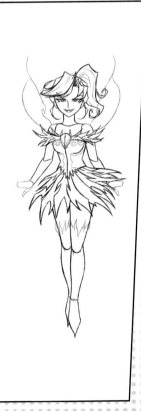

7 TO MAKE HER WINGS LOOK SKELETAL, DRAW SHARP LINES COMING OUT OF THEM AND A ROW OF SPIKES ALONG THE TOP EDGES. ADD MORE SPIKY, POINTY DETAILS TO HER OUTFIT, INCLUDING LONG, SHARP FINGERNAILS ON HER GLOVES.

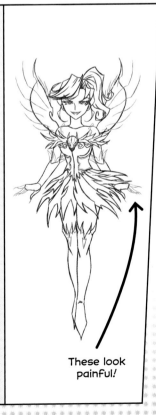

These look painful!

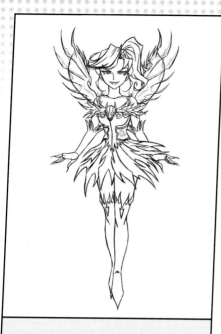

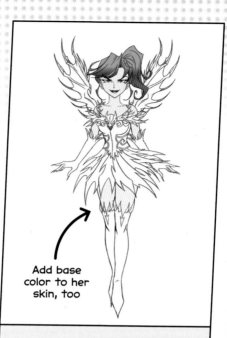

Add base color to her skin, too

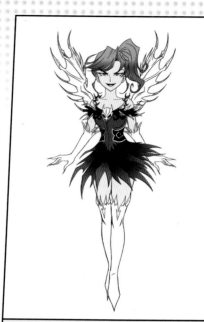

8 DRAW BONY CLAWS ON THE WING LINES, CONNECTED TO EACH OTHER BY CURVED LINES. THESE WILL BE THIN PIECES OF SKIN STRETCHED ACROSS. CONTINUE ADDING THE FINAL DETAILS TO THE DRESS, GLOVES, AND BOOTS.

9 FINALIZE YOUR OUTLINES AND THEN COLOR HER HAIR, FACE, AND SKIN. I'VE USED THE SAME HAIR COLORS AS BEFORE, BUT IN BOLDER SHADES. HER EYES ARE STILL GREEN, ALTHOUGH THEIR ANGULAR SHAPE GIVES THEM A WHOLE NEW LOOK.

10 INSTEAD OF THE PALE COLORS OF HER FORMER OUTFIT, LET'S MAKE HER DRESS BLACK, RED, AND MAGENTA—MUCH SCARIER THAN PASTELS! USE CONTRASTING COLORS TO MAKE SMALL DETAILS POP.

11 COLOR THE WINGS, GLOVES, AND BOOTS NEXT. GIVE THE SCALY BLACK WINGS A TINGE OF RED AND USE A SIMILAR BLEND FOR THE BOOTS. SHE LOOKS VERY DIFFERENT FROM HER ANGELIC DESIGN EARLIER, WHICH HAD WHITE WINGS, GLOVES, AND BOOTS!

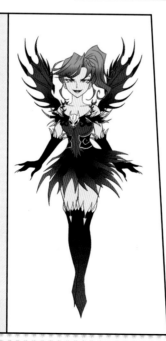

12 FINALLY, ADD SHADING AND HIGHLIGHTS TO MAKE THIS FORMER ANGEL LOOK EVEN MORE DANGEROUS. THE DARK SHADOWS OVER HER EYES ADD TO HER INTIMIDATING LOOK, AND THE SHINY HIGHLIGHTS ON HER GLOVES AND BOOTS SHOW THAT SHE MEANS BUSINESS!

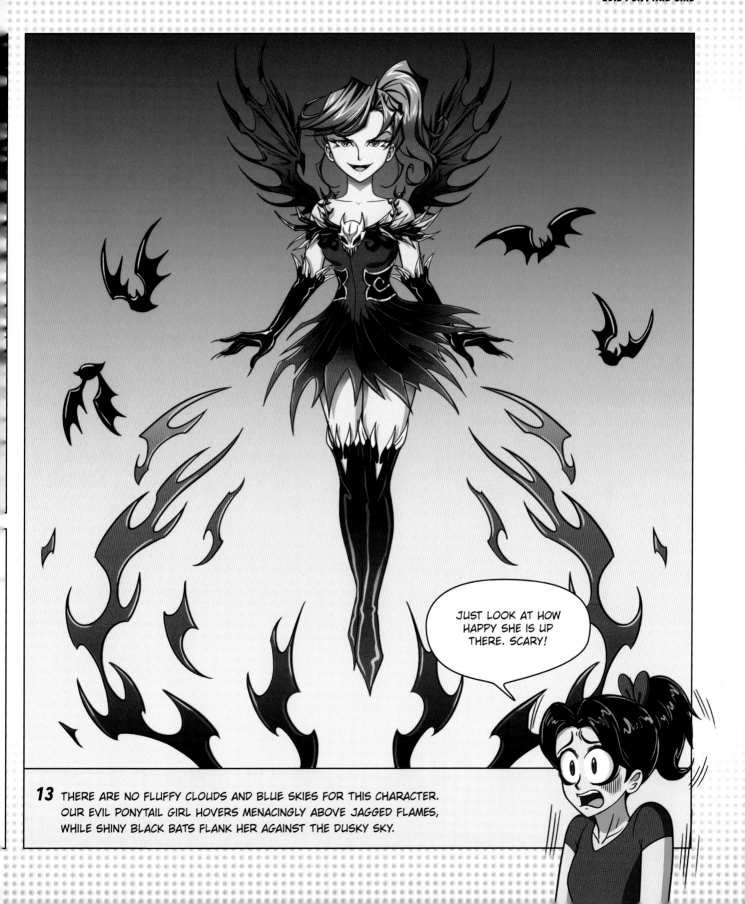

13 THERE ARE NO FLUFFY CLOUDS AND BLUE SKIES FOR THIS CHARACTER.
OUR EVIL PONYTAIL GIRL HOVERS MENACINGLY ABOVE JAGGED FLAMES,
WHILE SHINY BLACK BATS FLANK HER AGAINST THE DUSKY SKY.

BEYOND CHARACTERS

CELESTIAL LOVE

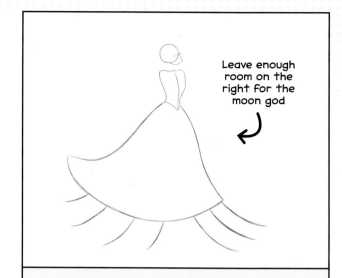

It's time to take everything you've learned in this book to create full scenes. Imagining the stories behind your characters can help develop their personalities—and your storytelling skills. First up, let's draw an enchanting, romantic scene between a sun goddess and a moon god.

Leave enough room on the right for the moon god

1 SKETCH OUT A BASIC HEAD AND BODY FOR THE SUN GODDESS. HER HEAD IS TURNED TO THE SIDE. FAN OUT HER SKIRT GRACEFULLY, LIKE A CURVED TRIANGLE. HER DRESS WILL HAVE MULTIPLE LAYERS, SO DRAW LINES RADIATING OUT FROM UNDER THE TRIANGLE FOR NOW.

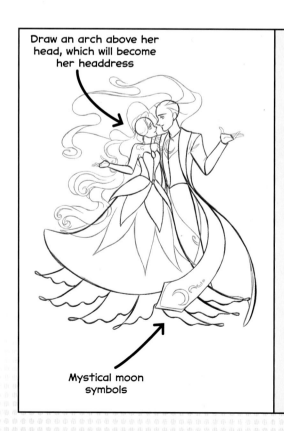

Draw an arch above her head, which will become her headdress

Mystical moon symbols

4 START ON THEIR HAIR. FOR A MAGICAL FEEL, I'VE DRAWN LONG, WAVY LINES WITH TIPS THAT CURL GRACEFULLY, ALMOST LIKE SMOKE. THE MOON GOD'S HAIR FLOATS UP AND AROUND THE SUN GODDESS. THEN, ADD MORE DETAILS TO THEIR CLOTHING. COMPLETE THEIR HAND SHAPES WITH FINGERS.

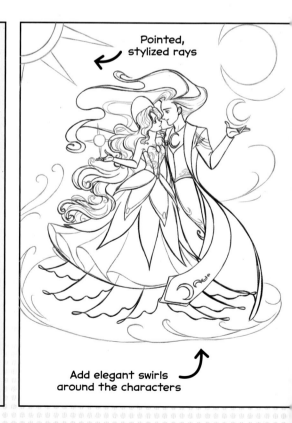

Pointed, stylized rays

Add elegant swirls around the characters

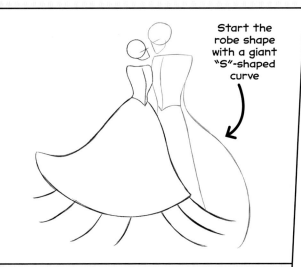

Start the robe shape with a giant "S"-shaped curve

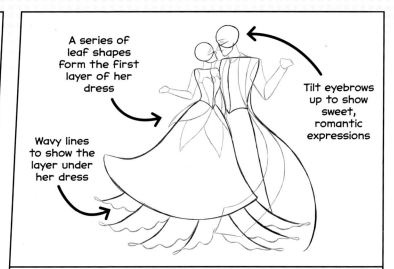

A series of leaf shapes form the first layer of her dress

Wavy lines to show the layer under her dress

Tilt eyebrows up to show sweet, romantic expressions

2 DRAW THE MOON GOD, TALLER AND WITH A BIGGER HEAD THAN HIS SOUL MATE AND WIDE SHOULDERS THAT TAPER DOWN TO HIS WAIST. HIS LOWER BODY IS MOSTLY OBSCURED BY THE GODDESS'S DRESS. HE WILL WEAR LONG ROBES THAT FLOW AROUND HIM.

3 SKETCH THE MAJOR DETAILS FOR BOTH CHARACTERS. EACH HAS ONE ARM OUT AND BENT, WITH THEIR WEDGE-SHAPED PALMS FACING UP. DRAW THEIR FACIAL FEATURES AND NECKS. THEN, START ON SOME DETAILS ON THE GODDESS'S DRESS AND THE GOD'S ROBES.

5 START ON THE BACKGROUND, WITH A LARGE SUN AND MOON IN THE CORNERS. ADD A SMALLER SUN AND MOON FLOATING ABOVE THE CHARACTERS' HANDS. DRAW HAIR TEXTURE LINES AND ADD INTRICATE CLOTHING DETAILS, INCLUDING SOFT FOLDS OF FABRIC AT THE BOTTOM OF THE DRESS.

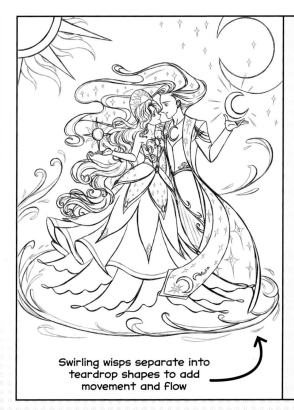

Swirling wisps separate into teardrop shapes to add movement and flow

6 NOW FOR THE SMALL DETAILS. COMPLETE THE BACKGROUND WITH MORE SUN RAYS, STARS, AND MYSTICAL SWIRLS. THEN, ADD DAZZLING STAR PATTERNS TO BOTH CHARACTERS' CLOTHING AND IN THE MOON GOD'S HAIR—IT DOUBLES AS THE NIGHT SKY! COMPLETE THE LARGE ARCH ON THE GODDESS'S HEAD WITH A SUN SYMBOL.

7 ERASE ANY EXTRA LINES AND INK YOUR FINAL ART. NEXT, ADD BASE COLORS. I USED A SUNNY PALETTE FOR THE GODDESS, ALTERNATING LIGHT AND DARK LAYERS ON HER DRESS SO EACH LAYER STANDS OUT. FOR THE MOON GOD, I'VE GONE WITH DARK BLUES AND INDIGOS TO EVOKE THE NIGHT, ADDING GRAYS AND WHITE FOR CONTRAST. THEN, FILL IN THE BACKGROUND SUN, MOON, AND SWIRLS IN SIMILAR COLORS.

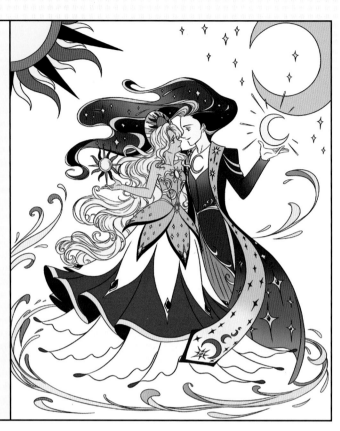

9 FINALLY, LET'S GIVE THIS ROMANTIC COUPLE A DARK BACKGROUND SO THEIR LOVE CAN SHINE BRIGHT! MAKE THE MOON COME ALIVE WITH A GLOWING LIGHT EFFECT AND PLAY WITH THE COLOR FADES ON THE SUN TO COMPLETE THE STYLIZED, SATIN EFFECT. OUTLINE THE MOON GOD'S HAIR AND THE SWIRLS AROUND HIM WITH A VIBRANT LIGHT-BLUE GEL PEN. SERIOUSLY, THE ROMANCE BETWEEN THESE TWO IS OUT OF THIS WORLD!

8 NEXT UP, SHADING AND HIGHLIGHTS. I'VE USED SHADOWS TO MAKE EACH LAYER OF THE GODDESS'S DRESS POP. FOR HER RICH, FLOWING HAIR, ADD ORANGE AND BROWN TOWARD THE BOTTOM TO GIVE IT A GOLDEN APPEARANCE. SHADE THE EDGES OF THE GOD'S CLOTHING TO ADD DEPTH. THEN, SHADE THE REST OF THE ART AND USE LIGHT SQUIGGLY LINES ON TOP TO ADD SHINE.

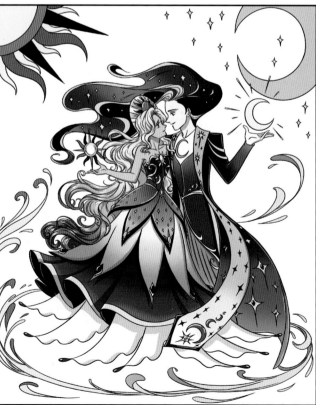

TIP!

When adding a background to your art, you don't need to make it complex or even realistic. The background here is stylized and actually very simple. It gives a dramatic effect and allows the characters to really shine!

IN THE NEXT FEW LESSONS, WE WILL CREATE MORE INTRICATE BACKGROUNDS FILLED WITH PLENTY OF DETAIL, INCLUDING OTHER CHARACTERS!

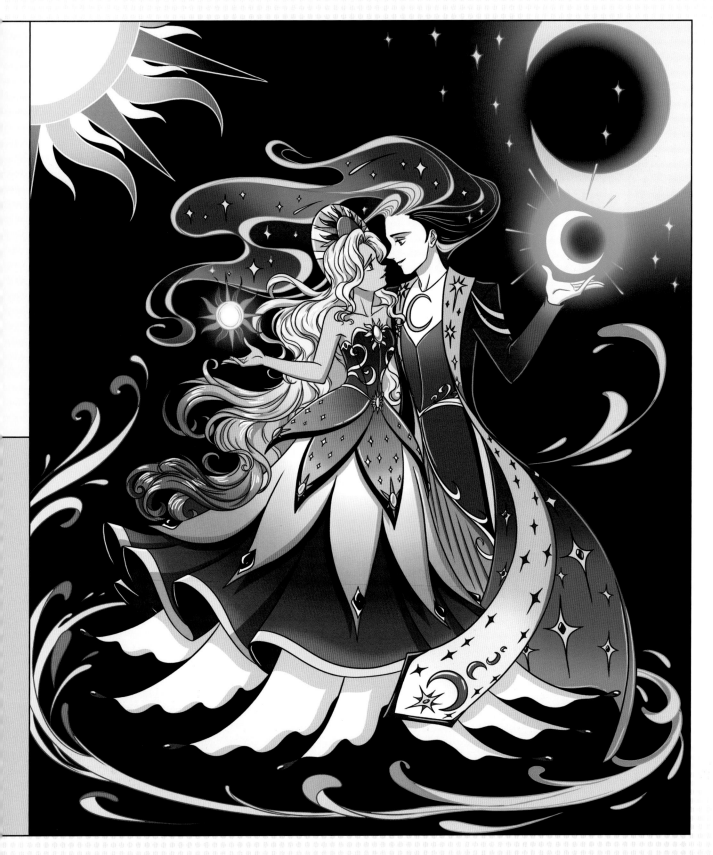

NATURE FAIRY SCENE

Now, let's draw a beautiful natural setting for a timid fairy and her cute companion! This character is the size of a butterfly, so the scene's perspective will include enormous flowers and towering blades of grass. The focus is on the character in the foreground, with her mushroom house in the mid-ground behind her.

Use a pinched rectangle shape for the torso

1 BEGIN WITH BASIC SHAPES FOR THE FAIRY'S HEAD AND TORSO AND INCLUDE GUIDELINES. HER POSE WILL REFLECT HER SHY NATURE, SO TILT HER HEAD DOWN TOWARD THE TORSO.

Vary the width and shapes of the petals for an organic look

More leaf shapes make up her fairy shoes

3 ADD FACIAL FEATURES AND START ON HER HAIR WITH POINTED CURVES. MAP OUT A PRETTY FLOWER DRESS WITH LEAF SHAPES ON THE BODICE AND A WIDE LAYER OF FLOWER PETALS TO FORM THE SKIRT.

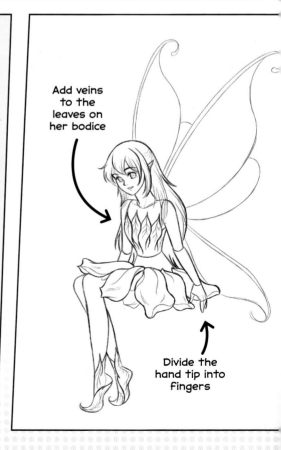

Add veins to the leaves on her bodice

Divide the hand tip into fingers

2 DRAW CYLINDER SHAPES FOR HER LIMBS. THEN, ADD A SLENDER NECK AND POINTED EAR. START THE HANDS AND FEET WITH SIMPLE SHAPES FOR NOW—WE'LL ADD DETAILS LATER.

Shoes have pointed tips

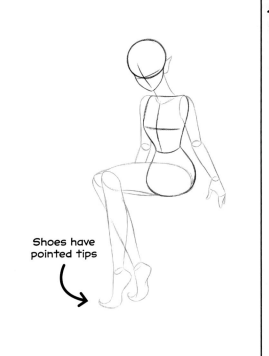

TIP!

Draw general outlines of your mid- and background objects lightly in pencil first. This allows you to see if they are the size you want, relative to the characters in the foreground.

MID-GROUND OBJECTS WILL BE SMALLER THAN YOUR FOREGROUND CHARACTERS, BUT NOT AS SMALL AS BACKGROUND OBJECTS!

4 ADD SIMPLE TEXTURE LINES TO HER STRAIGHT HAIR AND MORE DETAILS TO HER FACE. THEN, DRAW BEAUTIFUL FAIRY WINGS, ORIGINATING FROM A CENTRAL POINT ON HER BACK. MAKE THEM AS POINTED, LONG, SHORT, OR CURVED AS YOU LIKE! DRAW SOFT LINES INTO THE PETALS OF HER SKIRT TO DEFINE THEIR SHAPE.

This will be her mushroom home, with steps up to the front door

Uneven bumpy lines for a branch

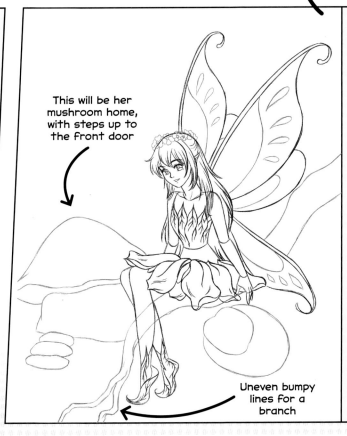

5 GIVE THE FAIRY A PRETTY FLOWER CROWN AND ADD DETAIL TO THE WINGS. THEN, START PLANNING THE SETTING: THE FAIRY IS CLOSEST TO US, SITTING ON A LOW BRANCH, WITH HER BUSY BEE BESIDE HER. START THE BEE WITH TWO LARGE, ROUND SHAPES. SKETCH THE BASIC SHAPES OF THE MUSHROOM HOUSE —WE'LL BUILD ON THEM LATER.

6 NOW, ADD FLOWERS! VARY THE SIZES FOR A MORE INTERESTING LOOK. I'VE ANCHORED THE SCENE BY PUTTING THE LARGEST FLOWERS IN OPPOSITE CORNERS (TOP LEFT AND BOTTOM RIGHT). THEN, BUILD HER FAIRY HOME BY ADDING MORE DETAILS. GIVE THE BEE CUTE EYES, ANTENNAE, AND LITTLE WINGS.

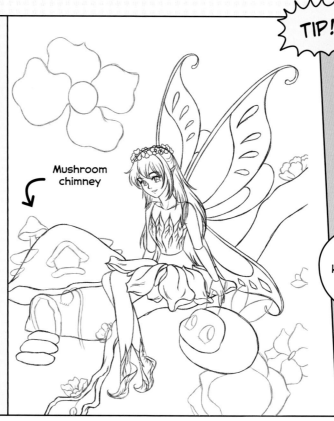

Mushroom chimney

TIP!

When planning busy scenes, start with basic shapes, just like how you would start drawing a character. Sketch the main composition and then add more details once you're happy.

WE'VE SKETCHED THE BASIC FLOWER SHAPES HERE, AND WE'LL ADD THE DETAILS OVER THE NEXT FEW STEPS.

8 NOW, ADD ALL THE FINISHING TOUCHES, INCLUDING BRANCH TEXTURE, FLOWERS AND PETALS, AND DETAILS ON THE HOUSE. ADD SMALL TUFTS OF GRASS HERE AND THERE TO FILL OUT THE MID-GROUND. FINALLY, CREATE A BACKGROUND OF CLOUDS COMING UP BEHIND EVERYTHING.

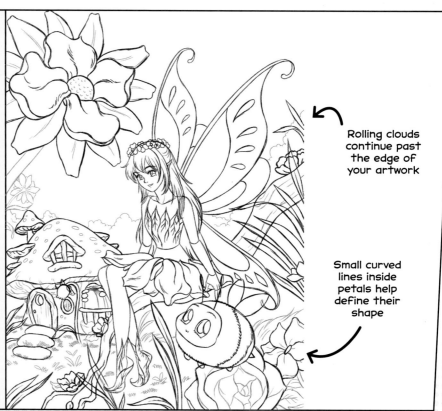

Rolling clouds continue past the edge of your artwork

Small curved lines inside petals help define their shape

7 ADD MORE DETAIL TO THE LARGE FLOWER WITH TEXTURE LINES AND A SECOND LAYER OF PETALS. CREATE MORE DEPTH AND A SENSE OF PROPORTION BY ADDING TALL BLADES OF GRASS COMING IN FROM THE EDGES OF THE IMAGE. DRAW MORE OF THE MUSHROOM HOUSE, INCLUDING WINDOWS. THEN, GIVE THE BEE SOME CUTE FACIAL DETAILS, SMALL LEGS, A TINY STINGER, AND A FUZZY FINISH, USING LITTLE BUMPY LINES. AWWW!

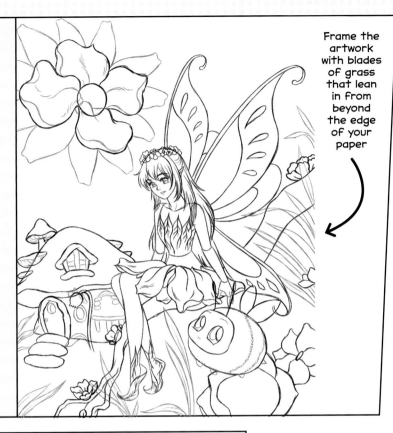

Frame the artwork with blades of grass that lean in from beyond the edge of your paper

9 CAREFULLY ERASE ANY LINES YOU DON'T NEED AND THEN INK YOUR FINAL LINES. ADD BASE COLORS TO THE FAIRY, BEE, AND HOUSE. CONSIDER WHETHER YOU WANT TO USE WARM COLORS, COOL COLORS, OR OTHER SPECIAL COLOR SCHEMES, DEPENDING ON THE LOOK YOU WANT TO ACHIEVE. I'VE CHOSEN MOSTLY WARM COLORS, WITH POPS OF GREEN AND BLUE FOR CONTRAST.

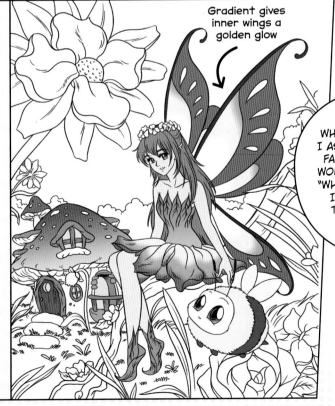

Gradient gives inner wings a golden glow

WHILE CREATING THIS SCENE, I ASKED MYSELF, "IF I WERE A FAIRY, WHAT KIND OF DRESS WOULD I LIKE TO WEAR?" AND "WHAT SORT OF HOME WOULD I WANT?" IF YOU WERE IN THIS SCENE, HOW WOULD YOU CHANGE IT?

10 NOW, FILL IN THE BASE COLORS FOR THE BRANCH, FLOWERS, AND GRASS. I'VE USED SEVERAL COLORS, BUT NOT TOO MANY —YOU DON'T WANT THE IMAGE TO BE OVERWHELMING! NOTICE HOW I'VE REPEATED PINKS, YELLOWS, AND GREENS IN VARIOUS SHADES.

12 NEXT, ADD THE SKY COLORS AND... WE'RE DONE! I'VE MADE THE UPPER PART OF THE SKY A BOLDER BLUE THAT GETS LIGHTER AS IT GOES DOWN TOWARD THE CLOUDS. THIS SIMPLE GRADIENT CREATES A SENSE OF DEPTH.

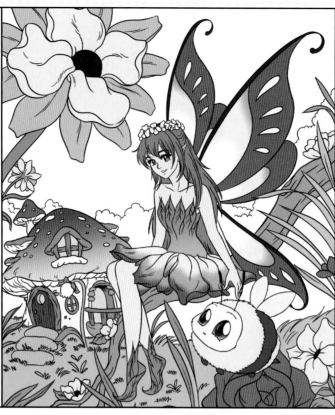

11 ADD SHADING ACROSS THE SCENE TO CREATE DEPTH, ESPECIALLY AROUND THE FAIRY, SO SHE REALLY POPS! NOTE HOW SHE CASTS A LARGE SHADOW ON HER BRANCH. I ALSO USED FINE, ROUNDED SHADING TO GIVE THE BEE A REALLY FUZZY FINISH.

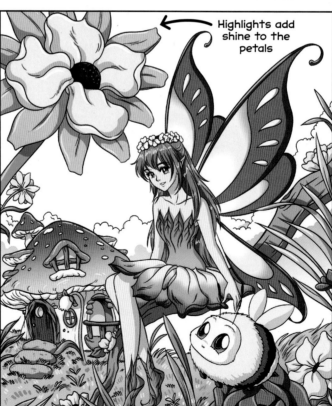

Highlights add shine to the petals

I LOVE YOUR NEW MUSHROOM HOUSE. IT'S FAIRY PRETTY!

THANKS! I JUST MOVED IN—IT'S UNBEELIEVABLE!

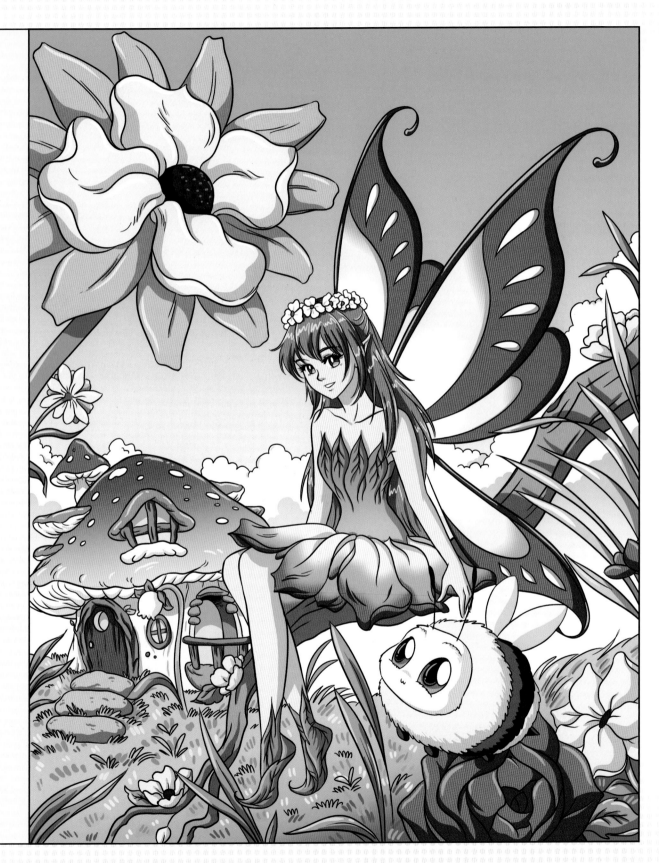

HIGH SCHOOL MAGICAL

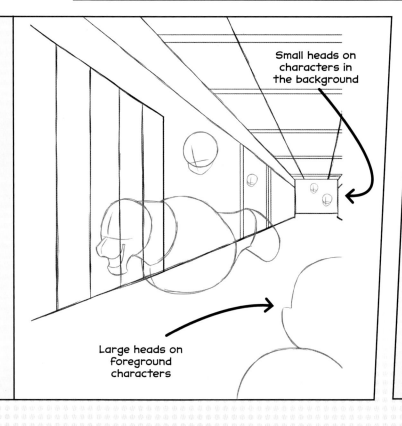

It's "Bring Your Magical Pet to School Day," but this uni-tiger can smell the fries in the cafeteria. Before it makes a big, delicious mess, let's draw the fun scene, which brings a touch of magic to an everyday background—with lots of secondary characters, small details, and a sense of mayhem!

The vanishing point, where the perspective lines originate from

1 THIS TIME, WE'RE STARTING WITH THE BACKGROUND! DRAW A HORIZONTAL LINE ACROSS THE PAGE AND ADD A POINT ON THE RIGHT. USE A RULER TO DRAW DIAGONAL LINES FROM THE VANISHING POINT TO THE EDGES OF YOUR PAPER.

3 ERASE EXTRA PERSPECTIVE LINES, AND LET'S START PLACING OUR CHARACTERS. USE THE PERSPECTIVE OF THE HALLWAY AS A GUIDE FOR HOW BIG TO MAKE THE CHARACTERS. IN THE FOREGROUND, DRAW TWO LARGE HEADS, WHICH BELONG TO GAWPING ONLOOKERS. IN THE MID-GROUND, DRAW THE BASIC BODY SHAPE OF THE CHARGING TIGER. ADD GUIDELINES ON ITS FACE AND CHEST. THE TIGER'S OWNER IS RIDING ON TOP, SO DRAW HER HEAD SHAPE FOR NOW, LEAVING SPACE FOR THE BODY. THEN, ADD THREE MORE ONLOOKERS IN THE BACKGROUND.

Small heads on characters in the background

Large heads on foreground characters

TIP!

THIS SCENE HAS A STRONG PERSPECTIVE, WITH A DISTINCT FOREGROUND, MID-GROUND, AND BACKGROUND, SO WE'RE GOING TO PLAN IT OUT WITH BASIC LINES THAT HELP US GET THE PERSPECTIVE RIGHT. WE ARE CREATING A BASIC ONE-POINT PERSPECTIVE DRAWING, WHERE THE HALLWAY WILL GO INTO THE BACKGROUND, TOWARD THE VANISHING POINT.

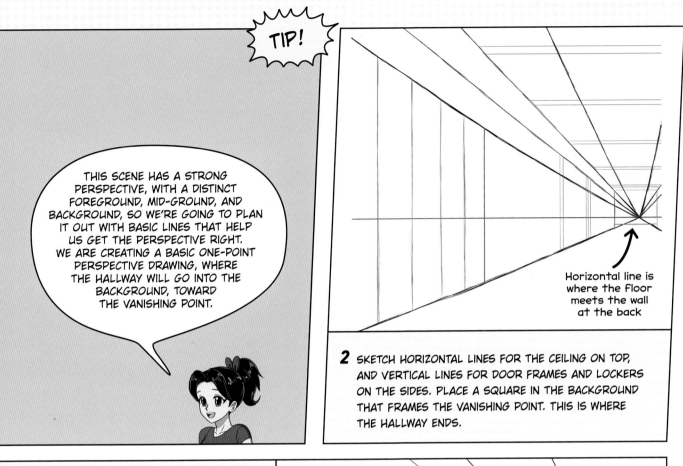

Horizontal line is where the floor meets the wall at the back

2 SKETCH HORIZONTAL LINES FOR THE CEILING ON TOP, AND VERTICAL LINES FOR DOOR FRAMES AND LOCKERS ON THE SIDES. PLACE A SQUARE IN THE BACKGROUND THAT FRAMES THE VANISHING POINT. THIS IS WHERE THE HALLWAY ENDS.

4 ADD FACE AND HAIR DETAILS TO THE STUDENTS IN THE FOREGROUND. THE ONE AT THE VERY FRONT WILL ONLY SHOW THE BACK OF HIS HEAD! THEN, SKETCH THE TIGER'S CYLINDRICAL LEGS, FACIAL FEATURES, AND FLOWING HAIR AND TAIL. GIVE ITS OWNER CURLY HAIR AND DETERMINED EYEBROWS. DRAW SURPRISED EXPRESSIONS ON THE HEADS THAT ARE FLOATING IN THE BACKGROUND. (DON'T WORRY, THEY WON'T BE FLOATING FOR LONG!)

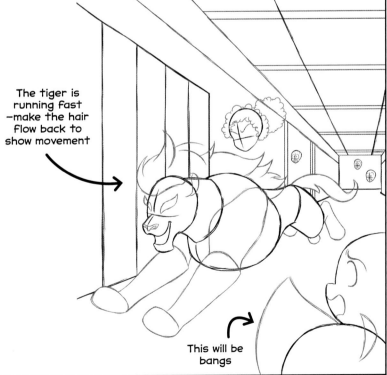

The tiger is running fast —make the hair flow back to show movement

This will be bangs

5 DRAW MORE DETAILS ON THE TWO STUDENTS IN FRONT. GIVE THE UNI-TIGER A GIANT HORN AND ADD MORE SECTIONS OF HAIR AROUND ITS CHEEKS, NECK, AND CHEST. DRAW CONTOUR LINES TO MAKE ITS LEGS LOOK MUSCULAR. DRAW THE BODY AND FACE OF THE TIGER'S OWNER. THEN, SKETCH THE BACKGROUND CHARACTERS' BODIES, CONSIDERING WHAT DETAILS YOU WILL SHOW ABOUT THEM. I'VE DRAWN ONE SITTING IN A WHEELCHAIR, ONE FILMING THE SCENE ON HER PHONE, AND ONE PEERING AROUND A DOORWAY.

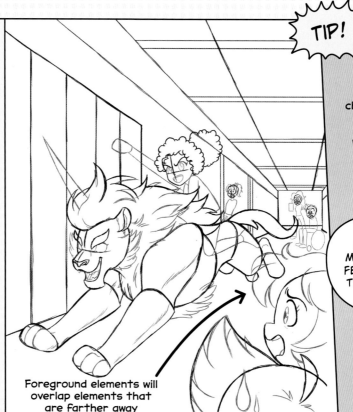

Foreground elements will overlap elements that are farther away

TIP!

The background characters are smaller and farther away, so they are drawn with less detail than the foreground characters.

THE BACKGROUND CHARACTERS HAVE MUCH SIMPLER FACIAL FEATURES— ALTHOUGH THEY ARE STILL VERY EXPRESSIVE!

7 NOW FOR THE FINISHING TOUCHES. GIVE THE TIGER A TWINKLING STAR ON TOP OF ITS HORN AND ADD DETAILS TO ITS OWNER'S FACE AND HAIR. LET'S DRAW THE HOMEWORK SPILLING OUT OF HER OPEN BACKPACK AND FLUTTERING AROUND THE HALLWAY. DRAW CUTE NOTES, STICKERS, AND A LOCK ON THE LOCKERS AND THEN FINALIZE THE REST OF THE DETAILS IN THE BACKGROUND.

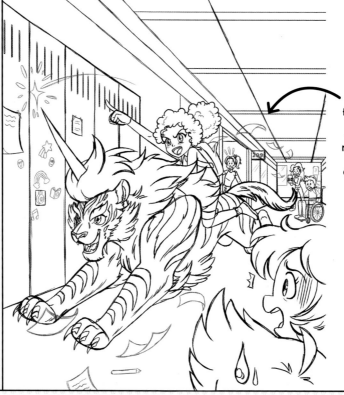

Fluttering papers decrease in size the farther away they are —which helps reinforce the perspective of the scene

6 DRAW IN LOTS OF FINE DETAILS, SUCH AS LOCKER LINES, TIGER STRIPES, AND PUPILS IN THE EYES. I'VE ADDED VARIOUS MANGA SYMBOLS (SEE PAGE 24) TO THE FOREGROUND CHARACTERS TO EMPHASIZE THEIR SURPRISE. THE TIGER'S OWNER HAS AN OPEN BACKPACK, WHICH WILL HAVE PAPERS FLYING OUT OF IT!

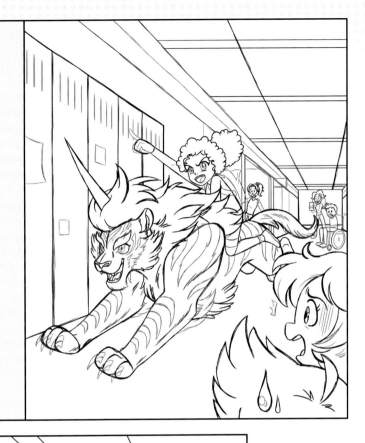

8 USE AN OUTLINER OR FINE-TIPPED PEN TO FINALIZE YOUR LINES. ADD BASE COLORS TO THE CHARACTERS FIRST. I'VE GIVEN THE TIGER COOL BLUE FUR WITH DARK-BLUE STRIPES. ITS FACE AND LEGS HAVE LIGHTER BLUE AREAS. THE HAIR, CHEST FUR, AND TAIL ARE WHITE, WITH GOLD TIPS. COLOR THE OTHER CHARACTERS' HAIR, SKIN, AND CLOTHING AND THEN THE WHEELCHAIR. I'VE USED A RANGE OF BOLD, BRIGHT COLORS SO THIS BUSY SCENE BURSTS WITH VIBRANT ENERGY!

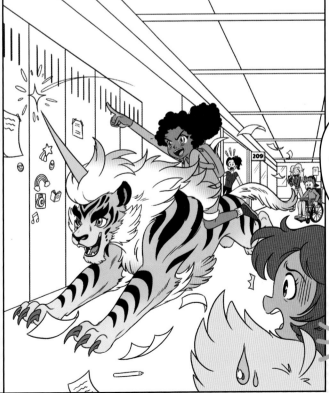

WHAT A CUTE KITTY! AND WHO'S THAT GORGEOUS YET SURPRISED BACKGROUND CHARACTER? SHE LOOKS SOOO FAMILIAR...

9 NOW FOR THE BACKGROUND. THE WALLS, CEILING, AND FLOOR ARE LIGHTER SHADES OF THE LOCKER COLOR. THIS ALLOWS FOR CONTRAST IN THE SCENE BUT STILL KEEPS THE COLOR SCHEME COHESIVE. THIS COHESIVENESS SEPARATES THE BACKGROUND FROM THE CHARACTERS, WHICH HELPS MAKE SENSE OF THE SCENE, EVEN THOUGH THERE IS A LOT GOING ON!

10 TIME TO SHADE! USE A DARKER BLUE TO SHADE THE TIGER FUR. ITS STRIPES ARE DARK ENOUGH, SO THERE'S NO NEED TO SHADE THEM. INSTEAD, ADD THIN STRIPES OF LIGHT PURPLE TO MAKE THEM STAND OUT. USE DARKER VERSIONS OF HAIR AND SKIN COLORS TO ADD SHADING TO YOUR CHARACTERS. THEN, USE LIGHTER TONES OR WHITE TO ADD SQUIGGLY HIGHLIGHTS TO THE HAIR.

11 FINALLY, SHADE THE BACKGROUND. FOCUS ON ADDING SHADOWS TO THE FLOOR BENEATH THE TIGER AND THE SPILLED HOMEWORK. THIS REALLY BRINGS OUT THE DEPTH IN THE SCENE AND GIVES THE SENSE THAT THE TIGER IS IN MID-AIR. COLOR THE STAR GLOWING ABOVE THE TIGER'S HORN WITH BRIGHT COLORS, BUT LEAVE THE CENTER WHITE AND ADD A BRILLIANT GLOW AROUND IT.

I THINK "BRING YOUR MAGICAL PET TO SCHOOL DAY" WAS A ROARING SUCCESS, BUT I'M NOT SURE THE KIDS IN THE CAFETERIA AGREE...

FANTASY BATTLE SCENE

For our final lesson of the book, let's go all out and create an epically EPIC, fantastic fantasy scene! It will be full of detail, including a warrior and his elf companion, a dangerous dragon, and a castle in the middle of a battlefield, surrounded by fire and evil, magical smoke. Let's go!

Draw a middle line along the dragon's neck so it's easier to place the spikes later

Draw elf companion shapes in profile view

Center the warrior's facial and torso guidelines

Dragon's mouth is open, with sharp points

1 DRAW THE WARRIOR'S HEAD AND BODY SHAPES FACING FORWARD. LEAVE A GAP TO HIS LEFT AND THEN START ON THE ELF COMPANION, WHO IS TURNED TO THE SIDE. THE LOWER PARTS OF THEIR BODIES WILL BE COVERED BY OTHER THINGS. SKETCH THE DRAGON WINDING AROUND THEM FROM BEHIND, USING CURVED LINES TO START ITS LONG NECK AND BACK.

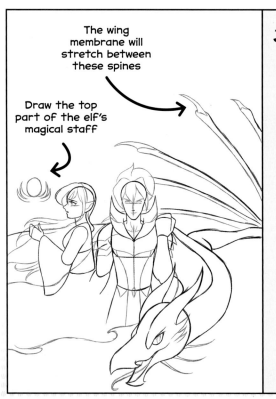

The wing membrane will stretch between these spines

Draw the top part of the elf's magical staff

3 SKETCH THE WARRIOR'S THICK HAIR AND DETERMINED FACE. DRAW DETAILS ON HIS COLLAR AND ADD ROUGH ARMOR SECTIONS AND THE OUTLINES OF A TATTERED CAPE THAT FLOWS AROUND HIM AND OVER HIS COMPANION. NEXT, DETAIL MORE OF THE ELF'S FACE AND HAIR. DON'T FORGET TO ADD A POINTY EAR STICKING OUT! ADD DETAILS TO THE DRAGON'S FACE AND THEN ADD SPINES TOPPED WITH FIERCE CLAWS TO ITS WING.

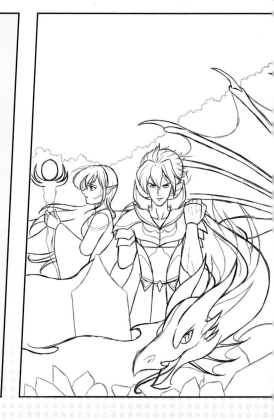

2 DRAW THE WARRIOR'S NECK AND A SHARP, EXAGGERATED COLLAR. THEN, SKETCH OUT HIS ARMS— ONE IS HELD UP IN A FIST. DRAW THE ELF'S EYE, NOSE, AND MOUTH FROM THE SIDE. START HER HAIR WITH BASIC CURVES AND DRAW HER ARM WITH A FANNED-OUT SLEEVE. GIVE THE DRAGON TWO GRACEFUL HORNS AND EYES. SKETCH LONG, SLIGHTLY CURVED LINES FANNING OUT FROM A POINT OFF THE PAGE TO START ITS WING.

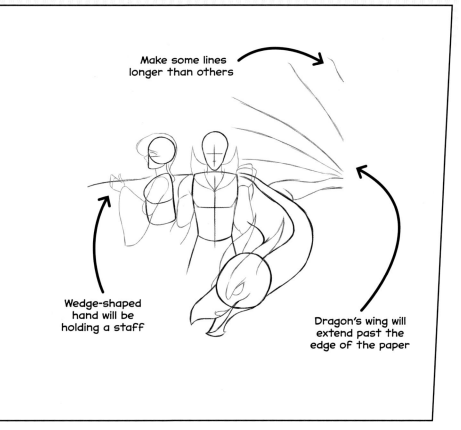

Make some lines longer than others

Wedge-shaped hand will be holding a staff

Dragon's wing will extend past the edge of the paper

4 DRAW MORE DETAILS ON THE CHARACTERS, INCLUDING HAIR, FACE, AND CLOTHING! GIVE THE WARRIOR A SHIELD, THE ELF A STAFF, AND THE DRAGON ITS SPIKES AND WING MEMBRANE. START ON THE SCENERY, WITH A GIANT PLUME OF SMOKE RISING BEHIND EVERYTHING. AT THE BOTTOM, SKETCH ROUGH, ROCKY SHAPES FOR GEMSTONES AND CRYSTALS IN THE FOREGROUND.

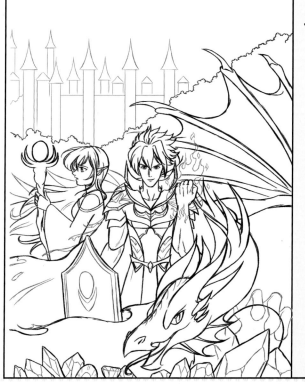

5 NOW, ADD BASIC TOWER SHAPES FOR A CASTLE BEHIND THE SMOKE. CONTINUE THE SPIKES ALONG THE DRAGON'S BACK THAT SHOW BEHIND THE WARRIOR AND ELF. DRAW THE DRAGON'S FINGERS CLUTCHING A LARGE GEM IN THE CORNER AND THE WARRIOR'S FIRE SPELL. FILL IN LOTS OF SMALLER DETAILS, INCLUDING ARMOR AND SHIELD DESIGNS, THE RIPS AND TEARS IN THE CAPE, AND THE CRYSTAL FACETS.

6 DRAW LOTS OF FINE DETAILS ON THE CASTLE: TINY WINDOWS, SPIRES, BATTLEMENTS, AND MORE TOWERS. ADD TO THE ELF'S STAFF, THE WARRIOR'S SHIELD, THE FIRE SPELL AROUND HIS FIST, AND HIS TATTERED CAPE. THEN, DETAIL THE DRAGON'S SCALES, TEETH, AND CLAWS. AND LET'S HEAT THINGS UP EVEN MORE BY DRAWING SOME FLAMES BY THE DRAGON!

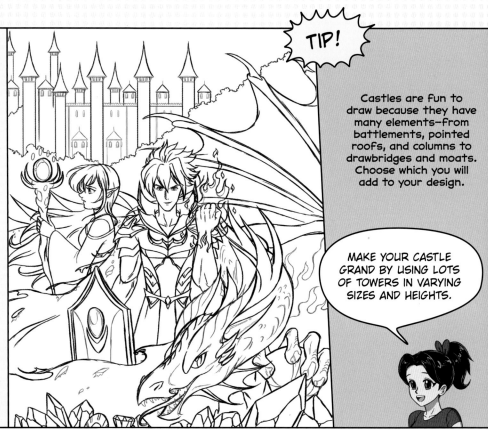

TIP!

Castles are fun to draw because they have many elements—from battlements, pointed roofs, and columns to drawbridges and moats. Choose which you will add to your design.

MAKE YOUR CASTLE GRAND BY USING LOTS OF TOWERS IN VARYING SIZES AND HEIGHTS.

8 FINALIZE YOUR LINE ART AND CHOOSE SOME EPIC COLORS TO BRING THIS SCENE TO LIFE! FILL IN THE BASE COLORS FOR THE WARRIOR AND ELF FIRST. I'M GOING TO LEAVE THE WARRIOR'S HAIR WHITE SO HE STANDS OUT AS THE FOCAL POINT OF THE SCENE. I'VE ALSO MADE HIS DARK ARMOR CONTRAST WITH HIS PALE UPPER CAPE. I'VE USED A PINK AND PURPLE COLOR SCHEME FOR THE ELF TO DIFFERENTIATE HER FROM THE WARRIOR. HER STAFF MATCHES!

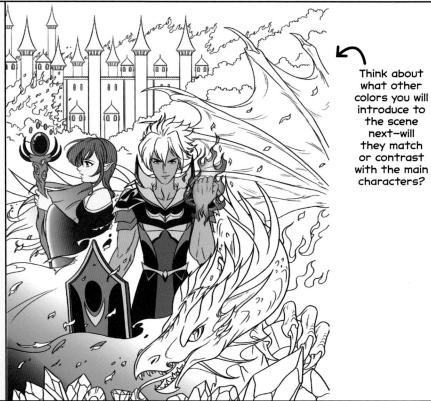

Think about what other colors you will introduce to the scene next—will they match or contrast with the main characters?

7 DRAW A RAGING FIRE BLAZING AROUND THE CASTLE WITH CURVED, POINTY LINES. ADD MORE LAYERS IN THE SMOKE AND THEN DRAW FLOATING FIERY EMBERS THROUGHOUT THE FOREGROUND. GIVE THE DRAGON'S WING MEMBRANE STRETCH LINES TO MAKE IT LOOK FLEXIBLE AND ORGANIC. ADD FURTHER DETAILS TO THE ELF'S STAFF AND THE GEM CLUTCHED IN THE DRAGON'S CLAWS.

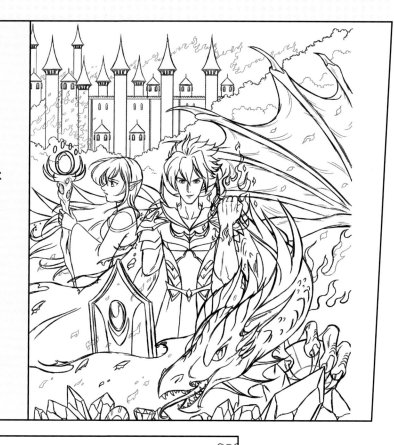

9 COLOR THE DRAGON WITH A MIX OF LIGHTER AND DARKER COLORS TO CREATE CONTRAST. I'VE USED LIGHT GREEN FOR THE BODY, WITH DARKER AREAS AT THE TIPS AND FOR THE WING. FOR A FEW SELECT PARTS, I'VE USED DARK RED TO GIVE HIM A DANGEROUS AND DRAMATIC LOOK. I CHOSE THIS COMBINATION BECAUSE GREEN AND RED ARE COMPLEMENTARY COLORS (SEE PAGES 18-19) AND WHEN PAIRED CREATE A STRIKING EFFECT. I'VE MADE THE EYE AND FACE SPIKES YELLOW FOR A POP OF COLOR.

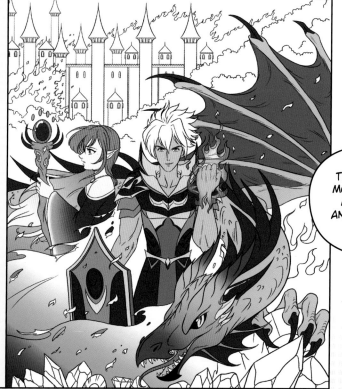

THIS COULD BE A MOVIE POSTER OR MANGA COVER! AND IT'S NOT EVEN DONE YET!

10 TO MAKE THE CASTLE, FIRE, AND SMOKE STAND OUT, USE DIFFERENT COLOR SCHEMES. THE FIRE INCORPORATES WARM COLORS, SO USE COLD TONES FOR THE CASTLE AND SMOKE. THE CASTLE IS LIGHTER WHILE THE EVIL SMOKE IS DARKER, TURNING TO BLACK. THIS ALSO PROVIDES GREAT CONTRAST AGAINST THE WARRIOR'S WHITE HAIR! COLOR THE GEMSTONES AT THE BOTTOM IN VARIOUS JEWEL TONES.

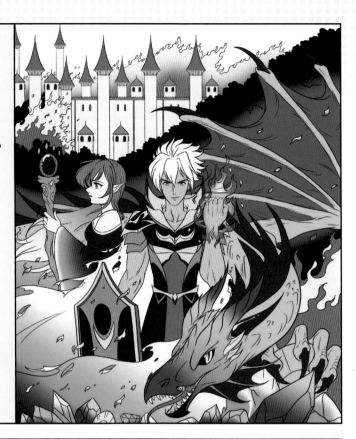

12 UP THE DRAMA WITH A TOTALLY BLACK SKY IN THE FAR BACKGROUND. THIS REALLY BRINGS OUT THE FLAMES. USE HIGHLIGHTS OF LIGHTER COLORS OR WHITE TO BRING OUT THE TEXTURE WITHIN THE SMOKE, THE SHINE OF HAIR, ARMOR, GEMSTONES, AND THE GLOW OF THE ELF'S STAFF AND THE WARRIOR'S FIRE SPELL. WHAT AN EPIC SCENE!

11 SHADING IS SO IMPORTANT IN THIS BUSY SCENE TO MAKE THE CHARACTERS AND OBJECTS STAND OUT FROM WHAT'S BEHIND THEM. IT ALSO ADDS TEXTURE TO THE CHARACTERS' HAIR AND THE DRAGON'S SCALY SKIN. SHADE THE WARRIOR'S ARMOR AND SHIELD TO BRING OUT THEIR SHAPE AND DEPTH. TO MAKE THE GEMSTONES LOOK IRREGULAR AND MULTIFACETED, SHADE THEM WITH UNEVEN STREAKS.

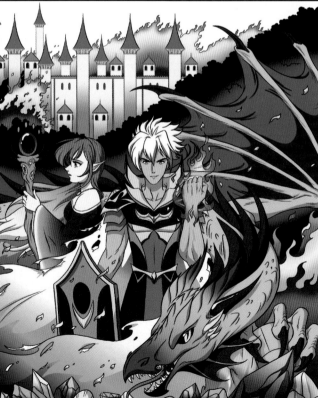

CONGRATULATIONS! YOU'VE COMPLETED YOUR LESSONS AT MANGA DRAWING SCHOOL. I'M VERY PROUD OF YOU! TAKE EVERYTHING YOU'VE LEARNED AND CREATE YOUR OWN MANGA CHARACTERS, SCENES, AND STORIES. SEE YOU NEXT SEMESTER!

FACE TEMPLATES

Assignment: Create your next manga main character! Photocopy these face templates and get designing. Use the faces in the middle as a guide on how to position facial features. But remember—it's OK to break the rules too!

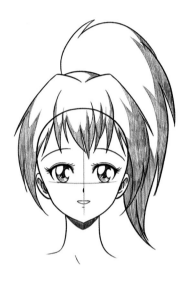

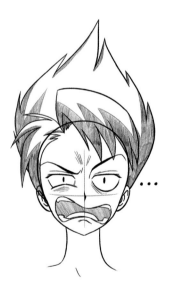

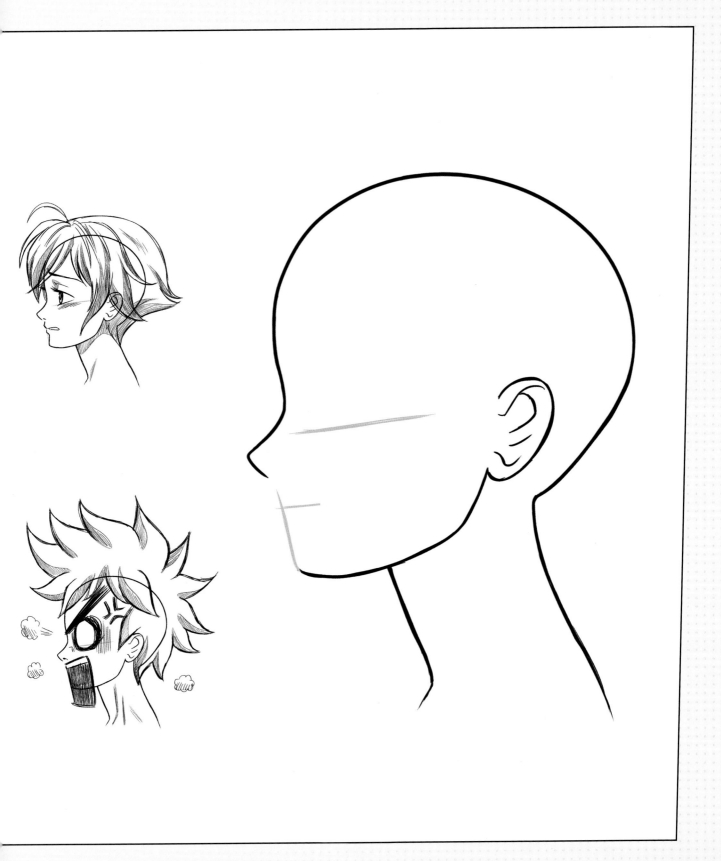

BODY TEMPLATES

Assignment: Unleash your inner fashion designer! Photocopy these body templates and design your very own outfits and clothes on top. What will you come up with?

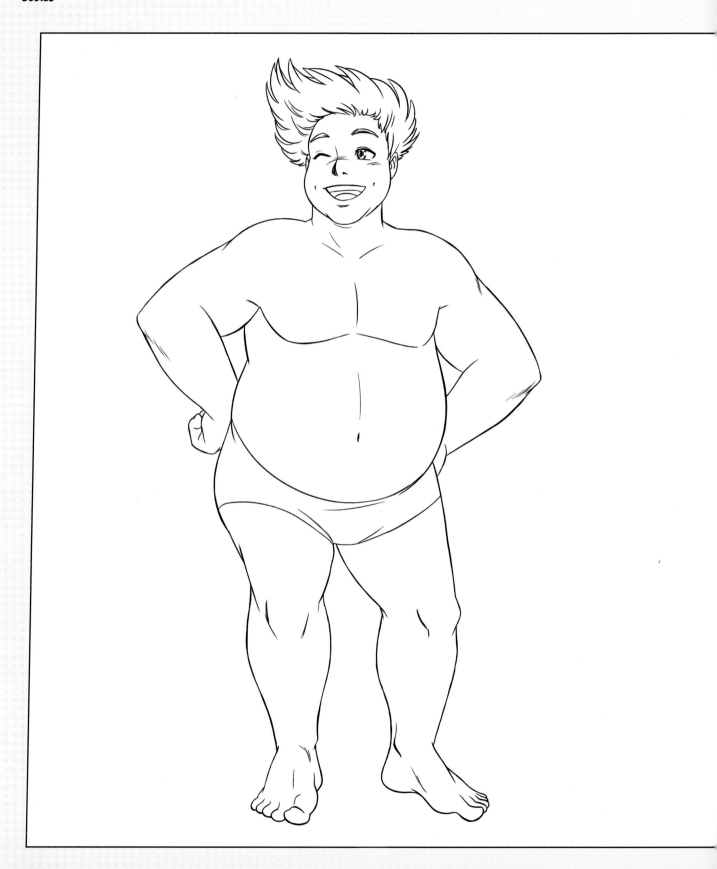

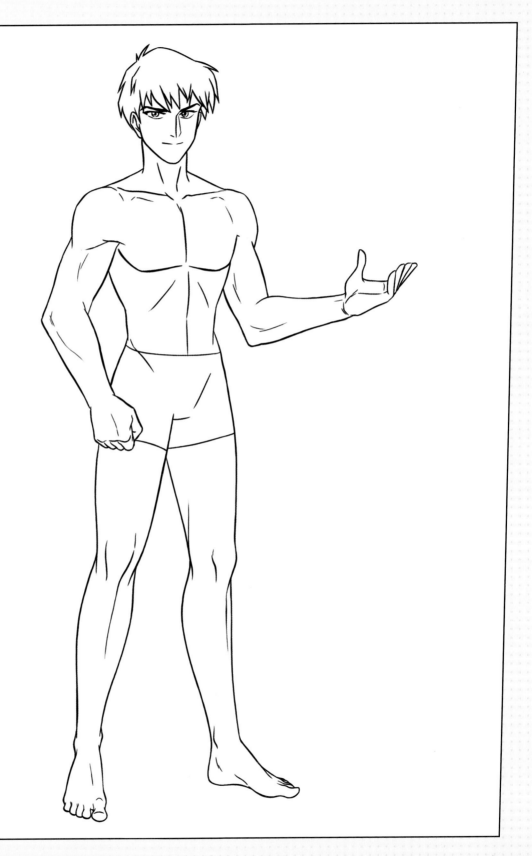

INDEX

Entries in **bold** indicate lesson titles

AUTHOR ACKNOWLEDGEMENTS

Manga Drawing School would not be possible without my DK family!

To my amazing editor Amy Slack, I'm so grateful for your extraordinary editorial guidance, planning, expertise, and your creative mind! To my imaginative designer Jordan Lambley, I love your unique manga panel page layouts, ideas, and dedication! A big thank you to Shari Black, Geoff Borin, Clare Double, and Katie Cowan! And a special thank you to Becky Alexander, for believing in me, introducing me to the DK family, and for kickstarting this amazing book.

To my hardworking agent, Steven Salpeter at Assemble Media, thank you very much for all your help!

To my Dad, Mom, and brother Shawn, thank you for continuing to believe and support me on my lifelong book journey since I was 9!

And thank you, all my wonderful fans and readers from around the world!

PUBLISHER ACKNOWLEDGMENTS

DK would like to thank Rachel Malenoir for proofreading and Vanessa Bird for indexing.

ABOUT THE AUTHOR

Mei Yu is a multitalented artist and author living in Vancouver, Canada. She has more than 1,000 art videos, 2 million followers, and 450 million views across her YouTube and Facebook platforms. Her collection of manga, anime, and cartoon drawing tutorials, art style challenges, and original "Animate My Life" animations are loved by millions worldwide.

Mei started drawing at age 2 and taught herself how to draw until high school. With more than 30 years of drawing experience and 20 years of teaching experience, Mei continues to inform, entertain, and inspire. Her debut graphic novel memoir, *Lost & Found: Based on a True Story*, has received great book industry reviews. She is currently working on her second graphic novel, and continues to create more books and art for her fans and readers.

Learn more about Mei at meiyuart.com, on YouTube @meiyu, on Facebook @meiyuartofficial, and on Instagram @meiyuart.

Acquisitions Editor Amy Slack
Senior Acquisitions Editors Zara Anvari, Becky Alexander
US Editor Heather Wilcox
Project Art Editor Jordan Lambley
Production Editor David Almond
Production Controller Luca Bazzoli
Jacket Designer Jordan Lambley
Jacket Editor Emily Cannings
Editorial Manager Clare Double
Art Director Maxine Pedliham
Publishing Director Katie Cowan

Editorial Shari Last
Design Geoff Borin

First American Edition, 2024
Published in the United States by DK Publishing,
a division of Penguin Random House LLC
1745 Broadway, 20th Floor, New York, NY 10019

A catalog record for this book is available from the Library of Congress.
ISBN 978-0-7440-9913-3

DK books are available at special discounts when purchased in bulk
for sales promotions, premiums, fund-raising, or educational use.
For details, contact: DK Publishing Special Markets, 1745 Broadway,
20th Floor, New York, NY 10019
SpecialSales@dk.com

Printed and bound in China

www.dk.com